Collection Jules STRAUSS

CATALOGUE

DES

IMPORTANTS

Tableaux Modernes

Pastels, Aquarelles, Dessins

PAR

P. BONNARD, E. BOUDIN, E. CARRIÈRE, G. COURBET, E. DEGAS, E. DELACROIX, E. DERAIN,
H. FANTIN-LATOUR, P. GAUGUIN, J.-B. JONGKIND, M. LAURENCIN, S. LÉPINE,
E. MANET, A. MARQUET, CL. MONET, A. MONTICELLI, B. MORISOT, C. PISSARRO, A. RENOIR,
K.-X. ROUSSEL, A. SISLEY, E. VUILLARD, J.-MC-N. WHISTLER

DONT LA VENTE AURA LIEU A PARIS

GALERIE GEORGES PETIT

8, RUE DE SÈZE, 8

Le Jeudi 15 Décembre 1932, à deux heures et demie très précises

COMMISSAIRES-PRISEURS

Mᵉ HENRI BAUDOIN | **Mᵉ ALPH. BELLIER**
10, Rue de la Grange-Batelière, Paris | 30, Place de la Madeleine, Paris

ASSISTÉS DE

M. JOS. HESSEL | **M. ETIENNE BIGNOU**
Expert près la Cour d'Appel | *Expert*
26, Rue La Boétie, Paris | 8, Rue La Boétie, Paris

EXPOSITIONS

PARTICULIÈRE : Le Mardi 13 Décembre 1932, de 2 heures à 6 heures.
PUBLIQUE : Le Mercredi 14 Décembre 1932, de 2 heures à 6 heures.

PICTURES, PASSIONS AND EYE

Pictures, Passions and Eye

A Life at Sotheby's

MICHEL STRAUSS

HALBAN
LONDON

First published in Great Britain by
Halban Publishers Ltd
22 Golden Square
London W1F 9JW
2011

www.halbanpublishers.com

A CIP catalogue record for this book is available from the British Library.

ISBN 978 1 905559 21 3

Book design by Spire Fine Art
www.spirefineart.com

Second Edition 2011

Typeset by Spire Fine Art
Printed in Great Britain by
MPG Books Ltd, Bodmin, Cornwall

For my mother Aline, Sally and Andrew

All prices are hammer prices and do not include
the buyer's premium, unless otherwise stated.

An eye to perceive
a heart to enjoy

From William Wordsworth,
A Complete Guide to the Lakes, 1846

His collection nourishes his mind, strengthens his soul and brings pleasure to his heart... he does not collect only for the pleasure to be derived from beauty, but in order to preserve examples of perfection for the future... The progress of all useful arts... must be one of the most noble occupations and pastimes of an honest man.

By Abbé Dulaurens, quoted in *The Robert von Hirsch Collection, the Collector, his Houses, his Bequests*, Sotheby's 1979, p.22

Qu'est-ce donc le goût?
Une facilité acquise par des expériences réitérées,
A saisir le vrai ou le bon, avec la circonstance
Qui le rend beau, et d'en être promptement et
Vivement touché.

Denis Diderot, found on a wall in the Musée des Art Décoratifs, Paris

Contents

CONTENTS

CONTENTS

CONTENTS

Preface

Writing a memoir is something I never conceived of tackling, but then, as so often happened when relating anecdotes concerning Sotheby's to others, it was suggested I should put pen to paper. About four years ago, I began to take the idea seriously and started on the lengthy task. Although I have an excellent visual memory for the pictures I have seen and the prices they have sold for, my recollection of events and conversations was much vaguer. Yet, as I started writing, more and more memories began to surface and, to help me further, I recorded numerous conversations, mainly with my mother, Aline Berlin, my son Andrew, other family members, friends and former colleagues.

Having fallen in love with art at the age of six when living in New York, I was to discover my grandfather's identical passion when I returned to Paris after the Second World War. Since that time I have been conscious both of the genes I inherited from him and how my life has been inextricably linked with his, in spite of the fact that he died when I was still very young.

It was not only my grandfather's passion for works of art that I inherited, but also his quest to hunt them down. A constant search for something new and unusual, something to excite the senses, the thrill of chasing after a rare object or painting, the pursuit of the finest quality and for fascinating historical associations, are what marked out Jules Strauss as a very special and much admired collector. All these elements have been passed on to his descendants: my father André, who also died when I was very young, me and my son Andrew. Four successive generations have

nurtured identical passions and deep feelings for paintings and works of art. What we all share is a highly tuned, intuitive 'eye', an instinctive notion of excellence in art, fostered by learning and experience. We all strive to test that 'eye' and knowledge, to keep on learning and discover new information, artists, movements and cultures.

There is one difference between Jules and myself: whereas he loved buying, selling and swapping, I find it difficult to part with anything, loving the buying but not the selling, unless I am trading up. For me, an acquisition becomes part of the fabric of the house or, as I have always said, 'one of the family'. From early beginnings in my teens, this predilection has evolved in me, as it did in Jules, and will continue to do so to the last of my days.

Having realised quite early on that the academic life wasn't for me, once my studies were sufficiently complete I determined to follow the dream I had had since childhood of working in a museum. When a position became available at the National Gallery in London I applied, but was unsuccessful and then, perhaps in what might be called a twist of fate, I fell almost by chance into Sotheby's. There I soon realised that what I really loved was the physical presence of paintings, the ability to look and touch them in the most direct manner. It was this synergy between art history and collecting and organising sales that became the perfect life for me, and in doing so I found in myself a previously inert ambition to succeed in all my endeavours.

These memoirs are not a history of the Impressionist and Modern Art market during the last fifty years, nor an exposé of any doubtful deeds in the world of auction houses, but much more a recollection of events that have touched me the most: the colleagues, the pictures, the collectors, the dealers and the sales, and how the guiding light of my eye and my passions have been inspired by my parentage.

Art and commerce have forever been inextricably linked: no artist can live without a market for his works and people have always had a very high regard and love for art which can transcend all boundaries and somehow raises their spirit to higher levels. Art is the expression of man's soul, emotions and beliefs and since pre-historic times has realised its potency, whether it be by means of cave paintings, Medieval altarpieces or the beauty of Impressionist paintings. In today's market such large sums of money are tied up with art, but as my step-father Isaiah Berlin once said to my mother when she complained that it's not proper to talk about money, he, the consummate intellectual, replied that money is the most interesting subject in the world: I believe art is the second.

The British Rail
Pension Fund Sale

There was a definite buzz of excitement in the air as people took their seats to attend the landmark sale at Sotheby's in London one evening in April 1989.

Amongst the significant events during my life at Sotheby's, there have been none so far-reaching in the time spent and sense of fulfilment achieved as the saga of the British Rail Pension Fund's investment venture into the art market. It all began following the 1973 Arab-Israeli/Yom Kippur war that prompted OPEC (the Organization of Petroleum Exporting Countries), to announce an oil embargo: they would no longer supply oil to those countries that had supported Israel. This in turn led to a global recession. Towards the end of 1974, the annual rate of inflation in the United Kingdom was 30%. Stock Markets had suffered heavy falls, the property market had collapsed and the art market was equally affected. We soon felt this in our sales – the price of many pictures slumped and quite a number did not find buyers at all. It was a difficult time for everyone and I remember hanging a sign which read 'THE DEPRESSIONIST DEPARTMENT' on the door leading to our offices. It stayed there until there were signs of real improvement at the end of the seventies.

However, for those who had money and a willingness to buy, there were some amazing bargains to be snapped up. It was then that Christopher Lewin, one of the executives responsible for the British Rail Pension Fund and an actuary by profession, as well as a collector of antiquarian books, decided to act. With an inbuilt comprehension of the collecting world, he was aware that the prices for such books were out-stripping other capital investments at that time and he had also spotted that works

of art could be bought in New York, for instance, without being penalised by the dollar premium which then ran at 58%. Art was a commodity that had unparalleled freedom of movement and international appeal. In the light of the economic climate, and keen to safe-guard the Pension Fund's investments, Mr Lewin put forward a plan to the trustees that they diversify into Fine Art and that an approach be made to Sotheby's to act on their behalf. He was given the go-ahead on the proviso that there should be a reasonable prospect for long-term capital growth which would at least equal inflation and, further, that there would be the possibility of an increase in real value in excess of inflation.

Accordingly, Christopher Lewin had a series of meetings with Peter Wilson, Chairman of Sotheby's, and, after much discussion, they agreed on ways to proceed which were approved by their respective boards. The Pension Fund made the decision that it would be better to buy in almost every field of art so that the funds available were spread widely – in a way covering their bets – and also not to buy any works dating beyond 1900 as they mistakenly thought Modern Art, even that of the early twentieth century, was too speculative. In retrospect, what a colossal mistake they made.

Needing a manager to run the project with Sotheby's, the Fund, at the suggestion of Peter Wilson, appointed Annamaria Edelstein, an Italian living in London, who was married to Victor Edelstein, a well-known couturier and one of Princess Diana's favourite designers. For some years she had edited *Art at Auction,* Sotheby's annual review, and thus was familiar with the departments and their experts, as well as having a broad knowledge of the many areas covered. The way the system operated was that prior to each relevant sale, the expert head of that department would propose a group of items considered suitable for the Fund. One of the problems was to get all the departments to say what they actually would like to recommend – and as is so often the case in life, some were tremendously enthusiastic and thorough, which resulted in marvellous sales, while others showed little interest and did less well.

Each expert had to make their proposals in writing accompanied by a description of the work's physical condition, quality and importance, a justification of the estimate and a suggested bid. Before all this was presented to Christopher Lewin and his committee, that expert had to make a presentation to a small group of colleagues, chaired by Annamaria, who would accept, modify or reject the proposals. Personally, I tended to steer the Pension Fund towards quite characteristic, fine quality examples by major artists and having to pass them by Annamaria certainly made me concentrate my mind on what was real quality as against what was superficially pretty. Under pressure from all sides, she was undoubtedly

good at separating the expert's desire to sell what they had from what was a good investment and, despite the Fund's embargo on works created after 1900, I was able to slip in an early coloured drawing of 1904 by Picasso, and a Matisse bronze of 1906.

Although the majority of the purchases were bought at Sotheby's, we were also instructed to consider Christie's sales and to buy from private collections (for example Picasso's 1905 gouache, *Le Garçon Bleu*) and from the trade when the right opportunities arose. A major element of the contract was that we had to guarantee the authenticity of all works purchased at auction. It was agreed that we would not charge the Pension Fund a fee for buying at auction, whether it was at Sotheby's or Christie's, but when it came to purchases from dealers we would charge them a five per cent commission since we had to guarantee the authenticity of those purchases.

The Pension Fund committee, taking into account our suggestions and relative enthusiasms, considered which works they wanted to bid on but did not let us know their decision or the size of their bids. Sometimes they would place lower bids, sometimes higher, sometimes they bid on works that we suggested, sometimes they did not. So as to further maintain an 'iron curtain' between us, they gave their bids to outside people to prevent us knowing when they were part of the action on any particular lot.

Annamaria's role was an enormously responsible one. As she did not have the depth of knowledge about specific markets, she had to exercise her own judgement after listening to the experts and before being cross-examined by the Pension Fund. We in the Impressionist and Modern Art department tended to propose sensible bids within the estimate range which Annamaria almost always accepted and, as the quality of the works the Pension Fund was bidding on was usually high, certainly as far as the Impressionists were concerned, they in fact only succeeded in obtaining between half and a third of what they bid on. Sometimes this was no bad thing, as that left more to be spent on subsequent sales as well as demonstrating to them that the bids were in line with the market and were not being ramped up.

During the late 1970s, at the height of their spending on art, the amount invested represented only 2.9% of the total assets of the Fund. Between 1974 and 1980, having spent a total of £40 million pounds on 2,425 works of art, the Pension Fund decided that was enough; there would be no more purchases. They had obviously begun to realise that such a large quantity of works of art was a nightmare to store, to value annually for the auditors, and on top of this, they had to keep track of the

many items that were sent on loan to museums and exhibitions.

Ten years later, when the art market had fully recovered, the Pension Fund, listening to our recommendations, decided it was a good time to start selling. By the terms of the contract, they had to sell at Sotheby's, either at auction or by private treaty, and as such it was agreed initially that our standard commission rate of 10% would be reduced to 5%. However, in 1975 we had introduced the non-negotiable, buyer's premium of 10% and I could understand why the Pension Fund refused to pay the agreed commission: why should we have an additional 5% from them, which they saw as a direct erosion of their profit? As a result the decision was made that the Fund would pay our expenses, but not a seller's commission.

By 1989, the Impressionist market was in the middle of a massive boom, fuelled by intensive buying from Japan, and with this in mind the Fund's holdings in that field were one of the first sales. The sale was quite heavily promoted internationally and included pre-sale travelling exhibitions to New York, Tokyo, Zurich and Paris. This not only had a promotional effect on Sotheby's image as the major auction house, but it also allowed buyers who might not be able to attend the sale in person to view the works themselves and subsequently bid by telephone. If a particular very important collector or institution was a potential buyer, but unable to go to one of these viewings, we were prepared to send one or more of the paintings to any destination in the world. For example the Getty Museum, then still in its original building in Malibu, was interested in Renoir's *La Promenade*. I asked my number two in the department, Melanie Clore, who was still in her twenties, to take the finest pictures from the Fund's collection to exhibit in our offices in Los Angeles. Accompanying these fabulous works and staying in the Beverly Hills Hotel, she later told me she thought she had died and gone to heaven. At a dinner there, she was placed next to George Goldner, then curator of paintings and drawings at the Getty Museum, who became a firm friend of hers and when, a short time later, the Getty decided to deaccession some of its Impressionist paintings, he contacted Melanie. The resulting sale took place in London in November 1989, just a few months after the Fund's own sale.

Finally, after months of preparation, the night of the sale had arrived – the final denouement. As in so many of the great sales I have organised, the months of catalogue preparation, travelling the paintings around the world, the week long view in London and the paraphernalia of a sale were all in place. The gallery staff was primed and ready, the paddle registration desk was in order and all were nervously waiting for the excited mass of people to shove their way into the packed saleroom and the adjacent galleries.

During the weeks leading up to the sale, the department had been talking to all potential buyers, some like myself, quietly informative and persuasive, whereas a few members of staff tended to be over-enthusiastically pushy, an attitude that I did not approve of. An hour before the sale was due to start, there was nothing more to do; I was sitting quietly in my office, tensely waiting for the main door to open at 6.30 when the crowds would be let in. At 7 o'clock sharp, I watched as Julian Barran (a senior colleague in the department and head of Sotheby's France at the time), our regular auctioneer, mounted the rostrum, welcomed everyone to the sale and began taking bids. The first lot, *L'Entrée du Port du Havre* by Eugène Boudin, made a disappointing £68,000, below the estimate, as did the next two before the action really began to gather pace when a fine watercolour, *Les Avocats* by Honoré Daumier made a substantial price. Thereafter, the bids rocketed up.

As with all these great sales over the years, it was fascinating to watch the bidding progress, people in the room indicating their bids by a wave of their paddle, by a discreet raise of the finger or by a simple nod of the head or lifting of the eyebrows. To the side of the saleroom, serried ranks of staff on their telephones were quietly relaying bids from collectors at the other end of the telephone who didn't wish their identities to be known. In the room itself, seasoned dealers, some nosier than others, were shuffling around in their seats, chatting amongst themselves (in later years talking on their mobiles), desperately trying to see who was bidding against them.

I watched intensely the toing and froing of Julian taking all these bids, gesturing from one side of the saleroom to the other, his eyes flicking forwards and sideways, into the middle of the room and to the back, just like an umpire in a game of tennis. But what was most exciting for me was to be bidding on the phone with a collector who might be sitting in his office on the other side of the world, sunning himself on his yacht off the coast of Turkey, or who had woken up in the middle of the night in a different time zone. Perhaps I would be bidding against another colleague, Andrew or David Nash, for example, themselves on a line to one of their own clients, for one of the highlights of the sale, pushing up the price, bid after bid, to unheard of record heights – another game of tennis, a very personal one, another match won or lost. The rush of adrenalin was extreme as the sums went higher and higher, repeating the bids to the client on the other end of the phone, saying, 'It's now at £4.8 million – do you wish to bid?', perhaps extracting another bid, nodding to the auctioneer, and so on till towards the end, as another collector bid again, I asked, 'One more bid?', trying to persuade him to go further, or, at times even advising him to stop if, in my opinion, the price became ridiculously high.

Finally, the last lot was knocked down, the sale was over and applause reverberated around the saleroom. The hordes of press gathered around to hear the statistics of the sale and bombarded us with questions about the identities of the buyers (always anonymous unless instructed otherwise) and what percentage were American, European or Japanese. A sense of great satisfaction washed over me, but gradually, as the excitement died down, this feeling was replaced by one of almost sadness that this great sale was over.

This Impressionist painting sale on behalf of the British Rail Pension Fund in April 1989 was one of the most exciting and personally satisfying events of all my time at Sotheby's. I was so proud of the final outcome which was a vindication of my knowledge, my taste and my eye. The fact that the sale realised so much for the Pension Fund was fantastic: their original outlay was £3.4 million and the resulting sale made them £34,869,000, some 70% above the pre-sale estimate; some of the works fetched twenty or thirty times their original purchase price from only ten or fifteen years earlier. I believe that part of the success was due to the fact that these pictures were my own personal choice – I would have been more than delighted to have had any one of them on my own walls – and this gave the group the character of a private collection, a factor that obviously appealed to buyers, as well as the fact that they had been acquired during a low point in the market and had been unseen for more than ten years.

At the same time as the British Rail Pension Fund was buying, some other great collections had come up for sale, notably the Robert von Hirsch collection from Basel in 1978, from which they acquired Camille Pissarro's 1871 portrait of his friend Paul Cézanne for £300,000. This was sold for £1.2 million. The Fund had also bought another portrait of Cézanne in a sale at Sotheby's in New York in 1976, a pastel by Pierre-Auguste Renoir executed in 1880, which was a much softer and sweeter work than the Pissarro. It made £1.3 million against a purchase price of $124,000. I was delighted to see these fine portraits of Cézanne, painted by his two friends, hanging together on the red baize-covered walls in the Entrance Gallery in New Bond Street, and it was so rewarding that they were both bought by the same British collector, Laurence Graff, the diamond merchant. He later sold the Renoir as he didn't think it was strong enough, but he still owns Pissarro's famous portrait which is on loan to the National Gallery in London, when it is not travelling to some Pissarro or Cézanne exhibition in Paris or New York.

Among other works from the Robert von Hirsch Collection, there was a fabulous Paul Cézanne watercolour, *Nature Morte au Melon Vert,* for which the Fund had paid £300,000 in 1978. This went to another

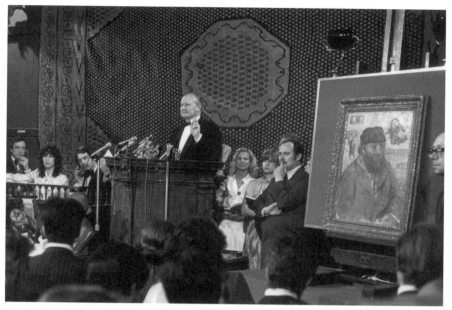

Peter Wilson at the rostrum selling Pissarro's *Portrait de Cézanne* at the von Hirsch sale, 1978

distinguished London collector for £2.3 million, who subsequently sold it at Sotheby's in 2007 for $22.75 million. The third von Hirsch purchase was a very strong, Vincent van Gogh reed pen and sepia ink drawing of fishermen's cottages at Saintes-Maries-de-la-Mer in the Camargue, which realised £2.1 million as against a purchase price of £205,000, this time acquired by an American collector.

A picture that I really loved in the group was of a splendid, brilliantly coloured view of the church of Santa Maria della Salute in Venice, painted by Claude Monet in 1908, during the two months he spent there painting. Monet, like John Singer Sargent a few years earlier, lodged in the Palazzo Barbaro on the Grand Canal and from there painted some of his thirty-seven canvasses of Venice. There are six variations of the same view of Santa Maria della Salute which he apparently painted while standing on the steps of the Palazzo, hopefully at low tide and undisturbed by the swell of water thrown up by passing gondolas. The Pension Fund received £6.1 million for this work, which I was particularly excited by and which I had first seen in a collector's house in Germany. I was delighted when he agreed to give it to us for sale in 1979 and even more so when the Fund decided to bid on it and successfully bought it for £230,000.

I was quoted, at the time, as saying that people had collected paintings from every period in Monet's *œuvre*, but they had done exceptionally well when they bought colourful, sunlit and appealing

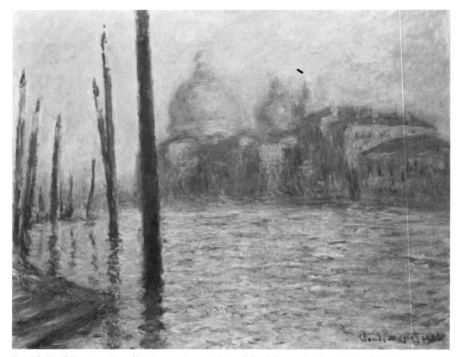

British Rail Pension Fund's Monet, *Santa Maria della Salute et le Grand Canal, Venise*, oil on canvas 1908, private collection

subjects such as the Venetian views. This applied to most of the works the Fund purchased. For example, the 1870 Renoir, *La Promenade*, in which George Goldner of the Getty Museum was so interested, is a beautifully painted representation of a fashionable gentleman helping a young lady in a pretty, white summer dress up the bank of a river. Of superb quality, it was painted when Renoir was at the height of his powers and is one of the great works of his early period. *La Promenade* had been in the Spingold Collection, a fine American collection, and realised £620,000 when it was sold to the Pension Fund in London in 1976. The Getty Museum paid £9.4 million and this is still, some twenty years later, one of the highest prices ever paid for a painting by Renoir. As for the important 1906 Matisse bronze, *Deux Négresses*, one from an edition of ten casts which I had managed to persuade the Pension Fund to buy for $100,000 in 1977, by selling for £1.6 million, it showed the greatest capital appreciation of all.

When I think that my grandfather, Jules Strauss, had begun boldly collecting a hundred years earlier what was then contemporary art by the leading Impressionist painters, the Pension Fund, by limiting itself to pre-1906 works, was playing very safe. They were extremely lucky to

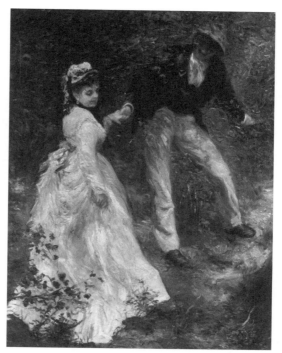

British Rail Pension Fund's Renoir, *La Promenade,*
oil on canvas 1870, J. Paul Getty Museum, Los Angeles

have begun buying at such a low point in the economy, brought about by
the oil crisis, and then to have sold at such a high point in the late eighties
boom, fuelled mainly by the Japanese speculative bubble economy.
Interestingly, all the works in that 1989 sale were bought by American
and European collectors and none by Japanese buyers. It would appear
that although the Japanese were a huge buying force in the Impressionist
and Modern market, these paintings were not to their taste which ran to
pretty Renoirs, of which there were truck loads, boring Monets, colourful,
repetitive Chagalls, tanker-loads of paintings by the artists of the School
of Paris, Utrillo, Vlaminck and, of course, their own artist, Tsuguharu
Foujita who spent almost all his working life in Paris.

In other areas, Chinese porcelain did exceptionally well and the Pension
Fund also had moderate success with Old Master paintings and Medieval
manuscripts, but in some fields such as Tribal Art, they barely recouped
their money, as was the case with Printed Books, Christopher Lewin's own
collecting field. With hindsight, if the Pension Fund had collected in only
a few areas, including the twentieth century, they could have had a much
greater overall success, but as has been said, they believed in a wide spread as
they always did with their other investments in financial markets.

The Pension Fund had decided to invest only a tiny percentage of their members' annual pension contributions in art, but even so there had been an enormous amount of negative comment from the press and from within the art world at the time, and how ill-founded that criticism proved to be. Members of the Train Drivers' Union had also objected initially, but some were pleased and I remember one engine driver telling a journalist how proud he was to own a painting by the famous Renoir. What is so interesting is that over the years the term 'a British Rail picture' has become an accolade and an enhancement to any provenance.

CHAPTER TWO

My Ancestors

Jules and Marie-Louise Strauss

On one of our regular visits to the Louvre in 1947, when there were few other visitors around, my grandmother, Marie-Louise Strauss, whom I affectionately called Mémé, told me that it was important to actually feel the physical surface of the pictures, that I should touch the surface very lightly with the back of my little finger. So I did. A guard rushed up to us, '*Madame, Madame, c'est défendu, vous devez l'empêcher!*' ('That is forbidden. You must stop him!') A small, quite formidable lady who always dressed in black with a matching black hat, Mémé stabbed her umbrella at him and said, '*Je suis Madame Strauss...*' at which he retreated, grumbling, finally recognising her.

Mémé had proprietorial feelings about the Louvre, treating it as if it were her own drawing room, no doubt because my grandfather had given the museum many important period frames. Jules Strauss loved Paris's museums, particularly the Louvre and, during his visits there, had observed that the great Italian pictures – the Raphaels, the Leonardos, the Titians – had inappropriate, ugly, 19th-century frames. One day in 1935, as he was passing by Lebrun, the famous dealer of antique frames, he noticed a very fine 16th-century Italian frame, recently bought in Florence, and knew it was exactly what was needed for Leonardo da Vinci's *Virgin of the Rocks*. Taking the frame to the Louvre, he tried it out with the curator of the Painting department and both were delighted with the result. For a few years after this, he continued to look for the right antique frames, making a gift to the Louvre of as many as fifty-six for Italian

Renaissance and French 18th-century paintings by, amongst others, Mantegna, Raphael, Leonardo, Titian, Velasquez, Vermeer and Watteau; all quite remarkable, considering he must have found them in the short space of time between 1935 and the start of the Second World War. He also donated to the museum a number of 18th-century French paintings as well as making gifts to the Château de Versailles.

The value he placed on the role of frames is certainly a trait I share with him, believing that as the beauty of a woman is so often enhanced by the quality of the clothes she is wearing, so too are pictures shown to their best advantage by the frames they are 'wearing'. In the same way, Renaissance paintings look their best in period frames, Impressionists are much enhanced 'dressed in' Louis XIV, XV and XVI frames, while 20th-century pictures are so often shown to advantage in simple but bold 16th- and 17th-century Italian and Spanish frames. After Jules died in 1943, Germain Bazin, the curator of the Painting Department at the Louvre, wrote in his condolence letter to Mémé, 'Certain collectors like to have their name attached to their gifts so as to be noticed by the public but M Jules Strauss, with a modesty that deeply touched us,

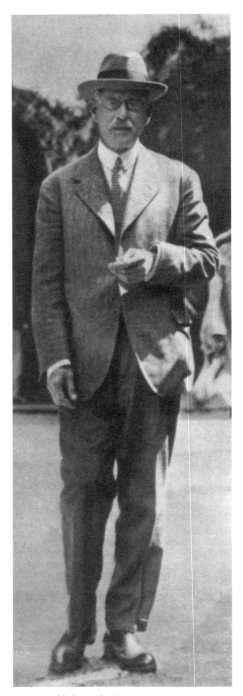

My grandfather Jules Strauss

My grandmother
Marie-Louise Strauss

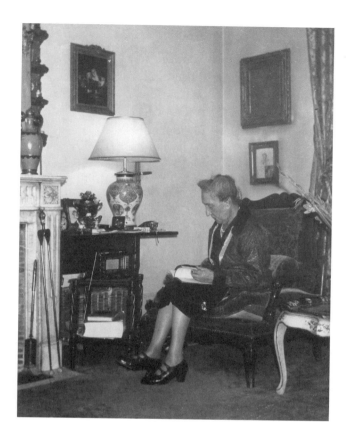

preferred to make his gifts in a more discreet way which was no less appreciated by us.'

Whatever paintings have passed through my hands – mostly during my professional life at Sotheby's – I have touched the surface very lightly with the back of my right index finger, feeling if there is much impasto as evidence of the artist's original surface, or whether the paint has been ironed flat during a relining of the canvas, although this technique for long-term conservation is, today, much less favoured by museum curators, collectors and dealers. Sensing the thickness and tightness of the canvas in this way can often tell you whether the picture has been relined or not, if it is in good or doubtful condition: that is something which I learnt from Mémé and which would prove to be a vital tool of my trade in years to come. In the same way, I have always felt a need to run my hands over sculpture (except in museums!), feeling the fineness of the chiselling, the quality of the patina as indications of age and authenticity and the forms revealed by the genius of the sculptor.

Mémé, *née* Marie-Louise Kahn, was born into an upper-middle-class Jewish family in 1872. The Kahn family originated in Frankfurt, although my great-grandmother, Adelaide Kahn, came from Leeds and, keeping her surname, married her first cousin Julius who lived in Paris. The Kahns were known to be outspoken and Mémé, who was born in Paris, was very much in the family mould. Unconventional, as a very pretty young woman she had courted disapproval by, for example, wearing a shocking red hat. Although she aged into quite a formidable old lady, Mémé was really sweet to me, one reason being that when I was two and a half years old, her only adored son, my father André Strauss, had died at the age of thirty-five; the fact that I was his son meant a great deal to her.

Ironically, although I had happily inherited my grandfather's genes, it was Mémé who taught me how to look at art, to appreciate and develop critical faculties. She introduced me to paintings, furniture, silver and porcelain, in museums such as the Musée Carnavalet (the museum of the history of Paris) and the Musée des Arts Décoratifs which was to instil in me a love of furniture, objets d'art and textiles. We visited the Jeu de Paume where the great collections of Impressionist paintings were beautifully exhibited in an almost intimate setting until, deplorably, they were moved to the cavernous gloom of the Musée d'Orsay in 1986. We wandered happily through all the galleries of the Louvre – the paintings and sculpture of the French and Foreign Schools, the antiquities of Egypt, Greece and Rome, Medieval art and the treasures of the Cabinet des Dessins. She also taught me that the quality of a great artist could be recognised by the skill with which he painted hands; I find this is something I am still very aware of when looking at portraits where, so often, hands play an important, expressive role. One of the lasting memories is of the day she told me to feel the surface of a painting with the back of my index finger, in particular, touching, very gently, the dark, quite heavily varnished surface of a Renaissance masterpiece, Raphael's majestic portrait of *Balthasar Castiglione*. That was, without doubt, the moment I discovered a special love for portraiture as a great artistic expression of a person's character.

My grandfather, Jules Strauss, the son of a banker, was born in Frankfurt in 1861. He developed an early passion for art and, from a very young age, his dream was to leave Frankfurt and Germany, where he felt Jewish life and the local German culture were too restrictive and narrow minded, and go to Paris. In 1880, when he was eighteen, he had the good fortune to be sent there as a trainee at the stock-broking firm, Daniel Dreyfus, and, by the time he and Mémé married in 1897, he had his own modest company, Société Strauss et Compagnie, a private bank at 13 rue Taitbout in the *9ème* arrondissement. In 1904 they moved into a large

apartment on the third floor of 60 avenue du Bois de Boulogne (renamed avenue Foch after the First World War), which they took over from the playwright Georges Feydeau.

It was his habit each morning to visit the dealers around the rue Taitbout, in particular one nicknamed '*Le Brigand Sympathique*' (the charming bandit) and, in later years, Nicolas Landau with whom he shared a similar vision and taste for rare and unusual objects. In the afternoons he would make his way to the nearby auctions at the Hôtel Drouot or the Galeries Georges Petit, where he bought numerous works at the Degas *atelier* sales of 1918–19, and at least three times a week he visited his beloved Louvre. My father, André, who was born in 1903, showed similar artistic sensibilities and from a very young age Jules often took him along on his daily visits to the auctions.

By 1884 my grandfather was already collecting art for which he had a natural instinct. He bought Dutch and Flemish Old Masters, and especially French pictures of the 18th century. He had a particular passion for the paintings of Antoine Watteau, owning several pictures by him and his followers, as well as putting together a considerable archive of documents and related books, even writing several articles on Watteau which were published in art historical journals. Collecting rare, interesting pieces of furniture from the Louis XIV, Régence and Louis XV periods that had a special quality and meaning to him, in addition to sculpture, porcelain, unusual collector's cabinet objects such as 17th-century babies' coral rattles, bronze fire irons by Cheniller and illustrated books were all part of this passion. He was incapable of resisting the temptation of acquiring any object of great curiosity and quality that crossed his path. They came and went because he disposed of as much as he bought; this came about as his tastes changed and evolved, sometimes through necessity, but often just for the simple pleasure of swapping one object for another with friends. His friend Nicolas Landau, a dealer in the finest Renaissance and Baroque Works of Art from the 1920s till his death in 1979 and known in Paris as *Le Prince des Antiquaires*, described '*le goût Strauss*' as 'a unique object of special quality, fascinating as long as you knew how to understand its merits. It is, for example, the coffee service that belonged to the Marquise de Pompadour, of which the cups are enamel "because", Jules Strauss explained, "Louis XV was too clumsy to be served with porcelain".'

Although his real love was for the Venetians – Titian, Tintoretto and Veronese – he was also drawn to those contemporary artists whose work was readily seen in several Paris galleries and available at the moderate prices he could afford. By the very end of the 19th century, he had acquired a considerable number of Impressionist works, which included six Monets,

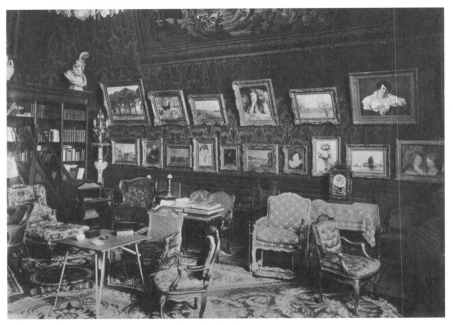

Jules Strauss' Impressionist paintings hanging in his study

three by Degas, a Manet, two Cézannes, fifteen Sisleys and a group of Renoirs which were mostly hung one above the other in his study. After twelve years of avid collecting, Jules decided to put up for auction his first collection of seventy-one Impressionist paintings and a further fifteen works on paper. Prior to the auction he explained to a journalist, 'I have no place left in my study, frames touch each other, covering all the walls, and I am even obliged to leave some of my paintings on the floor, stacked against the wall.' *'Catalogue des Tableaux Modernes et Aquarelles composant la Collection de M Jules Strauss'* announced the sale which took place at the Hôtel Drouot on 3 May 1902. In the preface to the catalogue, Arsène Alexandre, the highly respected art critic of the time and author of Monet's first biography, describing Jules' confident and excellent taste, predicted that this, combined with his preference for quality over quantity, would ensure that the Strauss sale would be a milestone in the annals of Impressionism and Modern Art. 'All these paintings have different characteristics, but with their own individual intensity, they hold up admirably against each other. When such a homogenous collection comes up for sale it is an education for all. It is for us to enjoy the generosity of a collector, who has had the exquisite pleasure of having had them in his own house for a time.'

He may have decided on the auction in order to raise capital, but it would seem likely that he saw it as a way of testing the growth potential

of this relatively new market as other collectors of Impressionist paintings of their time, such as Eugène Blot and the Prince de Wagram had recently done, and with success. Whatever the reason, this sale was to make him even better known among dealers and collectors: all but a few works, which he kept back when they didn't reach their reserve price, were sold.

Jules' passionate collecting at this time places him in the third wave of Impressionist collectors, the first being a few devoted French collectors, mainly friends and critics of the artists in the 1870s. The second comprised those American collectors who had access to the finest Impressionist landscapes and portraits, thanks largely to the Impressionists' dealer, Paul Durand-Ruel, who opened a gallery on New York's 5th Avenue in 1886, and to the influence of Mary Cassatt, the American painter who befriended Degas and had a close circle of friends, in particular the sugar king, Horace Havemeyer and his wife Louisine. The third wave, to which Jules belonged, consisted of European buyers prior to 1900.

As a great admirer of Sisley, the best of my grandfather's fifteen examples of the artist's work was the 1876 *Inondation à Port Marly*. Among the several Monets, *Les Pins Parasols, Cap d'Antibes* was bold and striking, but, looking through his beautifully produced catalogue, the painting I would most like to have inherited is *Débacle*, Monet's depiction of ice flows smashing into each other on the Seine during the harsh winter of December 1879. A desolate picture, you can feel nature gripped by the great freeze. Sadly it will never be mine as it is now in the Calouste Gulbenkian Museum in Lisbon, bought by the eclectic Armenian collector in 1925.

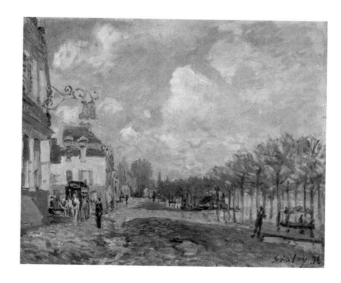

Jules Strauss' Sisley,
Inondation à Port Marly,
oil on canvas 1876,
Thyssen-Bornemisza
Museum, Madrid

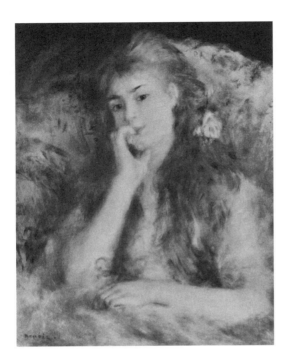

Jules Strauss' Renoir, *La Pensée,*
oil on canvas 1876, National
Museum of Wales, Cardiff

The most ravishing picture of all was Renoir's *La Pensée*, an oil painting of 1876 representing a seated young woman, deep in thought. Renoir objected to the name saying, 'Why has this title been given to my canvas? I wanted to portray a lovely, charming young woman without giving a title which would give rise to the belief that I wished to depict the state of mind of my model... that girl never thought, she lived like a bird and nothing more...' Fifty-six years later, *La Pensée* was one of the famous seven paintings sold for an unprecedented amount at the Jakob Goldschmidt sale held at Sotheby's in 1958, a sale I regretted not attending as I was still at Harvard.

The new artists at the turn of the century, Picasso, Matisse, the Fauves or the Cubists, did not seem to have attracted Jules as a collector. However, he must have been impressed by these younger artists as, during a journey to Moscow in 1914, where he visited the famous contemporary art collection of Sergei Shchukin, Jules, astonished by what he saw, wrote 'In the music room, twenty Matisses, brutal, captivating, Asiatic, in the dining room, twenty Gauguins, finally in the bedroom Picassos'. Now shared between the State Hermitage Museum in St Petersburg and the Pushkin Museum in Moscow, these extraordinary collections include many of the greatest works by Gauguin, Picasso and Matisse produced during that revolutionary upheaval of the arts between 1900 and 1914.

Believing that everything you could possibly want to see in the world existed in his adopted city, my grandfather often repeated, 'You only travel in Paris'. However, he visited Italy every year, but, according to the notes he made of all his purchases, he only bought works by Tiepolo while there. Amongst other purchases abroad, he negotiated with the Berlin dealer Paul Cassirer and brought back to Paris a famous portrait of Richard Wagner which Renoir had painted in Palermo in January 1892. Wagner had at that time just finished writing his opera *Parsifal*.

Jules relentlessly sold, bought and exchanged works of art. After his death Mémé gave me his fascinating notebooks in which he describes his buying and selling activities. These, together with the catalogues of his two sales, reveal that, over more than forty years of collecting, my grandfather owned more than 200 Impressionist paintings. Between 1902 and 1932 he began another collection, this time more interesting and varied, adding Bonnard and Vuillard, but still rooted in the tradition of late 19th-century painting. Then, distressingly, in 1932, he had another sale of his Impressionist paintings. His two sons-in-law had the misfortune to get into financial difficulties during the Depression, and in order to bail them out and preserve the family honour, he felt obliged to sell his whole Impressionist collection of eighty-five works. If I had been in his shoes I would have been devastated to part with my treasured Impressionists but, in the end, would probably have done so for the sake of my children's well-being. Given the timing, the sale was certainly perceived as a sensational event in the art world, although the prices were disappointing – not only was it the talk of the town in Paris, but it was also featured in New York's *Art News* magazine at the time.

The highest price achieved was for Manet's ravishing portrait of Berthe Morisot (an Impressionist painter married to Manet's brother Eugène), which made the highest price of 360,000 francs (now in the Cleveland Museum of Art). Included were twenty works by Degas, many of which came from the Degas atelier sale of 1918–19, paintings by Bonnard, Delacroix, Sisley, Vuillard and Renoir, whose portrait of Richard Wagner was bought by the famous pianist Alfred Cortot, who bequeathed it to the Louvre, eventually ending up in the Musée d'Orsay.

My first cousin, Nadine Baer, remembers so clearly how our grandfather would leave his apartment in the avenue Foch each morning with an object in his pocket and return each evening with something quite different. After my grandmother complained that he was spending too much money buying art, Jules started locking his surreptitious purchases away in a large cupboard in his study or would store them in dealers' shops

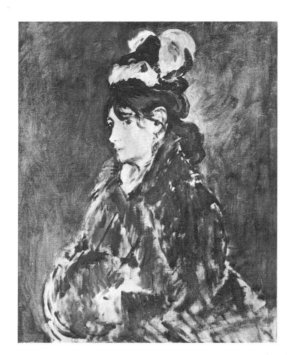

Jules Strauss' Manet,
*Portrait de Berthe Morisot au
Manchon,* oil on canvas 1868–9,
Cleveland Museum of Art

rather than take them home. She would also send their chauffeur, Robert, to collect Jules from one of the dealers, perhaps in order to curtail his collecting activities, but Jules, with his well-tuned antennae, would decline the lift saying he preferred to walk or take a taxi.

For almost fifty years this tall, grey figure with a distinctive German accent, was a familiar sight in galleries such as Durand-Ruel and Ambroise Vollard in the rue Lafitte and the salerooms of the Hôtel Drouot. He wore old-fashioned round-rimmed glasses, and a Gauloise cigarette permanently hung from the side of his mouth, as he lit one from the butt of another, resulting in him sporting a nicotine-stained moustache. My grandfather made a good recovery following a heart attack in 1939 and ceased smoking from one day to the next, although he continued to suck on a Bakelite cigarette which infuriated Mémé.

Even though he loved chocolate éclairs, something I must have inherited from him as well, my grandfather remained as thin as a rake. He adored young people and especially, in later life, his grandchildren. He would fetch my cousin Nadine from school each day and take her to a patisserie for a cake before lunch. Sometimes they would visit the Louvre together or he would spoil her by taking her to eat her favourite delicacy of caviar with slices of grapefruit in a restaurant on the Place Beauvau, opposite the Elysée Palace.

Jules adored women and had long-term mistresses, including Mme Léon-Paul Fargue (wife of the poet) and, more importantly, Olga, the wife of André Wormser. Both Mme Wormser and her husband, André, were close friends of my grandparents. It comes as no surprise that Jules played a modest but key role among his collector friends for he was much admired for his knowledge and eye for quality and thus became an informal advisor to family members and close friends, including the Wormsers. Over the years he advised them on acquiring a fine, collection of Impressionists, including works by Monet, Degas, Renoir, Vuillard and Bonnard. The Bonnard, *Les Promeneurs sur la Digue*, painted in 1906 and bought on the advice of my grandfather only four years later, is an example of his appreciation of certain contemporary artists. Over the past twenty years, my son Andrew, who joined Sotheby's in 1983, and I, have sold several paintings for the family, including the Bonnard, and their Monet, *Glaçons, environs de Bennecourt*, which made £340,000 in June 1996. It is true to say that, even now, after all these years the name Jules Strauss found in the early provenance of a painting somehow adds cachet to its history.

When he died in 1943, he left neither land nor a significant portfolio of shares, but hundreds of works of art which had been put in storage at Tailleur's warehouse in Paris. They miraculously survived the war and were eventually recovered by my grandmother Mémé after the Liberation of Paris.

Emile Deutsch de la Meurthe

On my mother's side, her maternal great-grandfather, Alexandre Deutsch was born in 1815 in a village in Lorraine. He too, like Jules, moved to Paris and, starting from scratch, founded a vegetable oil refinery in 1845 at Pantin on the outskirts of the city. In 1861, after he heard of the opening of the first oil well in Pennsylvania, Alexandre ordered a shipment in order to examine its properties and quickly realised its potential for providing brighter and cleaner lighting for oil lamps, the principal form of general lighting until the development of electricity. With his two sons, Emile and Henry who joined their father in 1866 and became partners in the firm of A. Deutsch et Fils in 1877, Alexandre eventually built two large oil refineries near the Atlantic coast and began importing oil from America, so moving into oil refining and distribution. In 1879 the family joined forces with the Rothschild brothers in Paris to take over the Spanish market and their business quickly spread into Russia and Austro-Hungary. By the end of the century, they were amongst the first to realise

the potential of petrol refined from oil in the development of the combustion engine.

Alexandre's sons both married into affluent Jewish families in 1877 and later changed their name to Deutsch de la Meurthe, named after the *département* in Lorraine from which the family originated. They were known for their patriotic sponsorships and philanthropy. After the death of his wife Louise in 1914, my great-grandfather Emile founded the Cité Internationale Universitaire in Paris in her memory in 1922, the first university campus in France. His brother, Henry, a member of the French Aero Club was fascinated by the possibility of air travel in which he also saw a future market for the family oil company. As an incentive to the development of air travel, he offered a prize of 100,000 francs to the first airship pilot to complete the 11 km flight from the Club's Parc d'Aerostation at St. Cloud, round the Eiffel Tower and back to the Club in less than thirty minutes. The prize was won on 19 October 1901 by the famous Brazilian aviator, Alberto Santos-Dumont.

In the years preceding the First World War, Henry successfully lobbied for an air force as he feared Germany's superiority in this new form of warfare. During the war, the Deutsch firm supplied oil and explosives to the French government, which from that point on tried to take control of the business. Shortly after the end of the war Henry died in a motorboat accident. Emile continued to run the company on his own until 1921 when, given the fact that all eight daughters of the two brothers had married charming men with no interest in business whatsoever, together with pressure from the French government to nationalise the business during the First World War, he decided to sell the company to Royal Dutch Shell, with whom he already had a close relationship. Emile remained a member of the board until his death in 1924.

Emile had married into the Halphen family and of his four daughters, Yvonne (born in 1882), who was to become my grandmother, and her sister Lucie, the baby of the family, had little interest in art, but the other two sisters, Valentine Esmond and Marie Goldet, collected fine examples of 18th-century and Impressionist paintings and several 20th-century works by artists such as Bonnard, Vuillard and Matisse.

On my maternal grandmother's side of the family, the best known collector was Alice Halphen who owned one of my favourite paintings by van Gogh, *La Sieste, d'après Millet*. It depicted two harvesters dozing in a haystack, after a print by Millet, and was painted when van Gogh was being treated in the *Hôpital St. Paul* at St Rémy in Provence in 1889. Alice gave it to the Louvre in 1952 and it was one of the many masterpieces transferred to the Musée d'Orsay.

Baron Horace de Gunzburg

On her father's side, my mother's paternal great-grandfather, Evzel Ginzburg, was born in Vitebsk in 1812. When the State monopolies in Russia were privatised and made available to Jewish investors in the mid 1800s, Evzel applied for one of the first liquor tax farms: at that time liquor tax was by far the largest source of revenue for the Russian government. It is said that Ezvel married the daughter of a local vodka merchant in Odessa and the family fortune was based on the fact that he was awarded the concession (which gave beneficial terms to the Russian treasury) to sell vodka to the Russian army during the Crimean War. Whatever the truth of the matter, Tsar Nicholas I, who rejected most petitions from Jews for hereditary honorary citizenship, granted this status to Evzel, his wife and children in 1852. During the time of liberalisation under Alexander II and the ending of the State monopoly on banking, Evzel became one of the first private Russian bankers, founding banks in Kiev, Odessa and St Petersburg.

From 1872, Evzel's son, my great-grandfather Horace, served as an unpaid Honorary Consul in St Petersburg to the Prince of Hesse for whom he had arranged substantial loans and, as a result, was awarded the hereditary title of Baron. At this time, his family were living part of the year in France, writing to each other in French and adding '*de*' to their surname, to emphasise the newly acquired title: Horace's visiting card read '*Baron H. de Gunzburg*'. The Gunzburgs' palace on Konnogvardeiskii Boulevard in the centre of St Petersburg was known as a gathering place in both intellectual and artistic circles. Horace, although not a collector as such, did commission a huge bust of Alexander II from M.M. Antokolsky, a sculptor of Jewish origin, and with the aid of Vladimir Stasov, the Russian critic, was influential in getting Antokolsky recognised as one of the greatest Russian sculptors of the time. In 1880, Horace, with one or two other Jewish benefactors, founded an organisation which came to be known as ORT (*Obshestvo Remeslenogo Zemledelcheskogo Truda*) – the Society for Trades and Agricultural Labour among the Jews of Russia – and ORT schools can now be found in 1,959 cities around the world, continuing the tradition of training, education and the teaching of skills to both young Jews and non-Jews.

It had long been the custom among the Russian nobility and wealthy merchant families to spend part of the year abroad, particularly in Paris. Horace's parents had been buried there and when he died in St Petersburg in 1909, his body was taken to Paris for burial. As Horace had been a great benefactor during his lifetime, he decided not to leave any

bequests to charities, but rather to his children in the hope that they would continue the family tradition of philanthropy. However, the Bolshevik Revolution of October 1917 wiped out a large part of the family fortune.

Dmitri, one of Horace's sons, was a patron of the arts and an early sponsor of Diaghilev's ballet company, while his cousin, Nicky de Gunzburg, an elegant man about town in New York in the 1930s, became fashion editor of *Vogue* and *Harper's Bazaar* in America; amongst his protégés was the fashion designer Calvin Klein. Another of his sons, David, a famous Oriental linguist who owned one of the largest private libraries in Europe, subsidised Marc Chagall during 1908–9 and introduced him to his liberal Jewish friends in St Petersburg.

André and Aline Strauss

My grandfather, Baron Pierre de Gunzbourg (at some stage he added an 'o' to make his name sound French), another of Horace's sons, married Yvonne, the daughter of Emile Deutsch de la Meurthe, in October 1902. Although she was to grow up in Paris, my mother Aline, the youngest of their four children, was born in January 1915 in London where the family had moved temporarily to ensure safety from the advancing German army at the outset of the First World War, fearful that Paris would be shelled. In Paris, the family lived in one of the huge apartments in the *hôtel particulier* built by Emile in 1882 at 54 avenue d'Iéna, one of the avenues radiating from the Arc de Triomphe. He lived on the first floor while the other apartments were occupied by my grandmother's sister, Valentine Esmond and her family, my grandparents Pierre and Yvonne and their children Philippe, Beatrice, Cyrille and Aline, and later by the Fould family who were not related, but were very close friends, especially my mother Aline with their two daughters, Thérèse and Liliane.

Each family had an abundance of servants when my mother was growing up. She remembers with great clarity, more than eighty years later, that the household consisted of two cooks, Alcide the *maître d'hôtel*, *valets de pied et valets de chambre*, nurses and under nurses, lady's maids, chefs, kitchen maids and two chauffeurs. Alcide sometimes got a little drunk when serving, but no one seemed to mind. The *valets de pied* were dressed in the Gunzbourg family's dark green livery; the children's prams were painted the same dark green as were the cars which also had the family crest emblazoned on the side. A petrol pump was installed in the courtyard of 54 avenue d'Iéna for the use of the family and there it remained until shortly before the outbreak of the Second World War when my grandfather

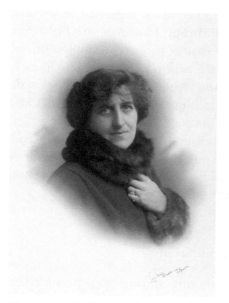

My grandmother Yvonne de Gunzbourg

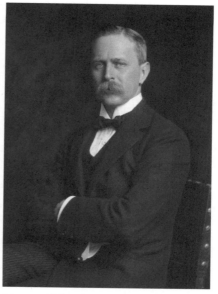

My grandfather Pierre de Gunzbourg

had it removed, having discovered that it had become a free-for-all for cousins and beyond.

Aline was brought up bilingually, speaking both French and English, thanks not only to her formidable nanny, Miss Bradbury and her governess, Miss Benton, but also to my grandparents' love of the British lifestyle; they would spend summers at North Berwick in Scotland in the house rented each year by the Esmonds. Aline was a timid child, but life in avenue d'Iéna was wonderful for her. There were three other little girls to play with: Thérèse (Poppy) and Liliane Fould and her first cousin Lulu Esmond. They would meet in each other's nurseries, on the grand staircase, or in the nearby park on Place des Etats Unis. As a treat they were allowed to peep through a glass door giving a view on to the 'galerie' watching grand guests arriving for dinner. When, later, the four girls had private music lessons or homework after school, a prearranged code played on the piano announced the end of their studies and they would rush to meet each other on the staircase. It is strange to think that until she was thirteen, Aline had to share a bedroom in such a large apartment with her nanny and her brother Cyrille whom she adored.

At the age of seven my mother had her first golf lesson at the St Cloud golf course adjacent to the country house at Garches, a village just west of Paris, which my grandparents had had built in the then popular mock-Tudor style in 1921. She continued to play both there and during

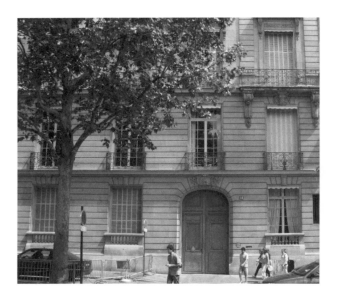

The family *hôtel particulier* at 54 avenue d'Iéna, Paris

holidays spent in North Berwick, becoming an extremely fine and competitive golfer. At eighteen she received the first of many proposals of marriage, including one from Jacques Schumann, whose father my grandmother Mémé had been very much in love with before she married Jules Strauss. Jacques would later marry Henriette Halphen, Aline's cousin, and it was Henriette's mother, Alice, who had donated her famous van Gogh to the Louvre in 1952.

It was through Philippe, her older brother by eleven years who had married Antoinette Kahn in June 1934, that Aline got to know Antoinette's first cousin, André Strauss. He first spotted her in Kitzbühl and quickly thought of her as a possible wife. So it was, one day late in 1933 he asked her to join him at the Closerie des Lilas in Montparnasse, a café-restaurant where famous artists and writers of the time congregated. For her, meeting a young man unchaperoned in a café was an exciting experience that involved crossing the Seine to the 'bohemian' left bank – the first time Aline had visited that *quartier,* further evidence of her restricted and sheltered upbringing. She was completely taken aback when, over coffee, André asked her to marry him, but declined his offer as she was not really interested in him at that time. So many proposals of marriage obviously worried my grandparents and early the following year, 1934, when she was just nineteen, they decided to take their youngest daughter to the United States. They not only wanted to prevent her marrying too young, but also to avoid her breaking a leg if she went skiing that winter. She was soon to do both. During long train journeys across America, my mother thought

a lot about André and on her return they met again and became secretly engaged on 23 April 1934. The very next day she won the French golf championship – all in all it was an extraordinarily good week for her.

André, known to everyone as Dédé, eleven years older than Aline, was noted for his charm and good looks. He quickly won over her parents who finally agreed that he could marry their daughter. The wedding ceremony took place on 23 October 1934 in the synagogue on the rue de la Victoire, a ceremony which my father hated as he was not a practising Jew.

On return from their honeymoon, which was spent travelling around the Mediterranean, my parents lived for a while in my father's *garçonnière*, a lovely apartment in the rue Marignan where the walls of one room were covered in Chinese porcelain birds; a *pièce aux oiseaux*, as it was called. André was a man of great taste and passion, especially when it came to collecting very fine French furniture and Old Master pictures. Although he worked in a bank, he was far more interested in collecting and most afternoons would go to the sales at the Hôtel Drouot, often buying without telling his wife – exactly like his father, Jules. My mother was only to discover this in sad circumstances a few years later, after Dédé died, when several prominent dealers contacted her asking her to collect his purchases. Fortunately for her, they were willing to cancel the sales.

Aline and André soon moved into an apartment on the second floor of the avenue d'Iéna, which he decorated beautifully; they continued

My parents Aline and André (Dédé) Strauss in 1934 (photograph Georges Hoyningen-Heune)

My father's *garçonnière*

buying furniture and pictures to complement those my father had had in his *garçonnière*. It was there, in Dédé's bedroom which was set up as a delivery room, that I was born on 23 September 1936. My mother told me that when her sister-in-law Antoinette became pregnant, she and my father quickly decided to follow suit. Six weeks before my birth, my first cousin, Patrice, was born and thereafter, until the war separated us, we were brought up together, each with our own nanny; his a formidable English woman, Nanny Joyce, and mine a nice Swiss woman, Mademoiselle Weber.

I don't think we were always the best-behaved of boys for one of the many pranks we got up to took place when an army officer came to visit; we threw his military cap into the bath tub for which we were severely punished. Before the arrival of Mademoiselle Weber, I had had several inadequate nannies, including one who left me sleeping in my pram in the middle of the afternoon, outside a building where she had gone to meet her lover. I was spotted by a friend of my mother, who immediately reported back and the nanny was sacked on the spot.

In the year after my birth, my father was diagnosed with cancer in 1937, but, following two operations, the disease went into remission. Cancer was an almost taboo subject then and nobody, apart from Mémé, was aware how ill he was; even my mother did not know the extent of his illness until very much later. In September 1938, my father was drafted as part of the general mobilisation. Fearing that war might break out imminently and Paris be bombed, we left the city on 29 September only to return the next day after hearing that the Munich agreement – Chamberlain's 'Peace in our time' – had been signed. That winter, believing Dédé to be well, my mother went skiing and it was then that she finally broke her leg. Feeling that they would need a refuge in case

On the beach at Deauville, July 1937, aged ten months

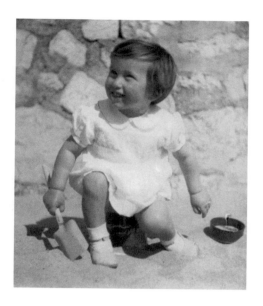

of war, my father bought the classic red brick and stone 17th-century Château de Brécourt in Normandy. Tragically, it was not to be a place of safety for my father. By the end of that year he fell ill again: cancer had spread to his liver and he died on 2 May 1939, aged only thirty-five. As he lay dying he made my mother promise not to bring me up in the Jewish faith. Although I am not a practising Jew, I am proud of the history, traditions and culture I inherited.

In his memory my mother gave the Louvre a superb bronze bust of Louis XIV as a child. It had been bought by Jules Strauss some years earlier and is now one of the most important 17th-century bronzes in the museum. I must admit that, although I am happy that the bust is there, it is probably the family object that I would most have wanted to have inherited.

Escape from France

During that September of 1939, which marked the start of the war, Mémé and Jules, their two daughters Françoise (Franca) Sorbac and Elisabeth (Bebeth) Baer, together with their children, moved to Brécourt. However, when the Germans invaded Belgium and then northern France in May 1940, they decided to return to Paris, as they felt they would be safer there. My mother, however, felt differently. She wasn't particularly worried, but rather excited, not really believing that things could go badly, so we stayed

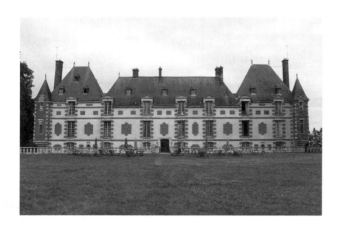

Château de Brécourt,
Normandy, 2009

on at Deauville throughout the autumn and even had a winter holiday in
Megève in the French Alps before returning to Paris in January. By the
beginning of May, when the Germans invaded Belgium, the atmosphere
in France began to change and, feeling that Paris was no longer a safe
place for us, my mother drove me and my nanny, Mademoiselle Weber,
to Brécourt. We travelled there in her black 1937 Bentley coupé with red
leather seats: this beautiful car with its customised bodywork had belonged
to a friend of my grandparents, Pierre-Louis Dreyfus, who had had it
specially made. The car had been offered to my Uncle Philippe, but, as he
didn't want it, my mother was delighted to have it.

Through a golf-playing friend, my mother heard about an American
woman, Ann Morgan, who, at the time of the First World War, after the
Germans entered Belgium in 1914, had picked up fleeing refugees and
organised a hostel for them. Ann planned to do the same again at the start
of this new war and my mother, then aged twenty-four, decided to help,
although she was made to promise she would return to Brécourt and her
small child, should the Germans approach. On one occasion she drove
north towards Belgium in her father's Ford station wagon, to pick up a
whole family of Belgian refugees. She agreed to take them to a shelter and
that if she moved on she would take them with her. They were forced to
leave almost immediately because the Germans had arrived at Laon, which
was very near and so, at 4 o'clock in the morning and without head lights,
she drove cross-country to Brécourt with the Belgian family.

By this time the Germans had taken the town of Sedan in the
Ardennes. While the Belgians set off by themselves, my mother drove us
all the way down to Biarritz in one day – fortunately she had a spare can
of petrol in the car as it was impossible to pick up any fuel on the way.
Bravely, and with great foresight, she then knew we had to escape from

France. Her parents were in Deauville at the time and she told them to join us in Biarritz, as did her sister-in-law, my aunt, Antoinette de Gunzbourg and her children. At that time Biarritz was full of refugees, all desperately trying to get hold of visas to get out of France via the nearby Spanish border.

Sadly, after our departure, I did not see my grandfather Jules again. He and Mémé, having returned to Paris, left their apartment on the avenue Foch and went to live in the avenue d'Iéna, where they stayed until the German Admiralty appropriated the building, at which point they moved, still within Paris, to their daughter Françoise's apartment on rue du Ranelagh in the 16th arrondissement. Jules died of old age in 1943, but Mémé spent most of the Occupation years in Paris and was fortunately not rounded up by the Gestapo. My Strauss grandparents had converted to Catholicism in 1938, as others did, fearing what might happen to Jews if the Germans invaded France, but this made no difference and when the Germans did arrive in Paris, they were forced to wear the yellow Star of David. According to my cousin Nadine, who was born in 1925, Mémé showed no fear and was proud to flaunt her Star, even in such places as the Paris metro.

In Biarritz, people were desperate to get out of France as the Germans were fast approaching but my mother was unable to get the exit visas we needed to leave the country. While on an earlier skiing holiday she had met the Argentinian ambassador, Miguel Angelo Carcano, and it so happened that she bumped into him again in Biarritz. Asking for his advice, he unexpectedly said he would give us all visas to the Argentine, adding that at Bayonne near Biarritz itself we could get transit visas to cross Spain and on through to neutral Portugal – our ticket to safety away from Europe. We should have left the next day, but that particular day was a Sunday and the Spanish Consulate was closed. As there was time to spare, my mother decided to call on the Ambassador to thank him for all he had done, but he greeted her with some grim news. On that very day, 22 June 1940, the Armistice had been signed which divided France into an occupied and unoccupied zone and the Spanish border was closed to all. Meanwhile the Atlantic coast was over-run by the Germans and Brécourt was appropriated by a German Sanitary Corps which arrived at the beginning of August.

Now that the border with Spain had been suddenly closed, we could no longer get out of the country. The ambassador advised her to leave immediately for the unoccupied zone in southern France. As there was not enough room for everyone in the Bentley, it was left in a garage in Biarritz and my mother drove us all away in her father's

station wagon. (She did not think she would see her car again but, after the war was over, a friend spotted the Bentley in the garage; apparently the devoted garage owner had painstakingly hidden it from the Germans. Although it was in a very bad state, the Bentley was eventually restored and returned to her.)

My grandmother, Lala, remembered that her old chef lived nearby in a village outside Pau, in the unoccupied zone, and so they decided to drive there. Not only did he insist on us staying in his house for three weeks, but he also made sure that we were well fed. From Pau we made our way to Antibes in the South of France. By then it was mid-July; that summer was very quiet and the weather was lovely – it was extraordinary and unreal after everything that had happened.

At the end of the summer we moved to Cannes and then, on 3 October 1940, the Vichy regime announced the first anti-Jewish laws. My mother was so disgusted and knew that one day we must again try to leave the country for America. However, Lala wouldn't dream of abandoning France, although my grandfather, who had only recently taken French nationality, and who was aware of what was to come, did want to leave. My mother was determined that we all stay together and knew that, despite Lala's protests, if she left, her parents would follow.

Every morning she used to go with her father to the American Consulate in Nice in order to apply for a visa. As the necessary affidavits had not arrived from America, they were not allowed to see either the consul or vice-consul for two months. In the end she made her way to the American Embassy in Vichy and saw a young third secretary called McArthur (he was the nephew of General McArthur) and he in turn asked the vice-consul in Nice to see them. She immediately returned to the Consulate and this time the family was given the necessary visas. All that needed to be done was to book the journey, but another obstacle was put in my mother's way: she was told she had to obtain an exit visa from the Vichy government and, on applying for it, her request was refused. Frustratingly, she had to go back to the beginning. This time she was asked why she wanted to go to America so she inventively replied that she was going to get married there. It was on this basis that they agreed to issue that necessary exit visa, but when she returned to collect it, some trumped-up Vichy rule was manifested – if you are going to be married abroad the banns have to be published. Again, she had to go through the entire application process and, once more returning to the American Consulate, she explained this new demand. The Consulate lawyer issued a paper confirming that in America banns do not need to be published and with that she returned to Vichy to be finally granted the exit visas

she needed for me and for herself.

My Uncle Philippe, later a leader (codename Philibert) of one of the groups working in the south-west of France for the SOE (Special Operations Executive) in London, and Mademoiselle Weber came with us as far as Narbonne, where my mother and I took the train into Spain. My Swiss nanny then made her way home and after that it was just the two of us, my mother and me; my grandparents left France for New York a month or so later. My aunt, Antoinette, and her two boys, Patrice, and Jacques who was born in 1939, stayed in France with Nanny Joyce and it was only later that they managed to cross the border into Switzerland on foot with a *passeur* where they remained safe until the Liberation in 1944.

The train took us to Barcelona where the Germans were celebrating New Year's Eve. We stayed at the Ritz Hotel overnight, but the following morning my mother found she was unable to pay the bill, which added up to more than she had in cash. Fortunately, she remembered that her father's cousin, Jacques de Gunzburg, had been one of César Ritz's financial backers, whose shares her father had inherited. She therefore introduced herself to the manager who kindly agreed to waive the bill. The train journey from Barcelona to Madrid was long and crowded, but my mother was able to cook a little food for us on a primus stove. We were very tired by the time we reached a freezing-cold Madrid, so we walked across the vast windswept Plaza Canovas del Castillo to rest for a few hours in the Ritz Hotel, before returning to the station just before midnight to catch the train to Lisbon. There we stayed for a week in a small hotel in Estoril before boarding the neutral passenger ship, the American *SS Excambion*. The sea journey took ten days and my mother remembers how much we enjoyed the trip together. There was one incident when I went missing while playing hide-and-seek and she had a sudden terrible thought that I had fallen overboard. Several hours later she found me under the bed where I had been hiding as a prank. There were others on board who knew my mother, but there was also someone she didn't know then who admired her from a distance; he was the man who was to become so important to her later in her life – Isaiah Berlin.

CHAPTER THREE

A Childhood in America

New York

On arrival in New York on 20 January 1941, we were met by my mother's first cousins, Sybil Uzielli and Diane Wallis, who had arrived from Paris a few months earlier. As it took a very long time to get through Immigration and clear our luggage through Customs, my mother thought it would be better for Sybil to take me directly to the Delmonico Hotel at the corner of Park Avenue and 59th Street, where we were to stay for a few weeks. Apparently I was totally terrified by this strange lady and very upset at being separated from my mother. My earliest, real memory is of that hotel room and bathroom and the vague figure of a nanny who had been engaged to look after me – she was an unpleasant woman who didn't remain long.

Three months later my de Gunzbourg grandparents, Lala and Bonpapa, arrived from France. They took rooms in the Beekman Hotel and there, when I was about five years old, I remember hearing a parade of soldiers marching down Park Avenue ten floors below. Curious and excited, I climbed on to the window sill and sat down, legs out, watching the troops go by. Lala suddenly saw where I was perched and, petrified I might fall, managed to control her terror long enough to grab me. In 1943 they moved to an apartment on the fifteenth floor of the Carlyle Hotel on Madison Avenue at 76th Street with a fabulous view of Central Park. After my grandfather died in Paris in the summer of 1948, Lala continued living there for the rest of her life. She loved being in New York, away from her responsibilities as head of her family. However, every summer

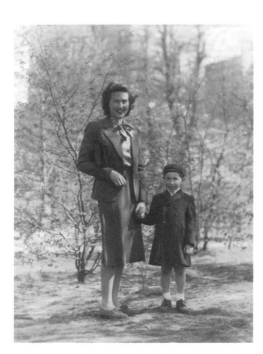

With my mother, Central Park,
New York 1942

she did return to Paris, on one of the great Cunard liners, the *Queen Mary*
or the *Queen Elizabeth*, to see the family; children, grandchildren, cousins
and old friends. She died at the Carlyle Hotel in March 1969 and was
buried in the Gunzbourg vault in the Montparnasse cemetery in Paris.

Within a year my mother and I had moved to an apartment in the
Volney Hotel on 74th Street between Madison and 5th Avenues, next to
Central Park where I played in the children's playground. I already loved
reading, especially war-time comics depicting Nazi brutalities in glorious
colour with graphic descriptions of enormous tanks running down fleeing
children. I recently found, slipped into an old photo album, a drawing I
made at the time, of an American fighter plane attacking a Nazi tank, in a
landscape dominated by two large sunflowers (influenced by visions of van
Goghs I had recently seen for the first time). I was a nervous and excitable
child, which given my history was understandable, and had a succession
of mostly disagreeable nannies until I was seven. There was little affection
or kindness; they spanked me, they forced me to eat what I didn't want to
eat until I was sick and then punished me for that. I bottled everything
up and said nothing, but when my mother, who led a busy social life in
New York, did eventually discover what was going on, she got rid of the
last of the nannies and from the end of 1943, when she married Hans
Halban, she looked after me herself.

My mother came from a family where the arts played little part – in her childhood home there were few pictures of any merit apart from family portraits, few pretty objects and only a small number of books; however, during their five-year marriage, my father, Dédé, had taught her a great deal about painting and furniture. Over the years she developed a discerning eye and excellent taste for creating a very special and individual style in her houses, after the war in Oxford and Italy. Before leaving Paris in May 1940, she had arranged for the contents of her apartment to be sent into storage. Although much of it disappeared during the German occupation, luckily some beautiful and rare 18th-century furniture did survive and these she has mostly passed on to me in recent years.

To celebrate my birth, my father had laid down twenty-five cases of 1928 Bollinger to be drunk at the time of my twenty-first birthday and these, too, remained behind. As well as the Admiralty, the headquarters of Einsatzstab Reichsleiter Rosenberg, the German office that confiscated works of art from Jewish families, was billeted in our house at 54 avenue d'Iéna and between them the staff must have drunk the lot.

My memory of those early years is hazy, but there are two events that I can vividly recall. The first took place two years after we arrived in New York when, at the age of six, my mother began taking me to the Metropolitan Museum. There I saw for the first time pictures by Manet, Monet and Degas, in particular those Impressionist masterpieces that had been given by Louisine Havemeyer in 1929. However, the paintings I really fell in love with then were that of a young woman in a white dress, sitting sketching by the light of a window, by Marie-Denise Villers, a lesser known, early 19th-century painter, and Degas' ravishing composition, *Femme aux*

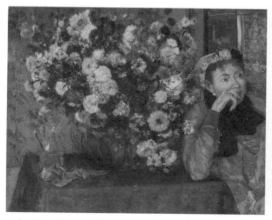

Left: Edgar Degas, *Femme aux Chrysanthèmes*, oil on canvas 1865; Right: Marie-Denise Villers, *Jeune Femme Dessinant*, oil on canvas 1801; both Metropolitan Museum of Art, New York

Chrysanthèmes. These works continue to have a strong effect on me and, even after almost seventy years, they give me the same pleasure and thrill on seeing them. On another occasion, shortly after my seventh birthday, we went to see *The Art and Life of van Gogh*, an exhibition of eighty of his paintings held at the Wildenstein Galleries: I have a clear recollection of specific pictures hanging on red-velvet covered walls. Inspired by these visions I came home and drew my own awkward versions of van Gogh trees – I have never been able to draw or paint – and it was at about this time I decided I wanted to become a museum curator. Already, at a very early age I was passionate about art and the museums that housed them.

Thinking back, it is curious how attracted I also was to classical music at that time. Perhaps this was due to the influence of Hans Halban, my first step-father, who loved listening to music on the gramophone in the living room. There had not been much music in our lives before he arrived on the scene: neither my grandparents nor my father were interested. From a family background where the arts had little place, my mother avidly adopted the tastes and interests of her husbands: from my father, she discovered an eye and sensitivity for art, from her second husband Hans and her third, Isaiah, music, in particular opera. I especially loved Bach's Brandenberg concertos in those early days and Bach to this day remains my favourite composer. The sense of order, structure and build-up of nervous energy within those great pieces seems to reflect some of the characteristics of my own personality.

Every summer from 1941 to 1946, my grandparents rented a house on Long Island for three-months, the first year in Amagansett, and those following in nearby Easthampton. I felt very close to them; it meant so much to have them by me in New York. Lala was such an affectionate and loving grandmother and those three month summers in Easthampton were the happiest I experienced during the war years. It was during our first holiday there that my mother taught me to read and write in French using the Babar books which my Aunt Franca had given me just before leaving France. From the time I began talking at the age of two, I was bilingual in French and English: the family was French, as were the servants, but the nannies in the avenue d'Iéna had always been British.

Throughout my early years in America, my mother insisted on speaking French with me as I could so easily have forgotten it. Even now we speak only French when we are alone together, but immediately switch into English when others are around, including my half-brothers Peter and Philippe, who were both brought up in England. Although both of them now speak fluent French they naturally speak English with our mother – I suppose early childhood habits die hard. A family friend had warned her

that as I was Jewish, it might be difficult to get me into New York's kindergartens and schools: anti-Semitism was rife in America, even in New York with its large Jewish population. On top of this, I was a very nervous child and it was at that time that I started having asthma attacks. My mother has reminded me that I said to the kindergarten teacher on the first day, 'I lost my father, I lost my dog'. Even at that early age, I felt the loss of my father really affected me: it was a tremendous sadness not to have had a father from such an early age. When I was accepted, at the age of five, by one of the top boys' schools in New York, St Bernard's School, thanks to Freddy Warburg, a great friend of my mother who in fact wanted to marry her, the teacher was annoyed that I could already read and write. She obviously felt that I was usurping her role and so made me join the beginners' class. This must have made me even more aware of being an outcast in that very New York, upper-class prep school.

Hans Halban

In the autumn of 1943 my mother married Hans Halban. An Austrian-born Catholic with some Jewish ancestry, Hans was a nuclear physicist leading the Anglo-Canadian team at the Montreal Laboratory of Atomic Energy as part of the Manhattan Project to develop the first atomic bomb. They had met through my mother's close friend and cousin, Bertrand Goldschmidt, a French chemist who was also working on the atomic bomb programme.

My first step-father Hans Halban

Immediately after their wedding, we moved to Montreal where we lived for two years. I remember well the thrill of my first flight, in a DC3 flying from La Guardia airport in New York to Montreal. However, this was the beginning of another very unhappy time for me. I was sent to the local English Prep School where I was bullied and beaten by other boys for being both French (hated by the English community in this French province) and a Jewish refugee – there was just one other Jewish boy in the school who

was to be my only friend in Canada. I was unhappy at home and only later realised that my new step-father lacked the sensitivity to appreciate my feelings or even demonstrate an awareness of the fact that I had lost my father at an early age. Hans said to my mother that she had no control over me, that I needed discipline and that she must take proper charge of me. He was a strict Germanic disciplinarian and any transgression led to spankings on my bare bottom with a hairbrush. I particularly recall one incident when, flushing the lavatory one morning, I woke him up and in his fury he delivered another of his painful punishments. I can only imagine what my mother felt. It was then that I began to stammer.

This was during a period of great stress for him which, although does not excuse his behaviour towards me, I can now understand the tremendous pressures he was under, particularly after the Liberation of France in August 1944, when he returned to London and Paris to see his old colleague Frédéric Joliot Curie. This was strictly against the wishes of the American, Canadian and British governments, fearful Hans might divulge secrets about the atomic bomb to Joliot Curie who was a Communist. As a result Hans was removed from his position as head of the Montreal laboratory, forced to remain in America for one year and not allowed to work.

Despite these moments of unhappiness, I felt some consolation in reading and luckily there was an extensive collection of children's books in my bedroom. Reading has remained an important factor in my life, allowing me to escape into so many different worlds; they satisfy my curiosity about people and the world and I'm particularly drawn to novels, biography and travel books. Before every holiday I get such pleasure searching for recent publications, buying them in bag loads almost exclusively from my favourite bookshop, Hatchards in Piccadilly, where I have been a faithful customer since arriving in London in 1959. Fortunately, I have shared this passion for reading with both my wives.

My mother and Hans had rented a house on the slopes of the Mont Royal, an affluent, very English neighbourhood on a hill overlooking Montreal, but the residents were not happy to have a Franco-Jewish neighbour in their midst (the discrimination between the French and English communities of Canada was quite shocking to us). On the positive side there was a small ski lift close by where I would head almost daily in the winter months to discover the joy of skiing, even skiing down the hill to school whenever there was enough snow. I was, I suppose, a fearless child, and one day attempted to ski down the big, local ski jump after it had closed for the day, landing flat on my back: I never tried this again, preferring to keep my skis flat on the piste rather than lose control flying

My de Gunzbourg grandparents with their grandchildren: from the left, Jacques, Patrice, Peter and me at Easthampton, 1946

in the air. In those early days I was to fall often but never broke any bones. Later, in my teens, when I became a good downhill and slalom skier, I would throw myself, flat out, down steep slopes, loving the speed, the thrill of being almost out of control, and of testing myself to the limit.

During those two years I did not see much art. There were probably a few art and picture books in the house, but not much else to see locally. The Montreal Museum of Fine Arts did not have a significant collection, but I have a clear and strong recollection of being taken by my mother to see a group of Dutch paintings, loaned by the Rijksmuseum in Amsterdam, and of the indelible impression Vermeer's *Milkmaid* made on me, once more a painting of a woman standing by a window, bathed in light.

As Hans was forced to leave Montreal in the spring of 1945, we returned to New York and rented an apartment on 5th Avenue, not far from the Metropolitan Museum where I renewed my passions for its multitude of treasures. Hans's daughter, Mauldely, from his first marriage, who was two years younger than me, came to live with us that year. She was my only friend in New York; I loved her sense of fun and her great laugh and remained very fond of her throughout her life, much of which was spent living in Oxford with her husband, the philosopher Jim Griffin, and her two children. Tragically, her life was cut short when she was in her early fifties.

In September 1945 I was sent to the local Lycée Français, the only year I had any kind of French education. Although I was by then used to an English system of education, I was able to cope with the change without too much difficulty since I was still fluent in French – anyway, anything was better than the awful prep school in Montreal. In the following

summer, my Uncle Philippe, who had survived the German occupation as a leader of the Resistance in the south-west of France, arrived in New York, soon followed by my Aunt Antoinette and first cousins, Patrice and Jacques. I was so happy to see Patrice again after a separation of six years: we had been like brothers in Paris and had more or less been brought up together. Mauldely was part of our 'gang' and we all had such a wonderful time that summer, playing on the fabulous beaches and diving into the rolling waves, cycling around the dunes and generally fooling around. On 1 June 1946, three months before my tenth birthday, my first half-brother Peter was born. This was our last summer in Easthampton before finally sailing back to Europe, to a very different world ravaged by war.

CHAPTER FOUR

A New Life in Oxford

Early that September in 1946, we boarded the recently refitted *Queen Mary* (she had been used as a troop carrier during the war) and returned not to Paris, as might have been expected, but to Oxford, where Hans had finally been offered a position as Professor of Physics at the Clarendon Laboratory, sponsored by Lord Cherwell, Churchill's scientific advisor during the war. Thus, the future course of my life took a quite different direction, leading me to follow a happy and successful life and career in England, rather than one in France, possibly in the museum world, where I would have been surrounded by my extensive Parisian family.

At first we lived in a rented mock-Tudor house outside Headington and I was sent to St Andrew's, the local primary school, housed in a typical red-brick Victorian building. The children were friendly, the work was quite easy and I enjoyed my time there. By the end of the summer term I was top of the class (the only time in my school career) although I did suffer several, probably deserved punishments administered by a strict teacher.

During the Christmas holidays in December 1946, I arrived in Paris by the night train from Victoria Station, to finally see my Strauss grandmother, Mémé, after an absence of six and a half years. Although I had no recollection of her, I was absolutely thrilled, happy and moved to see her as she was to see me. I was excited at the prospect of meeting all my cousins, aunts and uncles – that vast family I had heard so much about. Lala and Bonpapa had returned to a small apartment on the ground floor of the avenue d'Iéna which had been restored during the two years since the Libération, while I with the rest of my family occupied an apartment on the ground floor which my mother and Hans had recently redecorated.

Thinking back now, it regrettably never occurred to me to ask Mémé what life had been like for her during the war. After it was over, she had returned to the grand apartment she had lived in with my grandfather since 1912 at 60 avenue Foch. It was a large apartment with a long corridor leading to my grandfather's study at the far end. All the Impressionist paintings had been sold in 1932, but others, French and Italian Old Masters, remained, mainly in his old study. The formal drawing room with fine 18th-century French furniture, *boiseries* and paintings, was used only when friends came to dinner. Mémé had her own bedroom and sitting room and the apartment was shared by then with her daughter, my aunt and uncle, Elisabeth (Bebeth) and Louis Baer and their daughter Nadine.

A year after we arrived in England, we moved into Hilltop House, a finely proportioned Georgian house with a large garden at the top of Headington Hill. My bedroom overlooked the main road down to Oxford and my mother allowed me to choose the wall paper which I recall had a wide dark green and black stripe (I think these first attempts at interior decoration were quite successful and a foretaste of a future love of arranging and decorating the houses in which I have lived). We only spent a few years there as, in 1953, my mother and Hans found a quite beautiful, larger Georgian house nearby in Old Headington. Headington House, set in the middle of six acres, became my mother's home for the next fifty-two years until she finally decided it had become too much of a burden for her to look after. She was, by then, ninety years old.

I left St Andrew's primary school at the age of eleven and was sent to Magdalen College School, a good grammar school down in Oxford, where I was taught by old-fashioned masters clad in black gowns and

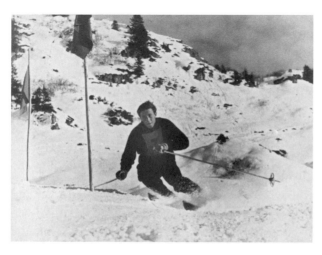

Skiing at Megève, 1953

mortarboards. Every morning I cycled downhill to school, freewheeling most of the way, but the return journey uphill was always a breathless chore, especially with my asthma. The studies became more difficult with the introduction of such subjects as Latin, but I managed to get by with fairly decent marks. I enjoyed the sports, especially rugby and cricket on the beautiful playing fields down by the river Cherwell, an idyllic place to be on summer days; yet it was skiing during the Christmas holidays that was my real passion. School meals were held in a local workers' canteen and this was at a time when rationing was still in force: on a number of occasions we were dished up slices of something grey and greasy, which turned out to be whale meat rather than beef, a rare commodity in those days, swimming in a tepid sea of overcooked cabbage and mushy potatoes. I did manage to eat it and it was, supposedly, nourishing.

In 1949, my grandmother Mémé finally decided to move to a much smaller apartment on the rue Marbeau in an Art Deco apartment building overlooking the Bois de Boulogne, keeping enough of her favourite pictures, furniture and various objects to retain some of the former character of a Strauss interior. That same year, what she could not house was sent for sale to the Hôtel Drouot, comprising pictures, furniture, porcelain, and silver collected by my grandparents since the last years of the 19th century.

As well as Mémé herself, there were three other heirs to my grandfather's estate: my two aunts and me, as my father's son. At the sale it was agreed that we could buy back as much as our share represented. I apparently was too young to go to the auction or make any choices (perhaps even then I would have liked to have had a say), but my mother, knowing I was due a quarter of the value of the sale, purchased a number of lots (mainly French furniture including a Régence mechanical desk and a marvellous pair of chairs that came from Marie-Antoinette's bedroom in the Château de Fontainebleau). She felt, quite rightly, that these would reflect what my grandfather liked and what I might appreciate later. Most of these are still with me and they mean a lot to me as physical reminders of my grandfather's taste and connoisseurship.

Adolescence

During my childhood I suffered from regular asthma attacks and I was neither a happy nor, on the whole, an easy child which led my mother and Hans to believe I should get help from a psychoanalyst. The first one I was sent to, a Mrs Helman, lived in Belsize Park Gardens in London, while the

second had a consulting room in Wellington Square in Chelsea. I found it extremely difficult to talk about my early childhood and on many occasions in the first months I would lie on the therapist's couch, mostly silent, unable to talk about myself and my feelings at all. Eventually I began to open up and in the end did benefit from almost two years of psychoanalysis. My stammer gradually began to disappear, although some vestiges still reappear, especially when I am feeling nervous in certain awkward situations. I have always found it difficult to express negative feelings whether through a sense of pride or shame, while, conversely, I am quick to articulate positive emotions. An unwillingness to show myself in an unfavourable light is probably a defence mechanism born out of these childhood experiences. But then I am also convinced these childhood characteristics and experiences have fostered in me a determination and enthusiasm which have served me so well throughout my life.

In the summer of 1951, the psychoanalyst said that I must stand up to Hans and that if I did, it would greatly help overcome my difficult relationship with him. That August, when we were all on holiday at Crans-sur-Sierre in the Valais, Switzerland, Hans and I were standing outside the Hotel Rhoddania one morning when he unfairly accused me of some misdeed. I ran away from him and as he chased me I shouted, to our mutual astonishment, '*Tu es un salaud, ça y est je l'ai dit*,' ('You are a rotten bastard, that's it, I've said it.') and Hans, I think forewarned by the psychoanalyst that this would be a significant step in my development, did not react in his usual bullying manner. Soon, to my astonishment, our relationship altered for the better and from then on we became very fond of each other. This real friendship continued even after he and my mother divorced in 1955.

Early Passions for Art

Holidays were by far the best times, visiting my grandmothers, aunts and cousins in Paris, visiting museums, travelling, and, most exciting of all, skiing during the Christmas holidays, occasionally at Easter, principally in Megève in the French Alps. These were idyllic times and were an enormous relief from what were mostly grim school days. One of my fondest memories is of the summer of 1951 when we rented a pretty 1930s' house on the golf course in Biarritz, it's terrace edged with a profusion of red geraniums. From there I was taken on my first tour of the Continent. I was totally captivated by the varied landscapes we travelled through and enthralled by the architecture of the Gothic and Renaissance cathedrals

and cities. For some time I had owned a camera and it was that trip which triggered my everlasting fascination for photography, composing through the lens and already aware of the individual way artists had interpreted landscape; I know for a fact that the device of using a tree and its branches to frame a distant view is something that I remembered from Cézanne's depictions of the Montagne Sainte-Victoire. Leaving Biarritz, we first drove across the southern Pyrenees via Pamplona, visiting Burgos's sublime Medieval cathedral, then back into southern France and finally into Italy, spending the first night in a grand old hotel on Lake Como.

The next day, our first stop was Bergamo where I discovered great frescoes for the first time in the Coleoni chapel with its lovely Tiepolos and then, twenty-four hours later, the majesty of Giotto's fresco cycle of *The Life of Christ and The Life of the Virgin* in the Scrovegni chapel in Padua. Finally, Venice's unforgettable sky-line appeared as we drove over the causeway linking it to the mainland, its magical roofs and campaniles getting closer and closer. Leaving the car, we boarded a *motoscafo* and travelled the whole length of the Grand Canal, landing at the Hotel Bauer Grunewald, very close to the Piazza San Marco. I was utterly overwhelmed by the beauty of Venice, by the myriad of its palazzos and the shimmering light reflecting off the agitated water of the Grand Canal. However, what completely bowled me over was the vision that greeted me when the door opened on to Vittore Carpaccio's famous cycle of nine paintings depicting the Life of St George. The beauty of these narratives painted between 1502 and 1507 in the tiny chapel of the Scuola di San Giorgio degli Schiavoni, a guild founded in the Middle Ages by Venice's Dalmatian colony, dazzled me. Of all the paintings in the series, the one that has had the most profound effect on me depicts St Jerome in his study. Although a popular

Vittore Carpaccio,
Saint Jerome in his Study,
oil on panel ca.1502,
Scuola di San Giorgio
degli Schiavoni, Venice

subject in the Renaissance, in Carpaccio's version the setting is more intimate and colourful, each object in the study clearly delineated, a feeling accentuated by the little white dog gazing up at his master. When the time came for us to leave Venice I vowed to return every year, but regrettably my visits became more sporadic whilst I was at Sotheby's, though much more frequent in recent times. Every time I do return, even after sixty years, I experience that same extraordinary frisson of excitement.

Following those later sessions with the psychoanalyst in Chelsea, when I was thirteen and before catching the train back home, I would occasionally wander into a nearby, antiquarian bookshop just off the King's Road, where I loved picking up, and sometimes buying, 17th- and 18th-century printed books, for only a few shillings each. One day I discovered a leather-bound 1753 edition of the *Comédies de Rousseau* which had a lead bullet lodged in its spine and I had the romantic notion that a soldier had been carrying the book in his pocket when fired on and that it had perhaps saved his life. Spending only a few shillings at a time, I began collecting books, all of which I have kept. They may not always have been very interesting *per se*, but I liked the feel and the musty smell of their worn, leather bindings. Knowing of my interest, my grandmother Mémé, over the years, gave me several of my grandfather's books, including several 18th-century publications on Antoine Watteau, as well as two of Ambroise Vollard's rare editions illustrated with woodcuts by Pierre Bonnard and Jean Puy, both evidence of Jules' avant-garde taste and his friendship with Ambroise Vollard.

My favourite small museums in Paris are the Musée Rodin, where the sculptor lived and worked, and the Musée Picasso founded in the 1970s. From an early age, I have always been fascinated by and tremendously admired the power and sheer beauty of Rodin's sculptures and his sensual interpretation of the human figure, either on its own or in vast interlocking groups as in the Gates of Hell. There is no doubt that, as far as I am concerned, he was greatest sculptor of the human form since Donatello, Michelangelo and Bernini (some might include Canova in this group, but not me, as I see no passion in his cold, perfect white marble forms). It was there I made my first serious purchase when I was fourteen.

It happened in 1949 that my mother discovered my father had left me a small amount of money in a bank account, the equivalent at that time of about £90. A few days later, we were at the Rodin Museum and I was surprised to discover that the museum owned the rights to Rodin's estate and therefore were legally allowed to sell a limited number of duplicate bronze casts in its shop. I had had a particular fondness for a bronze cast

Auguste Rodin's bronze, *Tête d'Hanako*
my first purchase, 1951

of the head of Hanako that Jules had bought before the war and which Mémé now kept on a table next to her armchair in her living room; I was disappointed to learn she had already promised to leave it to her daughter, Elisabeth Baer.

The sitter, Hanako, was a famous Japanese dancer who had come to Paris for a number of performances in 1908. She so impressed Rodin, that he asked her to pose for him and made several studies of her head. Judith Claudel, Rodin's mistress and first biographer, watched him model her head and commented, 'Hanako did not pose like other people. Her features were con-tracted in an expression of cold, terrible rage. She had the look of a tiger, an expression thoroughly foreign to our occidental countenances. With the force of will which the Japanese display in the face of death, Hanako was enabled to hold this look for hours.' I was, therefore, very excited to find that the museum shop still had a cast available for sale and, without hesitation, bought it on the spot: it remains one of my treasured possessions and sits proudly on the mantelpiece in the living room.

Bryanston School

My mother and Hans decided on the advice of my psychoanalyst that I would benefit from being a boarder at a public school. Having made enquiries, they decided upon Bryanston, which was housed in a grand Queen Anne style mansion outside Blandford in Dorset. It was thought to be a most suitable place for me, as it had the most liberal and progressive attitude of all the schools at the time, attracting boys who were not always typical public school material (Lucian Freud amongst others in the 1930s). Crucially it did not believe in corporal punishment, though punishments were still inflicted, these consisting of five-mile runs between the front and rear gates of the school's extensive grounds. During my first year, in 1952,

I became increasingly disobedient, disruptive and disrespectful of authority, and managed to acquire more than eighty 'runs', certainly a school record in those days. My Housemaster, J.C. Royds, wrote in an early report, that I was 'too excitable' and too little in control of my emotions. In a spirit of harmless rebellion against authority, my offences ranged from talking out of turn in class, eating in church, consuming too many biscuits, throwing puffed wheat about the dining hall, and whistling in the corridors with my hands in my pockets, all 'wicked' offences against the rules. I can only imagine this was a reaction to being sent away from home for the first time in my life, added to a natural spirited disposition and naughtiness that first manifested itself before the war in Paris with my cousin, Patrice. At the end of three and a half years of mostly unruly behaviour, I had the proud distinction of being the only boy in those years who was never made a monitor or prefect, much to my great relief.

I hated admitting that I wasn't happy, especially to my mother, and that I didn't fit into the traditional English public schoolboy mould. I was one of the very few foreign boys and Jewish as well, often the butt of bullying, sometimes physical, often verbal, or just ignored. But it wasn't all that bad and, best of all, I enjoyed the weekly art class. Although some history of art was taught, the lessons mainly involved painting and drawing. I was pretty inept at both yet spent whatever spare time I had in the art room. The master I have the fondest memory of was Andrew Wordsworth who taught English Literature; a tall, long-haired, eccentric man, and grandson of the poet. An inspirational teacher with a passion for his subject, he introduced me to Thackeray, Dickens, Balzac, Zola and Gide. Reading avidly once more became a refuge, enabling me to survive those years.

Sex education was not taught at school then and I don't remember being told about the facts of life at home. Like most children we acquired basic knowledge from each other and the smutty stories we passed around. One aspect of my 'education' at that time, however, harked back to my Parisian roots. Although living in England, I was still a French boy at heart and it was traditionally expected that boys of my *milieu* would have early sexual experiences (early by the standards of those days). I remember so well my mother saying to me when I was seventeen, 'I hope that by the time you are eighteen you will have slept with a woman,' to which I answered, very simply, '*C'est déjà fait*,' and that was the end of the conversation. In fact, it happened one night when I was sixteen. Walking down the Champs Elysées after dinner at my Aunt Bebeth's apartment nearby, I was accosted by an attractive youngish woman who asked me, '*Tu veux venir avec moi?*' So, realising what she was, I answered, somewhat nervously, '*Avec plaisir*' and to a chorus of 'cradle snatcher' from her friends

on the beat, she took me to a cheap *hôtel de passe* nearby. That first experience wasn't much to write home about, although it did break the ice!

During those years, part of our summer holidays was spent at Crans-sur-Sierre as Hans, an Austrian brought up in Zurich, particularly loved the Alps. My Aunt Antoinette and her four children, including my cousin Patrice, usually joined us. Much of the time I played golf and tennis and to my great excitement, as it appealed to my love of taking risks, Patrice and

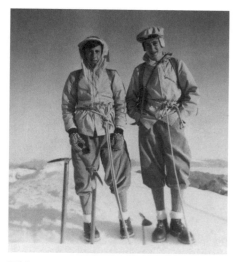

With my cousin Patrice at the summit of the Dent Blanche, 1952

I began mountain climbing together with a highly experienced guide in the summer of 1952. There was nothing I liked more than climbing the steep rock faces at the end of a long exhausting trek up the high grassy slopes of the mountain. A highlight of those teenage years was climbing a 4,000-metre mountain, facing the Matterhorn. Fifteen hours of steady climbing up to the base of La Dent Blanche, and a night spent in a high altitude hut, was followed by the ascent of the mountain's snow-covered, pyramidical summit. Once we left school, Patrice and I went our separate ways during the holidays and the only mountaineering I ever did again was many years later with my son Andrew, at Pralognan in France. By then years of smoking and lack of any serious exercise had taken its toll on my endurance.

Life at school improved in my last A-level year; I finally had a private study and enjoyed much more freedom. Tolstoy, Pushkin, Turgenev and Gogol were among the authors I read and I could freely listen to records of my favourite classical composers as well as those my grandmother Lala sent me from New York, usually the latest hits chosen for her by her local record store. In the spring of 1954 an Elvis Presley album appeared in the mail. The other boys and I had heard of the 'King' but none of us had heard his music, so that was a time when I was suddenly very popular and had many visitors to my study, which resonated to the rhythm and beat of 'Blue Suede Shoes'. That was also the year, aged seventeen, when I began illicitly to smoke and drink beer with a few other sixth-formers in a pub just outside the school gates in the tiny village of

Durweston. We were finally caught, but my Housemaster's punishment wasn't too severe.

The first time I tried smoking, I had climbed an old oak tree near my study and, sitting on a branch, inhaled deeply. As I got up, I had a dizzy spell and fell to the ground, gashing open the sole of my foot.

At the end of term I took and passed A-levels in History and French; school was finally over for ever and I could now look forward to a long holiday before going up to Oxford the following October.

Christ Church, Oxford, and London

In my last year at Bryanston I had miraculously passed Christ Church's entrance exam, in spite of my atrocious Latin; being an 'Oxford' family Cambridge was never a consideration. The one subject I would really liked to have read was History of Art, but there was no such school, either there or at any other university in Britain in the 1950s, apart from the Courtauld Institute in London which offered only post-graduate diplomas. I was rather shocked when, in reply to my question about History of Art, one of the dons at Christ Church expressed the view that it was 'a dilettante subject' and therefore not an appropriate field of study. In fact it was not until 1968 that a BA in History of Art was established, first in Cambridge, soon followed by other universities and only in 2004 did Oxford finally do likewise. Lord (Kenneth) Clark, the art historian and Director of the National Gallery during the Second World War, told my mother at the time that it was better to read History or Greats (Classics) first in order to develop one's intellectual mind before reading History of Art at graduate level. An alternative choice would have been History, but in those days that would have involved a lot of Latin. In fact, I only managed to scrape through Latin O-level on the second attempt by one point above the pass mark. As that was not an option either, the only possible subject left that I thought would interest me was PPE (Politics, Philosophy and Economics).

After six exciting weeks travelling around Greece with a Greek school friend, Spiros Spiropoulos (and seeing only one other tourist in all that time), I stopped in Venice (of course) for a few days. Apparently my mother had told Isaiah to keep an eye open for me – he was there with John Sparrow, Warden of All Souls College in Oxford. In a letter to her dated 8 September 1954 he wrote: 'I have not been able to find Michel' and later in the same letter 'on the next day, despairing of finding Michel, I walked to the Accademia landing stage, bought six newspapers and sat there, completely blind, waiting for the boat. My neighbour tapped

me on the shoulder – it was Michel. Had I come ten minutes earlier or later we should not have met – he avoided the Piazza. I was delighted and he had lunch and dinner with Sparrow and me. He was a little melancholy, I thought, and full of sensibilities; most observant, serious and sweet. But I should have liked an hour alone with him, but Sparrow's presence formalised it... you must let him look at pictures en route: Pieros even more than mosaics: particularly San Sepolcro and Monterchi. Despite his shyness and inner look, he is capable of sudden leaps into unheard precipices: I hope he does not bruise himself too much. I should like to be there, after the leap and its consequences, to bind the wounds he is sure to sustain.'

My first term at Oxford began in October. I had a set of rooms comprising a sitting room and bedroom in a grim Victorian Gothic building facing Christ Church Meadow; the bathrooms were across a courtyard – an unpleasant trek during damp, freezing Oxford winters. Oxford itself still maintained a vestige of 19th-century misogynistic morality, which manifested itself when I was summoned to the Moral tutor's set of rooms, at the beginning of term. This crusty old don, who was supposedly there to look after undergraduates' well-being, threw me out of his room, much to my astonishment and amusement, after I had replied 'yes' to his enquiry about whether I had ever had sex with a girl. That was the last time I saw him.

I quickly found new friends among a number of young men who had already done their National Service and, by and large, were in their second or final years at Oxford so were several years older than me: as a French citizen I was not required to do National Service, but two years later when I was called up for the French *service militaire,* I fortunately failed the medical thanks to my asthma. The friends I mostly frequented were part of the Christ Church 'fast set', many of them Old Etonians and members of Bullingdon, the notorious dining club: there was Colin Clark, the son of Lord Clark, the Belgian brothers Bernard and Alain Camu (whose daughter, Sophie, worked for several years in my department at Sotheby's in the 1990s), Tim Rathbone, later Tory MP for Lewes and the Italian, Giuseppe Gazzoni, who distinguished himself by driving one night from Oxford to London in his Jaguar XK120 in thirty-five minutes – a record. I also much enjoyed the company of Reggie Bosanquet, the ITV news presenter, John Hemming, a long-time Director of the Royal Geographical Society and Robin Hanbury-Tenison, the well-known explorer and conservationist and was envious of Nikita Lobanov's successful escapades with foreign girls who had come to Oxford to learn English.

These were the friends I made and who, I like to think, were partly responsible for leading me astray, for then began a period when, straight out of school and quite shy, I went wild. I started drinking, playing poker and roulette, and generally having a good time rather than settling down to my books. I remember, now with amusement, the night, following a party at Lady Margaret Hall, and drunk as usual, I was stumbling along St Giles (a wide avenue leading from North Oxford to the centre of the city), weaving between the lamp-posts, when I was spotted by my mother, who happened to be driving Isaiah Berlin back to his rooms at All Souls, after a dinner in North Oxford. She wanted to stop the car and scoop up her child, but Isaiah prevented her, saying that was the worst thing she could do for an undergraduate's reputation. However, there were limits to what I would do. Towards the end of the spring term, an acquaintance said he had been invited to a friend's digs in Holywell to smoke opium and would I like to go? I thought this was an appalling idea and naturally refused.

In those days, Oxford colleges locked their doors at 10pm and there was no chance of re-entry unless you had a chit signed by one of the dons. As I had friends in different colleges and sometimes stayed up late, I would have to climb over college walls in the time-honoured fashion. While shinning up a lamp-post next to one of the Magdalen College walls, I impaled my left knee on a thick rusty spike. Bleeding, I took myself off to the Radcliffe Hospital in Woodstock Road where a nurse patched me up and gave me a tetanus injection. But this was no deterrent and my experience of rock-climbing with my cousin Patrice proved very useful.

At the end of Michaelmas term I was invited to join the Oxford University ski team for their annual fixture against Cambridge. That year it took place in Zurs in Austria, the team including my friends Alain Camu and Gazzoni. Although we lost we had a tremendous time; a lot of skiing, a lot of jollity, a lot of schnapps. Gaining a Half-Blue was my only achievement at Oxford, but one that I have always been proud of. Many years later, when my daughter Julia went up to Oxford, she liked to wear my skiing Blue sweater when coxing her college boat and loved dining out on her father's 'success' and somewhat questionable Oxford career.

I found my studies at Oxford difficult and exceedingly dull. Politics was not a problem, but philosophy and economics were totally beyond my understanding – my brain didn't seem to work along those lines. I failed Prelims (first year exams) that spring of 1955 and was sent down at the end of the summer term, but given the chance to retake them in the autumn. I must admit I wasn't too bothered, but my mother was obviously disappointed and angry with me and arranged that I attend a crammer in

The Oxford University ski team, Zurs, December 1954.
From the left: M.Lacotte, J.R.Searle, A.Camu, M.Strauss, F.Lowbeer, G.Gazzoni

London the following October, with a view to re-taking Prelims and being reinstated at Christ Church.

Aline and Isaiah Berlin

At the beginning of the summer of 1955, following my liberating year at Oxford, my mother and I went to Amsterdam for a few days, enjoying concerts at the Concertgebouw, visiting the Rijksmuseum and the Stedelijk Museum which then housed the vast collection of van Goghs, still on loan from his nephew, Engineer V.W. van Gogh. It was while we were in Amsterdam, and probably the underlying purpose of the trip, that my mother told me that she and Isaiah Berlin had fallen in love and that she and Hans were getting divorced. I had suspected that things were not going all that well between them, but by then I had become very fond of Hans. Although I was happy for her and liked Isaiah, and did not find their friendship difficult to accept, yet this news

subconsciously affected me and manifested itself in an immediate, quite severe asthma attack.

These events coincided with the time Hans had been offered an important job. He had been invited back to France in 1954 by Prime Minister Pierre Mendès France to direct the construction of the nuclear research laboratory at Saclay near Paris. This was a great opportunity for him, but my mother, due to her developing relationship with Isaiah, was quite unwilling to return to France with him. I continued to see Hans in Paris and at his chalet in Crans-sur-Sierre until his untimely death in 1964.

Once I had recovered from the asthma attack, I drove over to France in my first car, a second-hand, 1952, sandy-coloured, convertible Morris Minor; in Paris I had my first advanced driving lesson by successfully negotiating the frightening traffic zooming around the Arc de Triomphe. After a few days, I went to stay with my Aunt Antoinette in St Tropez, a seventeen-hour drive in a car which had a maximum downhill speed of 50mph. After a week or so I moved on to Italy where Giuseppe Gazzoni had invited me to stay at his father's grand country house outside Alessandria. The house had a pre-war grandeur, a formality reminiscent, I suppose, of life in the avenue d'Iéna when my mother was growing up. I was thoroughly enjoying myself at dinner that first evening, when my eyes lit upon another guest, a pretty, dark haired American girl, a few years older than me. I was struck by her smile and laughing eyes and I remember so well that spark of attraction as we looked at each other across the table. It was love at first sight (for me anyway) and when, after a couple of days, I told her that I was driving to Venice, she enthusiastically joined me. Jean Stein, an editor in New York, and I stayed at the Danieli, something I couldn't afford myself (I was quite broke after my year of drinking and gambling in Oxford and had to sell my camera in order to continue travelling), but Jean's father, Jules Stein, founder of the Music Corporation of America, must have had some kind of arrangement there.

It was amazing to think that Venice, the ultimate romantic city, became the ultimate romantic setting for my first love affair. After a few blissful days, we left Venice and drove in a leisurely fashion to Rome taking in Ravenna's dazzling Byzantine mosaics in San Vitale, Giotto's frescoes in the Church of St Francis of Assisi and Piero della Francesa's frescoes of *The Legend of the True Cross* in the Church of San Francesco in Arezzo which never fail to give me a deep emotional thrill every time I see them. In Rome we stayed in Jean's parents' pretty, top-floor apartment in Trastevere, with its terrace overlooking the rooftops of the ancient city. It was exceedingly hot and humid so we explored the city in my open-topped car – a perfect way to see the ancient Roman sites and Renaissance

buildings. At the end of August she went back to London while I stayed on for a day or so before driving back. On my return to London Jean told me she had to fly back to New York to look after William Faulkner who was ill. It was then I discovered that Jean was in fact Faulkner's mistress and realised her affair with me was but a brief summer of love, an exciting interlude with an eighteen-year-old boy, away from her fifty-eight-year old lover. From such a high, I was suddenly brought back to earth with a severe bump which triggered another asthma attack, made even worse by the thought of having to spend several months at a crammer.

My mother let me use a flat in Mill Lane, Cricklewood, until the lease ran out before Christmas 1955; this was where she used secretly to meet Isaiah for a few months before their liaison became official. Coincidentally, I often drove by that very building when, more than forty years later, I had begun living with Sally Lloyd Pearson in her nearby flat facing Gladstone Park; it was strange how, in a small way, my life mirrored my mother's. At the beginning of the New Year I rented a room in a mews house in Montagu Mews South, sharing it with a girl I had met at Oxford. This was a convenient arrangement and our friendship was purely platonic.

Undergraduate girls at Oxford in the 1950s were considered frumpy, so most of my set would drive up to London for parties and to meet 'faster' girls. At first I had ridden there on my Vespa, but once I had a car and could drive there, I soon made new friends in London. It is true to say that during this period of my life I was not interested in visiting galleries or museums – girls and parties were my focus. My closest friend there was Penny Ansley, daughter of a merchant banker, an attractive Jewish girl of my age. There was no sexual attraction between us, but she was a person I liked very much and felt I could talk to about anything on my mind with the greatest of ease. A debutante, she arranged for me to be invited to many of the balls and parties of the 1956 Season – I became what was then known as a 'deb's delight'.

Sickened by a year of drunkenness and by now almost tee-total, I was really able to enjoy myself and staying sober sometimes gave me a clear advantage over other young men who were either loud drunks or who passed out on the floor. There were balls in grand London mansions and in country houses, nights dancing in the 400 Club in Leicester Square and listening to jazz in Soho clubs, and even for a few weeks trying unsuccessfully to bed a dancer who performed in shady night-clubs in London and Paris.

That summer of 1956 I fell in love again, this time with Penny's sister Jackie, a delightful eighteen-year-old with the fresh plumpness of one of Renoir's young nude bathers of the 1880s. We had a lovely summer

My second step-father Isaiah Berlin
and my mother Aline, Oxford, 1974
(photograph Alice Kelikian)

together, a youthful affair spent mostly in London, going to balls around the country and staying at her mother's house in Godalming or on holiday in the French Pyrenees near St Jean-de-Luz. Fortunately, her kind mother was unusually broad-minded and did not at all mind us sharing a bedroom when I came to stay. At the end of that summer, Jackie and I parted; she stayed in London and I left for America. Our letters to each other soon petered out and that was the end of another summer of delightful romance.

Earlier that year, in February, I attended my mother and Isaiah's wedding at the Hampstead Synagogue. This extraordinary, enriching man made my mother happy and fulfilled for the next forty-one years until his distressing death in November 1997, at the age of eighty-eight. Curious about everything and everyone, with vast interests and knowledge, he had a phenomenal memory for even the most trivial of facts and was the greatest conversationalist of his time. He particularly loved being with students and the younger generations and in all the years I knew him, I never heard him put anyone down. He spoke incredibly quickly in quite a high-pitched, precisely enunciated, pre-war Oxford accent, talking passionately about any subject on earth, a flow of images and ideas cascading out of his mouth. He was very direct and liked people who were warm-hearted and spontaneous. Even Sir Maurice Bowra, former Warden of Wadham College, a frequent visitor and one of his oldest friends, found it hard to keep up with Isaiah, later writing that in his view this reflected 'an extremely supple and lively mind, but it was almost indispensable in his eager exploration of almost every human element that he could find'. He knew from the moment he first met Isaiah, then an undergraduate at Corpus Christi, Oxford that 'someone very remarkable had emerged'. Further on in his *Memories* Maurice Bowra wrote about my mother, Aline, at the time of her marriage to Isaiah, that 'She was extremely intelligent,

pretty, warm-hearted, rich and devoted to Isaiah, as he is to her.'

My mother was considered one of the most beautiful women of her time and even now, in her nineties, she retains that special look and a natural style that is still much admired. Brought up between the wars, she retains a certain formality and belief in the right and proper way to behave that harks back to the old-fashioned Anglo-Parisian manners she was born to. She is loving and very caring of her three sons. Not particularly outwardly affectionate with us, she is forever worrying about her family and anxious that we always behave properly towards others, but she is proud and supportive of our achievements. Highly intelligent, she retains a sharp mind allied to a fierce independence of spirit. As a child I was proud of having such a young mother, particularly one day at Bryanston. She had come to take me out during half-term and one of the senior boys asked me whether he could take my 'sister' out on a date. I told him it was not possible as she was in fact my mother.

Isaiah introduced me to the lavish theatre and music of opera on the rare occasions we went to Covent Garden together, sometimes sitting in the Royal Box when he was a Director of the Opera House. He was tremendously knowledgeable about the singers and the decors as well as the music, with a special passion for the operas of Mozart and Verdi. Driving back to Oxford after a performance, he was wont to sing or hum arias he had just heard (while singing was not his strong point he would become entranced by that particular performance, conducting with his head and his hands). Amusingly, his fluent Italian was closer to the language of Verdi lyrics than to the current spoken word.

I suppose it was mostly art that we talked about. I was in a way a bit intimidated by his intellectual genius and only felt confident when broaching my own subject. Isaiah's friends used to say he knew nothing about paintings, but he regularly went to museums and exhibitions, had an excellent eye and knew a great deal more than suspected or would admit. He had a special fondness for Venetian painting. Another reason we talked about art together was that for ten years, he was a trustee of the National Gallery, both under the chairmanship of Lord (Noel) Annan and then of Jacob Rothschild, a great family friend. There his skills at presenting an argument and negotiating were much appreciated and it was he who successfully resolved the dispute between the National Gallery and the Tate over the pre- and post-1900 collections, which ended up with them being divided between the two along those lines.

I shall always regret I didn't see more of him, but three years at Harvard followed by marriage on my return to England, meant we saw each other infrequently; it was generally during weekend

lunches at Headington House, sometimes in London and only two or three times in thirty years at their house in Italy, mainly because, since the early 1960s, we spent every summer holiday in our own house in the South of France.

Harvard and, at last, History of Art

Harvard and Marriage

The crammer which I was forced to attend continued to bore me stiff and before long I abandoned those studies. Obviously worried, my mother talked to Isaiah about this lackadaisical son of hers who did no work and it was he who came up with a brilliant idea. Earlier in the 1950s, he had twice been a visiting professor at Harvard and had many old friends there. He knew that Harvard had a History of Art department, based in the University's Fogg Art Museum, and suggested this would be the ideal place for me. At the time it was regarded as the best in the world, with some of the greatest professors, rivalled only by the Courtauld Institute. I was naturally tremendously enthusiastic, applied in the summer of 1956 and was accepted on the basis of my A-level results in History and French, along with a recommendation from Isaiah's friend, Arthur Schlesinger, Professor of History at Harvard and a few years later Special Assistant to President Kennedy.

When I arrived in Cambridge, Massachusetts, I was taken in hand by my cousin Masha de Gunzburg (her father Theodore was my grand-father's nephew), then in her fourth and final year who introduced me to her friends (by then she was so much nicer to me than when we had been children in White Plains during the war!). Among them was André Gregory, like Masha in his final year, who later became quite a well-known actor, and his brother Alexis, a very sociable, cultured man, more European than American in attitude. Their parents, Russian-Jewish émigrés, had a collection of Impressionist paintings and Alex himself became a

collector of Renaissance bronzes. Alex, who has remained a life-long friend, went into publishing and founded the Vendome Press, specialising in books on art, architecture and travel. A friend of Alfred Taubman and his wife Judy, he acquired some of Sotheby's shares at the time of Taubman's takeover in 1984 and has been a member of Sotheby's Advisory Board where he has made an important contribution over the years and is now Deputy Chairman of that Board.

My major, History of Art, accounted for two of the four credits students needed to take and pass each semester. From an extensive catalogue of subjects offered by the University, I chose 19th-century Russian literature, another of my passions, which made up the remaining two credits. Isaiah was delighted to hear this and in his letter to me dated 8 November 1956 he wrote: 'I am glad that you are doing Russian literature; your mother is studying Russian with Mrs Pasternak [sister of Boris Pasternak, author of *Dr Zhivago*]; I seem to have given a strong Russian twist to the entire family. I am sure that Harvard has many more people who talk about things in a serious, sympathetic, spontaneous and attractive way than you could possibly have found at Oxford, and I cannot deny that dear old Berk [Elliott Perkins' nickname], although an excellent housemaster, and full of knowledge of how to live at Harvard, is perhaps somewhat pompous and boring, but I like his wife very much. I would love to know what you think of her too.'

It was a great life and when I wasn't attending lectures, writing essays, playing squash or snooker with friends, or lying in bed reading Pushkin, Tolstoy, Dostoyevsky and Gogol, with Verdi operas (mainly *Traviata*) and Chopin *Nocturnes* playing in the background, I would go to the Boston Museum of Fine Arts and the Isabella Stewart Gardner Museum or, when possible, drive or take the train down to New York for the weekend and stay with my grandmother Lala at her apartment in the Carlyle Hotel (opposite Parke-Bernet's auction galleries, later to be bought by Sotheby's). On one occasion, Lala took me to one of the first performances of *My Fair Lady* starring Rex Harrison as Professor Higgins and Julie Andrews as Eliza Doolittle; in fact this was the only time I really enjoyed a musical. And, of course, these visits afforded me another opportunity to visit New York's great museums.

At Harvard I was attached more to an international group of friends than to your typical American, many of whom I then felt were quite insular, although my closest friend was a well-travelled American, Roger Wolcott Behnke. An aspiring writer, eccentric but somewhat unbalanced, he was later to commit suicide. My cousins Masha and Victor Wallis, another cousin and son of the Diane who had met me as I came off the boat in 1941, were

part of my circle as were three irresponsible but fascinating Iranians, several Greeks, and English and French undergraduates.

During my three years at Harvard I lived in Lowell House, a dormitory house. At first I shared a set of rooms on the ground floor overlooking a courtyard, with a tall, mid-western boy from what is now known as the 'Bible Belt'. On the second night we were lying in our bunks, casually talking, and he suddenly asked whether I had ever slept with a girl – my Oxford Moral tutor had come back to haunt me – and when I replied that I had, he expressed disgust. Discovering that I was obviously a degenerate European, within a few days he managed to swap rooms with Roger Behnke who equally wasn't happy with his room-mate in Lowell House.

Roger was a non-conforming individual who did not like the campus life of an American college so, within a few weeks, he moved into an apartment just down the road from Harvard Square. As a result I had a bedroom and a sitting room to myself; I liked the independence of having rooms where I was free to do what I wanted and to invite anybody of my choosing, including girlfriends. I hung the walls with drawings and prints, some brought from home, others acquired at local galleries in Cambridge and Boston. Spending five dollars here, three dollars there, my best finds were a little 16th-century drawing of houses on a Venetian canal attributed to Fialetti, a study for the descent from the cross by Cambiaso, a pair of black and white Toulouse-Lautrec lithographs of actors, and an Indian miniature – a drawing of men seated in a circle, apparently still not worth much more than what I paid for it in 1958. I tended to have a penchant for sometimes liking works that had a limited appeal to collectors at the time I acquired them, but in later years attracted a wider group of buyers. This, for example, included being one of very few collectors loving 16th-century Elizabethan portraits during the late 1970s when they were still readily available at affordable prices.

The quality of teaching at the Fogg was superb and finally I was studying what I had aspired to all along. Most of the professors regarded and taught the history of art from an analytical and stylistic view, including Seymour Slive, a great character and scholar of Dutch and Flemish painting (at one memorable Fogg Art Museum Christmas party, he dressed as an authentic Breughel peasant, codpiece and all), my tutor Sydney Freeberg, who was an imposing, austere figure, professor of Italian Renaissance and Mannerist painting, Fred Deknatel, a popular man who lectured on 19th- and 20th-century painting and who was an excellent generalist, Millard Meiss, a very well-known historian of early Italian Renaissance art and James Ackermann, an authority on Renaissance architecture.

All were great scholars whose work I admired, but could not get close to as teachers.

But the professor whose lectures and seminars I admired the most was an elderly German professor, Jakob Rosenberg, the renowned Rembrandt scholar of his day. He was inspirational, teaching not only academic interpretations and dry analyses, but, and in a way far more important to me, connoisseurship and appreciation; that is to say how to look at paintings and understand the emotions that can be generated, and why art has always held such a fascination for man since the Stone Age. Eventually I came to realise that I was interested in art for its own sake, in a much more emotional and visual way, not art as a dry academic subject.

At the Fogg, undergraduates were principally taught the history of Western Art from Ancient Greece to the 20th century. Then, in our final year, we had to concentrate on a particular period and, from it, focus on a precise subject on which to write a thesis. My years at Harvard had confirmed what I had already begun to believe, that I would want to devote my future professional career to Impressionist and Modern Art. I also knew that in order to really understand Impressionist and Modern Art, Renaissance painting had to be studied as that extraordinary, formative period had become the basis and inspiration for artistic movements that followed down the centuries.

Since I first visited Venice as a young teenager I had been passionate about the art of the Venetian painters of the late 15th and early 16th centuries. I loved the clarity of the vision of Jacopo and Gentile Bellini, Vittore Carpaccio, Giorgione and Titian, the exotic nature of their highly animated scenes, so influenced by visions of the East following Venice's occupation of and close connections with Byzantium. Therefore, to devote a thesis to the finest of that group of narrative painters was an obvious choice and would give me the opportunity of spending more time than ever in my beloved Venice. At the end of the summer of 1958, before returning for my third and final year at Harvard, I spent three weeks in Venice, looking, writing, working towards my thesis, and even enjoying myself with newly found Venetian friends, working in the morning, going to the beach at the Lido in the afternoon and socialising in the evening.

The seven compositions illustrating the patron saints of the Dalmation community in the Scuola Grande di San Giorgio degli Schiavoni (St Augustine, St George and St Jerome were the patron saints of the Dalmatians whose meeting place this was) had so enchanted me on my first visit to Venice in 1951 that I decided that Carpaccio and his Cycles would be the subject of my thesis. The Venetian Scuole were religious confraternities or guilds placed under the auspices of their patron saints.

In these Cycles, Carpaccio subordinates the legend or the narrative to the more immediate purpose of creating an enchanting image of the public and private life of contemporary Venetians. I was delighted to later learn that the Cycles had also captivated Isaiah who was to compare Winston Churchill's life to a legend by Carpaccio, as follows: 'The whole is a series of symmetrically formed and somewhat stylised compositions, either suffused with bright light or cast in darkest shadow... with scarcely any nuance, painted in primary colours, with no half tones, nothing intangible, nothing impalpable, nothing half spoken or hinted or whispered: the voice does not alter in pitch or timbre.'

During my time at Harvard, I spent each summer travelling around Europe, as well as seeing my family. In the summer of 1957, having visited my mother and Isaiah who were renting a house in Portofino, I continued driving down to Rome then on to Naples and finally to Sicily, accompanied by Roger. Having admired the vastness of Pompeii's ruins, we stopped briefly to look at the perfect, majestic Greek temples at Paestum, before continuing on through the austere, rocky landscapes of southern Italy. Reaching Reggio di Calabria, we crossed by ferry to Messina, the first port of call in Sicily. It was so hot that day that as soon as we docked, I blindly dived into the water near the jetty straight into a school of jelly fish – fortunately not too painful an experience, but to this day a vivid memory.

Driving past Mount Etna, we spent a few days in a *pensione* in Syracuse, an ancient city that still retained many traces of its antiquity. We continued on to the complex of Greek temples at Agrigento, set in the beautiful Sicilian landscape. There were few other tourists and it felt as if the island had remained unchanged for centuries. In Palermo I was shocked by the utter poverty: the smell, the dirt, the rubbish, the destruction, everything was run-down yet outside the city, in stark contrast, I was dazzled by the sumptuous late Byzantine mosaics that covered the walls of the cathedral at Monreale.

It was in the autumn of 1958, during a seminar on the early Impressionists, that one of the girls sitting in front of me turned around in her chair and asked me a question about Eugène Boudin, the Impressionist painter of Normandy's ports and beach scenes. As we walked out of the room, I asked her to have a coffee with me. Margery Tongway, from Bendigo, near Melbourne in Australia, was working towards a Masters degree in the History of Art and was at Harvard on a Fulbright Scholarship. I was immediately attracted to her delicate features and mixed origins; her mother was an Australian of English descent

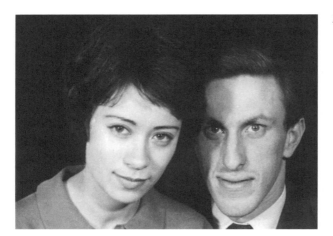

Margery and me, 1959

while her father, who had been born in Australia, was of Chinese ancestry. One of the survivors of the First World War, he had been the Principal of a Teacher Training College.

Our friendship gradually evolved, we fell in love and by the time the summer semester ended, we had decided to get married. Before leaving the States, I was contacted by John Walker, Director of the National Gallery in Washington, once again a family friend. He knew I had just graduated and offered me a most exciting job as his assistant, but, sadly, only a week later he told me he had discovered that the Gallery could only be staffed by American citizens and therefore, could not employ me. He then turned to Carter Brown, a fellow student at the Fogg, who accepted and eventually succeeded John Walker as Director. This was an extraordinary opportunity, unwittingly snatched away from me.

Margery and I flew back to London on one of the first trans-Atlantic jets and spent the summer months happily travelling around England, France and Italy.

As I was Jewish and Margery Presbyterian, we had no choice but to be married at the Oxford Register Office on 2 October 1959. The next morning we flew to Marseille to begin a two-week honeymoon in Provence, where we stayed in a delightful hotel at Villeneuve-les-Avignon, a village just outside Avignon. Using this as our base, we visited ancient Roman sites in Nimes and Orange, the hill villages of the Luberon and the various places depicted by Vincent van Gogh around Arles and St Rémy, and by Cézanne in and around Aix-en-Provence and the Montagne Sainte-Victoire. It was during those weeks we discovered a shared love of travelling and of looking at art and architecture which endured during the many years we were married.

Douglas Cooper

While in the area, we visited Douglas Cooper, an eminent art historian, exhibition curator, distinguished collector and a friend of my mother and Isaiah. Douglas was then living with John Richardson in the romantic 18th-century Château de Castille in Argilliers, near the famous Roman aqueduct at the Pont du Gard, a house notable for its 18th-century fake ancient Roman ruins at the entrance and its mural by Picasso in the hall. The Château had become a great meeting place for intellectual, artistic and social figures whenever they were in Provence and the South of France. Picasso, Leger, Braque, Jean Cocteau, de Staël, Graham Sutherland and Jean Hugo frequently visited the Château, as did Daniel-Henry Kahnweiler, the famous dealer and promoter of Picasso and the Cubists, Sir Anthony Blunt, Surveyor of the Queen's pictures, Clive Bell and even the Queen Mother. Douglas and John were also good friends of Picasso and often visited him in those years when he was living in Vallauris and later at 'La Californie' in Cannes. John, young, good looking, witty and knowledgeable, went on to write the most detailed and fascinating biography of Picasso in three intensely researched volumes, with a final volume yet to be published.

One evening Picasso was at a dinner given by Douglas where my mother and Isaiah were also guests. I cannot think of a single artistic figure of the twentieth century, whether a painter, writer or composer, who has the stature of Picasso and, for once, Isaiah remained silent. After dinner, as Picasso was about to leave, Isaiah decided he must speak to him and told him a story which had in the past greatly entertained others: when the Spanish poet Lope de Vega was assured he was near to death, his final words were, 'Well then, Dante bores me.' My step-father could not have been aware that death was a taboo subject when it came to Picasso and, to add insult to injury, the fact that the story of the dying Spaniard was intended to be humorous infuriated Picasso still further and he stormed out of the Château. Picasso's dread of death had haunted him from an early age: he had grown up in a Spanish environment that was obsessed by the subject and had been traumatised both by his sister's early death and by the suicide of his best friend Carlos Casagemas in Paris 1901. When Isaiah was told the reason for Picasso's sudden departure, he was, as John Richardson recounted, mortified.

Douglas had a stunning collection of Cubist paintings and drawings by Picasso, Braque, Léger and Gris, many of which he had bought in the 1930s when he first arrived from Australia, as a very wealthy young man. He did not restrict himself to any particular media and collected paintings,

Douglas Cooper and Picasso at La Californie, 1961 (photograph Edward Quinn)

drawings, *papiers collés*, prints and sculpture by all four artists, much of which could be seen in the house. 'What he enjoyed even more than showing his paintings to fellow experts and connoisseurs', as John Richardson has written in *The Sorcerer's Apprentice,* 'was opening young minds to the glories of the movement he regarded, with some justice, as the principal begetter of modernism.' A man with a great eye, and an encyclopaedic knowledge and understanding of art, Douglas was a large, florid, extremely voluble man, often bad-tempered, with strong, loudly expressed, controversial opinions; many admired him and many disliked him. But he had another side to him, charming and warm hearted and eminently fascinating. He was a great letter writer, sending out missives like darts in green ink, some vituperative, others, such as those to me, scholarly and informative. His long-lasting relationship with Picasso, equally volatile, eventually came to a bitter end, when he harshly criticised Picasso's 1969 exhibition of his late paintings at the Palais des Papes in Avignon.

In the 1950s and 60s, Douglas organised major Monet and Gauguin exhibitions during the Edinburgh Festivals, but the most notable was the *Cubist Epoch* at the Los Angeles County Museum and the Metropolitan Museum in 1970. This ground-breaking exhibition explored the development of Cubism between 1909 and 1921 and also revealed work, often derivative, sometimes highly original, by some of the lesser-known members of that loosely connected group: Gleizes, Metzinger, Picabia, Delaunay and the Italian Futurists, the Avant-Garde movement in Russia and the British Vorticists.

Douglas was a great help to me in later years when he would warn me of fakes coming on the market, as I made sure he always received catalogues of forthcoming sales. Although he had controversial, sometimes extreme views on art and the art establishment, I found him a very

stimulating man. Two years after he moved from Château de Castille, he sold seven Cubist works in my July 1979 sale. Included was a very fine 1916 Juan Gris, a Fernand Léger *Contrastes de Formes* of 1914 and an imposing 1924 Braque still life which all sold well, yet an awkward and, I felt, unsuccessful Picasso from 1932, a year considered one of his best when he was deeply in love with Marie-Thérèse Walter, did not find a buyer. However, taste or fashion if you like, changed and, when sold by Douglas's heir in 1992, it realised $3.85 million and then, when reoffered eight years later, it made a highly respectable $9 million.

In 1972 Douglas Cooper adopted William McCarty, a young American architect and designer. After Douglas died in 1984, Billy McCarty-Cooper took on the task of documenting and exhibiting his collection, making a gift of several Picassos to the Musée Picasso in Paris. The Tate Gallery in London, together with Billy, organised an exhibition titled *Douglas Cooper and the Masters of Cubism*, which opened in February 1988. To celebrate the launch of the exhibition, a dinner was held in a grand marquee on the Duke of York's parade ground in Chelsea. The evening was inevitably cold and damp and, in a typically thoughtful gesture, Billy draped beige and pink cashmere stoles on the back of each lady's chair. Arriving early, my mother's oldest friend, Liliane de Rothschild, checked where she was sitting and quietly swapped her beige stole for a pink one, an amusing, but rather outrageous gesture from a woman known for her sensitive taste in colours.

On our return from our honeymoon at the end of October 1959, I began work on a doctoral thesis at the Courtauld Institute in London. Initially I wanted to write about Degas' portraits, but soon discovered that Jean Sutherland Boggs, who in 1966 was the first woman to be appointed director of the National Gallery of Canada, had already chosen that subject for her own thesis. Instead I decided to write about the *Pointilliste* group of painters of the 1880s and 1890s in Paris. I had long been fascinated by their analytical approach and the recent colour theories promulgated by Seurat, Signac and their followers, whose subject matter, the rivers and ports of France had a tremendous appeal for me. However, although I loved the subject, after a time I began to lose interest in academic studies and finally realised that the thought of spending years researching and writing was not the path I wanted to follow. I needed to be directly involved in the art world, looking, learning and continually exercising and broadening my vision.

At about this time, Douglas Cooper told me that Benedict Nicolson, son of Harold Nicolson and Vita Sackville-West, who was the editor of the *Burlington Magazine*, the principal art historical journal of the time,

was looking for someone to write his monthly exhibition reviews and that he had recommended me. Soon after we met, I was delighted to be offered the job and my first published review in February 1960 was about the James Ward exhibition (famous for *Gordale Scar*) at the Tate, and Drawings from the Whitworth Gallery at the University of Manchester, shown at the Arts Council Gallery. I continued writing reviews throughout 1960 and most of 1961, working on them while I was still at the Courtauld where, incidentally, my tutor, rarely seen by me, was Sir Anthony Blunt, the highly distinguished Director of the Institute, and foremost specialist on the paintings of Poussin as well as Surveyor of The Queen's Pictures. Twenty years later, in November 1979, he was revealed to be the fourth man in the notorious Cambridge Communist spy ring.

In the early 1960s, magazine and newspaper reviews were descriptive, and not necessarily very critical, but Ben Nicolson gave me the freedom to write what I thought and to say what I liked and didn't like in a frank and critical manner. I really enjoyed reviewing contemporary art and exhibitions of British painting, although a few dealers, for instance Dudley Tooth, did show the best of the French painters I admired at that time such as de Staël and Dubuffet. Sadly, they were the last of a long line of great French painters. Since then France, once home to the Impressionists and the Post-Impressionists, the Nabis, Fauves, Cubists and Surrealists, has produced nothing new and exciting and has been completely overtaken and overwhelmed by American, Italian, German and British and now by Russian, Indian and Chinese artists. It is tragic to think that the extraordinary artistic traditions of France have come to a virtual halt after three hundred and fifty years, having produced such geniuses as Poussin, Watteau, David, Ingres, Delacroix, Gericault, Manet, Degas, Monet, Cézanne, Picasso and Matisse.

Writing about the new developments in British art was exciting and I feel proud to have had the perspicacity then to single out at the 1961 Royal College of Art graduate degree exhibition, two remarkable young painters whom I felt had a great future: David Hockney and Peter Blake. This for me is evidence that, in spite of clever marketing and promotion by museums and commercial galleries, in the end an artist has to have a unique talent and individuality to be universally recognised. This was certainly the case with Hockney and Blake in the 1960s and 1970s, although I now feel that Hockney has become more of a decorative painter and has lost much of the tremendous potential he showed in those early years. However, I am probably alone in this stern assessment of him as he is still much admired in many quarters and now commands ever higher prices in international galleries and auctions.

CHAPTER SIX

A Chance Encounter

One day in 1960, Isaiah and my mother were at a lunch in London where she was placed next to Peter Wilson, the Chairman of Sotheby's. During casual conversation she happened to mention she had a son who was a graduate student at the Courtauld Institute and reviewing exhibitions for the *Burlington Magazine*. Obviously interested to hear this, he told her I should call him about a possible job. This I quickly did and he said he was looking for a cataloguer in the Impressionist and Modern Art department and wondered whether I would be interested. At that time, however, I wanted to follow the dream I had had since the age of six of working in a museum, but arranged to see Peter Wilson all the same. I didn't turn down his offer there and then, but said I would like to think about it and thanked him for his interest in me. A few weeks later, the National Gallery announced it was interviewing for an assistant curatorship in the 19th-century Painting department. I was one of several candidates, but was not chosen, to my great disappointment, possibly because when asked my opinion about cleaning pictures, I answered undiplomatically that I was not in favour of extensive restoration; as the Gallery had been undertaking much criticised over-cleaning, this was not an astute response. However, it eventually turned out to be one of the best things that ever happened to me.

Remembering Peter Wilson's offer, I asked several friends, in particular Bob de Vries (Director of the Maurithuis in The Hague who happened to be married to one of my mother's Gunzburg first cousins) as well as Isaiah, what they thought of my joining an auction house. Almost everyone thought I would gain a lot of experience, as seeing such a variety

of pictures would be of enormous benefit if I ever secured a museum curatorship, ideally, for example at the Tate Gallery. I, therefore, contacted Peter Wilson again to ask whether there was still a vacancy. He confirmed there was indeed still a place as the year before he had created a separate Impressionist department; Bruce Chatwin was the sole cataloguer, but he needed another for the fast growing department. He asked me to come in for an interview and, accompanied by Carmen Gronau, Director of the Old Master Painting department, on whose advice he very much relied, Peter Wilson took me to lunch at the Westbury Hotel, just around the corner from Sotheby's. Half-way through lunch, he suddenly had to go, leaving me alone with Mrs Gronau. She was difficult to talk to, and probably did not appreciate being left alone to interview me, yet I must have made some kind of impression as I was offered the job. When I informed my tutor Sir Anthony Blunt I was joining Sotheby's, he was extremely angry, considering anything but an academic or museum career a total waste of talent, and any hint of art commerce an abomination. However, I was relieved to finally abandon my studies and started working at Sotheby's on 13 November 1961, on an annual salary of £850.

Peter Wilson

From an aristocratic family, Peter Cecil Wilson, was a tall man, elegantly dressed in a traditional black jacket, pin-striped trousers and stiff white collar. He had enormous presence, was highly respected throughout the art world for his knowledge and expertise, and was the greatest auctioneer of his generation. Quite simply he had one of the best eyes in the business, not only for pictures, but also for furniture and sculpture – especially Antiquities, Renaissance and 17th-century sculpture. Like me, he had failed his first year exams at Oxford and worked for a time at Spink's (the coin and medal dealer) and then Reuter's, but he didn't last long there as he couldn't take shorthand. Before joining Sotheby's as a trainee in the Furniture department in 1936, he had sold advertising space for *Connoisseur* magazine. He quickly moved up the ranks within Sotheby's and two years later became a partner and director, already with a vision for future worldwide expansion of the business.

At the start of the Second World War Peter Wilson was called up and joined the mail vetting department operating from Littlewoods and Vernon's football pools' buildings in Liverpool. Within a short time he was moved to Gibraltar to check diplomatic bags, and from there he transferred to Bermuda where transatlantic mail was examined. By such means, a

Peter Cecil Wilson
(known throughout
the firm as PCW)

number of foreign agents were discovered and Peter himself later joined MI6 where, strangely enough, he was given the code name '007'. At the end of the war he returned to Sotheby's where, in the words of Nicholas Shakespeare, Chatwin's biographer, 'His Byzantine cast of mind, useful in counter-intelligence, was equally so in the art world.' Peter Wilson, or PCW as he was fondly referred to by all in the firm, became chairman in 1957.

Peter Wilson was a friend of Ian Fleming and relished the idea that he was the inspiration for James Bond. Unaware of this or of any connection between the two men, when I took on the editorship of Sotheby's annual review, *The Ivory Hammer*, in 1963, I commissioned Ian Fleming to write a short story. This came about once again through my parents; Isaiah had known Ian for some time, his wife Anne became one of my mother's best friends and, because of this connection, I had the nerve to ask Ian to write a story titled *The Property of a Lady*, which perfectly captured the atmosphere of an auction house. The plot revolved around the discovery of a famous, rediscovered Fabergé Easter egg, its sale at Sotheby's, the KGB and, of course, the involvement of '007'; I loved his apt description of a sale:

'He [James Bond] went up the broad stairs with the fashionable, excited crowd and along a gallery and into the main auction room that was already thronged...and looked around him. The lofty room was perhaps as large as a tennis court. It had the look and smell of age and the two large chandeliers, to fit in with the period, blazed warmly in contrast to the strip lighting along the vaulted ceiling whose glass was partly obscured by a blind, still half drawn against the sun that would have been blazing down on the afternoon's sale. Miscellaneous pictures and tapestries

hung on olive green walls...There were perhaps a hundred dealers and spectators sitting attentively on small gilt chairs. All eyes were focused on the slim, good-looking auctioneer talking quietly from the raised wooden pulpit. He was dressed in an immaculate dinner jacket with a red carnation in his button-hole. He spoke emphatically and without gestures...

'"What you've got to do is to watch Peter Wilson's eyes and then try and see who he's looking at, or who's looking at him. If you can spot the man, which may be quite difficult, note any movement he makes, even the very smallest. Whatever the man does – scratching his head, pulling at the lobe of his ear, or whatever, will be a code he's arranged with Peter Wilson. I'm afraid he won't do anything obvious like raising his catalogue. Do you get me? And don't forget that he may make no movement at all until right at the end..."'

Later, in the 1970s, Sotheby's main saleroom in London was to be the scene in the Bond film *Octopussy* starring Roger Moore. In the film Bond was outbid by the seller of a Fabergé egg being offered at auction as the 'property of a lady'. (Of course such practices of bidding on one's own property to raise the price are not permitted.) The scene ends with Bond hailing a taxi on Bond Street to follow the glamorous bidder to Heathrow and onwards to India.

Nothing much has changed since Bond's encounter with Sotheby's, apart from the colour of the walls and the opening up of the main saleroom, the disappearance of the chandeliers and the introduction of a currency converter board behind the rostrum to facilitate international buyers as well as a large screen that projects an image of each lot as it comes up for sale.

Because of the time involved in preparing *The Ivory Hammer* during the summer of 1963, I wasn't able to take a usual summer break. Margery and I decided to have a holiday after Christmas and once more my mother came to the rescue. She had asked Anne Fleming's advice as to where we could go in the Caribbean and Anne and Ian very kindly offered us *Goldeneye*, their house in Jamaica, where Ian wrote all his James Bond novels. A simply furnished house, open to the breezes on all sides, it sat on a cliff overlooking its own private beach where, on several days, fishermen landed to offer us their catch including delicious spiny lobsters.

A Description of Sotheby's

Sotheby's was founded in 1744, twenty-two years before Christie's, when Samuel Baker, a Covent Garden bookseller began selling his stock at

auction. After he died, his estate was divided between his partner George Leigh and John Sotheby, his nephew, thus the name. When I joined, Sotheby's was still quite a small company, on the verge of international expansion and, with Christie's down in King Street, south of Piccadilly, was the principal auctioneer of fine and decorative arts and literary material in the United Kingdom. Certainly, both Christie's and Sotheby's were more important than any other auction house on the Continent of Europe and, at that time, the only other firm selling important pictures was Parke-Bernet Galleries in New York. Parke-Bernet benefited from very large supplies of such pictures either being sold by the American collectors of Impressionist and Modern Art or as a result of the considerable influx of fine art that found its way to America before and during the Second World War with refugees from Nazi-occupied countries.

When I arrived at Sotheby's, the galleries and offices at 34–35 New Bond Street comprised a warren of at least six buildings stretching from Bond Street back to St George Street, which ran parallel, just to the east. The buildings, all at different levels, were a combination of styles from early Georgian to later Victorian. At least a third of the space was occupied by connecting passages, corridors, sloping floors and stairs which certainly did not make moving pictures and works of art around the building easy. I always did a lot of walking from one place to another, to the galleries, to colleagues' offices, to the library and once, when I used a pedometer out of curiosity, I found that my average per day was about five miles: but it did keep me fit. I understand this is little when compared to the postman at the Louvre who covers twice that distance each day, although he does wear roller-skates.

The Bond Street façade of Sotheby's consisted of three arcades: the main entrance was in the left arcade, the one on the right was the goods entrance and, strangely enough, a popular newspaper kiosk occupied the central arcade. Sitting on top of that arch is a stone sculpture of the lion-headed Egyptian goddess Sekhmet, reputed by legend to have been Bought-In

Sotheby's New Bond Street façade, 1960s

(Sotheby's term for an unsold lot, usually expressed in house as BI) from a sale in the early 1800s, but never collected by its owner. There the kiosk remained, thriving very well on business from staff, clients and passers-by until much of the front of the building was redeveloped in the mid-1980s by Sotheby's new owner, Alfred Taubman.

From the main entrance, a staircase led straight up to sky-lighted galleries which Gustave Doré, the French painter who was very active in England in the 19th century, had used to exhibit his pictures. There were four of them at that stage: the Main Gallery where auctions and viewings took place, the Entrance Gallery used to show the more important pictures and furniture, the North Gallery, lined with bookshelves, for books and manuscripts and the recently added New Gallery for exhibiting drawings and smaller decorative objects such as silver and jewellery.

Our department occupied three small rooms on the ground floor of a red-brick, 18th-century building at the back of Sotheby's at 3 St George Street. I soon discovered that 'two ladies of the night' were using the top floor for their lucrative activities. Some mornings we used to observe them having a late breakfast in the coffee shop opposite, which we too frequented. I don't know what the rental arrangement was but, to my knowledge, it was not paid in kind. They were soon gone, giving us a bit more office space to cope with the expanding numbers of staff. Interestingly, Sotheby's second office in Paris on the rue de Miromesnil had been an active brothel run by a certain Madame Lina at the turn of the 19th century. Due to its proximity to the Elysée Palace, Madame Lina catered to politicians and the like.

When I arrived, I was to share an office with Bruce Chatwin, who had by then been working at Sotheby's for three years. Another, larger room was occupied by a porter and our secretary and, attached to that, was a narrow gallery that had recently been created from empty space where, during the weeks before the auctions, we were able to show the best pictures coming up for sale to prospective buyers before they went on public view. The space in the basement under our two offices was lined with storage shelves for pictures that had come in for sale, waiting to be inspected and catalogued.

The other new recruit to the department that day was David Nash who, at nineteen, was six years younger than me. After leaving Marlborough, which coincidentally was Bruce Chatwin's old school, he had had various odd jobs around the countryside, such as gardening for Surrey County Council, and he had even been a gravedigger at one stage. His father, a jewellery salesman at Harrods was a friend and former colleague of Graham Llewellyn, head of Sotheby's Jewellery department,

and through that connection, David obtained a starting job as a porter, in our department.

David was under the misapprehension that, as auctions didn't begin until 11 am, he wouldn't have to start work much before that time, so he was a bit surprised when he was told to be in by 8.30 and, to add insult to injury, that he would have to wear an overall. I think he was even more taken aback when I wandered in at 9.30 and did not have to wear an overall. David told us he knew very little about art and once said that he didn't even know who van Gogh was, but I think that was a bit of an exaggeration. He was certainly an incredibly fast learner. Early on he started helping Bruce and me with cataloguing. There was something about him that really impressed me, along with his sharp eye and sense of humour, and within a year or so he was cataloguing pictures himself.

Until 1960 there had been only one Picture department that handled all painting and drawing sales dating from the 14th to the 20th centuries. In that year, seeing that picture sales were rapidly expanding during the Post-War period, Peter Wilson decided to split this large department into three sections: Old Masters, British and Impressionist and Modern. Until 1965, our department was managed by the head of the British Picture department, John Rickett, whose duty it was to keep an eye on us, which was understandable as Bruce was only twenty-one and I was twenty-five.

Bruce Chatwin and Somerset Maugham

My early days at Sotheby's were exciting and perplexing: Bruce Chatwin was upset and furious when I arrived. Perhaps what riled him so much was the fact that I was the first person with a History of Art degree to join the company and walk straight into a job as a junior cataloguer – everybody else had started as a porter and if they showed promise, and many did, they gradually started cataloguing, as was the case with Bruce. Family concerns about money and the fact that he didn't know what to read at university had prevented him from furthering his studies. He thought of going on to the stage or of leaving for Africa, which horrified his mother and both his parents were relieved when he was introduced to Peter Wilson and offered a job at Sotheby's. Beginning as a porter in the Works of Art department on a weekly wage of £8, Bruce assisted Marcus Linell, who gave him as his first task the job of numbering the porcelain and glass lots. He was completely hopeless at the task and never did develop the ability to concentrate on the mundane. However, it was obvious from

the start that he had an instinctive eye and was soon noticed by PCW, who quickly moved him through the departments.

There had been a tradition at Sotheby's of teaching young recruits to the firm and of passing responsibility on to them at an early stage. This was particularly true of Jim Kiddell and Tim Clarke, respectively Directors of the Chinese and English and European Porcelain departments, but, of course, I was moving into a new department with no such tradition and, although others did help me, in particular our secretary, Bruce, because of his resentment, would not show or introduce me to any of the procedures. I was thrown in at the deep end: I had to gauge the market place for myself and then develop from there. The only way for me to learn was by looking and listening and perhaps in the end it was for the best. Within a month, in December 1961, my first major auction of Impressionist and Modern paintings took place.

That first auction was such a thrilling event and I remember how struck I was by the star lot of that day; it was a Cézanne, *Nature Morte aux Poires*, bought by the Zurich dealer, Marianne Feilchenfeldt for the Wallraf-Richartz Museum in Cologne for £67,500. Also included was *Number Three*, a drip painting by Jackson Pollock, completed only twelve years earlier, which made £22,000 and bought by Klaus Perls for his Gallery in New York. It was fascinating to see that already we were being offered recent contemporary art and were able to sell it successfully. This was a strong sale, with some great results, and as people were leaving the sale I was struck by an over-heard comment, 'These prices are crazy and we will never see them again.' This comes to mind whenever I hear similar remarks, even now.

As young cataloguers, larking around, Bruce, David and myself, one day signed our initials lightly in pencil on tiny unpainted areas of a Jackson Pollock and there they remain, perhaps to this day. I later realised that what we were doing was in the grand tradition of scratching names and initials on monuments, following in the exalted footsteps of Lord Byron (The Temple of Poseidon in Attica) and Raphael and Michelangelo (the ruins of Nero's Golden House in Rome) and I am sure of many others. My only other act of 'vandalism' was to stick a pin into a van Gogh to see if the paint had dried in the thick impasto areas: seventy-three years on, the pin emerged sticky.

In January 1962, barely a couple of months after I joined, Somerset Maugham's collection, scheduled for the April sale, arrived. This included an important early work by Picasso. While on his second trip to Paris in 1901, Picasso painted a vision of a fashionable *Femme Assise dans un Jardin*

Pre-viewing the Somerset Maugham sale, 1962: Bruce Chatwin, me, Katherine McLean and David Nash

on one side of a board, while on the other – he must have been short of material to paint on – was *La Mort d'Arlequin* which he had painted some four years later, during his Pink Period, at a time of his fascination with circus people and the life they led. Having previously been owned both by Rainer Marie Rilke and Somerset Maugham, this work with such a distinguished history, was bought for £80,000 by Paul Mellon of Upperville, Virginia. Paul and his father Andrew were the great benefactors of the National Gallery in Washington, where this work now hangs.

As soon as the Somerset Maugham collection was unpacked, cataloguing had to be quickly completed and Bruce said, 'We'll start tomorrow morning, let's say at 9.30', but when I arrived, on time, I found that he'd been there since 5.30 in the morning and had finished the job by himself. Feeling that here was an act fuelled by jealousy and competitiveness, I thought to myself, if that's the case, then two can play that game.

Then, a catastrophe; shortly before the sale, Somerset Maugham changed his mind and wanted his collection returned to him. PCW was appalled but, knowing the writer's tastes, he soon hatched a plan which it was hoped would make Maugham reconsider. Charming as Bruce was to both sexes, collectors of a certain persuasion liked him a lot and PCW was

Somerset Maugham's
Picasso, *La Mort
d'Arlequin*, gouache
on board 1905,
National Gallery,
Washington, DC

perfectly aware of the fact. He first asked Bruce to wash his hair and then visit Maugham at the Dorchester Hotel where he was staying at the time. Sitting together, with Maugham grumbling about his toothache while at the same time running his fingers through Bruce's hair, had a positive effect and Sotheby's were back on track with the sale. PCW had set up Bruce as a honey-trap and it had worked.

When the next collection was sent in for sale a couple of months later by the widow of Sir Alexander Korda, the famous film director and producer, I made sure that I did all the cataloguing before Bruce could get his hands on it. That was a fine collection with two outstanding works: Monet's large canvas *La Barque Bleu: Madame Blanche Monet et Madame Jean Monet* (his wife and daughter-in-law) painted in Giverny in the summer of 1887, a great composition in tones of blue and pink, which was a forerunner of the waterlily paintings he started working on at the end of the 1890s. It was sold to Baron Heinrich von Thyssen-Bornemisza for his then wife, the beautiful fashion model, Fiona Campbell Waters, for £56,000. The other picture which touched me deeply, one of those paintings whose moving experience sometimes brings tears to my eyes, was van Gogh's *Nature Morte aux Citrons et Gants Bleus* painted in Arles in 1889. He commented in a letter to his brother Theo dated 22 January 1889, 'I've just finished a new canvas which has an almost chic look to it...' A symphony of blue and yellow, it depicts lemons in a wicker basket next to a branch of cypress and a pair of blue gloves on a yellow table top. The surface is painted in thick impastos; vibrating with pure colours, the lemons and the cypress are redolent of the clarity of a Provençal morning. This was the first picture I had catalogued that I really fell in love with; it remains

Sir Alexander Korda's
van Gogh, *Nature Morte
aux Citrons et Gants Bleus,*
oil on canvas 1889,
private collection

high on my list of all time favourites and made a very satisfying £80,000, once again purchased by Paul Mellon.

Within a few months, Bruce and I started going on visits together. On one occasion in those early years we went to do a valuation of a few Impressionists at an elderly gentleman's apartment in Paris. On opening the door, and seeing two young men, he greeted us in typical, arrogant Parisian fashion with the remark, '*Mais, vous êtes trop jeunes pour être experts*'. Explaining ourselves, he finally let us in and, on completing the work to his satisfaction, he gave us each a rather hideous tie as a mark of his appreciation. This matter of age is a problem suffered by many young colleagues to this day.

I think Bruce began to get my measure and to realise that he couldn't walk all over me; he was intelligent enough to know that it was much better to work together and create a successful department. An androgynous figure, with striking, boyish good looks, blue-eyes and blond hair, he was a favourite of PCW. Very clever, very sharp, very inquisitive, he would listen to people, to their stories, absorb information incredibly quickly and rehash it his own inimitable and sometimes outrageous manner. When examining a picture, for example, PCW's favourite put-down word was 'unprepossessing' voiced in an accent which left no doubt about his background. Bruce pounced on this, mimicking PCW perfectly, 'That is just *so* unprepossessing,' leading to some hilarity in the department. He had a particular interest in Antiquities, Archaeology and Pre-Colombian art, and taught me much about them. For four years we formed a good partnership and put together exciting sales, but, although we became effective and excellent colleagues, we never socialised outside working

hours. David Ellis-Jones who joined Sotheby's as a porter in January 1963 perfectly described us as 'chalk and cheese'.

In the spring of 1963, Peter Wilson asked me to move to New York and open an Impressionist and Modern Art department in the existing Sotheby's office on 5th Avenue at the corner of 56th Street in the Corning Glass building. Margery and I were living in Montagu Square in London and by then we had a one-year-old son, Andrew. I knew New York well, but Margery and I decided we did not want to live there permanently and would much prefer staying in London. When I told PCW he asked whether I had any ideas as to who might be a suitable replacement. I suggested David Nash as a possible candidate since, after only two years, he was already quite knowledgeable, communicated well with clients and had, I felt, the necessary ambition and enthusiasm. PCW agreed and so, at the age of twenty-one, David left for Manhattan, where he settled in quickly and stayed, developing and running this major department, so vital to our business, for the next thirty-three years.

By 1964 Bruce was increasingly involved in running the Antiquities department as well as working with me. His extraordinary eye and feel for objects lent well to this field of ancient civilisations, for which we both shared a passion. I had the art historical background and was a much better organiser, while Bruce was very sociable and outgoing, but the friendly competitiveness between us continued: I later realised that this atmosphere was actually quite healthy and constructive. It kept us both on our toes, which is what Peter Wilson intended, no doubt. It is quite extraordinary to think how encouraging he was to us young experts in this rapidly expanding company; he gave us responsibility and he had faith in us; we were all in our twenties, soon to head up our own departments and become partners in the firm.

Sotheby's in the Sixties

It was due to Peter Wilson's highly acute business sense, forceful personality, worldly charm and encyclopaedic knowledge that so many of the Impressionist and Modern Art collections sold during his lifetime were to end up at Sotheby's. He was always the person to whom major business decisions and personnel issues were referred, but generally he let me get on with it. However, I soon found that he was short on complimenting work well done and quick to criticise. I accepted this was his way, but occasional praise when deserved does no harm.

Soon after joining Sotheby's I befriended his secretary, Katherine McLean. Kind, highly efficient and patient, Katherine was devoted to PCW and worked for him for more than twenty years. In order to counter Bruce's competitive attitude towards me, I soon began turning up in her office at 9 o'clock each morning to look at any mail that concerned Impressionists where estimates were required; I would jot down my thoughts in the margins of the letter and return them to her in time for PCW's arrival between 9.30 and 10. Sometimes he would call me in, often joined by Bruce, to discuss them further and although I assumed he appreciated my initiative, I felt he just took it for granted. But, if I did do something he did not approve of, he might sometimes have had sharp words with me. It happened rarely, but it was a very useful learning process.

PCW had a brilliant, innovative mind and would regularly devise new objectives for developing sales and new business ventures. Should any colleague disagree with him, he was wont to fly into a rage, a ploy often used to get his own way. I am not confrontational by nature so when he came up with an instruction or something which I did not think sensible,

I would agree to go along with it at first, but a few days later would come back and might say, 'I've looked into that idea you had but unfortunately it's going to be very difficult to achieve.' That approach would usually satisfy him and, by working my way round him, I managed at the same time to retain his respect. We got on well and I greatly enjoyed going on visits with him, in particular to Paris and New York over the next fifteen years or more. He was one of those grand gentlemen who never had any cash on them, so I would end up having to pay for taxis and restaurants – to be reimbursed by the accounts department later.

In April 1965 Peter Wilson and his fellow partners were in the forefront when it came to encouraging and rewarding young expert department heads. Bruce and I were offered directorships, along with Richard Day in Old Master Drawings, Howard Ricketts in Arms and Armour and Marcus Linell in Ceramics. We were each given the opportunity of buying 2500 £1 shares which represented 2½% of the total equity. I was then twenty-eight and was, quite naturally, surprised and delighted as I had been at Sotheby's for only three and a half years. Bruce and I were made joint-heads of the Impressionist and Modern Art department, reporting directly to PCW, which angered Bruce as he had not expected me to be promoted at the same time. Much to my amusement Bruce celebrated his elevation by discarding his cheap grey suit and hanging it on the office wall, saying it was evidence of his rags to riches status.

While at Harvard I had been a friend of an American girl, Elizabeth Chanler, who was also studying History of Art; in about 1962 she turned up as one of PCW's secretaries. To everyone's astonishment, in August 1965, Elizabeth and Bruce got married.

Bruce, a mercurial character, was one of those people who do something brilliantly, but quickly become disenchanted. He had been PCW's blue-eyed boy until their relationship soured after a blazing row attributed to PCW's private dealings with the sale of the Pitt-Rivers antiquity collection. No doubt too, boredom got the better of him and, at the age of twenty-six, Bruce left Sotheby's and went to Edinburgh to read archaeology. He eventually abandoned that course without taking his degree and thereafter travelled extensively, studying the lives of nomads and settlers. As well as writing travel articles for the *Sunday Times,* he became a well-known and respected author of such books as *In Patagonia, On the Black Hill,* a novel set on the Welsh borders, and *The Songlines,* an account of invisible pathways followed by Aborigines across Australia. Tragically, Bruce died of an AIDS-related disease in 1989 at the age of forty-eight.

As the sales and the number of lots were expanding, we began to take on several junior cataloguers; Richard Nathanson was one, as was David Ellis-Jones, James Dugdale (later succeeding his father as Lord Crathorne in the House of Lords and now Lord-Lieutenant of North Yorkshire) and Walter Feilchenfeldt. Walter was the son of the eminent Swiss dealer, Marianne Feilchenfeldt, a tall, imposing and kind woman who was a dear friend of Carmen Gronau and PCW. After a thoroughly instructive eighteen months, Walter left to join his mother and eventually became one of the foremost experts on Cézanne and van Gogh. His father, also called Walter, had been a partner in Berlin of the famous dealer, Paul Cassirer, who was the first to introduce the late 19th- and early 20th-century painters, in particular van Gogh and Cézanne, to German private collectors and museums. Prior to the Second World War, Feilchenfeldt moved to Zurich, but died still quite young. His wife, Marianne carried on the successful business which is now in the hands of their son.

Another who joined us for a year in the mid-1960s was my cousin Hubert Goldet. His main interest at that time lay in Contemporary Art, which included persuading his father to buy one of Dubuffet's Sahara paintings of 1947, which we sold for him in 1995 for £1 million. Once back in Paris, he began to discover African Tribal sculpture, trawling through the salerooms of the Hôtel Drouot, the flea markets and the specialist dealers on the Left Bank. He created one of the finest collections of its kind, almost all of it displayed in the living room of his small apartment. Hundreds of wooden representations of man filled the room in a low light as he never opened his curtains. The majority were bundled into an extraordinary display of figures on a four foot square coffee table, reminiscent of some strange, denuded jungle. A quiet, introverted chain-smoker, he would sit with me in front of the table, passionately telling me about his recent discoveries, which tribes they came from and who the previous owners had been.

This was a completely foreign world to me. Unlike Matisse and the Fauves, or Picasso and Braque, or the Surrealists who took such inspiration from them in the early 20th century, I at first found them primitive and mostly unattractive, the exact opposite of the sophisticated, finely crafted high art that I had been exposed to my whole life. Eventually, as Hubert talked enthusiastically about them, some pieces began to interest me. These were mainly the Fang and other West African figures that were to have such an effect on Picasso: their influence is principally evident on the whole series of works that culminated in *Les Demoiselles d'Avignon* and beyond into Cubism.

Hubert was a solitary man, but we did see each other on occasions

when I was in Paris, as did Andrew who had tremendous admiration for him. In fact Andrew was far more attuned to Tribal Art than me; in more recent times we would sometimes view these sales together and gradually, influenced by his eye and his feelings towards these arts, I began to enjoy looking at certain pieces, probably more so those from Oceania and Australasia than from Africa. Hubert died at the age of fifty-five and, although he had always promised the sale of his collection to Sotheby's, last minute changes to his will stipulated a sale in Paris to be conducted by French auctioneers and catalogued by his Tribal Art expert friends. The sale took place in July 2001. This was a service Sotheby's was unable to provide until later that year when foreign auction houses were finally allowed to hold sales in France.

After Bruce's departure for Edinburgh, I was left alone to run the department. One of the responsibilities I most enjoyed was cataloguing: researching the history of paintings, their past owners, exhibitions where they had been shown and the various publications in which they had appeared. At first our catalogue entries were quite summarily described, but as the years went on and the market expanded globally, we wrote more and more extensive notes, and, eventually, long essays for important paintings.

I discovered very early on that the six-year-old boy who had demonstrated a passion for art, had it in his blood: I so enjoyed estimating and valuing pictures, meeting the collectors and the dealers, as well as learning the more practical, commercial, financial and legal issues needed to provide a serious professional service. For example, the whole issue regarding the import and export of works of art had to be quickly learned and explained to sellers and buyers to avoid them falling foul of their own national regulations. Strangely enough, the seeds of a business mind, the intellectual challenge and the fun of guessing what the pictures in a sale might fetch had already been planted in my brain as, during the two years I spent in London before I joined the Impressionist department, I would often view the sales at Sotheby's and Christie's, writing down what I instinctively thought paintings were worth and then comparing my estimates with the results, often quite accurately.

I believe there was, as now, an element of chance in the auction process as one can never be sure of the final result. Once I had learnt the ropes and gained enough expertise, I was quite prepared to take a risk, consulting PCW and other colleagues in the department if necessary, willing to accept an estimate and reserve price demanded by a collector who had grand ideas of value, if I felt the picture had a significant quality.

Most of the time the gamble paid off, but then, occasionally, when no buyer was prepared to raise his hand and the painting was unsold, as soon as the sale was over, someone, usually a dealer looking for a bargain, would make an offer acceptable to the owner, now more anxious than before to be rid of it. My philosophy was that if I took such a risk I would get some very good consignments which would add to the quality and value of the sales and in that way would be successfully competing with Christie's in London and Parke-Bernet in New York. And I took these risks because as the years went by, throughout the 1970s and '80s, there was nobody in the firm to rein me in, unless there was a major financial commitment involved. In both rock-climbing and skiing I was capable of recklessly pushing myself to the limit and this same trait came to the fore at Sotheby's. Nevertheless, before each sale I feared failure, that the work would not sell, and the tension showed in my face to such an extent that, many years later, I learnt that the Auction Room Services staff led by my future second wife Sally Lloyd Pearson gave me the nickname 'Scary Strauss'. My son Andrew, now Vice-President of Sotheby's France, shares a similar trait for he is sometimes fondly known in Paris as '*Andrew Stress*', a play on his surname. In the end, I must now admit, it was not my money at risk, so it was easier to plunge in. The ambition and competitiveness in me was just waiting to come out and now did so, in part because of Bruce Chatwin's initial attitude towards me, but also because what I was doing during those early years at Sotheby's was largely successful.

You need a special talent to be a successful auctioneer and Peter Wilson was without doubt the finest of his time: this was certainly one of the contributing factors in his effectively acquiring collections. He had a tremendous presence on the rostrum, but strangely, not during more minor sales. It was as if he needed a special occasion, such as an important Impressionist or Old Master painting sale of a famous

Jacob Goldschmidt's Cézanne, *Garçon au Gilet Rouge*, oil on canvas 1890-5, National Gallery, Washington DC

collection, for his unique abilities to shine. There is the story that, during the Goldschmidt sale in October 1958, when Cézanne's *Garçon au Gilet Rouge* reached the then astronomical figure of £220,000, he looked at the under bidder with a smile and in an incredulous tone asked, '£220,000, £220,000? What, will no one offer any more?' To everyone's relief the tension in the room snapped and the audience burst into laughter. The way he did that, his style, what we now call charisma, was quite extraordinary and there is no doubt that this brought more and more private collectors to buy and sell at Sotheby's.

Most heads of department took their own sales, but to be a successful auctioneer you need some of the qualities of an actor. Reticent by nature, I really disliked the idea of getting up on to the rostrum. However, I thought I should at least try and see how it felt, so in 1964 I climbed the steps to sell a collection of pretty pastels of birds by Simon Bussy, a friend of Matisse. It was a nerve-racking experience and although I managed to get through it without making too many mistakes, I decided to leave auctioneering to others better suited. Bringing in property and organising the sales was what I loved and was best at.

I was convinced that as the sales were growing, we had to devise ways of bringing in more private buyers, making the whole auction process easier and more efficient for them. To take an example, one day in 1967 I was talking to an American collector who had come to view the sale. He loved one of the works by Monet, but unfortunately, because of a meeting he had to attend in New York that coincided with the day of the auction, he said he would not be able to bid on the work. I suggested he get a dealer to bid for him or, alternatively, he could leave a commission bid with us. He declined these suggestions as he was not sure how much he wanted to bid, adding that he liked to be at the auction in order to have a feel for the

My only stint
at the rostrum

atmosphere. Suddenly I had a flash of inspiration and proposed that I telephone him directly from the saleroom so he could participate, if not in person, then through me: in that way he could follow the bids and come in if and when he deemed necessary and thus enjoy the bidding tactics, almost as if he were in the room. He thought that was an excellent idea, the phone connection worked through the international operator and he finally bought the painting while sitting in his office in Manhattan. He was delighted with the process as was I. On that day telephone bidding started and from that point on it became routine. Within a few years there were three or four telephones in use for each Impressionist and Modern art sale; by the 1980s there were perhaps ten or fifteen members of staff manning the telephones and at the beginning of the 21st century, that figure has quadrupled as more and more clients have availed themselves of this service.

Developing Theme Sales

To become a fully-fledged expert takes between five and ten years and by the late 1960s, feeling confident in my role, I was ready to tackle new ventures. I had gained enormously from my involvement in the annual pattern of a series of three sales, each a mixture of paintings, drawings and sculpture, roughly between 200 and 300 lots. Now I wanted to take certain risks, to try something different, and began to look out for special opportunities on which I could capitalise and increase our sales.

The Diaghilev Ballet Auctions and Thilo von Watzdorf

The first such exciting opportunity came about early in 1967 when I had a call from Vera Bowen, the translator and editor of Sergei Grigoriev's *The Diaghilev Ballet 1909–29*, asking me to come and see her. A year earlier she had sent in a consignment of designs by Léon Bakst which had sold well and she followed this with two boxes of musical scores for Diaghilev ballets. She explained that Grigoriev, by then old and bed-ridden, was living with her in her small Belgravia house, and that Diaghilev and Colonel Wassilly de Basil had given him a large collection of costumes which he in turn gave to her in the 1950s. Grigoriev had trained at the Imperial Theatre School in St Petersburg and in 1909 became *régisseur* (stage manager and rehearsal director) of Diaghilev's Ballet Russes which my great-uncle, Dimitri de Gunzburg, had sponsored. Mrs Bowen explained that the collection was stored in large baskets at the Pantechnicon's storage facilities in Chiswick and wondered if Sotheby's

would be able to sell their contents. Intrigued, I made my way to Chiswick and inside the baskets was amazed to find amongst the neatly folded and well preserved costumes, several worn by Nijinsky. There were also two boxes of costumes that she had already sent to us separately. Straight away I had the idea that we could organise a spectacular sale devoted to Diaghilev and the Russian Ballet and make it a very special event.

Running a now expanding department, I was keen to bring on young colleagues whom I wanted to encourage to develop their own interests. A few months before I received Vera Bowen's call, Thilo von Watzdorf, the half-French half-German nephew of Prince Bernhard of the Netherlands, joined the department. Thilo had been brought up in a house filled with music, art and literature by his French mother and his step-father, Aschwin Lippe, who was curator of Far Eastern Arts at the Metropolitan Museum. After Thilo left university, his step-father approached Carmen Gronau, whom he knew professionally, and she arranged for him to meet PCW, who immediately took to Thilo and engaged him as a 'learner porter' in September 1966. He certainly learned a lot about people, and, as he recently told me, watching potential expert buyers on their hands and knees counting stitches in rugs did not appeal to him as a future area of expertise. As a lover of porcelain he was shocked to observe a London dealer surreptitiously take out a tiny penknife and drag it along an exquisite and extremely valuable 18th-century Meissen figure by Kaendler. He reported the incident, but was told that one should not say anything; the client was a regular dealer. Of course, the piece had been devalued and was not attractive to others, so the dealer could buy the figure at a knock-down price, restore it and sell it at a huge profit. Silver dealers were amongst the naughtiest of the lot and Thilo was appalled to watch a regular London dealer getting away with bending silver trays out of shape in order to buy them more cheaply.

Thilo happened to be a friend of a Swiss girl, Huguette Burrus, my secretary at that time, and through her he got to know David Ellis-Jones who had been working with me since 1963. One evening they bumped into each other in the Chelsea Kitchen on the King's Road and had dinner together. David told Thilo that we were looking for someone to help us in the department, and, after interviewing him, I knew right away he was just the kind of person we were looking for.

Well before coming to Sotheby's, Thilo had ballet connections. His brother was married to Leonide Massine's daughter Tanya and when she started her own ballet company, Thilo had been taken on as a young dancer. He had had lessons while at university although he did not consider himself to be a dancer. As he loved the ballet, I asked him to help me

organise the sale. We brought in Richard Buckle, the ballet critic and biographer of Diaghilev and Nijinsky, as a consultant. Students from the Royal Ballet School were recruited by David and Thilo who had travelled to Liverpool where they were performing at the time. They were chosen to model the costumes and be photographed for the beautiful catalogue illustrations, according to their height and shape, as they had to fit into the original costumes. Lydia Sokolova, one of Diaghilev's former dancers, trained the students to adopt the correct poses for each costume.

This was London in the 'swinging sixties' and the wonderful costumes, made from richly embroidered velvets and silks, were incredibly fashionable and attracted much attention. We organised a special gala evening preview which was attended by the then patrons of the Royal School of Ballet, Princess Margaret and Lord Snowdon. Because PCW 'chickened' out of showing them around, Thilo was asked to do so. On the evening of 13 June 1967, during the sale itself, which was taken by Peter Wilson, each lot was displayed by the students in identical poses to the catalogue illustrations. At one moment during the auction, I noticed a rather strange, sweet smell wafting through from the back of the saleroom. Wondering what it was, someone said, 'Don't you know that's marijuana?' The ballet students had been given a little room to change in to the side of the saleroom and were obviously smoking a not-so-discreet joint.

The sale of 152 lots included not only Mrs Bowen's property, but we had also taken the opportunity of gathering together, from a variety of other owners, costume and set designs, posters, books, performance contracts, musical scores and porcelain figures of dancers, all related to Diaghilev's ballets. The undoubted highlights were the original costumes worn by Nijinsky for *L'Oiseau d'Or* (sold for £900) and those designed by Léon Bakst for *Le Dieu Bleu* (£400). It is extraordinary to think now that this wonderful

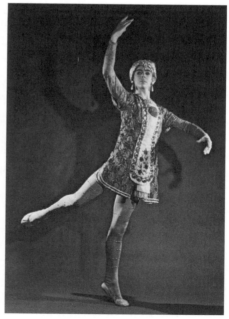

Nijinsky's costume for *Le Dieu Bleu* designed by Léon Bakst at the 1967 Diaghilev Ballet sale

93

sale fetched only a total of £30,000, equivalent to the price of a single Impressionist painting in a sale in Bond Street three weeks later.

All was up and running for the Diaghilev sale when Anthony Diamantidi, president of the Diaghilev and de Basil Ballet Foundation and sponsor of the Ballet Russes, got in touch with Richard Buckle to suggest that Sotheby's also sell the Diaghilev and de Basil costumes, curtains and musical scores which he himself had stored at Montrouge in Paris. David Ellis-Jones and Thilo accompanied Buckle to an incredibly dirty warehouse and pulled out, from maybe two hundred trunks and wicker baskets, marvellous costumes which hadn't seen the light of day for some thirty or forty years. These included the Chinese costumes Matisse designed for *Le Chant du Rossignol*, a Bakst-designed coat for *The Sleeping Princess* and all the costumes for *Swan Lake* which had been purchased from the Bolshoi in the pre-Second World War Years. It was a veritable Aladdin's cave.

What we did not know at the time was that Diamantidi had turned up out of the blue to see Grigoriev in what was a most acrimonious visit, accusing the sick man of selling what did not belong to him. The fallout from this dispute was the threat that the sale would have to be cancelled. It seemed that there were old scores to be settled: Diamantidi had promised Grigoriev an allowance which had not been forthcoming. Happily, the upshot was that the sale did take place and Diamantidi gave Grigoriev half the money raised. As for the sale of Anthony Diamantidi's own collection, this took place in July 1968 at the Scala Theatre in London. He donated the proceeds towards the establishment of the Victoria & Albert's Theatre Museum which came into being in September 1974, but was sadly closed in 2007, and transferred to the V & A Museum itself in 2009.

Thilo had spent much of the previous winter sorting through the costumes which had been shipped to another dreary warehouse in London and Dickie Buckle helped him catalogue the collection. On 17 July PCW took the sale and once more the costumes were modelled by students from the Royal School of Ballet. What gave me particular pleasure was to see the curtain for *Le Train Bleu,* actually a hugely enlarged replica of Picasso's 1922 gouache, *Deux Femmes Courant sur la Plage* (Musée Picasso), painted by Prince Schervashidze, the scene painter for Ballets Russes, but dedicated by Picasso who had been delighted and impressed by the result. At the sale it made £69,000 and PCW announced it was 'bought by Mr Richard Buckle for the Nation'. The total sum raised at this sale was £88,000.

A second sale was held in December 1969 at the Theatre Royal in Drury Lane which included the glorious costumes for *Prince Igor* and Roerich's stencilled woollen smocks for *The Rite of Spring.* Lydia Sokolova, who had been a member of the Corps de Ballet in Nijinsky's original

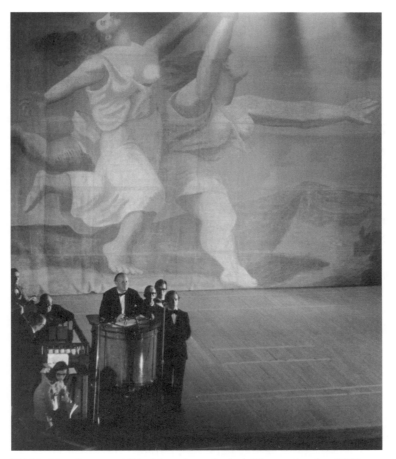

PCW taking the second Diaghilev sale at the Scala Theatre, London, 1968,
Picasso's curtain in the background, Victoria and Albert Museum. Thilo von
Watzdorf, John Cann and David Ellis-Jones are standing next to the rostrum

version, choreographed a dance for our young students which they
performed and at the end of the evening she received a round of applause.
In 1914 she had danced on the very same London stage and this was to
be her final curtain call.

Diaghilev ballet material had been keenly collected and was very
fashionable in the post-war years but, by the end of the 1970s, the market
had begun to dry up and prices tended to stagnate in the 1980s. Much
had disappeared into museums and private foundations or probably was
still in the hands of those who had acquired them originally, or perhaps
had been passed on to their heirs. But the wheel turns and with the advent
of the new Russian buyers there is renewed interest in items connected
to the Ballets Russes.

David Ellis-Jones and the Drawing Sales

Following on the success of the Ballet auctions and, as the department continued to grow, and there was an increasing abundance of material, I had the concept of organising more sales with a particular theme or emphasis. The next opportunity to do so came in 1967 when it was apparent that the time had come to separate out drawings and watercolours from the larger category of paintings and sculpture. I was acutely aware that there were dedicated connoisseurs who collected only drawings and to have sales that specifically attracted them seemed a good idea. It was possible then, and it's still the case to this day, to buy fine and rare drawings at a fraction of the price you would have to pay for the equivalent quality in paintings. Added to this was the passion I had always had for graphic art, be it drawings or prints – in fact I was thirteen when I bought my first drawing, an English 17th-century red chalk study of two small children (unfortunately it turned out to be a reproduction, but it taught me a good lesson and helped me later to develop a natural instinct for detecting reproductions and fakes).

The first such sale titled *Impressionist and Modern Drawings and Watercolours* took place in New Bond Street in April 1967 and was catalogued by David Ellis-Jones. David had joined Sotheby's as a porter in January 1963. Twenty years old, he had been introduced to Jim Kiddell, a senior Director, through a family friend, Max Robertson, the BBC sports commentator. David had always had a special feel for the Impressionists; he spoke French and had French friends including the sister of Marc Blondeau (later head of Sotheby's France) whom he had met when she came to learn English in Bournemouth. In the spring before the William Cargill sale of June 1963, we were quite stretched in the department and while having coffee in the *5 to 7*, a dingy little Trattoria round the corner from our offices in Maddox Street, I bumped into David who realised we needed extra help, as by that time David Nash was about to leave for New York. So, this was how he came to join Bruce and me as a temporary porter.

In those early days, while he was still a young porter, we would juggle our roles as to who was going to type and who was going to measure the pictures we were cataloguing in the basement. My typing was a bit faster than his so I got to sit in the chair, but David told me that he, as the junior, should do the typing. To which I replied, 'The typist sits in a chair and the one measuring is down on his knees!' And so he trudged back and forth to the shelves, fished out the pictures to be catalogued and knelt down to measure them in that dark and

dusty basement where, he said, he learnt a 'fantastic amount'.

A year later, in 1964, having outgrown our office space at 3 St George Street, we moved into galleries across the road from Sotheby's main entrance, recently vacated by the Matthiesen Gallery. It was then that David Ellis-Jones was promoted from a temporary porter to a cataloguer working closely with me. At that time of rapid growth, others had joined the department in various capacities. There was friendly jostling for position amongst these colleagues, but David felt disadvantaged as the others had art history backgrounds while he didn't; nevertheless he was the one who remained the longest while the other two went on to pursue other interests.

The more David catalogued in the succeeding years, the more I realised that he too had a particular feel for works on paper, and so it was that we decided in 1968 to put together a sale, both from consignments that were coming in on a regular fashion and others solicited from a few selected dealers and collectors who were attracted by this new concept. To quote David, 'I felt it was a way of giving me a niche. It was important for me. You may not have realised that.' In fact I was quite aware of the importance for him, as I had been that year, when I asked Thilo to organise the Ballet sale and, later on, when I asked him to work on the first of many contemporary art sales. This, of course, echoed PCW's trust in his younger colleagues which, in turn was demonstrated by David Nash.

Finding a niche at the start of a career is a vital tool in gaining confidence and under the guidance of David Nash, my son Andrew, many years later, managed to find his own way as a cataloguer of works on paper during his early days at Sotheby's in New York in 1983.

This first sale of Drawings and Watercolours took place one afternoon in April 1967, following the morning's Painting and Sculpture sale. It was a success, attracting interest from specialist collectors and museum curators, and a similar pattern of sales, adopted some years later by Christie's, has mostly continued every year on both sides of the Atlantic to this day. Two years after we began the drawings sales, David Ellis-Jones received a phone call from an Indian lady who told him that she had a lot of works by some Viennese artist called Schiele, which she wanted to sell in order to send her son to Cambridge. David jumped into his Mini and drove way beyond the North Circular Road to a red-brick terraced house in the outer suburbs and there, on top of a wardrobe in an upstairs bedroom, were stored at least ten watercolours by Egon Schiele, some in good condition, others not so good, but all-in-all an extraordinary find. Then, to his astonishment, the Indian lady pulled out an oil painting from behind a wardrobe, a rare treasure by the artist called *Die Freunde (The*

Egon Schiele, *Kneeling Nude*, tempera and black crayon on paper 1917, private collection

Friends), painted in 1918 as the study for the famous poster for his one-man show at the Viennese Secession in that year. It depicted Schiele with a group of friends, including Gustav Klimt and Alfred Kubin, seated around a table. Estimated at £15 – 20,000, it was bought for £39,500.

As some of the works required restoration, David and I decided to sell them two by two, the finest a kneeling nude which made £8,700, was a new artist record at the time. But once again, as was the case with Grigoriev and Diamantidi, a spanner was thrown into the works. It transpired that the Indian lady's husband had, before the Second World War, been the lover of a German actress. When it was obvious that war was imminent, the actress told her lover to return to India, get married and have a family. She gave him the Schieles, saying that although they were worth nothing then, they would be some day. And now, of course, she wanted her share. Her claim was accepted and she was granted 25% of the sale proceeds, but we also made her realise that the works were the property of the Indian family: they used the remaining money to set up an educational trust. Since then, Schiele watercolours have become highly sought after, as seen by a record price of over $11 million for a work of similar, exceptional quality in 2007.

This reminds me of an event which typifies what happens when 'auction fever' takes over. In November 1985, one of the finest watercolour and gouaches by Egon Schiele appeared in our sale in New York. This *Portrait of Johann Harms* was estimated at $200–250,000, but the feeling was that due to its importance, it might very well fetch more. Before the auction I was discussing its prospects with a very well-known collector, for whom I had bid previously on several occasions, each time he let me use my discretion when he could not attend the sale in person. We decided I could go up to $320,000 with some extra discretion if necessary. The

bidding rose quickly and at $300,000 I saw that Serge Sabarsky, the famous Schiele dealer and expert was bidding against me. I decided that if he was bidding, then I could continue, as he must surely know something very special about this work. The bidding went up and up, well past the $500,000 mark, and, I must admit, I got quite carried away. Finally, when Sabarsky bid $620,000, I dropped out, to my sudden, great relief, realising what I would have had to tell my client if I had bought it for him at a price way beyond his instructions. The next day, I bumped into Sabarsky in the street. He asked me why I had carried on bidding. I said it was because, he, the great Schiele expert, must have known something very special about it. To which he replied, that he had kept on only because I was bidding, and he thought I knew something he didn't. We laughed, and he added, there is no fool like an old fool, and that he often lost his head at auctions! I never told my collector the story. Yet, if he had bought the Schiele, it would now be worth at least ten times as much.

David Ellis-Jones was an affable person, a great raconteur, enthusiastic and a fine specialist in his field. In his view, as in mine, an auction house expert is one who, if he doesn't know the answer, always knows how to find out or who to ask. He was a pleasure to work with, so I was shocked when he told me he had decided to leave after ten years at Sotheby's in 1973. He was rather a sensitive person and often not happy on a day to day basis, thinking that he was 'too close to the job'. I never thought or felt in those terms. I suppose I was not so susceptible to taking offence, or at least did not show it. For David, the last straw was having an argument via a memorandum with Graham Llewellyn, head of the Jewellery department, that the company must come first, the client second and individual members of staff last. David strongly believed, as do I, that the success of a company such as Sotheby's lies in putting the client first, followed by the welfare of the staff second: these are the main elements which, I believe, contribute to the success of a company. He thought that if that was the policy of a Senior Director, then he didn't want to stay. Admitting that he also had itchy feet, David moved to a small office in South Molton Street, up the street from Sotheby's, where he specialised in selling 19th- and 20th-century drawings. Seven years later, finding the private market difficult during another recession, and realising he functioned better working with other people, he joined Christie's Impressionist and Modern drawings department until, once more dissatisfied with the way affairs were run, he eventually left to manage Wildenstein's London Gallery on New Bond Street, which later moved to a small office in St James's Place. There he has remained, his 'wanderlust' obviously cured, friendly as ever.

The Russian Avant-Garde and George Costakis

I continued to develop sales that concentrated on particular areas such as Drawings or Contemporary Art as well as Russian Avant-Garde and 20th-century Modern Italian art, as a way of bringing in more business, of making our sales even more interesting and of motivating us. For example, in 1969 we discovered, in an old English collection, a masterpiece by the Italian Impressionist painter, Giuseppe de Nittis, titled *L'Avenue du Bois et l'Arc de Triomphe,* painted in 1880. This gave us the idea of putting together a modest sale to test the Italian market, much at the insistence of Carmen Gronau who had a house in Florence and had opened an office there. Although the de Nittis sold well at £38,000, the rest of the Florentine sale was a catastrophe. Only a very few paintings sold, because, we came to realise, the Italians do not like to be seen buying in Italy, drawing unwelcome attention from the taxman, whilst happy to do so abroad. A sale of Flemish 19th- and 20th-century painting was more successful when staged in London in 1970, but then again future supply was limited by a lack of availability so that 'theme' was abandoned by the late '80s. These sales may not have been hugely successful, but they served to introduce us to new buyers, and although we may not have had further sales in Italy for another twenty years or so, we began to export more and more Italian paintings and sculpture for sale to London.

Then, in the 1990s we resumed sales in Italy, this time in Milan, concentrating on Italian 20th-century material which appealed to local collectors and dealers. As with sales in other European cities, such as Munich and later Berlin, their purpose was to help finance the costs of an office and to facilitate the handling of material of moderate value which, due to its particular local flavour, would perhaps be uneconomical to export. At the same time, we initiated specialised sales in London of important Modern Italian and German material, which continue to produce excellent results.

In the mid-1960s we began to be offered works by artists of the Russian Avant-Garde, that crucially innovative movement at the beginning of the 20th century, represented by such major artists as Goncharova and Larionov, Malevich and Popova, Tatlin and El Lissitsky. The first approach I had from a member of this group was early in 1964 when we were contacted by the second wife of Mikhail Larionov. By then, the eighty-three year old Larionov was bedridden, living in a tiny apartment on the rue Jacques Callot, on the corner of the rue de Seine, and was in desperate need of money. As soon as I could I flew to Paris, eager to meet this famed figure from the beginning of the 20th century, who had moved with his

first wife Natalia Goncharova (who died in 1962) to Switzerland in 1915 to work for Diaghilev, designing costumes and decor for his ballet productions. Sitting by his bed was a sad and touching experience, but also a great privilege. He told me to take my pick of the pictures painted both by himself and his wife and sell them as best I could. His small, dingy room was crammed with all sorts of works: paintings were stacked against the walls; drawings, posters and handbills were stuffed into a large chest of drawers. I selected a few of the best, including two

Mikhail Larionov, *Hot Summer* from the *Four Seasons*, oil on canvas 1912, private collection

of his paintings of the *Four Seasons* executed in 1912 (the other two are in the Tretyakov Gallery in Moscow), seminal works of the Avant-Garde movement which had been widely exhibited around Europe from 1913 onwards, as well as a classic earlier painting by Goncharova of 1909 titled *The Fishermen*. Their appearance in the sale that summer of 1964 caused quite a lot of excitement amongst a small group of connoisseurs of that rare period in Russian art. In terms of the market at that time, they sold relatively well, the two Larionovs making £5,600, the Goncharova £1,100, but nothing compared to the £6.4 million pounds recently made by another Goncharova at auction in London in 2010, which was bid to record heights by several of the Russian collectors. Mikhail Larionov died in Paris later that year.

In the summer of that same year, 1964, one of the legendary figures of Russian Avant-Garde collecting landed on our doorstep bearing roughly packed parcels. This was George Costakis, who had just arrived from Moscow. A gruff, bear-like man, he spoke with a heavy Russian accent. Fascinated by this apparition from the Soviet Union, right at the height of the Cold War, I gathered him up with his packages and took him to my office, impatient to hear his story.

Born in Moscow in 1913 of Greek parents who had emigrated to Russia in 1907, he worked most of his life as a major domo at the Canadian Embassy. He explained that, from 1946, when he had first met Rodchenko and Roszanova, he started collecting paintings and drawings, buying them

in large numbers from any surviving painters, their widows or children. Over the next thirty years, he amassed an enormous, quite extraordinary collection of works from that experimental movement, active between 1910 and 1930. He painstakingly searched out Constructivist and Suprematist works (the two principal sections of the Avant-Garde movement, influenced by Cubism and Futurism, which a few painters had actually seen in Paris) some of them well-known, others forgotten till they were rediscovered by Costakis.

From his various packages appeared several paintings by artists, some known to me, such as a Murnau period Kandinsky, others by Liubov Popova, including two Architectonic Compositions of 1917 and 1918, which fetched £900 and £600 respectively in the 1964 auction. Popova was unknown in the West at the time and few had any concept of the importance of her abstract paintings, but gradually they began to be appreciated. Three years later in 1967, Costakis appeared again with even more important paintings. One of Popova's greatest cubistic compositions, *The Traveller* of 1915, was bought by Norton Simon for £9,000 (Norton Simon Museum, Pasadena), while two more of her Architectonic Compositions were making almost ten times more than three years earlier. He also brought a little 1912 masterpiece by Robert Delaunay, which he had acquired from Alexander Tairov, founder of the Moscow Chamber Theatre. It was bought for £14,500 by the Tate Gallery. Also included in that group, was a fine Jawlensky and a Max Ernst, which he had acquired from the film director, Sergei Eisenstein. Now that Russian collectors are buying back the art that was ignored or forbidden during the Soviet years, these prices seem derisory.

During subsequent years, Costakis would sporadically reappear, bringing more pictures which he was able to take out of the Soviet Union in the Canadian Embassy's diplomatic bag. He became a well-known figure in Russia where art

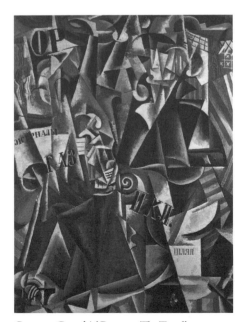

Georges Costakis' Popova, *The Traveller*, oil on canvas 1915, Norton Simon Museum, Pasadena

collectors and curators visiting Moscow were drawn to meet him and his vast collection, all housed in a relatively small apartment. Articles were written about him, including one by Bruce Chatwin which appeared in the *Sunday Times* magazine in 1973, under the title, *Moscow's Unofficial Art*. It was through the works he brought out before leaving the Soviet Union, that we discovered lesser figures, each fascinating in their own right. Aside from Popova, the artist whose work I most liked was the Constructivist, Ivan Kliun. Costakis owned piles of his watercolours and a few paintings, which began to appear quite regularly whenever he brought us a new consignment, particularly after he had left Russia.

In 1977, at the age of 64, Costakis finally decided to leave the Soviet Union, settling first in Canada, but soon taking up permanent residence in Athens. To be allowed to take his collection with him, he had to give over half to the Tretyakov Gallery, Moscow's museum of Russian painting. When I visited Moscow for the first time in 1989, I was very fortunate to be shown its Avant-Garde collections, including many owned by Costakis; these were not then allowed on public view, but hung on sliding racks in the basement where I was taken by one of the curators, a friend of Irina, Sotheby's Moscow interpreter. On one occasion in 1980, he brought a little gem, a rare 1917 Kandinsky oil, *Red Square II*, painted during the time the artist was living in Moscow between 1914 and 1921. However, by then, feted by museums who wanted to exhibit his collection, and collectors and dealers who tried to buy from him, Costakis began having inflated ideas about the value of his remaining collection, which was by then out of the Soviet Union. He demanded exorbitant prices and it was always a struggle to get him to be more reasonable. The estimate I finally got him to agree to on the Kandinsky was £240–280,000, which I thought was achievable, considering the painting's pristine quality. However, neither collectors nor dealers responded to it, and it failed to sell, much to my disappointment.

Partly due to an increasing flow of Russian Avant-Garde works from Costakis and other consigners, Julian Barran and I decided to start having specialised sales devoted to this period. Many came from Paris, where Russian émigrés had settled after the Revolution and from Sweden to where, I suspect, works were being smuggled from the Soviet Union. Another source was Germany, supplied by diplomats who were exporting paintings (including an unknown number of fakes) via diplomatic bags.

Once he had settled in Athens, I occasionally visited Costakis, enjoying his company and was fascinated to hear about his early collecting days, the painters he encountered and life in Russia under the Soviets. Then, in the winter of 1990, already quite ill, he indicated he wished to

raise a substantial sum of money for his daughter, Natalia. Julian Barran and I flew to Athens and spent two days with him, sorting through a mass of material which, by then, consisted principally of works on paper. We made our choices and, in consultation with Costakis, put together an excellent and varied sale. However, we had to fight with him over every single estimate, as he thought this group was so important, in spite of the fact that many of the best works had either already been sold or given to the Tretyakov Gallery. Asya Chorley, our Diaghilev ballet and Avant-Garde specialist, produced a fine catalogue, but, regrettably, the sale in April 1990 was a failure. Known for his greed and inflated ideas of price, many potential buyers were reluctant to bid. Although we had managed to get the reserves reduced to a more reasonable level, many of the lots were returned to him. We had believed it worth taking the risk, and, as I have already said, if you don't take risks, you don't have a chance to succeed. That same year, George Costakis died, leaving his vast collection to his daughter. She managed finally to sell all the remaining works in 1997 to the Greek State. A few months later I was asked to come up with a valuation to help the Thessaloniki Museum of Contemporary Arts arrive at a purchase price; the Costakis collection is now housed there.

Post-War and Contemporary Art Sales

The next concept Thilo von Watzdorf and I had was to siphon off Post-War and Contemporary Art from the main sales and give it a separate identity. This represented artists who started evolving their style during and after the Second World War, including Jean Dubuffet, Jean Fautrier and Yves Klein, the Russians, Nicolas de Staël and Serge Poliakov, who lived in Paris and the Abstract Expressionists in New York – Jackson Pollock, Franz Klein and Mark Rothko to name but a few. Many of them had begun to make their presence felt in our sales ever since the late 1950s and some, such as de Staël and Pollock, had major works included in my first sale in December 1961.

In New York, more and more of these artists were being included by David Nash in his Impressionist and Modern Painting sales. The first opportunity to hold a specialised, single-owner, purely Contemporary Art sale occurred in 1970 when Robert Scull, the owner of a fleet of taxi cabs in Manhattan, decided, as a result of his divorce from his wife Ethel, to sell a significant part of his quite recently acquired collection of mainly 1960s' New York artists, including Jasper Johns, Andy Warhol and Roy Liechtenstein. It was highly successful and, thereafter, David and I decided

Left: David Hockney, *The Splash*, acrylic on canvas 1966, private collection;
Right: Andy Warhol, *Flowers*, silkscreen and enamel on canvas 1967, private collection

to hold specialised sales of Post-War and Contemporary Art. The first were held in New York in the late '60s and finally London in July 1973: it was this very exciting change of focus and market taste that I encouraged Thilo to develop. Traditionally, all catalogues had dull green covers, but we felt this new departure needed a different kind of distinguishing cover. To that end, Thilo came up with the idea of using black with an arresting illustration on the cover, the first being that of a set of Dan Flavin's coloured neon tubes. This sale included some extraordinary works such as David Hockney's *The Splash* of 1966 (£25,000) and a monumental Warhol *Flowers* (£24,000), paintings which today would be valued in millions.

Many years later, for financial and organisational reasons, Post-War and Contemporary Art became a separate department, but still very much within my domain. These sales in London and New York have now reached such extraordinary levels of value that in 2008, for the first time, Contemporary Art sales began producing totals nearing those achieved by auctions of late 19th- and earlier 20th-century works. It is due partly to the shrinking availability of the latter, including the classic post-war iconic painters which have become much sought-after trophies, while more recent Contemporary Art has constantly renewable, global sources and has become the focus of thousands of new collectors and dealers.

Memorable Colleagues in London

I believed that finding replacements or additional personnel for the department so often hinged on the chemistry which could be instinctively felt between us within a few minutes of an initial interview. I needed to recognise an enthusiastic attitude, a sense of purpose, intelligence and initiative. Over the years I have rarely made a mistake and almost all the colleagues I hired have turned out successfully. When I did find the right person, be it cataloguer, administrator or secretary and I had gained confidence in their abilities, I would soon delegate responsibility to them.

This was my way of bringing them on quite quickly and as soon as I felt they were coping well, I gave them their own sales to run; either the smaller mid-season sales or the day sales catalogues that contained works less valuable than those in the important evening auctions. As they gradually succeeded, I was able to increase their responsibilities to the point where, with some guidance from me, they began developing their own client base and business getting opportunities for the important sales. We were in general a harmonious department, perhaps due to the fact that I employed a certain type of recruit: I believed that if I liked them there was a strong possibility that they would like each other and work well as an effective team.

Julian Barran

One of these earlier recruits was Julian Barran. At the age of eighteen, interested in art and looking for work, he noticed a newspaper

advertisement for a gallery assistant placed by the antiquities dealer Robin Symes. He applied, but, as he said, almost didn't get an interview because his handwriting was so illegible. However, his enthusiasm must have come across as he got the job and within a very short time realised the art world was his future. As a child, he had been taken on the usual round of museums and cathedrals with his parents. In the 1950s his aunt had worked at Sotheby's, although Julian's father, Sir David Barran, the Chairman of Shell at that time, had little interest in the subject.

During his short time with Robin Symes, Julian travelled to Italy in order to learn the language and study History of Art. On his return, Robin offered him a partnership in the gallery, but Julian declined because, although he loved the work, he saw his future in an auction house. Julian had met John Hewitt, a close friend of PCW, one of the great antiquities and works of art dealers in England at that time, from whom I had bought a number of Japanese ceramics as well as a superb Roman 1st-century bronze portrait head in the early 1960s. Together with Robin, they recommended Julian to PCW. After an interview with Michael Ritchie, then Managing Director, and the Earl of Westmorland, Julian joined Sotheby's as a porter in the Furniture department in May 1968. Soon after, Duncan Maclaren, who was assisting Thilo organise the 1968 Ballet sales, was involved in a car accident, so I asked Julian to step into his shoes. Thus began his twenty-three year career with Sotheby's, culminating in him becoming head of Sotheby's France, one of the most important positions in the company. Following PCW's retirement, Julian gradually took on the role of the department's chief auctioneer, conducting many evening sales in an excellent fashion.

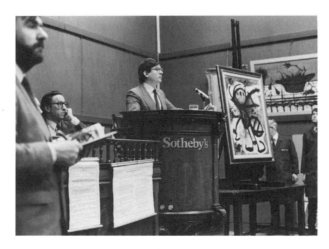

Julian Barran at the rostrum, with Marc Blondeau on the far left and me executing a phone bid

Once David Ellis-Jones had left in 1973, I took on Peter Romilly to catalogue the drawings and when he in turn left, I assigned Julian, who had displayed a flair for works on paper, to organise those sales; at the same time he continued developing the Ballet and Russian Avant-Garde sales. This made much sense due to the close relationship of such designers as Bakst, Benois and Exter with Larionov and Goncharova, who were instrumental in the development of the Avant-Garde movement.

Due to the weakness of the market during the recession of the early 1980s, good consignments had reduced to a trickle so any Impressionist, Modern and Contemporary Art sent to us for sale, was combined into one quite small catalogue for economic reasons. Understandably disappointed by this turn in the market, Thilo transferred to New York to head up the 19th-century European Painting department, to be replaced in 1980 by a young Italian who soon turned out to be ineffective and totally unreliable. We soon realised the reason why – he was permanently high on drugs. I managed to get rid of him amicably and, luckily, a far superior replacement was found. Through Uschi Niggeman, head of our Cologne office, we were recommended to speak to Lucy Mitchell-Innes who had previously worked on the archives of Henry Moore and Anthony Caro. She came for an interview and, much impressed by her attractive personality and knowledge, I offered her the Contemporary Art position which she fortunately accepted.

During the late 1970s and early 1980s, several cataloguers left for one reason or another: Max Rutherston transferred to the 19th-century Continental Picture department, Jane Roberts went to live in Paris, while Vanessa Walden, who had been cataloguing the major sales with me, decided to get married (my daughter Julia was her only bridesmaid). That meant I had several vacancies to fill and I found that a way of achieving this at no cost to the department was to take on volunteers or interns as they are now called, a system that continues very efficiently to this day. These were young people often desperate to work in the Impressionist and Modern Art department at a time when we had no resources to take on any more staff. It was also the case that this was an excellent way of introducing students fresh out of university to the department and, if we liked them and their enthusiasm, we were able eventually to offer them a permanent job whenever there was a vacancy.

An early volunteer, in 1986, was Caroline Lang, a distant Basel cousin, who now is Managing Director of the Geneva office. There have been many others, but amongst the most notable is Oliver Barker, who was recommended to me by an old friend, the Renaissance and Baroque sculpture dealer Danny Katz. He was initially trained in Paris by my son

Andrew who, equally, had started his career as a volunteer under David Nash in New York in 1983. Oliver is now the highly successful head of London's Contemporary Art department. Emmanuel Di Donna, from Paris, was keen to work at Sotheby's, so after the usual interview we took him on as a volunteer in London and soon sent him to Paris to help Andrew organise the complex Man Ray estate sale held in London in 1995. He then became a full member of the department, and was later promoted to a senior position in London's and New York's Impressionist and Modern departments, eventually resigning last year.

Hugues Joffre

Hugues Joffre arrived in my office one morning in 1982 asking for a job. He told me that he had first heard about me in Paris, where he had been brought up, when he was twelve years old and ever since had dreamed of working for me. This young Frenchman, who spoke good English, was the grandson of Maréchal Joffre, Commander-in-Chief of the French armies during the First World War. Despite the blatant flattery, I was impressed by his enthusiasm to come and work for me although I had to tell him there was no vacancy at that moment, but that he could join us for a trial period as a volunteer.

Within a relatively short period, I was able to employ Hugues on a full time basis as a junior cataloguer. When business began to improve after the recession of the early 1980s, I gradually moved Hugues to catalogue Post-War paintings until, quite soon, I was able to put him in charge of this small department assisted by a secretary, sharing a room next to us. Before too long property was being consigned more frequently, so we were able once again to have separate Contemporary Art sales. These sales began to grow, modestly at first, but soon gathered pace as Hugues gained the confidence of the market, which in any case was improving after Alfred Taubman bought the firm in 1983. In order to motivate Hugues, at the beginning of every year I would give him a sales target which he had to achieve, and on reaching it I would then double it for the succeeding year. He responded to the challenge extremely well and, gradually from small beginnings, the sales were making between £15 and £20 million per annum by the late 1980s, highly satisfactory for then, but paltry compared to the totals now reached.

Hugues and I got on very well together; I was his mentor and for a long time I was able to guide him through the complex workings of management and the various service departments. However, over the years,

he began to show a certain attitude which was out of step with some of the policies of the company and the way it was managed. The situation reached a flashpoint in 1992 when Hugues had such serious differences of opinion with Tim Llewellyn that he resigned, as he felt he had been unfairly treated.

During the recession of the early 1990s, Tim, who had formerly been head of the Old Master Painting department, was by then Managing Director while the Earl of Gowrie (Grey) was UK Chairman. Michael Ainslie, as Taubman's CEO, was instructed by the Board to drastically reduce fixed costs as well as control travel budgets. The first step was redundancies, as well as other cost saving measures. Tim Llewellyn decided to cut the salaries of the two highest paid expert division heads: Marcus Linell and me. He bluntly told us that our salaries were to be reduced by 40% and that we would only be required to work three days a week. This idea of curtailing the business-getting activities of two of the most productive directors was, I believed, ill-judged, particularly when Sotheby's so needed to increase its sales and earnings. Infuriated, I immediately went to see Michael Ainslie and Dede Brooks, then head of New York's Finance department, telling them of Tim's decision. There was much support from colleagues and soon we were both re-instated.

This unfortunate affair was one of the reasons Hugues decided to resign. Souren Melikian, art sales correspondent of the *International Herald Tribune*, heard that Hugues was leaving Sotheby's, and promptly published this in his regular Saturday column, which upset me. Hugues had been a very good friend and one whom I had helped and encouraged in his, up to then, brilliant career. Gradually our friendship withered as his attitude towards me became increasingly unpleasant as time and circumstances changed. He soon reappeared as head of Christie's Contemporary Art department in London followed by a period with Christie's in Paris, until he left in 2001.

Following Joffre's departure, we urgently had to find a replacement. We had been hearing excellent reports from Roberta Thompson, Director of Christie's Contemporary Art department and a former Sotheby's colleague, about Tobias Meyer who was then number three in her department. He was more than happy to join us as head of the department and within a relatively short time, was making significant progress, to such an extent that when Lucy Mitchell-Innes resigned in 1995, he was immediately 'poached' by Sotheby's in New York.

Born in Germany, Tobias had trained with an antique dealer in Vienna before coming to London. He and I quickly established a good rapport and have remained excellent friends. Tobias was one of the few

people at Sotheby's who had that European sensitivity and wider knowledge of the arts, and was one of the rare colleagues I felt culturally attuned to, in the same way as I was with Peter Wilson, Bruce Chatwin and Andrew. He has made a tremendous success of his career in New York and his theatrical manner in the rostrum has made him one of Sotheby's star auctioneers.

At this time, in the mid-'80s, Julian Barran was working much more closely with me, travelling all over Europe, especially in the Scandinavian countries, visiting collectors, dealers and potential vendors and bringing in consignments for our important sales. Therefore, we needed someone to take charge of the Drawing, Ballet and Russian Avant-Garde sales and appointed Asya Chorley. She already had a good knowledge of the subject as her step-father Alexander Shouvalov was the Curator of the V&A's Theatre Museum.

Melanie Clore

In 1982 Melanie Clore, a bubbly young woman, fresh out of university, appeared on the scene. She was the great-niece of Sir Charles Clore, the owner of Selfridges, as well as a highly successful property developer and well-known collector of Impressionist and Modern paintings. I knew the family well; the Clores were friends of Hans and my mother, and my half-brothers when small had often played with their children, Alan and Vivien, while their mother, Francine (née Halphen), happened to be a cousin of my mother, through their mutual grandmother. Coincidentally, Hans and Francine had been seeing each other in the 1950s at the same time my mother was seeing Isaiah Berlin. Therefore, Melanie's appearance was yet another, but distant, link between our families.

What I did not know then was that Melanie had already worked at Sotheby's as a volunteer one summer before going off to read History of Art at Manchester University. Whilst an undergraduate, she wrote asking me to give a talk at the Whitworth Arts Society on the subject of working at an auction house. I had never given a lecture in my life, so I apologised and sent Jane Roberts, my cataloguer at the time, in my place. I found out later that Melanie wasn't so much looking for a speaker as wanting to get a toe in the Impressionist department. After she graduated in 1981, I discovered her, one morning in September, manning the Front Reception counter: she had successfully managed to get her foot in the door. A few weeks later I bumped into her cousin Vivien Duffield and in her typically provocative way, she said to me in front of Melanie, 'You realise that what

Melanie really wants is your job?' to which I replied, 'Good, that's the kind of attitude I like to hear.'

Full of initiative and enthusiasm, Melanie began coming up to the Impressionist department when the reception area closed to the public at 4.30, to ask if there were any little jobs she could do. Naturally there were always plenty of them and so we began to get to know her. It happened at that time that Julian had agreed to run an auction in aid of the Duke of Edinburgh's Award Scheme and, as we were all very busy on other

Melanie Clore

projects, Melanie offered to put together this rather glamorous black-tie auction. I was much impressed by her performance. She was an attractive, exotic-looking girl, with a stylish, quite individual way of dressing. Already familiar to all of us and with the workings of the department, she was obviously very keen to join us, so when a vacancy appeared after Max Rutherston left for the Continental Picture department, I quickly moved her up to our offices to replace him in January 1982. As a fully fledged member of the department, she soon proved to be hard working and dedicated. From cataloguing the mid-season and the more valuable day sales that followed the evening auctions, Melanie was quite soon working closely with me, helping catalogue and organise the evening sales with their big, glossily illustrated catalogues for auctions that took place annually in early April, late June and early December.

Melanie and Hugues had very different characters; one was typically English, the other had a decidedly French attitude; they were from different countries and cultures, and exhibited different body language. The atmosphere in that large office where the cataloguers and secretaries worked in close proximity was decidedly frosty and Melanie and Hugues became very competitive with each other. Remembering my own early experiences with Bruce, I thought this might be a good thing, but in the end it became a problem and soured the atmosphere. I resolved it at the time Hugues began to catalogue Post-War and Contemporary Art by moving him to an adjacent office; Melanie was much relieved

while Hugues was pleased to have his own little 'principality'.

In the summer of 1985, I asked Melanie to accompany Julian and me to a London warehouse to examine and value for sale a number of paintings from the estate of her great uncle, Sir Charles Clore. Clore had been one of a group of property developers who, from the 1950s to the 1970s, had vied with each other in collecting fine Impressionist and Modern Paintings: men such as Jack Cotton (who had bought my grandfather's Renoir *La Pensée* in the 1958 Goldschmidt sale, Jack Lyons and Max Rayne (whose collection we sold many years later, thanks to Melanie's friendship with the family). Clore was a great benefactor, recognised not only for his charitable donations to Jewish charities, but also for providing most of the funds for the Clore Gallery at Tate Britain which houses the Turner Bequest. On his death in 1979, his collection was divided between his children, Alan Clore and Vivien Duffield as well as his Charitable Settlement whose trustees decided to sell their part in December 1985. By then the art market had recovered from the recession of the early 1980s and prices for the best works were strong. My favourite among Clore's Charitable collection was an early, superb *Pointilliste* work by Paul Signac. Entitled *Brise Concarneau – Presto,* it was one of a sequence of five pictures executed in Brittany in1891 which he called *Symphonies of the Sea,* giving each a musical title. This beautiful work, painted in tightly arranged, contrasting colours of fishing boats with purple sails was bought for the then high price of £660,000 by Mick Flick, the Mercedes heir. Other notable pictures sold included a 1926 Kandinsky from his Bauhaus period which Clore had acquired at the famous Guggenheim Museum

Sir Charles Clore's Signac, *Brise Concarneau – Presto*, oil on canvas 1891, private collection

sale of fifty Kandinskys at Sotheby's in 1964, and a rather beautiful and touching 1934 study by Picasso of a couple reading a book, which he had purchased once again in our saleroom in 1960.

As for Vivien Duffield's outrageous comment about her cousin's ambition, Melanie did finally, fully succeed me, first when I ceded the management of the department to her and then when I retired at the end of 2000. She continues to be the driving force of the London sales with the same energy and enthusiasm she had when she first joined the department. Much respected and liked by British and American collectors, Melanie has developed a special flair for selling pictures, and is much admired for her clever marketing ideas combined with her ability to manage the department in a sensitive and caring way. Her skills and influence were recognised by the Company when she was appointed a Deputy Chairman in 1997 and once I had retired, she took my place as Co-Chairman of the Worldwide Impressionist department. Her current Co-Chairman is New York's David Norman.

Philip Hook

A relatively more recent arrival was Philip Hook. He worked at Christie's for about fifteen years, eventually running the 19th-century Continental Picture department. However, he decided to leave in 1990 with his colleagues, David Bathurst (formerly head of Christie's Impressionist department) and Henry Wyndham, to form the St James's Art Group with offices in Jermyn Street. On one side of the street was Paxton and Whitfield, the cheese merchants, and on the other side Floris, the perfumery, so, as Philip recounts, at one end of the office, there was a mouth-watering smell and at the other delicious scents. At first, their private dealership was quite successful, but the early 1990s saw a significant drop in the art market, partly due to inflation and high interest rates, and partly to the crash of the Japanese economy. Following the tragic death of David Bathurst, they found there was absolutely nothing to do, so to fill the depressing vacuum, Henry and Philip took to going to the cinema in the afternoons.

Having left Christie's, Philip was clear that he never wanted to work for an auction house again. During quiet times he had written *Optical Illusions,* a wickedly satirical book about Christie's and its managing director, and has since written other fascinating thrillers, based on stolen pictures or events and activities during the Second World War. One morning in 1993, Henry Wyndham told him that he

Philip Hook

had been offered the UK Chairmanship of Sotheby's. Philip thought the idea so far-fetched that he responded, 'Oh yes, and my name's Napoleon Bonaparte.' But it was true although Henry, not wanting to leave Philip in the lurch, told him he had turned down the offer. Philip was appalled and told him to get back on the telephone, accept the Chairmanship and take him along too. Appointing Henry Wyndham was an inspired move on Grey Gowrie's part and he has become the best UK Chairman Sotheby's has had since Peter Wilson retired in 1980.

Philip first began working in the 19th-century Continental Picture department, but soon came to join us in the Impressionist department, as, by that stage the market was just beginning to pick up again. Melanie and I felt we needed another very experienced person to travel and help us bring in good property. He was a great addition. Tall, good-looking and known as Sotheby's 'heart-throb' by the female staff, Philip has an excellent eye, is a keen observer of people and has an engaging sense of humour. Although he admitted to having little knowledge of Impressionist and Modern artists, this wasn't strictly speaking the case. As a private dealer, Philip had increasingly been dealing in Impressionist pictures. He eventually developed into a much respected expert in that vast field and a very effective business getter.

CHAPTER TEN

Expansion into North America

Economic restrictions following the Second World War and the huge debts owed by the United Kingdom to the United States forbade the export of currency. Then, in 1954, the Conservative government decided to abolish exchange controls for commercial and financial organisations (which did not, however, apply to private individuals). Taking advantage of this opportunity, Peter Wilson began to plan for the international expansion of Sotheby's. Now financial institutions were free to import and export foreign currency, but more significantly, from Sotheby's point of view, works of art could be consigned to London from abroad and the sellers paid in the currency of their choice.

As Sotheby's was known to have unrivalled expertise in many specialist fields, property began to flow into London and some very good American collections came up for sale. The first of any significance to cross the Atlantic belonged to Wilhelm Weinberg, one of the many old Jewish refugees who had escaped to New York before the Second World War with his collection of fine pictures, which included a group of early works by van Gogh from his Dutch and Paris periods; this sale was a resounding success. Then, in the following year, in October 1958, came a sale that is regarded as the landmark post-Second World War auction, of seven Impressionist and Post-Impressionist masterpieces that had been part of Jakob Goldschmidt's collection. Moreover, there has never been a sale of such quality since and I doubt there ever will be in the future, unless one of the two greatest private collections formed since 1945 should ever come on the market.

The Jakob Goldschmidt Auction

A banker and collector, Jakob Goldschmidt lived in Berlin until the Nazis came to power, at which time, forced to flee Germany, he had to leave many of his precious paintings behind. These were sold by the Nazis at auction in 1941 and the mansion in Berlin, which Goldschmidt had built to house his collection, was appropriated by Mussolini for use as the Italian embassy. Nonetheless, Goldschmidt did manage to get a large part of his fabulous collection out of Germany in advance of the Nazis and to London where he was to stay for some time before leaving for a new life in New York in the mid-1930s. He decided to sell part of his collection of 18th-century Chinese porcelain at that time and first approached Sotheby's, but Geoffrey Hobson, who later became chairman, refused to negotiate the commission. Goldschmidt therefore turned to Christie's who raised almost £25,000, a remarkable sum for the 1930s.

After his death in 1955, his son Erwin fought for the return of those paintings which had been looted by the Nazis and, after an arduous legal battle, on one occasion involving Peter Wilson as arbitrator, he managed to retrieve some of the works. Jakob Goldschmidt's will had stipulated that those paintings which he owned at the time of his death should be sold and the proceeds divided between Erwin and his two sons. Erwin decided to investigate whether or not he would be better off selling the paintings in Europe and first approached the renowned French auctioneer, Maître Maurice Rheims in Paris, only to discover that any such sale could result in the loss of up to 35% of the proceeds in costs, mainly in taxes. Accompanied by his wife and lawyers, he came to London and asked PCW and Carmen Gronau to call on him at the Savoy Hotel. Unbeknown to Sotheby's at the time, representatives from Christie's were also booked to see Erwin in another room at the hotel.

Due to a bureaucratic mix up at Southampton, customs would not release the paintings so they could not be examined by the London experts. As a result Erwin, who, in normal circumstances, was not the easiest person to deal with, was in a particularly filthy temper that day, and gave PCW and Carmen a gruelling time during their meeting. When the paintings were eventually handed over, Erwin and his wife found that their rooms were not sufficiently large enough to store the works, so the Savoy suggested housing them in the basement. That, however, was not a good idea as the paintings would be dangerously close to the central heating boiler. At this point, PCW stepped in and offered storage space at Sotheby's with the rather disarming offer that Erwin could show the works to anyone he chose: Erwin agreed and after complicated negotiations, Sotheby's won the sale.

The Goldschmidt and Embiricos Cézanne, *Nature Morte: Les Grosses Pommes*, oil on canvas 1890–4, private collection

Each one a masterpiece in its own right, the seven Impressionist pictures made a fabulous sale: Renoir's *La Pensée*, which had once belonged to my grandfather and appeared in his 1902 auction; three Manets, *Portrait de Lui-Même*, *Au Jardin de Bellevue* and *La Rue Mosnier aux Drapeaux*; van Gogh's *Le Jardin Public à Arles* and two Cézannes, *Le Garçon au Gilet Rouge* and *Nature Morte: Les Grosses Pommes*. These exceptional works realised the then astronomical sum of £781,000 and five paintings exceeded the psychological barrier of £100,000 for a single work, a barrier that had previously never been breached at auction. The sale was heavily promoted and the publicity generated was such that by the time of the sale, journals and newspapers in twenty-three countries had promoted the event.

Erwin himself added another glamorous dimension. He was a successful business man, had a beautiful wife and the request that those attending the sale wear evening dress made the event particularly special. The lighting was tested, closed-circuit television equipment was brought in for extra seating in adjacent galleries and, something which amused me when I heard about it later, during the rehearsal for the sale Peter Wilson 'sold' his esteemed colleague Carmen Gronau as a sample lot for the princely sum of £42,000. By the evening of the sale so many people had gathered to see the celebrities arriving that the police had to be called and New Bond Street was closed to traffic. Dame Margot Fonteyn, Somerset Maugham, Anthony Quinn, Kirk Douglas, Lady Churchill and other well-known figures, all attended. The anticipation was intense as PCW, impeccably dressed in black tie (as were most of the audience), climbed into the rostrum and the bidding began. Within five minutes three paintings had been sold.

Cézanne's *Nature Morte* was bought by the Greek ship owner, George Embiricos, for £116,000 (then about $325,000), which subsequently we sold for him in New York in 1993. Estimated at between $10m and $15m, it made $26 million at a time when the market was in the midst of another serious recession, evidence of what an exceptional investment great paintings could be, when kept for more than a generation. Renoir's *La Pensée* was purchased by Jack Cotton, the London property developer, and after he died, his daughter negotiated a sale in lieu of tax to the National Museum of Wales in Cardiff, although I did try and persuade her to consign it for auction.

The last lot in the sale was one of Cézanne's famous paintings, representing a boy wearing a red waistcoat, *Le Garçon au Gilet Rouge,* which was knocked down after spirited bidding for the staggering sum of £220,000 to Georges Keller, a New York dealer who was bidding on behalf of Paul Mellon; he subsequently gave the painting to the National Gallery in Washington, DC, Georges Keller also bought Manet's *Au Jardin de Bellevue* and *La Rue Mosnier aux Drapeaux* for him. The van Gogh went to New York dealers Rosenberg and Stiebel for £132,000, well over its reserve: they were buying it for Henry Ford II. He kept it until it was sold at Christie's by his estate for $5.3 million in 1980. The Goldschmidt sale became and remains an iconic event in the history of auctions, establishing unprecedented prices and thus breaking the age-old tradition that the highest figures were realised by Old Master Paintings. More importantly, it led the way to glamorous evening sales to which we have become so accustomed today, but which at the time were unthinkable in the wake of reconstruction after a war that had ended only thirteen years earlier. Although I was then at Harvard, I have since been able to see each of these paintings in various private collections or museums and over time continue to admire their breathtaking beauty.

The Acquisition of Parke-Bernet

Many American collections or individual pictures have been given or willed to US museums, the donors receiving a tax benefit in so doing, thus contributing to the vast art collections such institutions have accumulated since the 19th century. However, those deemed surplus to requirements can be sold as 'de-accessioned', thereby providing funds for future purchases of other works that are more relevant to their collections or building programmes. As an example of this practice, in 1964 the Solomon R. Guggenheim Museum in New York sold fifty works by Kandinsky from

its extraordinary holding of 150 paintings by that artist, for a total of £536,500 at Sotheby's in London, to fund a major extension to the Frank Lloyd Wright building on 5th Avenue. It is extraordinary to think that a single museum could not only sell that many fine Kandinskys, all collected by its founder Solomon Guggenheim, but have done so without diminishing the quality of their collection. Later another, smaller group of Kandinskys was de-accessioned and sold by us in 1971 to finance the construction of yet another building, and even more sales followed of other artists' works in 1990, including superb paintings by Kandinsky, Modigliani and Chagall. The records established for each of these artists' pictures, which formed part of that historic evening were overshadowed only by the sale of Renoir's *Moulin de la Galette* for $71 million.

The Goldschmidt sale in 1958 was a watershed moment in the history of Sotheby's and from then on PCW and Carmen Gronau frequently travelled to New York in pursuit of collectors and their collections. Business flourished, so opening an office there was the obvious next step and Peregrine Pollen, PCW's aide-de-camp, was sent over to run it. Eton and Oxford-educated, he had travelled widely, working as a pantry boy on a ship, an aluminium smelter, an orderly in a mental hospital as well as playing the organ in a Chicago night-club when times were tough. All this appealed to Peter Wilson who knew Peregrine would be the right kind of person for Sotheby's. Importantly, Peregrine's grandparents, Robert and Evelyn Benson, had been great art lovers, and had built a fine collection of Italian paintings dating from the 14th to the 16th centuries. After he opened Sotheby's first office in the Corning Building at the corner of 5th Avenue and 56th Street, Peregrine helped to develop further the American side of the business which was to lead to the acquisition of America's most important auction house.

In 1963, it became known that the Parke-Bernet Galleries were up for sale and, amongst other interested parties, Peter Wilson and a group of French auctioneers, headed by Maître Maurice Rheims, approached the shareholders. However, the French soon dropped out, principally because they felt they neither knew the language well enough nor had the capital to embark on such a different kind of business. However, there were divisions within Sotheby's. Some of the partners were strongly opposed to the acquisition, which they saw as risky and an unnecessary change to the character of the Company. When he needed to be, PCW could be a bully and after lengthy negotiations, he managed to railroad the Board of Sotheby's into agreeing to buy Parke-Bernet in 1964.

Another crucial personality to the development of the future of the business at this time was Brigadier Stanley Clark who was to transform

the way Sotheby's marketed its sales, which in turn resulted in a huge increase in press coverage. During the Second World War he had joined the army, fought at Tobruk, and later was involved in the 'Aid to Russia' line from Iraq. After the war he joined Reuters as a features editor and then started his own public relations firm, Clark Nelson, which was hired by PCW to promote the Goldschmidt sale in 1958. In reality, it was Stanley who invented the concept of public relations and marketing for the auction houses and, before long, he had joined Sotheby's as head of its Press Office.

Before the acquisition of Parke-Bernet, there were extraordinary rumours in the press about what might happen. News of Sotheby's planned take-over had been kept under wraps, but, once he was free to speak, Stanley Clark arranged for the *Sunday Telegraph* to publish an article detailing the enormous success Sotheby's had had in the previous year, compared to the extremely modest profit made by Parke-Bernet. This turned the tide in our favour and finally, after lengthy negotiations, the Board agreed to buy Parke-Bernet from the shareholders for the sum of $1.5 million in 1964.

The auction house was located at 980 Madison Avenue between 76th and 77th Street, in a building that occupied the whole block, stretching halfway down to 5th Avenue. It was ideally placed for the many collectors who lived on the Upper East Side, as well as the many galleries located on Madison Avenue and in the cross streets. Peregrine became President, while Louis (Lou) Marion, a major shareholder and the chief auctioneer at the former Parke-Bernet, continued to man the rostrum in his inimitable and much appreciated rapid, very American style, so different from the quiet British manner.

David Nash and the Impressionist Department

David Nash, still in his early twenties, was made head of the Impressionist and Modern Art department and started to expand the sales. We made a very good London–New York team, talking on the telephone several times a week, discussing what was going on in the market on both sides of the Atlantic, consulting each other about estimates on pictures offered to us for sale: all in all the very foundation of global co-operation. For many years, certainly until the late 1970s, when Christie's finally started sales of their own in New York (curiously on the premises of the Delmonico Hotel where my mother and I had lived for a few months after our arrival in January 1941), a number of American collectors still thought of London as the main international market place. Both Bruce Chatwin and I, and of

course PCW even more so, travelled quite regularly to help David and Peregrine, although negotiations with the collectors or their lawyers were left to the two of them.

Peregrine would sometimes get into a fury with Bruce in particular, but also with me at times, for visiting those he unfairly considered to be his clients. However, my excellent relationship with David continued to be as strong as ever. David wasn't the only English expert sent to New York. When Sotheby's took over, we found there was a serious lack of experts and expertise and far too many back office staff. Peregrine immediately began to alter the balance, getting rid of some of the excess administrative staff and importing a number of young English experts, among them Stephen Somerville, Prints and Drawings (he only stayed until 1968, at the time of the war in Vietnam; when he was drafted in to the armed forces he hurriedly left the country); Kevin Tierney (Silver); Hugh Hildesley (Old Master Paintings) and Marcus Linell (Porcelain). Kevin and Marcus relocated to London in the late 1960s to open Sotheby's Belgravia, a new facility devoted to selling the arts of the 19th century, and all bar Somerville have retained direct connections to Sotheby's in one form or another.

Within twelve months, a firm that had been making a loss became profitable enough to recoup the $1,500,000 it cost to buy the New York auction house. Even today, a number of the experts at Sotheby's and Christie's in New York are British, particularly so at Christie's, where the chief auctioneer, Christopher Burge, is still manning the rostrum after more than thirty years in New York.

In the late 1960s, Paul Rewald joined David in the department. He was the son of John Rewald, the art historian and author of *The History of Impressionism and Post-Impressionism,* which is still considered to be the finest history on the subject, as well as the *Cézanne catalogues raisonnés of the Paintings and Watercolours.* Paul and I soon became good friends and we especially enjoyed travelling to Japan together on business-getting trips from about 1970 onwards. He was a fine expert and a delightful person who possessed a great sense of humour. We were all devastated when he died quite suddenly in 1974.

Another Englishman, the art historian John Tancock, a graduate of the Courtauld Institute, joined the department in 1973. John was recruited from the Rodin Museum in Philadelphia which was founded by the film magnate and collector of Rodin's sculptures, Jules Mastbaum. While at the museum, John had written an extensive and authoritative study of Rodin's works based on works in the collection. On joining Sotheby's, John worked exclusively on the Contemporary Art sales, but after Paul died, he joined

David in the Impressionist and Modern department. John has tremendous perseverance through thick and thin and only retired at the end of 2008. He was respected by all for his scholarship and expertise, a seemingly disappearing attribute in this new world of global commercialisation of the art market, but ultimately a vital necessity to the business. As had been the case with Paul, we often travelled together to Japan, where John established a tremendous reputation for himself and for Sotheby's, often spending several months a year there, and at one stage even as acting head of the Tokyo office.

By 1981, Sotheby Parke-Bernet, as it was still being called, had run out of space due to the expansion of the auction business, escalating sales, increasing number of staff and a serious lack of viewing space and selling galleries. Peregrine wanted to build on extra floors, but the owner of the building, Peter Sharp, refused as it would have spoilt some of the view towards Central Park from his hotel, the Carlyle, just across the street on Madison Avenue. Therefore, we had no choice but to relocate to a much larger building – formerly a Kodak warehouse and less well-located site on York Avenue and 72nd Street. Many New York collectors and dealers, so used to the proximity of the old building, complained bitterly that York Avenue was too far for them to come; but come they did, grumbling all the way. Eventually even that building became too small and by the mid-1990s Alfred Taubman, who had acquired Sotheby's in 1983, had started an ambitious programme that added six floors, including the beautiful exhibition galleries on the 10th floor that had natural light flooding in from the skylights, designed by the renowned gallery architect, Richard Gluckman.

After Thilo von Watzdorf decided to leave in 1980 and with the young Italian gone, Lucy Mitchell-Innes took over the London department. Tall, slender and very pretty, classically English with long blonde hair, within a year Lucy was well established and sales were successful. When Linda Silverman, who had been running the Contemporary Art department in New York, left abruptly in 1983, David was left in the lurch and unable to find a suitable local candidate. Discussing the problem with him one day I suggested he should consider meeting Lucy, as I felt she was perfect for the job. When he was next in London, David interviewed her and, although initially unsure, he made her an offer, and within a short time she moved to New York to run the department. Even more fortuitous, it was not long before Lucy and David fell in love and married. She quickly became very successful as the market evolved and the financial results of her department expanded, and she was much admired by collectors and dealers. She had an instinctive feel for the market

and had an ideal personality for the frenetic contemporary New York scene. The performance of her sales played a vital role in the evolution of this market and ultimately contributed to the dizzying heights of contemporary art prices which, after a brief downturn during the recent recession, continue to flourish even more spectacularly.

By the early 1990s, Dede Brooks, then Sotheby's President and Chief Executive, was exerting her power and moving into and trying to take over the affairs of the major departments in York Avenue. Lucy's relationship with her became increasingly sour and fraught. They were both strong characters and the chemistry between them simply did not work. Lucy did not like Dede meddling in what she thought was her own business to the extent that she finally decided to leave in order to open her own gallery on Madison Avenue. David, equally, was feeling increasingly frustrated and angry at the way Dede was usurping his role of negotiating with his clients and potential consigners, muscling in on his deals and taking financial decisions, thereby belittling his position. In 1996, exasperated and unhappy, he resigned and decided to join Lucy as a dealer in what has become a very successful business under the name of Mitchell Innes & Nash. They now run two galleries in New York, one uptown on Madison Avenue and the other down in Chelsea. Shortly after I was delighted to hear they had engaged Lucy Dew as their gallery manager. Lucy had been my secretary and then helped me catalogue the important sales throughout most of the 1980s, eventually specialising in 20th-century German painting and, for several years, was head of our Berlin office and organised auctions there. A young woman with a kind and friendly disposition, she was the best of all the

David Nash and me discussing the prices at a sale in London in 2002 after we had both left Sotheby's

assistants I had over the years, ever calm, efficient and dependable.

I was inevitably sad and upset that my working relationship with David of thirty-four years ended in such a way. However, we remain good friends and I am delighted that my son Andrew and David have become such firm friends too. It is with some pride that I reflect on my involvement in David's life: through my efforts and encouragement he went off to New York when only twenty-one years old, made a great career for himself and then found both a wife and, subsequently, a business partner in the years after they had both left Sotheby's. Andrew has recently reciprocated the help David offered him, by taking on his daughter Josephine as an intern for a short period.

Alex Apsis, another of the young men who had started their careers under my guidance and went on to run the 19th-century Continental Picture department, left London in 1993 to replace David. He, too, eventually moved on four years later to become a private dealer, electing for a quieter life. Whilst Dede was searching for a suitable replacement for him, she asked me to spend two weeks a month in New York as head of the department. It was a challenge and one that I much enjoyed. In January 1998 she sent me to meet and interview Charles Moffett, then Director of the Phillips Collection in Washington. I was impressed by his scholarship and his qualifications which resulted some months later in him joining Sotheby's in New York and being appointed Co-Chairman with me of the International Impressionist and Modern Art department. Charlie ran the department in New York alongside David Norman, another colleague of Andrew's generation. Having joined as a secretary in the American Painting department before moving to the Impressionist department as a cataloguer, David was by then extremely knowledgeable and had built up excellent relationships with collectors. I was fond of him and glad to give him every encouragement and assistance whenever he asked for it. In 2006 he was put in sole charge of the department, but now has assumed a special client-focused role free from the day-to-day management that can be so draining. Another of my London protégés, Stephane Connery (step-son of Sean Connery), also moved to New York and has made a great success of running the Private Sales department and developing the new concept of selling large, outdoor sculptures which can be found in famous locations like Chatsworth in Derbyshire and Isleworth in Florida. Emmanuel Di Donna, whom I took on as a volunteer and sent to Paris in 1994 to help Andrew organise the 1995 Man Ray estate sale, played a vital role in New York, as does Simon Shaw, recently transferred from London to manage the department.

It gives me much pleasure and pride to have mentored and worked

with such wonderful teams of young experts (or specialists as they are now referred to), teaching them how to look at and value pictures, how to research their history and develop an eye, enthusiasm and passion for what they are doing. Throughout almost forty years, I have had the good fortune to have been instrumental in feeding New York with some of its best and most successful experts, most of whom have remained there and made splendid careers for themselves. They are much respected for the advice they give buyers, their acute business sense, their excellent eye, and for remaining courteous as ever regardless of the pressure and the stress they are subjected to.

CHAPTER ELEVEN

The Role of International Offices

The main purpose of any local Sotheby's office is to provide essential services and a point of liaison for collectors and dealers in those areas, informing them about forthcoming auctions, sending out catalogues, inviting local collectors and prominent citizens to receptions and generally promoting Sotheby's in those cities and countries. The offices have been mainly run by cultured people with good connections, but not necessarily with any specific expert knowledge. Vendors, in particular, prefer to contact their local Sotheby's office rather than London or New York directly, especially if they know the representative or have been recommended by a friend.

As the later 1960s merged into the 1970s, representative offices and local salerooms were gradually established around the world: after Paris, we opened in Munich, Florence, then Zurich, Geneva, Brussels, the Scandinavian capitals and others on the European Continent, around Britain and the United States, and before long in Tokyo and Hong Kong. From 1970 onwards Sotheby's Zurich office was energetically run by Dr Jürg Wille, a business man who had a wealth of connections, having been at school and university with many of the collectors of his generation. Much of the time I spent travelling, apart from to Paris and New York, was to Zurich and Basel, cities that were rich in fabulous old collections and active buyers. Jürg and I spent many fruitful and enjoyable years working together and it was a great loss to us when he finally decided to retire, succeeded for a time by his son Ully. In Amsterdam and Milan we acquired premises where we could hold regular sales of local material, either of pictures or decorative arts that were perhaps not worth enough to be sent

to London. In the case of Milan, this made particular sense as the export of any work of quality was regularly refused an export licence by the Italian Ministry, unless it was contemporary art less than fifty years old.

As the years rolled on I seemed to be travelling more and more around the world. I remember well the day in the 1990s when, after an early morning visit in Geneva, I flew to Paris for lunch with a client, followed by a late afternoon meeting in Brussels and finally back to London on the last plane of the day. It was mostly an exciting – although tiring – life, especially when these visits resulted in a great picture or collection for sale. In these cities I would occasionally have just enough time between appointments to see an exhibition, a museum or perhaps a local dealer, but there was never really enough time. I was often anxious to get back home to the family and always had much to do in the office before flying off once more a few days later.

CHAPTER TWELVE

Sotheby's Presence in France

The New York office and the acquisition of Parke-Bernet were the first and most important stages of a rapid international expansion – our first step towards globalisation. It soon became obvious that we needed an office in Paris, where there was a treasure trove of all forms of works of art and from my department's point of view there was so much business we could conduct among collectors and dealers of Impressionist and Modern Art. Our most intrepid rival in Paris was the Paris auctioneer, Maître Maurice Rheims. One afternoon, as PCW and I were walking down the rue du Faubourg Saint Honoré, we saw him approaching and to our great amusement, as soon as he spotted us he immediately crossed to the other side of the street – a measure of his sour feelings towards his London competitors. Maurice Rheims was later to write about Sotheby's taking over the French market as follows: 'Peter Wilson is no neutered pet but a formidable tom…in less than a decade he reversed the position, threw a blockade around Paris, and made London the turntable of the market.' France in the 1960s was still an important repository of privately owned 19th- and 20th-century painting as well as some of the finest French 18th-century furniture. In this new millenium, some forty years later, when so much has either been sold abroad or has disappeared into the French museums, great Impressionist and Modern pictures still come out of the woodwork and find their way to Sotheby's salerooms.

Valentine Abdy, a young English dealer living in Paris, the son of Sir Robert Abdy, one of the great dealer/collectors of his time and much renowned for his highly refined eye and taste, was an elegant, charming young man with some of the best connections in France. PCW persuaded

him to open Sotheby's first office in 1967 in the rue de Duras, a tiny street facing the Elysée Palace, only two doors from Sotheby's present day location. Before long, this tiny office with one secretary became too small as the number of staff expanded in line with the amount of business that we were doing there, so a space was leased nearby in the rue de Miromesnil. I enjoyed going on visits with Valentine, who was beautifully mannered in an old-fashioned way and had an amused glint in his eye. He stayed with us until 1974, by which time he had had enough of working in what was by then a quite large organisation and returned to a life of quieter dealing and consulting.

As was so often the case, finding the right person to run an overseas office was never easy. We needed someone with good connections, cultured and with administrative skills. In the case of Paris, as we were unable to find the appropriate, well-connected Frenchman, we appointed a retired British naval officer, then living in the city. Rear-Admiral John Templeton-Cotill was an engaging man, an excellent organiser, but he was not someone to initiate new ideas and was unfamiliar with the art world. Initially Sotheby's France was established as a limited company for local legal reasons until the Taubman takeover in 1984. As a member of Sotheby's Board and still a French national, I was appointed its *gérant* (manager). When I asked our French lawyer what responsibility that entailed, he replied '*Toutes*', implying imprisonment or heavy fines. Fortunately, nothing took place during those ten years that would have meant my being prosecuted. The office continued to grow and we had to move into larger premises on the rue de Miromesnil increasing the staff from three to thirty. In the end the Rear-Admiral found the burden too heavy and he finally resigned in 1980. By then, very fortunately, we had the perfect replacement in Marc Blondeau, who took over as head of Sotheby's France, as well as continuing as a picture expert, specialising in Impressionist and Modern Art.

Marc Blondeau

Marc, like me, was born on the avenue d'Iéna, albeit some years after the Second World War, and had been trained as an *expert* by Maurice Rheims. In search of more international experience, he asked David Nash for a job, initially in New York in 1969, before transferring to Sotheby's in Los Angeles at a time when Modern Art sales were held there. However, by 1973 Marc felt he had had enough of LA and decided to move on. When I heard this and, moreover, that he was considering taking up a better paid

offer from Marlborough Fine Art to work at their New York gallery, PCW and I asked him to move to Paris as our Impressionist and Modern Art resident, business-getting expert. Reluctant at first, Marc was seduced by our enthusiasm to have him join us and, finally agreeing to our terms, he started working in Paris in September 1974, which he described as '*un grand moment dans ma vie*'. Thus began our close friendship and a period of working together, which included handling several great collections, over the next thirteen years.

Despite our successes, we also suffered the big disappointments of losing two famous Monets to the French State. Marc had been approached by a distant cousin, a member of the Guerlain perfume family, who wanted to sell an early masterpiece, a snow landscape titled *La Pie*. He wanted to sell it at auction, but soon realised that it could never leave France so made an arrangement with the *Musées Nationaux de France*. The same happened when we were called in by Myron Eknayan, an Armenian collector living in Paris, who was seeking advice on what to do with his *Déjeuner sur l'Herbe*, the central part of Monet's first masterpiece executed in 1865. We knew that its export would never be permitted and eventually a deal was struck with the government so that it now hangs beside its companion in the Musée d'Orsay.

Marc Blondeau, a bearded man, with a keen sense of humour, gained a much deserved reputation in France for his integrity. He had a special eye for quality and rarity and often saw something different in a work of art that others didn't, something that we both shared and enjoyed discovering together. Marc was excellent at cultivating the dealers, giving them estimates on pictures they found in private collections, which they then bought and consigned to us, a practice I had started in the 1960s and continued during my time at Sotheby's. We were great believers in the quality of expertise, in rigorous cataloguing and always checking the information we were given. Marc said I taught him the methods which were passed on to all who were to join the Impressionist department.

As the 1980s went by, he became increasingly frustrated by the demands and the interfering inefficiencies of the management in London. On many occasions, especially when we were flying or driving to some place together, I would have to listen to his grumbles and complaints, calming him down for a time. As '*gérant*' or as Marc called me '*mon parrain* (godfather) *à Londres*', I looked after Paris's interests and concerns in London. There was always pressure to control everything from London and New York, but thanks to my efforts on his behalf, as I understood how everything functioned there, Marc felt freer in Paris to run things his way. None the less, by 1987 he had had enough and left to start up his own

successful art consultancy in an office only a few doors from Sotheby's in the rue de Miromesnil, before relocating to Geneva, this time fed up with France and its restrictive red tape and regulations.

The Kahn-Sriber Collections

Working on great collections together was the high point of our collaboration. The first took place a year after Marc came to work at the Paris office. It happened by chance that a private dealer I knew told me in 1969 about a little known collector in the city who had an important collection of paintings. The collector's name was Robert Kahn-Sriber, a very private man who, I was warned, would definitely not welcome any direct approaches. However, I managed to find his address and decided simply to send him Sotheby's annual review, *Art at Auction*, with a compliments slip, and continued doing so over the following six years in the hope that one day there might be a response.

Finally, this initiative bore fruit when Marc took a call from a certain M Robert Kahn-Sriber in the winter of 1975. He had first spoken to the Rear-Admiral who had passed the call onto Marc as he was too busy doing his travel and expenses report. The gentleman said in a commanding voice, '*Envoyez-moi un expert, vous savez qui je suis,*' and continued by stating the choice was between Sotheby's, the Paris auctioneers and Wildenstein. Although he pretended not to know what Sotheby's was, he had called us first. Marc and I had talked about Robert Kahn-Sriber so he immediately went to see him and, much impressed by the collection, called me as soon as he got back to his office. I was absolutely thrilled to hear this and by the next day, 17 March, was in Paris. Marc and I turned up after lunch at his sumptuous apartment on the avenue Foch, where we were greeted by a tall, thin, distinguished-looking, elderly gentleman and his good-looking wife, equally tall, who must have been in her seventies. As we introduced ourselves and shook hands, Mme Kahn-Sriber looked at me and asked a now familiar question, '*Etes-vous par hasard parenté à André Strauss?*' When I told her he was my father, she clasped me in her arms, gave me a big hug and said, '*Je le connaissais bien. Je l'adorais.*' From then on it was plain sailing; there were no discussions about the terms and conditions of sale, he was happy with the estimates and the suggested reserve prices. Marc was amused, and sometimes even slightly exasperated, by the fact that so often the collectors had either known Jules or Dédé, remembering them with much affection or if this was not the case, then often they were cousins of mine. Such connections made our dealings with these clients simpler than

usual, implying that family loyalty played an important role.

The first room Kahn-Sriber took us into was his rather small study: there, to my astonishment, hung van Gogh's famous *Nuit Etoilée: Arles*, depicting the town and the sweep of the River Rhône on a starlit night against a deep blue sky. Hanging next to it was a large and an impressive reclining Renoir nude, but a painting much less to my taste. Marc and I looked at each other, terribly excited, but M Kahn-Sriber told us he had promised them to the Louvre after he and his wife had died. (And so it was that Andrew went through an identical experience in 1992 following Mme Kahn-Sriber's death). Again, the first picture he saw was the van Gogh, then the Renoir, only to be curtly told the same thing by her grand-daughter. (Both works are now hanging in the Musée d'Orsay.)

Trying not to show our disappointment, Marc and I were led into a large, elegant drawing room, decorated in a classic Louis XV manner, where once again our spirits lifted. Hanging on the walls were wonderful Impressionist and Modern paintings, some of which the Kahn-Sribers had bought themselves and others they had inherited from their parents and from Mme Kahn-Sriber's first husband, Maurice Barret-Decap. In all, there were fifty pictures they had decided to sell. High up on one of the walls we spotted what could have been an early Cézanne landscape, but when asked what we thought we tried to be as non-committal as possible saying further research was needed (this was a discreet way of expressing our doubts about the picture's authenticity). We believed this was his way of testing us as he must have felt, like us, that there was something wrong with the work.

M and Mme Kahn-Sriber, fearful of art robberies of which there had been a recent spate much publicised in the press, were finding their large and very valuable collection such a responsibility that they dared not leave their apartment for any period of time and thus had decided to dispose of the majority of it. Over the years I often came across older collectors who had resolved to sell their valuable art for the same reason. In addition there was a reluctance to take out fine art insurance as well as not wanting the *fisc*, the French tax inspectors, to know what they owned. Once we had inspected the collection, M Kahn-Sriber stated that if we were to make the kind of proposal he liked, we could have it for sale. We then asked what commission he wanted to pay and he replied 7% inclusive of all expenses (shipping, insurance and catalogue costs). The norm was 10%, but generally not in the case of substantial collections. Marc and I immediately agreed, we shook hands on a most satisfactory deal, and left the apartment feeling quite euphoric.

My favourites in the collection included one of Maurice de

Vlaminck's finest paintings of the Fauve period, *Pont de Chatou*, a beautiful, violently coloured, early work of 1906; André Derain's *Arbre, Paysage au Bord d'une Rivière,* executed in 1905, and a large, quite stunning Wassily Kandinsky, titled *Starnberger See II,* one of a group of pictures that marked his transition from figurative painting to his final invention of pure abstraction in 1911. All three were excellent examples of Fauvism, that movement of wildly coloured, expressive painting that swept through France and Germany at the beginning of the century, led by Matisse, as a direct successor to van Gogh and Gauguin.

Aside from the paintings promised to the Louvre, the most exciting was undoubtedly Claude Monet's *La Cathédrale de Rouen,* which had been in the family since 1906 when Edmond Decap, the father of Mme Kahn-Sriber's first husband, had bought it direct from the artist himself. Monet's study of Rouen Cathedral, dated 1894, was an absolute beauty. From the second floor of a shop facing the cathedral, during the winter months of 1892, 1893 and 1894, Monet had painted thirty radical close-up studies of

the façade at different times of the day, interpreting the constantly changing effects of light and atmosphere. Monet, so often depressed by the progress of his work, would write to his wife Alice from Rouen, 'What I am doing this time is bad too, it's just bad in a different way…I am worn out, and that shows that I've given everything I had…' and, about a month later, 'I shall never manage anything good, it's an obstinate overlay of colours…but painting it's not…' But a year later he told his friend, the painter Paul Helleu, 'I am less unhappy than I was last year, and I think that some of my *Cathédrales* will do.' This series and the

Claude Monet, *La Cathédrale de Rouen*, oil on canvas 1894, Beyeler Foundation, Riehen

Waterlilies, that were to occupy the last thirty years of his life, were to be recognised as Monet's greatest achievements. It was fascinating to see that the Kahn-Sribers owned another famous view of Rouen cathedral by Camille Pissarro, on this occasion viewed from further back to include the street and its passers-by leading up to the steps of the south portal. Sold for £120,000, it was bought on my advice by the British Rail Pension Fund and when the Fund sold it fourteen years later, this lovely picture made £1,500,000.

The Kahn-Sriber sale in 1975 was a tremendous success, particularly at a time when the market was going through such a bad patch, a year after the Middle East oil crisis that had destabilised the art market. It was the first of a series of great sales that I handled during the second half of the 1970s, collections such as those of Sydney Barlow, Paul Rosenberg and Robert von Hirsch. The superb Monet Cathedral, estimated between £125,000 and £150,000, after fierce bidding was finally won by Norton Simon, the famous Californian collector for £210,000. He later sold it to the late Ernst Beyeler, one of the most important Modern Art dealers of the second half of the 20th century. It now hangs in his exquisite museum in Riehen a few kilometres outside Basel, a building so beautifully designed by the Italian architect Renzo Piano. Beyeler had a fruitful day at the sale, ending up with the Vlaminck which cost him £130,000, the Kandinsky £89,000, as well as, eventually, the Monet. One of the contributing factors to the success of the sale was the freshness and fine condition of the pictures: they had spent most of their lives in just one or two houses in Paris and very few had ever been publicly exhibited. Paintings from old French and European private collectors in near perfect condition that had rarely been seen in public, almost always attracted the strongest of bids. So often one sees paintings which look a bit tired or which may have been damaged as a result of the number of times they have travelled around the world, regularly changing hands, from collector to dealer to another collector, from continent to continent, sometimes ad infinitum. As well as this some paintings suffer from being restored and cleaned of old varnish, seemingly every generation, sometimes well and sometimes badly.

On my return to London the next day, I told my mother that I had met the Kahn-Sribers and seen their collection, and she said: 'Oh yes, Mme Kahn-Sriber was a notorious courtesan in Paris in the 1920s who apparently helped young men from the *haute bourgeoisie* lose their virginity.' My father, probably a few years younger than Mme Kahn-Sriber, must have been one of her 'friends'. Later she married Maurice Barret-Decap, a gambler who lost his fortune in the 1930s and had owned some famous Impressionist paintings, notably Renoir's *Danse à Bougival* which he had

to sell to the Boston Museum of Fine Arts in 1937. My mother also recounted that once she was married to my father Dédé, she was allowed to meet Mme Kahn-Sriber, but not before due to her reputation. Whether the collection would have been consigned to Sotheby's for sale so easily, without Mme Kahn-Sriber's association with my father, is debatable.

In the month before the Kahn-Sriber sale in June 1975, and before they went on public view, the paintings were hung in a small gallery we then had on the ground floor of 33–34 New Bond Street for pre-sale viewings. One afternoon I happened to be in the gallery when a young woman came in from the street, dressed in a T-shirt and jeans and asked whether she could see the pictures as she had just read about the sale in the press. She introduced herself as Pauline Parry and I was, of course, delighted to show them to her, influenced in part by the fact that she was a very pretty and friendly girl. I could see that she loved looking at them and hearing some of the stories I was telling her about the collection. As she was leaving the building she asked if she could have two tickets for the sale. My immediate thought was that as so many people were going to want to attend and seating was limited in the saleroom, I couldn't just hand out tickets to pretty girls who took my fancy. I mumbled something non-committal and to fob her off, asked her where the tickets should be delivered when they became available on the day before the sale. To my surprise she gave as an address 5 Grosvenor Square. Intrigued, I gladly sent her the tickets. She turned up for the sale looking very glamorous in evening dress and magnificent diamonds, accompanied by an older man. They proceeded to buy two of the lots: a Camille Pissarro of a peasant woman and her child sitting in an orchard for £65,000 and a beautiful painting by Edgar Degas of two dancers in bright yellow tutus waiting in the wings to come on stage which they bought for £100,000.

A few years later Pauline married Dinos Karpidas, her companion at the Kahn-Sriber sale. He had already been buying some important works from his friend and fellow Greek, Alexander Iolas, the famous, flamboyant dealer of Surrealism and the painter René Magritte in particular. Iolas had sold him several important late paintings by Picasso in the early 1970s at a time when few people understood the importance of the late work. Pauline soon plunged herself into that world and, with all the passion and knowledge she could muster, she subsequently became one of the great collectors of Picasso, Surrealism and cutting-edge Contemporary Art. Pauline later sold the two Impressionist pictures at a time when she and her husband were concentrating almost exclusively on acquiring Surrealist art. She had tremendous foresight and in the early 1990s she began to collect late works by Andy Warhol, now much sought after and vastly more

Vincent van Gogh,
Jardin près d'une Maison,
oil on canvas 1889,
private collection

expensive, but when she started collecting them she was among the very few who appreciated their quality and ultimate importance. Pauline has an amazing eye and an extraordinary vision and insight as to which young artists will 'make the grade'. She is one of the flamboyant characters of the art world who became a good friend, not only of mine, but also of Andrew, an equally passionate lover of Surrealism.

The following year Kahn-Sriber's brother, Marcel, decided to sell the major part of his smaller collection whose highlights were a Brittany period Gauguin (£220,000) and a really lovely *Jardin près d'une Maison* by van Gogh (£480,000). In one of his letters to his brother Theo, Vincent described this painting as follows: 'The vertical small farmhouse garden is superbly coloured in reality. The dahlias are a rich and dark purple; the double row of flowers is pink and green on one side, and orange almost without greenery on the other. In the middle, a low white dahlia and a little pomegranate tree, with flowers of the most brilliant orange red, with yellow-green fruit, the ground grey, the tall reeds – canes – of a blue-green, the fig trees emerald, the sky blue, the houses white with green windows, red roofs. In full sun the morning, in the evening bathed in shadow cast by the fig trees and reeds.' *(Letter to Theo, 8 August 1888)*

This time, in order to facilitate obtaining export licences, Marc arranged for Mme Hélène Adhemar, Director of the Jeu de Paume (Paris's

museum of Impressionist paintings before they were moved to the Musée d'Orsay), to come and see the collection and choose a work for the museum. To our relief, she chose a small study of a head by Ingres rather than one of the more important paintings, and, within a short time, the licences were granted.

Monte Carlo Auctions

Until the European Union regulations of 2001 declared otherwise, Sotheby's, like other foreign firms, was not permitted to conduct auction sales in France. However, Peter Wilson, keen to tap into the rich holdings of French Furniture and Old Master Paintings that were always more difficult to export from France than Impressionist and Modern Art for sale abroad, discovered he could conduct such auctions in Monaco, a separate principality that was not subject to French regulations. He negotiated an arrangement with Prince Rainier and his ministers whereby Sotheby's would have the exclusive right to hold auctions there. This exclusivity continued for many years, until Christie's, followed by several Paris auctioneers, were allowed in. The first highly successful sale, consisting of two magnificent collections of French furniture, flamboyant Renaissance objects and 18th-century gold snuff boxes belonging to Baron Alexis de Redé and his close friend Baron Guy de Rothschild, took place in the rooms of the Sporting d'Hiver next to the Casino and the Hôtel de Paris in May 1975.

The first time I became involved in the Monte Carlo auctions was in June of the following year when, as a way of further promoting it as an auction venue, we decided to hold a sale of Russian Ballet material, which was then still plentiful. Appropriately enough, Diaghilev had chosen Monte Carlo as the winter quarters for his productions between 1911 and 1929. Julian Barran, who had helped Thilo as a very young trainee organise the first Diaghilev sale in 1967 and who had a passion for the subject, put together a successful sale. Continuing the theme, many years later in the rooms of the Sporting d'Hiver in 1991, we sold property from the estate of Boris Kochno, a Russian writer and librettist, who had collaborated with Diaghilev during the last years of the Ballets Russes.

As far as I was concerned, the most exciting sale in Monte Carlo was that of a superb collection of sculpture in November 1979. The previous summer Marc had been contacted by a certain Mme Subes who had inherited a large number of works by Rodin and Bourdelle from the estate of Eugène Rudier, whose eponymous and famous bronze foundry

in Paris did most of the casting for Rodin under the name of his brother Alexis from 1897 until 1953, when Eugène was succeeded by his nephew Georges. Marc and I drove down to see Mme Subes who lived in a pretty Château near Orléans. Some of the sculptures were in the house while the larger, impressive ones were scattered around the garden. Mme Subes wanted to sell almost everything she had and was more than happy for us to transport the sculptures to Monte Carlo for auction rather than going through the more laborious process of sending them to London or New York.

Taking advantage of the publicity that would be generated, we decided to round out the sale by adding a few more lots belonging to other various owners. Of the eighty lots, sixty-five came from Mme Subes' Château. The sale was not a spectacular

Auguste Rodin's bronze sculpture *Jean d'Aire*, in Mme Subes' garden in 1979, private collection

one, but it did achieve a satisfactory total of 7,791,900 French francs. Most lots were sold within the estimates Marc and I had put on them, but the better, larger bronzes made double or more. For example Bourdelle's *Grande Pénélope* sold for 580,000 francs while Rodin's life-size *Jean d'Aire*, a study for the *Burghers of Calais*, realised 1,050,000 francs. However, the most exciting and rarest of the pieces was Rodin's *L'Appel aux Armes* which fetched what I felt was a slightly disappointing price, of 480,000 francs. I was delighted to see it again recently in a flat in Belgravia, occupying pride of place in a specially constructed niche in the front hall. The whole event, from the first visit to the conclusion of the sale was exhilarating, especially when I consider my very early passion for Rodin.

The Hélène Anavi Surrealist Sale

The other sale that was a joy to handle was that of the late Hélène Anavi's collection of Surrealist and Post-War art in March 1984. Hélène Anavi was the first wife of Claude Hersaint, the Surrealist collector, and together the couple had put together a formidable collection of paintings by the Surrealists, as well as by Balthus and Dubuffet. A close friend of these artists in the post-war years, she had bequeathed her collection to the Institut de France, to be sold for the benefit of the Pasteur Institute.

Marc Blondeau was initially contacted by a local intermediary who needed someone to value Hélène Anavi's art collection. Marc straight away went to her house in the south west of France to make an inventory and valuation and found that after she had died almost all of the paintings had been stacked in the attic for safekeeping, behind wardrobes full of her glamorous '*couture*' dresses.

Marc and I were thrilled to be offered such an opportunity and were determined to make it a memorable event. As on previous occasions, negotiations had to take place to get the collection out of France and, to achieve this, her best painting, Max Ernst's famous *Ubu Imperator* of 1923, was taken as a donation by the Centre Pompidou. Of particular interest in the collection there was a superb group of works by Max Ernst, including his 1950 *La Religieuse Portugaise*, which the de Menil Foundation acquired for £250,000. There were fifteen early works by Jean Dubuffet, one of which, a 1946 portrait of the writer Paul Léautaud, Ernst Beyeler bought for £130,000, but in the end it was a painting by Hélène Anavi's friend Balthus which, at £770,000, made the highest price in the sale. It was a rewarding event, bringing all the old Surrealist collectors out of the woodwork, and contrary to the Mizné experience, this was one where the owner had been much liked and admired, producing a result that far

The Anavi Max Ernst, *La Religieuse Portugaise*, oil on canvas 1950, private collection

exceeded our expectations, and, on top of that, for such a worthy cause.

Andrew Strauss and Paris

Another valuable colleague who started out as a volunteer and has become such an asset in the international Impressionist and Modern Art departments, is my son Andrew. Born on 6 March 1962, appropriately on Michelangelo's birthday and soon after I joined Sotheby's, Andrew's first experience of a 'business trip', albeit when he was only five weeks old, was in April 1962 when I was sent to New York to cover for Peregrine Pollen, then head of Sotheby's New York office, when he had to return to England for six weeks. Margery and Andrew came with me, staying at the Carlyle Hotel with my grandmother Lala. To have her first great grandchild visiting her for six weeks gave her tremendous pleasure.

We were very conscious of wanting our children to get to know and love art but at the same time would never oblige them to go to museums or exhibitions, realising that making any child do something against its will, could only spoil it for them in the future. I had heard too many stories of that happening in other families.

In 1963 we had had a house built on the Cap Bénat, a stunning location with a great view of the Mediterranean visible though the pine trees surrounding the house. When we travelled around France or other European countries, usually on the way back to London after the summer holidays at our Cap Bénat house, we sometimes could tempt Andrew and his younger sister, Julia, into a cathedral or a museum, all in the guise of cultural tourism, telling them it would be fun to light a candle or look at classical statues of naked marble figures, which usually got them rudely pointing and giggling. Occasionally, during the Easter holidays, we would take them to fascinating places such as Tunisia, Morocco, Crete and Istanbul, which I am certain must have had a powerful influence on Andrew's growing interest in exotic travel and Julia's future love for the Classics plus the history and languages of Greece and Rome. Eventually they developed a real curiosity about the arts, Andrew ending up at Sotheby's, while Julia went up to read Classics at Oxford and eventually wrote a doctoral thesis on Ancient Roman shipwrecks and trade, partly instigated by her life-long passion for scuba diving on wrecks. Her latest achievement, which has delighted us all, has been to give birth to a daughter, Elisabeth Olivia, on 13 January 2009.

Both my children have inherited my love for sculpture and objects. Many years ago on a visit to the Louvre's French sculpture gallery, I showed

Julia and her daughter Elisabeth, 2009 Andrew and his daughter Victoria, 2003

Julia the bust of Louis XIV as a child by Jacques Sarrazin, that my mother had donated in 1939 in memory of my father. This was a fine gesture, but knowing my taste for sculpture, it is a pity I wasn't old enough to first enjoy it at home before it went to the Louvre! In any case it is quite likely that it would have been looted by the Germans during the war whilst, at least at the Louvre, it was placed in safe keeping. Julia fell in love with it and, as a birthday present when she was in her early twenties, I commissioned a painted plaster replica from the Louvre.

Andrew's first practical introduction to Sotheby's took place in 1973 when he was eleven. That summer I arranged a sale, in aid of charity, of hundreds of remaining items from the Diaghilev ballet collection at the Chenil Gallery, Chelsea comprised mostly of stage costumes. James Mollison, Director of the Canberra National Museum in Australia, an old friend of Margery since their years at Melbourne University, was interested in acquiring a number of the lots to make a representative Diaghilev costume collection for the museum. He asked me to look at them for him, advise on values and quality and then to bid on a large number of lots. On the day of the sale, I took Andrew along and thought it would be exciting for him to do the actual bidding, nudged in the ribs by me when to bid and when to stop: he loved the whole process, bought almost all the lots we were asked to acquire and made no bidding mistakes. He therefore

learnt how to bid, a first step towards his later career at Sotheby's.

When he was sixteen, Andrew took a holiday job as a porter at Westminster Children's Hospital in order to earn enough money to buy the electric guitar of his dreams, a Gibson Les Paul. The best place to buy this finest of guitars was at the legendary Manny's in New York, so on one of my regular trips there, for the May 1979 Impressionist sales, I agreed to get it for him and carry it back on the understanding that, as he was by then seventeen and could legally drive a car, he should pick me up at Heathrow.

On the day of my homeward flight, I went to visit Joel Mallin in Connecticut, a New York lawyer whom I had known for more than fifteen years, as I wanted to see his notable Surrealist collection which was particularly strong in Magritte, Man Ray and outdoor sculpture by Henry Moore and Max Ernst, including a cast of Ernst's famous sculpture, *Capricorn*. I much enjoyed spending the day with Joel, looking at his art and talking about the market, until late into the afternoon when he was keen to show off his brand new Porsche. As we shot along a straight country road at about 100 mph, I saw the brow of a hill fast approaching, but Joel, obviously inexperienced at the wheel of a powerful sports car, did not slow down. We flew over the top and landed upside down in a ditch, but still more or less intact. Even more alarming, was the fact that smoke began to billow from the engine, so we kicked out the windscreen and crawled to safety. I straight away realised that my glasses (without which the world is slightly out of focus) were still in the car, so I instinctively turned back to reach for them, but, fortunately, someone held me back as, a few seconds later, the car's fuel tank exploded. By a combination of good fortune and German design (Porsches are so well built that although the body of the car was badly crushed, the strength of the cockpit kept us from being badly injured) albeit bruised and shocked, neither Joel nor I was really hurt. However, I was still seething with anger by the time I reached Heathrow, as I couldn't see properly without my glasses and Customs held me up because of the wretched guitar. Both Andrew and his daughter, Victoria, play and treasure the Gibson to this day. Already she has laid claim to the precious instrument, but her father says she will have to remain patient.

The irony of it all was that six years later, in 1985, Joel asked me to sell his collection. I arranged for the twenty-six works to be sold in New York in May 1985 with a single-owner catalogue entitled *Property from the Collection of Joel Mallin*. The highlights were a fine group of paintings, gouaches and sculpture by René Magritte; Max Ernst's *Capricorn* was bought by Ray Nasher (a leading collector of modern sculpture who years

Man Ray, *Portrait Imaginaire de D.A.F. de Sade*,
oil on canvas 1938, Menil Collection, Houston

later gifted his collection to the Nasher Sculpture Center at the Dallas Museum and to Duke University, North Carolina). The Ernst made $875,000 while Man Ray's *Portrait Imaginaire de D.A.F. de Sade* was purchased by the De Menil Foundation in Houston for $290,000. Andrew was working at Sotheby's in New York at the time of the sale and the appearance of this Surrealist collection was one of the early inspirations for his passion for the movement and for Man Ray, whose estate sale he was to organise ten years later.

Andrew's early experiences of Sotheby's took place in the summers of 1980 and 1982 when, after he had finished his A-Levels, he worked as a gallery porter. We often took on extra staff during the very busy summer season as on most days in June and July there might be three or four sales with exhibitions to hang and dismantle. Not only was this his first experience of how to handle and display works of art, but it was to be the time when he opened his eyes and became really fascinated by art and its different forms of cultural expression. In the same way that I did not expect either of my children to visit galleries and museums with us when they were small, neither did I have thoughts of wanting either of them to follow in my footsteps; it just happened that one summer there was a job for Andrew and it was appreciated that he did what was expected of him conscientiously. As another aspect of his continuing education, not only was he becoming familiar with the auction world, but he was also spending his lunch breaks playing poker with the rest of the porters in a locker room some two floors below street level.

In 1980, after a summer spent with us in the South of France, Andrew pursued his interest in the sciences by studying physiology at Queen Elizabeth College, London University. He had already specialised in science at Westminster School, taking A-Level Maths, Chemistry and Biology and was obviously intrigued by the two holiday jobs he had done as a porter at Westminster Children's Hospital: some of the descriptions he

Pierre-Auguste Renoir, *La Promenade*,
oil on canvas 1870,
J. Paul Getty Museum, Los Angeles

Edgar Degas, *Danseuse Basculante*,
pastel *circa* 1879,
Thyssen-Bornemisza Museum, Madrid,
from the Cargill and Norton Simon
collections

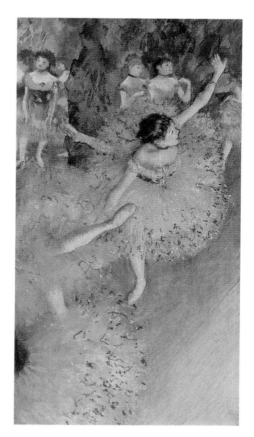

Paul Signac, *Concarneau, Calme du Matin – Larghetto*,
oil on canvas 1891, private collection

Claude Monet, *Pont du Chemin de Fer à Argenteuil*, oil on canvas 1873,
private collection, from the Cargill, Barlow and Nahmad collections

Vincent van Gogh, *Nature Morte aux Citrons et Gants Bleus*,
oil on canvas 1889, private collection

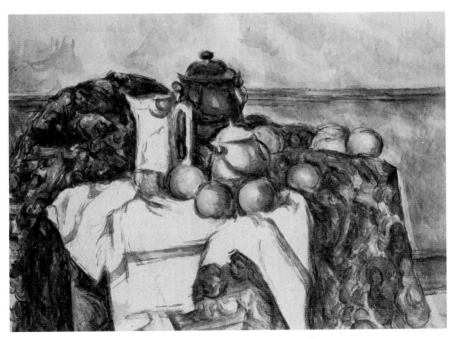

Paul Cézanne, *Nature Morte, Bouilloire, Pot-au-lait, Sucrier et Sept Pommes*,
watercolour *circa* 1895–1900, J. Paul Getty Museum, Los Angeles

Pablo Picasso,
Nu Assis s'Essuyant le Pied,
pastel 1921,
Berggruen Museum, Berlin

Egon Schiele, *Lovers I*, oil on canvas 1914,
private collection courtesy Neue Galerie, New York

gave us of the duties he had to perform were quite horrific – for example assisting operating staff perform open heart surgery or even a hysterectomy when he was only sixteen! Over one Christmas he was the sole night porter in the hospital morgue and our Christmas Day lunch was embellished with the previous night's ghoulish events!

Andrew started his university studies enthusiastically and was very interested in the practical element – research into the functioning of the mammalian body. He enjoyed his first year and went to Geneva on a gap year to work as a volunteer with my half-brother Philippe at his university laboratory, performing cervical surgery on rats as part of Philippe's diabetic research project, which I am told he was particularly proficient at. Andrew's research contributed to one of Philippe's scientific papers in1982 which was instrumental to the further understanding of diabetes. By the end of the second year of Physiology, he felt the course was becoming too theoretical and far from proven. He wanted facts not suppositions, so in a way he had lost direction and seemed more interested in travel and music. We thought that the American system of college education might suit him better and he was very happy to go along with this suggestion, welcoming the opportunity for a change to a campus environment to continue his studies. It was a way for him to get out from under the parental wing.

Another major inspirational influence on his growing interest and passion for the arts and peoples of different cultures was his extensive and adventurous travels around Asia and the Middle-East between the ages of nineteen and twenty-seven. His first independent travels were to Israel where he spent a few months on a kibbutz, including taking a precarious bus journey from Jerusalem to Cairo (shortly after the assassination of President Anwar Sadat of Egypt), across the Sinai desert, to discover Egypt for the first time. In the following years he made countless visits to Egypt, India, Nepal, the Himalayas, Bhutan, Tibet, Burma, China, Japan and Indonesia, and later to South America in 1989, this time as a Sotheby's expert. In many of these places he acquired beautiful, old textiles whose geometrical designs and colours must surely have inspired his growing passion for Modern art and cross-cultural influences.

When he arrived in New York in the summer of 1983 in order to look into which colleges he would like to go to and which might accept him, he lived temporarily in an apartment which my mother had bought a few years earlier. Margery and I were quite concerned that he was being let loose in this big city with its night life and it was then I had the idea of asking David Nash if Andrew could work for him for a while as a volunteer. David, who had known Andrew since he was a baby, was happy to take him on in the Impressionist department. Starting in September, he

quickly dropped all attempts to find a college and embarked on a great career and life in the arts and is still going strong after twenty-seven years.

He was already familiar with the 'language' of our auction world, which he'd unknowingly picked up as a child from hearing me talk about Sotheby's and the events of the day when I came home in the evening, as well as from the summer stints as a porter. He had often viewed the pre-sale exhibitions and even, occasionally, attended auctions, such as the time I had allowed him to bid in the Diaghilev ballet sale in 1972. Within a few months, David, appreciating the work Andrew was doing, took him on as a fully paid junior, cataloguing drawings and watercolours in the department, working under the guidance initially of Hermine Chivian-Cobb and then Linda Kramer, whose influence on Andrew's eye and appreciation for drawings has been undeniably important.

He travelled extensively around the United States during his time in the New York office and whenever I was over for the sales, or some years later, when we both travelled to New York for the spring and autumn auctions, we religiously and repeatedly visited museums and exhibitions in Chicago, Washington, Philadelphia and Boston. In New York we would see as much as possible, visiting clients, dealers and museums. The greatest treat for us was the Barnes Foundation outside Philadelphia. Formed by Albert C. Barnes in the first quarter of the 20th century, he had amassed a quite extraordinary range and number of masterpieces by his favourite painters: Renoir, Cézanne, Seurat, Picasso, Matisse, Modigliani and Soutine. They were hung idiosyncratically one on top of the other, interspersed with African sculpture, American Indian artefacts and European decorative arts and metalwork; it was a unique and inspiring experience. The Barnes Foundation is one of the last great collections remaining today, untouched and entirely intact, just as the collector had left it upon his death. By early 2010, some galleries were already closed off in preparation for transfer to Philadelphia's museum row. These were such rewarding times, travelling together and discovering we had very similar tastes. We enjoyed attending Christie's Impressionist sales together, commenting on the pictures and the prices achieved; on one occasion we were much amused to see a photograph of us in a Connecticut newspaper describing us as collectors contemplating our bids at a sale at Christie's in 1984. Now my sixteen-year-old grand-daughter Victoria, in contrast to Andrew at that age, loves visiting the Centre Pompidou and Tate Modern. I find it interesting to listen to her quite sharply critical comments about a work of art or the reasons why she likes it. Our museum visits, comprising three generations, are memorable with Victoria already revealing signs of a strong interest linked to an individual vision and interpretation of what she is looking at.

One of the most memorable occasions was the first time Andrew and I went to Israel together in 1983. We shared, what was for me, the most awe-inspiring and stunningly beautiful journey of my life when we crossed the sands and rocky escarpments of the Sinai desert by jeep, ending up at the Monastery of St Catherine's at the foot of Mount Sinai where God had delivered the Ten Commandments to Moses. There were no roads, only rough tracks through the stony wadis. We were both lost in wonder at this remote

Father and son – Andrew and me *circa* 1990

monastery, located in such an unlikely place in the Sinai, from which Israel had finally withdrawn in 1982 following the signing of the Israel–Egypt Peace Treaty.

For almost three years Andrew was happy working and gaining tremendous knowledge and experience in New York, but by 1986 his US work permit had run out and could not be renewed given his young age so, reluctantly, he returned to London. As I was head of the Impressionist department, it would understandably have been awkward for both of us and for our colleagues had he come back to London to join us on a permanent basis. Other colleagues might perhaps have felt jealous of the advantages Andrew would have been perceived to have had and there would undoubtedly have been charges of nepotism, though nepotism is hardly an unusual phenomenon in the art world. However, it just happened that at the time Andrew returned to London, our works on paper expert, Asya Chorley, was preparing to take maternity leave. As Andrew had built up almost three years' experience with drawings and watercolours in New York, he was the ideal person to replace her. This did not cause a problem with the staff as the job was only temporary and, in the end, it had many advantages since, not only did he learn how we worked and operated in London and the Continent, but he forged excellent working relationships with me and my colleagues, as well as with many others in key areas of the London and European business, which were to serve him so well when he moved to Paris.

In 1987, Marc Blondeau's decision to leave the Paris office coincided with Asya's return to work at the end of her maternity leave. Consequently Andrew was perfectly placed to move to Paris and continue running the Impressionist and Modern Art department while Sotheby's looked for a replacement head of the Paris office.

As Marc planned to leave in July, Andrew was sent to Paris in May of that year to learn the ropes and the special nature of the Parisian art scene. Marc introduced him to the staff and the workings of the office, showed him, to his bewilderment, the way business was done in France, with its complex export and tax regulations, and took him to meet some of the collectors and dealers with whom Marc had forged good relations. This transition period was obviously too short and the work ahead presented a real challenge to Andrew who, as a young expert at the age of twenty-five, was on his own with limited French and little experience in doing business the French way, but fortunately I was able to help him as I did all my other younger colleagues. I flew frequently to Paris and we went on many visits to clients together. I was always available to him by phone: in particular we discussed estimates together and generally I was as supportive as I could be from a distance. This was a labour of real love for me, and I was so proud of the way he was managing the business and securing for sale many superb pictures from old French collections. Over the years we worked on several fascinating single-owner sales together, notably those of Pierre Berès, the legendary antiquarian book publisher and dealer, Marie-Louise Durand-Ruel, the grand-daughter of Paul Durand-Ruel, and Alfred Richet, an eminent, early collector of Cubism and Modern art.

Amongst the fascinating visits Andrew had arranged for us, a special one was to Picasso's house in Mougins in 1993, still occupied at the time

Andrew standing next to Picasso's famous Hispano Suiza at Notre Dame de Vie, Mougins

by Jacqueline Picasso's daughter Catherine Hutin-Blay. Few before had managed to visit any of the various Picasso residences in the South of France, so the invitation to explore the mythical 'Mas de Notre Dame' was nothing less than a highlight of our careers. Going up the drive we first noticed the familiar arched windows of Picasso's studio. Inside, there were few if any works of art visible although we did spot a fine late drawing and a pile of photographs of Einstein, whom Picasso had much admired. In the garages under the house we found his famous 1930s' black Hispano-Suiza, complete with red leather upholstering. The car had been untouched for ages and was covered in a thick layer of dust. We had fun photographing each other posing with the car; it was another of those special Sotheby's days.

Following Marc's departure in the summer of 1987, Julian Barran successfully applied for his job as country head, but it wasn't until January of the following year that he moved to Paris. In an ideal world, the head of Sotheby's France should have been French, but initially we could find no local person to replace Marc so Julian's move to Paris was fortuitous: by then he had clocked up more than twenty years' experience with Sotheby's.

Like Andrew eight months earlier, Julian walked into a most extraordinary situation in the Paris office – twenty women and just four men (one of whom was Andrew), so a certain amount of structural change had to take place. Andrew became his number two, but the relationship was strained because Andrew had begun to build up a body of information about French collectors and dealers which Julian initially did not have. Julian stayed in Paris for three years and then returned to London, unfortunately at a time when the market was in a full recession and Sotheby's was seriously restructuring. There being no suitable position available for him in London, he decided to leave and set himself up as a private dealer; he continues to work in the successful niche market he made for himself.

Once Julian had left Paris, it was much easier for Andrew to take full control of our business opportunities in France and to involve me more in business getting. In fact we became a closely knit team and working together was a real pleasure, so much so that those years were some of my most fulfilling. At this time, an eminently suitable person was finally waiting in the wings to become President of Sotheby's France. Princesse Laure de Beauvau Craon, a Sotheby's Associate since 1986, had previously been reluctant to take on such an important role. However, she now finally agreed to lead the team in France. A tall and graceful 'grande dame', with great charm, intellect and the best of aristocratic and political connections,

and with whom Andrew always got on well, they thus made a formidable team. He was promoted to head the Impressionist and Modern Art department and flourished, becoming one of Sotheby's finest experts and very effective business getter, each year exporting from France large and valuable properties for sale in London and New York. Andrew is now Vice-President of Sotheby's France.

I always aimed to integrate younger colleagues into my peer nucleus of senior experts and get them to stand on their own two feet as soon as possible, whether it was sending Melanie off to Los Angeles with the highlights of a forthcoming sale (as happened in 1989, coming back from Los Angeles with a valuable consignment from the Getty Museum), Andrew to Paris or giving Thilo, Julian, David Ellis-Jones and Adrian Biddell a chance to develop their own specialities. By so doing, I hoped to give them the best foundations for their careers. Of course my relationship with Andrew is that of father and son, but once he went to Paris it became professional although closely so. He had never called me 'Dad' or 'Papa', always 'Michel' from the moment he started talking. This helped set the right tone *vis-à-vis* our colleagues, and enabled me to do my best to help and support him without making it too personal.

Andrew and I discovered, soon after he returned to London from New York, that we had a similar eye, often seeing something different in a work of art that others didn't, similar likes and dislikes and, so often, the same way of valuing pictures. We would speak several times a day, discussing estimates for property offered to us, especially the pictures Andrew had seen in Paris. These were not just similar, but identical. He would often cheekily ask why he even bothered sending a Polaroid in the mail and consulting me!

Andrew has inevitably given me an insight into other aspects of 20th-century art, in particular making me considerably more aware of certain elements of Surrealism and Primitive art and those specific Surrealist artists such as Man Ray, for example, with whom he is closely associated. Whereas my predilection for classical art is based on concepts of beauty and form rather than the wilder aspects of the Baroque or Expressionism, his is for Surrealism which is based on concepts deriving from literature, freedom of imagination and thought, dreams of the unknown or the unexpected.

Appropriately, two such events that were entirely Andrew's projects, were to make a lasting impression on my final decade at Sotheby's. The first was the Man Ray estate sale in 1995, the second, my last auction at Sotheby's, devoted to Surrealism, a few weeks prior to my retirement in December 2000. Although the Man Ray sale is Andrew's story, the four-year project happened during the recession and the sale itself was one of

the most important to us. The event drew unprecedented attention in the media and raised our public image further with the distinction of selling over five hundred and fifty works from the estates of Man Ray and his widow Juliet. The sale was heralded a terrific success, opening the way to renewed interest in Surrealism, popular as ever to this day, and of course helped to restore buyer confidence in a market coming out of recession. The settling of the Estate was extremely complex, involving a valuation of over 3,000 works located in two countries, including tax

The cover of the 1995 Man Ray sale catalogue

liabilities in France and the US, a gift of over 150 Man Rays plus his invaluable photographic archives which were to be donated to the Centre Pompidou. Man Ray would have been bewildered by all the attention this received. The project, with all its complexities, was an invaluable experience for Andrew as a young competent expert: to work with lawyers and beneficiaries of the Estate, arrange gifts of works to French museums in lieu of taxes and perhaps the most lucrative of all, becoming a Man Ray expert thus creating a new venture for himself for the future. To this day, he is the authority on the works of Man Ray, both authenticating works, advising on the choice of works for loan exhibitions at major museums and preparing the *catalogue raisonné* of his paintings, drawings and objects.

The fact that Andrew was descended from Jules and André Strauss was also of immense help to him, as it was to me with the pre-war dealers who remembered my grandfather and father. The pre-war dealers weren't the only people who fondly remembered my father. He had had several affairs before marrying my mother, including a long-standing liaison with Arletty, the famous actress, who is perhaps best known for her role as Garance in Marcel Carné's famous 1945 film, *Les Enfants du Paradis*. In that same year she received a prison sentence for 'collaborating with the enemy' – she had had an affair with a German officer during the occupation – and was later quoted as saying in French, '*Mon cœur est français, mais mon corps est internationale.*' There is still a trace of her memory in my family in

the bracelet of ruby beads which Arletty gave to André and my mother in turn gave to my daughter Julia.

On one of my earlier trips to Paris in the early 1970s, Valentine Abdy, the first person to head Sotheby's office in France, took me to see an elderly lady who was thinking of selling a pretty painting by Alfred Sisley. As soon as we were introduced she asked me, 'Are you by any chance the son of André Strauss?' When I told her I was, she smiled wistfully and said, 'Oh, I so remember dancing with him.' On the basis of that romantic *souvenir* she had no hesitation in giving me the picture to sell, just as it was with Mme Kahn-Sriber. This was to happen on a number of occasions. To this day Andrew, who continues to brandish the family flag in Paris, is still asked whether he is related to Jules, André and Michel. He calls this 'the Strauss effect'.

Japan

Sotheby's first foray into the Japanese market came as a result of an approach from George Whyte, an entrepreneur of Hungarian origin and an accumulator of a large number of paintings by minor artists. A director of Maples furniture store in Tottenham Court Road in London, George was one of the principal organisers of the first 'British Week' event in Tokyo, planned for early 1969. When he promulgated the idea that Sotheby's might like to participate by organising the first Western-style auction in Japan, Peter Wilson jumped at the idea, as I did, thrilled at the idea of going to Japan, a country I had long been fascinated by: I had begun to collect Japanese works of art in 1962 after joining Sotheby's.

Traditionally major Japanese department stores in Tokyo, Osaka and other cities, had fine art departments where exhibitions were held and 19th-century European and Impressionist paintings sold. Such fine art departments were usually found on the top floor of the building along with exclusive goods such as classic Japanese tea ceremony wares, paintings and lacquer work. These department stores worked alongside the more established commercial galleries and borrowed much of their stock from them. The selling of art in Japan was done on a very discreet basis. Each dealer would have a small number of private wealthy clients whom they closely controlled; outsiders, such as foreign dealers and auction houses, could never meet these clients. Therefore, for Sotheby's to be allowed to hold a public auction, where everything was relatively open and above board, was a unique opportunity and a radical departure for the Japanese art market.

The reason Sotheby's was more than willing to take part was two-

fold. The Japanese post-war economy had recovered and was becoming a powerful force in the world and secondly, new entrepreneurs and industrialists, influenced by the taste of the earlier collectors, wanted to continue that collecting tradition. On the whole, their interest in Western art lay in Impressionism and the School of Paris. Japan had a long-established tradition of collecting Impressionist paintings going back to the 1880s when the first Japanese diplomats arrived in Paris at a time when the Impressionist painters were becoming better known and more frequently exhibited. The most famous of these collectors was Baron Kojiro Matsukata, an industrialist, who by the end of the 19th century had acquired a significant number of paintings, including several wonderful works by Monet. Unusually, for he rarely allowed others into his studio at Giverny, Monet did welcome Matsukata who went on to buy thirty-four of his paintings. After Matsukata's death in 1950, these works were to form the basis of the Impressionist collection in the Museum of National Western Art in Tokyo, a dull and rather oppressive, concrete structure built in the 1960s in the then fashionable 'Le Corbusier' style.

The other superb collection in Tokyo is found at the Bridgestone Museum of Art, which happens to be the best museum of its kind in Japan. It is housed in the office building of the Bridgestone rubber tyre factory in Tokyo and was seminally influential in inspiring Japanese collectors, dealers, corporations and other institutions to venture into collecting Impressionist and Modern pictures. Founded by Shojiro Ishibashi, he gave his name both to the museum and to his international companies: his name translates into English as Bridge – 'bashi' and Stone – 'ishi'.

Mr Ishibashi, inspired by his art teacher at school, began collecting early on and aside from contemporary Japanese artists he also bought 19th-century and Impressionist paintings. During the course of the Second World War, his collection was confiscated by the Americans, but returned to him afterwards and, in 1952, he established the Bridgestone Museum. Its beautiful galleries sparkle with the light and colours of some of the finest examples of the period. I am particularly fond of Monet's *Crépuscule à Venise*, a shimmering study of San Giorgio Maggiore at sunset, painted in blue and gold, a vision of sublime, almost abstractly composed colours. The museum's other fine Monets range from the painter's early years at Argenteuil in the 1870s to a beautifully atmospheric Waterlily Pond from the beginning of the 20th century.

Mr Ishibashi collected in depth, works by Renoir and, in particular, Cézanne, including a superb view of the *Montagne Sainte-Victoire et le Château Noir*, several *Baigneuses* studies and one of his rare, informal self-portraits. Paintings by Bonnard, Rouault, Dubuffet, Modigliani and Klee,

and a really good group of paintings by Matisse, provide an individualist overview of some of the best painters in France in the first half of the 20th century. But, to my eye, the finest consists of a collection of superb works by Picasso that includes a 1913 Cubist *Assemblage* and three paintings from his Neo-Classical period of the early 1920s. The Bridgestone Museum had the great foresight to acquire a Picasso masterpiece of the period, *Saltimbanque Assis, les Bras Croisés*, at the Edgar William Garbisch sale at Sotheby's in New York in May 1980, where it made the first multi-million record price of $3 million for a 20[th]-century painting.

Pablo Picasso, *Saltimbanque Assis, les Bras Croisés*, oil on canvas 1923, Bridgestone Museum, Tokyo

The third impressive museum of Impressionist and Modern painting was the Ohara Museum at Kurashiki in southern Japan. Established by Ohara Magosabua, an entrepreneur and collector, who, before and after the First World War, bought a large number of pictures in Paris by El Greco, Gauguin, Monet, Matisse and Bonnard among many others, and also built up a fine collection of Chinese and Egyptian art. In 1930, he founded the museum in honour of his friend, the Western-style painter Kojima Torajiro, who had been instrumental in advising him on his acquisitions. I went to visit that delightful museum one weekend in the 1980s, combining it with a trip to the historic city of Hiroshima and its Peace Memorial Museum, as well as its Museum of Art which had several masterpieces of Impressionist painting.

During that 'British Week', Sotheby's held two auctions, one of Japanese and Chinese Art assembled by Julian Thompson and Neil Davey, both young London experts already eminent in their respective fields, and the other of Impressionist and Modern Art I acquired from private sources and the trade. Neither auction was of great quality as Japan was still virgin territory as regards international auction sales, and it was, therefore, quite difficult to persuade potential consignors to give us important pictures. In addition, Japan was considered too far away for the international

buyers to participate in person. The only buyers, therefore, were Japanese.

The two sales in 1969, held in the auditorium of the Mitsukoshi department store, were attended by potential bidders and a curiosity-seeking public. A certain amount of education had to take place to teach the Japanese how Western auctions worked. One specific moment has stuck in my mind: an elderly, portly gentleman turned up with his bodyguard, making us think he might be a senior member of the Yakuza, the secretive and powerful society of Japanese gangsters. Having bought a couple of pictures, at the end of the auction he marched to the front of the hall, pulled out thick bundles of yen to pay for the paintings and took them away. We never heard of him or the pictures again.

Both auctions had only moderate results, but they did serve the stated purpose of introducing Sotheby's to the local market before Christie's had a chance of doing so. Having made excellent initial contacts and in general been given an encouraging welcome, Julian and I made it a practice to visit Japan on a regular basis – sometimes bringing pictures from forthcoming sales in London or New York to show Japanese collectors – in order to keep in touch with the dealers and those private collectors who were happy to meet us: a very few even invited us into their homes and showed what they had been collecting. As a result, over time, we gradually built up relationships with a number of Japanese dealers who were becoming an important element in the international market in London and New York. By the mid-to-late 1980s their buying became a major factor in the rapidly growing art market, and the small office we had established in Tokyo gradually took on greater importance. So ended our first introduction to Japan.

Miss Kazuo Shiomi, our first representative in Tokyo, later led us to understand that art, whether oriental or western, was being used by large companies as a means of paying tax-free commissions to politicians who had acted as guarantors in contracts between two industrial giants. Apparently, even the Yakuza were deeply involved in this and so many other business transactions. This very unsavoury state of affairs amounted to money laundering and tax evasion on a large scale and this was certainly current practice at least until the summer of 1990 when the Japanese 'bubble' burst. The ethics, therefore, of the Japanese art world were quite different from those to which we have been accustomed in the West, where art collecting is based either on a love of connoisseurship, or a form of long-term investment as a way of creating family wealth, or as short-term speculation or even as a fashion accessory. Collectors are often individuals wishing to be seen as culturally sophisticated by acquiring fine art to be prominently displayed in their homes to impress their friends and business

associates as a mark of their newly acquired cultural status, of 'keeping up with the Joneses (or the Ishibashis)' or who simply have that childish attitude, 'mine is better that yours'! Many try to advertise their misguided sophistication by covering their walls with paintings of any period, of any school, value or quality.

This form of competitiveness among the rich can often raise prices and I witnessed an example of this schoolboy game in the late 1980s, when one day I was invited to lunch at his chalet in Gstaad by Louis Franck, the Belgian former chairman of the London merchant banker's, Samuel Montagu. The other guest was the legendary Greek ship owner Basil Goulandris, renowned for his superb Impressionist and Modern painting collection. After coffee, the two men started comparing their van Gogh paintings and put me in a quandary by asking me who had the better group. The *van Gogh catalogue raisonné* was pulled off the shelf and they proceeded to show me which ones they owned. I managed to ease my way out of a tricky situation by saying that it was not how many van Goghs each owned, but rather their individual quality that mattered, without having to explain any further. That seemed to satisfy them enough and the conversation moved on to the latest art market gossip.

For many years I visited Gstaad on a regular basis, an exclusive resort in the Swiss Alps where a number of international collectors kept second homes and their more valuable collections, and where I was to have success forging loyal relationships and obtaining consignments for sale.

The second half of the 1980s saw an extraordinary real estate boom in Japan, when property values jumped to astronomical levels, particularly in Tokyo where a few square metres of land could fetch trillions of yen. This frenzy was fuelled by the banks freely lending out vast amounts of cash on easy terms, allowing people to speculate in the rapidly rising property market and other similar assets. The paper profits could subsequently be used for further, even riskier investments. The banks, happy to see the profits rolling in, were also eager to lend hundreds of millions of dollars for the purpose of buying Impressionist and Modern paintings. Some so-called 'collectors' even vaunted their power by building their own private museums, some devoted to the works of a single artist such as Rouault, Chagall, Laurencin (three of them simultaneously), Bernard Buffet and Foujita.

This led to frenzied Japanese buying in the late 1980s which pushed prices, in particular for the Impressionists and the School of Paris, up to very high, dangerous levels. Our salerooms were full of Japanese dealers and department store managers, occupying whole rows of seats. Some were

on the telephone to their principals back home and all of them were buying many of the lots, often bidding against each other, regardless of the cost. One such buyer suddenly appeared in 1989 and spent $100 million in that year at Sotheby's plus undisclosed amounts at Christie's, but by the end of 1990 he was not seen again. Over the five-year period from 1985 to 1990 prices doubled or sometimes tripled. We saw huge amounts of money spent on second quality works. Simultaneously, a smaller group of Japanese collectors displayed a more sophisticated desire for the finest, most expensive paintings, be they by Renoir, Monet, Picasso, Mondrian or de Kooning. We were, therefore, witness to a mixture of unrestricted buying right across the board, the best, the worst and the mediocre.

Inevitably, in the summer of 1990, the overheated Japanese economy collapsed and all art buying stopped. Many of the investors and speculators faced bankruptcy and the banks and finance houses that had made the original loans, re-possessed whole collections. Only a few Japanese dealers attended the auctions, mostly in New York, not so much to buy, but occasionally to sell or, often out of habit, to observe what was going on. It took fifteen years for the Japanese economy to recover and for a few dealers and collectors to begin to buy again, albeit in great moderation.

Gradually, pictures that were bought for huge sums have trickled back on to the auction market, in some cases fetching much lower prices and in others some degree of profit depending on the quality of the work, albeit after many years. It is only now, in this 21st century, that some of these paintings are beginning to realise equivalent prices to those of the late 1980s, especially at the middle level, although their favourite artists, including Foujita and Marie Laurencin, continue to show marked losses. By now, the majority have been resold, mostly at auction in London and New York, and little trace is left of the massive typhoon-like buying, other than the memory of record prices, still standing twenty years on.

Of the few private collectors I met in Japan, the most memorable was Dr Hiroshi Ishizuka, a tall, imposing figure of a man who had invented a process for making artificial diamonds, used mainly for industrial purposes. He started collecting in the 1960s, amassing a very large collection of Old Master, 19th-century and Impressionist paintings, principally acquired at international auctions over a twenty-year period. He especially liked large-scale paintings, perhaps as a reflection of his own height. In a two-storey concrete gallery-warehouse adjacent to his traditional home in a relatively prosperous neighbourhood in Tokyo, the paintings were stored on sliding racks, while larger works were hung on the bare concrete walls, all dimly lit by overhead neon tubes. He rarely showed the pictures himself; that was

left to his elderly curator. After looking at his collection and duly admiring it, Dr Ishizuka and his wife would take Kazuo Shiomi and me to dinner in a private room at the best restaurant in the Okura Hotel. We were served rare and delicious delicacies, a treat for me as I have loved Japanese food ever since my first visit to Tokyo in 1969. The Ishizukas spoke no English, but Miss Shiomi was an excellent translator (prior to joining Sotheby's she had been a United Nations' interpreter), although I was never sure of what she was actually saying to him and translating back to me regardless of language. Throughout, the Ishizukas and I would smile at each other and nod our heads affirmatively as we listened to her translations.

During the 1990s recession, Dr Ishizuka, too, fell upon hard times when the diamond manufacturing business began to suffer from foreign competition. He started to sell a major part of his collection, some at Sotheby's, but more at Christie's since he had developed a better relationship with Sachiko Hibiya, Christie's representative in Tokyo. The best picture he owned was a monumental, early composition by Claude Monet, executed on a stormy day at Trouville in 1868 and depicting windswept men and women in crinolines, struggling to walk along the stone jetty that jutted out into the English Channel. It was sold in New York in 1993 and fetched $8.8 million.

Another collector, who bought a small number of eclectic, very fine works of art, was also called Ishizuka, but they were not related to each other. Dr Tadao Ishizuka had trained as an orthopaedic surgeon in America where he met his future wife, then working in the Japanese Embassy in Washington. On returning to Tokyo he built his own orthopaedic clinic attached to their living quarters in one of the many suburbs. They both spoke excellent English, so conversation was easy and interesting, on my side enquiries about my bad back and on theirs about painters and the current market. I was fond of them and used to have dinner at their house or in a restaurant, whenever I could when I was in Japan. Sometimes I was alone with them and other times John Tancock, whose trips to Tokyo coincided with mine in later years, would join us. The Ishizukas acquired some of the finest Chinese Imperial porcelain and Impressionist and Modern pictures, but the work that struck me the most forcefully was Picasso's final work, executed in 1972 shortly before his death the following year. This portrait in coloured crayons depicting the head of an old man, with extraordinary skull-like features and deep, dark eye sockets is a profoundly disturbing and evocative depiction of Picasso himself.

The most unforgettable man we ever had extensive dealings with in Japan,

originated from the Kyushu, the southernmost of the four main Japanese islands, although he lived mainly in Tokyo. Although it was believed he had a highly profitable Mercedes-Benz dealership, nobody quite knew how Shigeki Kameyama made his money. With little education and speaking no English whatsoever when he started buying in the 1980s he had an extraordinary ability to zero in on the finest pictures available. Turning up at auctions in New York or London, he would bid furiously, buying great Picassos, a highly important de Kooning, a superb early Rauschenberg, excellent Matisses, works by Degas, Chagall and Post-Impressionists, some for himself, some apparently as an investment for a bank down in Kyushu. Kameyama was a tremendous drinker and he once appeared at an evening sale at Sotheby's in New York in 1989, full of drunken antics. Hardly able to stand, he dragged one of the Client Service's women down to the floor with him, telling her to help him bid on some very expensive pictures. A generous and proud man, after the sales he would often take us out to dinner at the finest Chinese and Japanese restaurants in town, insisting we all drink bottle after bottle of Château Lafite and Château Margaux clarets of the finest vintages; he would constantly fill our glasses, right to the brim, urging us to drink, but I was usually able to cry off, now almost tee-total after my Oxford University youthful excesses, pointing to my stomach, indicating that I had medical reasons for not drinking more than half a glass.

In New York's November 1989 sale, Kameyama impulsively bought $47 million worth of paintings, including two masterpieces by Rauschenberg and de Kooning. He had always paid for his purchases on time, but this time he announced some weeks after the sale, to our dismay, that he wasn't able to pay. We never found out why, but Kameyama was a mysterious man who never talked about his affairs, although we suspected he mistakenly believed his client in Kyushu would buy the paintings as he had other expensive works in the past. This put us in an embarrassing position as the owners of the pictures had to be paid on the due date after the sale. We were aware that Kameyama had a large inventory of pictures back in Japan which he had bought either at auction or privately from dealers in New York, London or from private collections in Japan. We also knew from conversations Miss Shiomi had had with him that we could count on these as collateral. It was therefore arranged that at the beginning of January, David Nash, Mitchell Zuckerman, head of finance and responsible to Sotheby's Board for recovering the money, and I, would go to Tokyo to meet Kameyama to select paintings to be sold in the following spring and summer that would be sufficient to recover the $47 million that he owed us.

Having a fair idea of what he owned, David and I were quite confident that we would find enough stock to sell, but Mitch was in a state of heightened anxiety the whole time we were in Tokyo in Kameyama's apartment. We tried to reassure him, saying, 'It'll be OK Mitch, we'll find enough pictures to sell and recover his debt.' Not only did we believe there would be enough property, but we also knew that the quality and the current, still inflated, state of the market would make them very saleable. We spent three or four days completing the final selection made from batches of colour transparencies. All the while Kameyama was either fast asleep or in no condition, or unwilling, to talk about the pictures most of the time. Negotiations about estimates and reserves, obtaining colour transparencies for the catalogue, getting him to tell us where the paintings were stored and arranging the shipment, all with the help of Miss Shiomi who was both interpreter and responsible for trying to keep Kameyama amused and in a fairly good mood, were very complex but, by the end of that week, we managed to organise and achieve our goal.

We chose London as the main sale location since Kameyama had bought most of the paintings in New York, and they would, therefore, be less familiar to potential buyers in London and Europe. The majority were sold in April 1990, including fine works by Pissarro, Renoir, Picasso, an excellent 1933 Paul Klee, *Die Künftige* (*The Arrival of the Bridegroom*) which sold for £2 million, a Miró and an early Léger. The two that made the highest prices in relation to our estimates were works by Chagall, so enormously popular in Japan that two private museums devoted to him were founded in the 1980s. *La Mariée sous le Baldaquin* of 1949, one of the painter's better pictures, was sold for £3.4 million (against a reserve price of £1.2 million). I do not believe that kind of price has been achieved since for any of his post-war paintings. The other, *Le Bouquet des Fermiers* of 1966, a fine, even later example of his work, sold for £2.8 million and was bought by

Marc Chagall, *La Mariée sous le Baldaquin*, oil on canvas 1949, private collection, from the 1990 Kameyama auction

Seibu, the Japanese department store, on behalf of a client. Both paintings were, in fact, bought back by Japanese as were others in the auction. That sale, and the subsequent one in New York in May, happened to be perfectly timed, much to the relief of Mitchell Zuckerman, as only a few months later in the summer of 1990, the Japanese financial markets suddenly crashed, thus heralding the end of Japanese buying for many years to come. Curiously, *Le Bouquet des Fermiers* did come up for sale again in May 2006 in New York, where it sold for just under $3 million (about £1.75 million), roughly half what it made in the 1990 sale. This is a striking example of the tremendous influence the Japanese buyers had on the Chagall market in the 1980s, as well as the detrimental effect they had when they were no longer buying.

One of the most enduring pleasures of visiting Japan was spending Saturday evening and Sunday in Kyoto, that magical city of ancient temples, castles, Zen shrines and exquisite gardens. My special delights included the famous stone garden of Nanzeji, and the creaking floors of Nijo Castle, whose walls and doors were covered in seventeenth-century screens painted by the great masters. Most amazing was Ginkakuji, the extraordinary Temple of the Silver Pavilion where artists have sculpted a miniature Mount Fuji out of shimmering, silver sand, with intricately shaped pine trees and tightly massed groves of bamboo trees. The architecture is simple and perfectly proportioned, the whole suffused in such a Zen-like stillness, heightened on a rare occasion when I sat on the steps of one of the shrines, accompanied only by gently falling snow flakes. The emotions and enormous contentment I found in Kyoto, are only surpassed by my passionate feelings for Venice.

The State Hermitage Museum and 'Trophy Art'

During the Second World War, several German, non-Jewish, private collections of Impressionist paintings were sent for safe-keeping to the underground levels of the impregnable anti-aircraft tower in Berlin's Zoological Gardens in the Tiergarten. By 25 April 1945, the northern suburbs of Berlin had fallen to the Soviets who, two days later, reached the Tiergarten and, after fierce fighting, captured the tower on 1 May. Twenty-five days later, under the auspices of SMERSH, the military counter-intelligence unit of the NKVD, paintings from the Gerstenberg and Koehler collections were crated up and sent by air to Moscow. From there they were taken to Leningrad and stored in the vaults of the State Hermitage Museum. Other private collections turned up later: Otto Krebs' ninety-eight works which had been secretly stored in the cellars of his country estate outside Weimar in East Germany, were dispatched to the Hermitage in 1948.

Before their eventual public appearance in 1995, these Impressionist collections had only once been taken out of storage and shown to the people of Leningrad; that was in 1958 when they were included in a vast exhibition of some 200,000 works of art of all cultures which had been removed from Germany. They were then locked away again and remained unseen, apart from regular checks made on their condition by the curator of the German painting department, who was the only person to hold the key to the storerooms.

After the collapse of the Soviet Union, when Boris Yeltsin succeeded Mikhail Gorbachev, the residents of Leningrad voted to rename their city St Petersburg. Thus a new era of relative freedom and openness was

heralded and, following his appointment as Director of the Hermitage in June 1992, Professor Mikhail Pietrovsky took it upon himself personally to examine the German trophies held within the vaults of the museum. He subsequently announced his intention to exhibit the works, making them available to art lovers and scholars worldwide, whilst their legal status was resolved.

Apart from the particularly good relationship Sotheby's had forged with the Hermitage, in part through Peter Batkin, another link had been created in 1983 by Simon de Pury when he was involved in the organisation of an exchange exhibition between the Thyssen-Bornemisza Museum in Lugano, and the Hermitage and Pushkin museums: a further exchange took place four years later. I particularly remember the excitement of seeing for the first time in that 1983 exhibition, forty masterpieces of Impressionist and Modern paintings from the Shchukin and Morosov collections. These were the same works that had so captivated my grandfather on his visit to Moscow in 1914 and were captivating me likewise.

Due to the friendships that had been nurtured, Professor Pietrovsky invited Sotheby's to be present when the first Impressionist painting was brought out from the vaults in January 1993. Designated as the expert to identify its authenticity and physical condition, I was accompanied by Simon, Peter, and John Dowling, Lord Gowrie's assistant, who had played a role in the arrangements. This was my first trip to St Petersburg, the place where my grandfather, Baron Pierre de Gunzbourg, had been brought up, and the excitement of seeing that great city, under a clear blue sky, enveloped in snow and ice, the river Neva in front of the Hermitage deeply frozen over (where I managed to take a few steps on to the ice) took my breath away, physically from the cold, spiritually from the overwhelming architectural landscape around me.

On that memorable morning, we gathered in the director's grand, lofty office, before he and the curator of the German paintings – who had had sole responsibility for the Trophy Art (as the Russians described it) – escorted us to the top floor of the Hermitage, where the 19th- and 20th-century paintings are exhibited. We were shown into a smallish room in which the extraordinary collection of Caspar David Friedrich paintings was exhibited. This in itself was very special, as I had always had such a passion for his romantic visions but, surpassing that by far, to my delight and astonishment there on an easel in the middle of the room, unframed, in its natural state, was Degas' *Place de la Concorde*: for almost fifty years it was believed that this work had been destroyed in the destruction of Berlin in 1945.

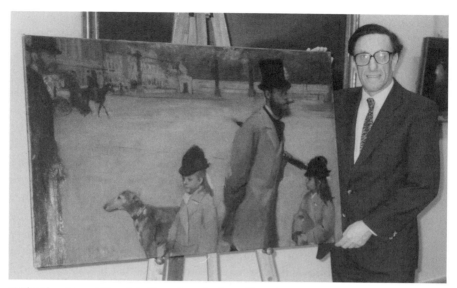

With Edgar Degas' *Place de la Concorde* at the State Hermitage Museum in 1993

I could not quite believe what I was seeing. I was thrilled and very moved but when I asked, after several astonished minutes, if I could take a photograph to record the event, my request was refused. However, Mikhail Pietrovsky told me that I could take the painting off the easel to examine the back of the canvas. Holding the masterpiece in my arms, examining this beautiful work, touching and feeling its surface as my grandmother had taught me, even smelling the dusty old varnish, turning it around gently so I could look at the back of the canvas and read the inscriptions and old labels on the stretcher, (including that of the Galerie Durand-Ruel in Paris which had sold it to Otto Gerstenberg in 1911) was one of the most moving moments of my life.

Covered in a discoloured yellow varnish, the painting looked to be in fine condition so I deduced that the temperature and humidity levels in the vaults of the Hermitage must have been very stable. Then, to my surprise, Pietrovsky said I could, after all, photograph the painting with my pocket camera. I now have a series of pictures of our group in the Friedrich room and a special one of me holding the Degas in my arms.

Place de la Concorde (Vicomte Lepic et ses Filles Traversant la Place de la Concorde) painted in 1875 is a relatively large work measuring 78 by 117 centimetres. In a very modern, almost photo-journalistic approach to portraiture, inspired to a certain extent by asymmetrical compositions Degas had seen in Japanese woodcuts, Ludovic-Napoléon Lepic is depicted on the right of the large expanse of paving stones in the Place de la

Concorde, a daughter on either side of him, one looking at her sister who herself looks away distracted to the left as does their Borzoi dog.

Otto Gerstenberg, an insurance magnate and well-known collector, had died in 1935 at the age of eighty-seven; *Place de la Concorde* was inherited by his two grandsons, Walter and Dieter Scharf, through their mother Margarete Scharf. Sotheby's had, for a number of years, been in talks with the Scharf brothers, as both Simon and Peter Wilson felt there might be a fair chance of recovering the grandsons' inheritance through our good relations with the Hermitage and Russia. If successful, Sotheby's would then have the opportunity of selling some or all of the paintings for the family and it was for that reason we made such an effort to try and ensure the restitution of the pictures.

The following year, in 1994, when the rest of the Gerstenberg pictures were brought up to the gallery from the vaults, Walter and Dieter and their families came to St Petersburg where they were welcomed and shown the collection by the Director. The Scharfs were overwhelmed at the sight of these paintings, which they must last have seen as children in their family home in Berlin, and spent a long time looking at their lost inheritance. Otto Gerstenberg had amassed a large collection of 19th-century paintings and, fortunately, many of the smaller works by Corot, Daumier and a complete set of Toulouse-Lautrec lithographs escaped the Russians. But those in Russia were significant and included an imposing work by Honoré Daumier entitled *Le Fardeau (La Blanchisseuse)*, a penetrating social comment on the grinding poverty of Paris in the 1850s and a pair of life-size Renoirs (commissioned for Georges Charpentier, the French publisher) which have a distinctive bourgeois feel in their depiction of a wealthy couple standing at the bottom of a grand staircase. The loveliest work, aside from the Degas, was Renoir's *Dans le Jardin*, an evocative portrayal of a young, courting couple in a summer garden painted in 1885.

A year later, we were called back for a third time when the remaining paintings and works on paper were removed from the vaults. They were brought up to a storeroom and were stacked around the walls or laid flat on trestle tables for me to examine. The majority had belonged to Otto Krebs, a highly successful businessman who had built up a fascinating and carefully chosen collection of later Impressionist and early 20th-century artists' work, in particular an impressive group of Cézannes and van Goghs, but none had the calibre of *La Place de la Concorde*. On his death in 1941 Otto Krebs had left everything to the 'Stiftung für Krebs und Scharlachforschung', a cancer research institute in Mannheim which exists to this day. Sotheby's had contacted the Stiftung and the others who

had had their collections taken by the Soviets in 1945, but, after all these years, and in spite of negotiations and pleas that these were collections owned by private individuals and not German State property, as in the case of the Gerstenberg collection, successive Russian parliaments and presidents still refuse to consider returning them. They remain in the Hermitage, rather poorly exhibited, and hung in badly lit galleries. Whether the Russians will ever release the paintings to these families remains to be seen.

The big stumbling block from the Russian point of view, is the fact that the Germans destroyed everything in their wake as they swept through Russia in 1941. In particular, the famous Amber Room at Tsarskoe Selo, outside St Petersburg, which Peter the Great received as a present from King Wilhelm I of Prussia in 1715 and was installed at Tsarskoe Selo in 1753 by Catherine the Great, has never been found, and probably never will be, although theories about its whereabouts continue to abound. In advance of the Germans, the amber panels were crated up and sent to the seaport of Kaliningrad (Königsberg in German) and it seems to me extremely doubtful that they would have survived the devastation following RAF bombing in 1944. However, some say that the panels were loaded on to the *Wilhelm Gustloff* which was sunk by a German submarine and others maintain that they were buried in deep mines in the Ore Mountains. Only recently, an anonymous Russian businessman claimed that two former German police officers, with whom he is in contact, know where the Amber Room is and will reveal its whereabouts if they are paid $17.3 million. Suspecting a hoax, few are prepared to help the businessman raise the money. I feel it is now unlikely that the true facts of one of the great mysteries of the Second World War will ever emerge, whatever theories and 'conclusive evidence' are revealed in a splash of publicity. Work began on re-creating a faithful copy of the Amber Room in 1979, involving collecting six tons of amber from the Gulf of Finland. Twenty-three years later, the Room was completed in time for the 300th anniversary celebrations of St Petersburg in 2003 – the project was financed in part by a large donation from the German company, Ruhrgas.

Until the unlikely day comes when Russia does decide to repatriate these works, I wish in the meantime they would clean, frame and exhibit them alongside their own fabulous collections, and that when the General Staff building on the other side of Palace Square, adjacent to the Hermitage, has been refurbished as the New Galleries to house its 19th-, 20th- and 21st-century art, these hidden treasures will be incorporated into the new displays.

★

Although we did not establish an office in Russia until 2007, partly because doing any kind of business there was so complicated, from the mid-1980s we had 'our man in Moscow'. This was Peter Batkin, who had begun his career in Sotheby's as a sales clerk and was of Russian descent. An expansive and generous man, immaculately and exotically dressed in a pin-striped suit, bow tie and two-tone shoes, Peter was regularly sent out to Russia to make connections with museum and government officials, as well as any collectors he could contact, accompanied by his interpreter Irina. In St Petersburg, or Leningrad as it was called when he first travelled there, the most useful contact he made was with Professor Mikhail Pietrovsky of the State Hermitage Museum, who was later to become its Director.

During those years Russian citizens could neither buy abroad nor export any works of art officially, but one result of all Peter's efforts was an experimental sale of Russian Contemporary Art held in Moscow in the summer of 1988. It took a long time to set up the complex logistics involved in allowing foreigners to purchase at the sale, export from the Soviet Union and then to pay with foreign currency. A weighty, fully illustrated catalogue was produced and sent to thousands of collectors and dealers around the world. It seemed to me as if half the Sotheby's staff was going to Moscow to join in the event, but I refused to join them, even though Contemporary Art was part of my fiefdom. When the project had first been discussed at several Board Meetings in London I was very much against it as I felt the sale would be a flop, that it would be a waste of our resources and in no way could it be profitable: to my mind it was just a huge public relations exercise in a country where we could not do any proper long-term business at that time. But I was wrong. The sale was indeed a great success; the buyers were all foreign and mostly paid high prices. The highest was for a Grisha Bruskin painting which sold for £242,000. The next morning I sent Peter a telegram to congratulate him.

He was touched by my gesture, especially since I had spoken out so strongly against the sale; as a result, a few months later he invited Margery and me to spend a week in Moscow. He laid on a fantastic tour and booked the Presidential Suite for us in the National Hotel overlooking Red Square. In 1989, food there was barely edible, but caviar and smoked sturgeon were cheap and plentiful. I especially wanted to visit the Pushkin Museum, where part of the Shchukin/Morosov collection was exhibited to the public by then, and we briefly met the famous but rather daunting director of very long standing, Mrs Antonova. We were allowed into cellars of the Tretyakov Museum of Russian art where the curator of the collections showed us its extensive collection of Avant-Garde art, then not yet allowed to be publicly exhibited.

Peter, the great fixer and arranger, even managed to get us into Lenin's private office and simply furnished apartment in the Kremlin which was normally barred to visitors. He also introduced us to a few of his artist friends living in shabby, cluttered apartments; especially memorable was meeting the grandson of Alexander Rodchenko who showed us some of his grandfather's famous original photographs. We subsequently were taken to the famous Avant-Garde house that the minimalist architect Konstantin Melnikov designed for himself in 1927 and which was now occupied by his son, an abstract artist. We really liked some of his work and wanted to buy one of his canvases, but the old man stubbornly refused to part with any of them in spite of his obvious need for money. Peter was constantly drumming up relationships but, in the end, as little actual business could be done in Russia at that time, Sotheby's decided that, as his expenses were at such a high level, enough was enough. Peter decided to leave and has gone on to more entrepreneurial activities.

Now, at the beginning of the 21st century, the enormous political changes that have taken place in the former Soviet Union have led to the emergence of the Russian oligarchs with their huge spending power, purchasing Russian art in large quantities: Fabergé and other 19th-century and early 20th-century artists which fetch enormous prices. Some of them have moved into buying Impressionist, Modern and Contemporary Art, in increasingly significant quantities, and are responsible for setting record prices such as the $95 million paid for a 1941 Picasso *Portrait de Dora Maar* at Sotheby's in New York in May 2006 and Francis Bacon's 1976 *Triptych*, bought by Chelsea Football Club's Russian owner, Roman Abramovitch, in 2008 for $77 million. As the Russians are currently buying in greater and greater quantities across several fields, my real hope is that one or more of them might emulate the great collectors of a hundred years ago and gift superb collections of Modern and Contemporary Art to a Russian museum, such as the Hermitage in St Petersburg which has benefited so much from those of Shchukin and Morosov, albeit confiscated by the Bolsheviks, that draw millions of visitors each year.

Through an old friendship with Geraldine Norman, dating back to the late 1960s when she was *The Times* art sales correspondent, I was invited to join the UK Friends of the Hermitage as a Trustee in 2006. Remembering me from the time I was present at the re-appearance of the Trophy Art, Professor Pietrovsky invited me to be his senior advisor in developing the Hermitage 20/21 Campaign. The aim of this Campaign is to extend the museum's collections beyond 1917 by adding Modern and Contemporary Art. As there will be no acquisition funding available from the state, the UK Friends have been charged with raising funds for the

project that consists of organising Contemporary Art exhibitions and obtaining long term loans from private collections and artists' estates. Successful exhibitions of new art by young British and American artists from the Saatchi collections have already taken place and amongst future plans are solo exhibitions of works by Anthony Gormley and Henry Moore's wartime Shelter drawings and related sculpture.

CHAPTER FIFTEEN

War-Loot and Robberies

Redon's *Bouddha*

One morning in 1970, I received a letter from a couple in Holland, accompanied by a photograph of a painting by Odilon Redon, the French symbolist painter working at the turn of the 19th and 20th centuries. They were interested in selling the painting which they had bought during the Second World War in good faith from J.H. du Bois. He was a well-known dealer in Holland who specialised in Redon's works and had bought a large number direct from the painter before the First World War. Therefore, the work's credentials seemed excellent on paper.

Although I was excited to see a photograph of this important work, one of Redon's rare subjects, a depiction of a Buddha standing under a tree, surrounded by an imaginary field of flowers, it was not, frankly, one that I was particularly fond of. I immediately replied to the couple giving them our terms, together with an estimated sale price which I put at £80 – 100,000; this they were happy with and they agreed to send the painting over to London for confirmation of the estimate once I had seen the original.

Checking provenance and other technical references is part of the diligent care one has to take in cataloguing pictures. Consulting the literature on Redon in the department's library, I found a reference to the work in Klaus Berger's biography of the artist and, to my surprise, the most recent provenance was given as Mme Fernand Halphen, a first cousin of my grandmother, Yvonne de Gunzbourg. Although I had not known Mme Fernand Halphen, her son Georges was a friend and he himself had a fine

173

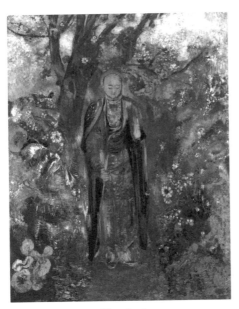

Alice Halphen's Odilon Redon,
Bouddha Marchant dans les Fleurs,
oil on canvas 1901, private collection

collection, both of Impressionists inherited from his mother and of early Chinese antiquities which was his main passion. I was under the impression that neither Georges nor his mother had ever sold any pictures, so I called him and asked if he knew if and when his mother had sold the *Bouddha*, adding that I had been approached by people who wanted to sell it. He was astonished and told me that in 1942 German soldiers had occupied his mother's house at La Chapelle-en-Serval, thirty miles north-east of Paris, and that, as the Redon had disappeared during the German Occupation, it was assumed that one of the soldiers had stolen the painting. The fact that it later turned up in Holland suggested to both of us that the soldier had later been stationed there and sold the painting to a local dealer.

Georges wanted the work to be returned to him forthwith but legally I could not do so. I suggested instead that he engage a lawyer and assured him that, when the painting arrived, I would immediately and quietly advise him of the fact. I then had to tell the Dutch couple that regrettably, in researching the painting, I had discovered its past history and was therefore obliged to inform Mme Halphen's family of the circumstances. They were naturally upset and had their lawyer contact us while I put the matter in the hands of Herbert Smith, Sotheby's firm of solicitors. At that stage, I made sure that the lawyers on all sides contacted each other to try and resolve the matter, if possible to everyone's satisfaction.

It appeared that given the situation under the laws of the 1970s, full restitution was still problematic. International law on the subject only became more clearly defined and formulated once the archives of Germany and the occupied countries had been accessed and studied from the early 1990s onwards. This affair fell under the jurisdiction of the three countries involved; Holland, France and England, as the painting was by then physically in London. However, all the parties eventually came to a

resolution that satisfied the Dutch, but not the Halphens. The Redon was restituted to Georges and his sister Henriette Schumann, while the Dutch couple were entitled to receive £100,000 in compensation. My cousins decided between themselves that Henriette would have the painting, as she was fonder of it, and for many years it hung in her apartment in Paris. After her death, her two daughters decided to sell the *Bouddha Marchant dans les Fleurs* in our June 1999 sale, where it made £440,000, not a great price compared to the £100,000 Henriette had paid for it in 1970. However, in the 1970s, Redon's paintings had been more popular: the Japanese had a high regard for his work, but now were no longer in the market and Ian Woodner, an American who had amassed a very large and varied collection of the artist's paintings, drawings and prints, had died in 1990. In that same sale my cousins also sold their mother's Monet, *La Seine à Asnières*, which had also been looted in the Second World War. The work had been acquired in 1948 by the Detroit Institute of Arts and returned to Mme Halphen two years later.

While the greater part of the 21,903 objects stolen from Jewish art collections was sent to Germany, fifty-three were ear-marked for Hitler, and, on more than a dozen occasions between 1940 and 1942, looted art was exhibited at the Jeu de Paume in Paris, enabling Goering to choose pictures for his own collection. I occasionally came across some of these looted works, distinguished by the ERR (Einsatzstab Reichsleiter Rosenberg) stamp on the back of paintings, as ever a fascinating but poignant occurrence.

The Bakwin Cézanne

The second intriguing affair began in the summer of 1998 when I was contacted by Julian Radcliffe, Chairman of the London-based Art Loss Register, an organisation which tracks stolen art. Julian for many years had been a loss adjuster at Lloyd's of London and one of his specialities was dealing with ransom demands in kidnapping cases. He told me that after many years of fruitless enquiry, he was finally on the track of a fabulous still life by Cézanne which had been stolen twenty years earlier, along with six other paintings, from the Stockbridge, Massachusetts home of Michael Bakwin and his wife. All seven paintings had vanished into thin air and the most important among the works by far was the Cézanne. It was not until a year later that Julian contacted me again, in September 1999, saying he now knew with whom the Art Loss Register was dealing and that a reward had been agreed for the recovery of the Cézanne, a reward which was only

a tiny fraction of its true value; in addition, as part of the deal, the remaining six stolen paintings would be signed over to Erie International, a company based in Panama. Both the British police and the FBI had been involved in this decision which, in my view, was a pragmatic one; I was also aware that Julian knew this was merely a beginning.

Julian asked me to join him in Geneva the following week, when the Cézanne was supposedly going to be handed back, in order that I could verify its authenticity and physical state. We finally arrived at the office of a local lawyer at 2.30 pm, accompanied by Caroline Lang from our Geneva office, and were shown into a large, waiting room. Julian asked me to remain there while he disappeared into the lawyer's office to make the final arrangements. At some point, the lawyer received a telephone call warning that the necessary documents would be late in arriving so we waited, five minutes, ten minutes, half an hour, an hour, time went by. Eventually, a hot and bothered looking Bernard Vischer, the local lawyer representing Erie International, turned up and Julian was able to sign the documents. Vischer promptly left the building, telling us to stay put and once out on the street, he was observed using his mobile phone. Julian had followed the Swiss lawyer down to the courtyard, where they waited until a car drew up and a package wrapped in a black plastic bin-bag was thrust out of the window into the arms of the lawyer. He and Julian raced up to the waiting room where I was handed the package with an abrupt 'Voilà', at which point the lawyer promptly turned and left. Nervously impatient, I tore a small hole in the bin-bag with my right index finger, pushed aside the layers of soft padding and revealed about six square centimetres of paint. I was instantly

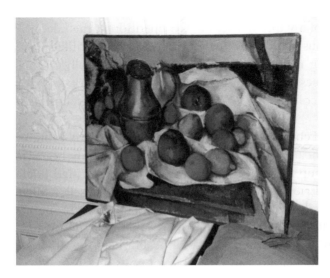

The Bakwin Cézanne, *Bouilloire et Fruits*, oil on canvas *circa* 1888–90, private collection, freshly unwrapped by me after its miraculous return in 1999

in no doubt that this was the Cézanne in question, recognising the patches of colour and the artist's distinctive brushwork. Impatiently, I finished unwrapping the package and brought to light the stunning still life, unframed and in fine condition.

Julian wanted us to take the painting back to London straight away, so I quickly arranged for export papers to be completed by Sotheby's office in Geneva, and called the insurance department in London instructing them to insure it for £12 million whilst in transit. I also asked that we should be met at the airport by a customs agent from one of the shipping companies, with all the necessary import documentation. We left on an evening flight with the painting, still wrapped in its bin-bag inside an anonymous, plastic shopping bag as added protection, lying at my feet on the plane. All went smoothly and by that evening the Cézanne was safely ensconced in Sotheby's strong room.

Shortly after the return of Cézanne's *Bouilloire et Fruits,* we heard that Michael Bakwin felt he could no longer be responsible for a painting of such value and instructed us to sell it at the first convenient moment. We were just in time to include the painting in our December 1999 sale and even to have it viewed in New York a few weeks before the sale. Michael Bakwin, after more than twenty years, was again able to see the picture which he had once described as the most beautiful thing in the world when first he saw it, and indeed it was he had who persuaded his parents, Ruth and Harry Bakwin, themselves great collectors, to buy the Cézanne.

The art market, thirsting as always for fresh material that had not been available, in this case for over fifty years, was excited to see such a dazzling still life of apples, oranges and lemons and a pewter jug, resting on the intricate folds of a white tablecloth. Competition at the sale on 7 December was ferocious and the estimated price of £9 -12 million was soon passed: the bidding, rising in increments of £500,000, finally reached £16.5 million. The successful buyer was a well-known New York collector, the owner of a superb collection of 20th-century art, a fact which pleased Michael Bakwin.

Five years on, in February 2005, four other paintings – two Soutines, an Utrillo and a Vlaminck – also stolen from the Bakwin family home in New England, turned up at Sotheby's, who immediately notified Julian Radcliffe. Once more Erie International was found to be the seller. Julian was able to block the sale and, joining forces with the owner, brought a law suit against one Robert Mardirosian. It was ruled that the original arrangement whereby Erie returned the Cézanne, but kept the other six works was void, and that Mardirosian was liable for costs of £1.7 million,

the sum of the court, legal and investigative fees incurred by the Bakwin family in trying to get their property back. The four paintings, after being restored to their original condition, were returned to Michael Bakwin in July 2007.

The whole murky story of the theft of the Cézanne and the other works was not revealed until the beginning of 2006. The paintings had been left by the alleged thief, one David Colvin, with Robert Mardirosian, a Massachusetts lawyer. Colvin was later shot and killed in an unrelated incident. As the Cézanne had not been insured by the Bakwin family, there was no reward, so Mardirosian decided to deposit the stolen paintings in a Swiss bank while he negotiated a ten per cent finder's fee, setting up Erie International, a dummy company in Panama, to facilitate his unsavoury cause.

Any decent lawyer would have handed over the paintings straight away, but Mardirosian had a different angle, saying, 'I know some things don't look good here but I believe I have a legitimate case to make. I could have sold these a dozen times but never did. My whole intent was to find a way to get them back to the owner in return for a ten per cent commission.' Mardirosian moved to the south of France and became a painter but, in another twist, in February 2007 he was arrested and charged in the United States with 'illegal possession and attempted sale of goods' – the goods being the seven stolen paintings from the Bakwin collection. After almost thirty years, the two remaining missing paintings by the minor French artist Jean Jansems are believed to be in Switzerland. The FBI continues to investigate.

A Restituted van Gogh

In the same sale as the Cézanne and only three lots later in the sale, there was a powerful, tormented van Gogh reed pen and brown ink drawing of an olive grove at the foot of Les Alpilles, a small chain of rocky peaks which van Gogh could see from his window at the Hôpital de St. Paul in St. Rémy. Titled *Oliviers avec les Alpilles au Fond*, drawn in July 1889, this was the first Impressionist work to be auctioned after being restituted to the family of its pre-war Jewish owner. The drawing had belonged to Max Silberberg, an industrialist from Breslau, who had been forced by the Nazis to sell the work at auction in 1935: it was bought by the Berlin Nationalgalerie. Silberberg later died in a concentration camp. Due to the strict restitution laws enacted by Germany, when the circumstances of the van Gogh's fate were revealed, the Nationalgalerie had no hesitation in

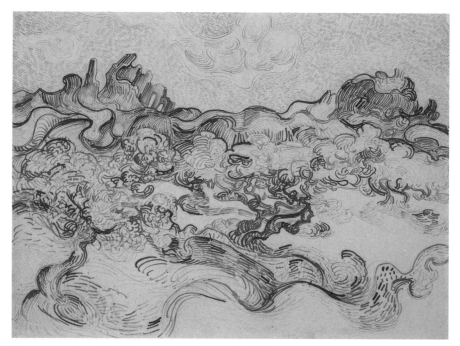

The restituted van Gogh drawing, *Oliviers avec les Alpilles au Fond*, reed pen and brown ink on paper July 1889, private collection

returning it to the rightful owners in 1999. Accompanied by Philip Hook, I flew to Berlin to examine and collect the drawing, bringing it back to London, this time in a more appropriate wrapping than a bin-bag. The beautiful drawing, which the owners had not been interested in keeping, sold for £4.8 million, once again way over its published estimate.

Of the two restituted works, the van Gogh and Cézanne, I would not hesitate when asked which one I would love to own: van Gogh, one of the greatest draughtsmen ever, produced masterpieces such as this work. It evoked in me much stronger emotions and admiration than the colder, analytical vision of the Cézanne. Van Gogh and Cézanne were two innovative painters whose influence led, in the case of the former, to Matisse and Fauvism, and the latter, to Picasso and Cubism.

CHAPTER SIXTEEN

Fakes, Forgers and Misattributions

To be successful in the art world, a good 'eye' is essential and some are born with it. Others can acquire it by looking and learning, but some may never do so in spite of many years working in the field. An 'eye' is more than the ability to identify the authorship of a work within its social and art historical context: it is the ability, instinctively, to recognise quality in a work, to pick out the best in a gallery full of pictures and latch on to the finest. Those who do have an eye are able, intuitively, to recognise an artist's work, but equally, in time, to develop the knack of recognising those works purported to be by a particular artist but which aren't. One has to be able to recognise the draughtsmanship, the colours and the colour combinations a particular artist favoured, his compositions, subject matter, the individuality of the brush strokes, even the size and make of canvas. The type and quality of stretchers a painter used has to be identified (for example, French stretchers are different from those made in England), as is an artist's way of signing and dating, the inscriptions, even to the extent of recognising collectors' and dealers' labels and whether these have been counterfeited or not. All these factors combine to develop an instinctive feeling as to whether a painting is authentic or not.

I was extremely fortunate to inherit such an eye and passion from my grandfather and father as well as a particular passion for Impressionist paintings, as Jules had. The ability to distinguish the original from a fake revealed itself early on in my career at Sotheby's when in December 1961, a few weeks after I joined, I was sent on my first visit to a house in Barnet, North London to estimate and take in for sale two paintings by the 19th-century French flower painter, Henri Fantin-Latour. As soon as I saw them,

I realised that they were copies, although quite sophisticated ones, and was relieved that on my first visit to a client I had had that ability to spot them. I already knew that Fantin-Latour had been very popular in his day and his work was avidly being copied and faked by the end of the 19th century, or even mistaken for his wife's (she painted flower still lifes under her own name, Victoria Dubourg). In fact, I was to realise that many of the most difficult fakes to spot were those made during an artist's lifetime, often by struggling students or impoverished painters, who either sold them themselves or put them into auctions in Paris and elsewhere.

It was very upsetting for the owners of such copies and I found it difficult telling them the bad news that, as I had doubts as to the authenticity of their paintings, which they often had inherited from a parent or grandparent, I would not be able to take them in for sale. Sotheby's made a point of never stating and still shouldn't, that any work is a fake as that could cause legal problems, particularly, as in more recent times, people have become increasingly litigious. When selling Impressionist and Modern pictures, we had to be one hundred per cent certain that any lot we sold was genuine. If I had to give an owner bad news, I tried to put it as gently as possible by saying, for example, 'Unfortunately, we don't feel that we can sell it for you as we can't be certain it's 100% genuine.'

My intuition can be demonstrated by the fact that, twenty-five years later, when one day all the younger experts were out at lunch, I was called down to the picture counter to examine a painting which was thought to be by one of the Impressionists. A couple was waiting with their painting at their feet. I was very busy at that time and unduly impatient, and as I came down the stairs I called out, 'I am sorry to tell you that I don't feel it's genuine, I don't think we can sell it.' Astonished and taken aback, the gentleman said, 'But you've only seen it for one second,' and, rather impulsively and arrogantly I blurted out, 'No, no, I've seen it for twenty-five years and one second.' That second was all I needed, although I shouldn't have said so. This instant recognition can be compared with, for example, knowing that a letter has come from one of my children simply by the handwriting on the envelope. This incident did not reflect well on me though: I was in too much of a hurry that day, so hadn't gone through the normal, more considered process of examining the painting and stating my opinion in a more delicate fashion.

Since that first experience in Barnet almost fifty years ago, my colleagues and I have seen almost as many fake as genuine works. 'Fake' is a general term covering three categories: the first comprising fully signed works that were made deliberately during an artist's lifetime by a studio

assistant or art school student for financial gain. A second, larger, category consists of paintings executed in the manner of a particular artist by unknown students, copyists, amateurs or minor painters, which are not intended to deceive. They were left unsigned, unattributed and, at some later date, the fake signature of an artist whose work they might vaguely resemble was added by a third party, either fraudulently or in hope. The last category concerns those artists (Cézanne or van Gogh, for instance, who rarely signed their work), whose genuine paintings would be signed by another, later hand. Such signatures were usually painted on top of the original varnish and could be identified by viewing them under ultra-violet light which would reveal they were added posthumously. In the rare instances when I came across such additions, I would get the owner's permission to have a restorer remove the false signatures for the simple reason that fake signatures can severely affect the value of a genuine picture; to have no signature is better than to have a fake one.

The Faker Elmyr de Hory

The most blatant example of deliberate fakery, conceived on a grand international scale, which flooded the art market in the 1950s and '60s, was that produced by the notorious Elmyr de Hory. From a family of Jewish bankers (his father was a Hungarian diplomat), de Hory attended art school, first in Munich and then at the Académie de la Grande Chaumière in Paris where he studied under Fernand Léger. At the age of twenty-one, one of de Hory's landscape paintings was accepted by the Salon d'Automne and was hung in the same room as a painting by Vlaminck. After the Anschluss of 1938, de Hory returned to Hungary, but was picked up and sent to a prison camp in Transylvania. He owed his survival there to a meticulous portrait he made of the camp commandant and was later released. However, he was picked up again and was so badly beaten by the Gestapo for being both Jewish and homosexual, that he had to be hospitalised. Slowly recovering, he was hobbling around the hospital grounds, when he noticed that the front gate had been left open so out he went. By the end of the war, his parents were dead and the family fortune had been confiscated, so accordingly he returned to Paris, broke, and began painting once more. One day in 1946, Lady Malcolm Campbell (wife of the record-breaking racing driver) visited his studio and admired what she took to be a Picasso drawing and gave him £40 for it. De Hory did not tell her it was his own work and when he heard that she had received £150 for the same drawing from a London gallery he knew what he should do:

he took two more of his 'Picasso' drawings and sold them to a Paris gallery. From then on he sold to galleries and museums in St Louis, Chicago, New York, Philadelphia, Washington, San Francisco, Boston, and even to the Fogg Art Museum, famous for its scholarship and collection of Old Master and Modern drawings. Over many years, Elmyr de Hory's pastiches of paintings and drawings by Picasso, Matisse, Modigliani and Chagall, and many others, fooled even the best of dealers and auction houses in America and Europe, but not quite all.

Someone who was not taken in was Frank Perls, a well-respected and much liked dealer in Los Angeles. In 1952 he was visited by a man who said he was related to the French art critic, Maurice Raynal. Calling himself 'Louis Raynal', it was actually de Hory himself, who showed Frank drawings by 'Picasso', 'Matisse' and 'Renoir'. At first Frank couldn't believe his eyes, but when studying a Modigliani portrait of Soutine he felt uneasy – he was suddenly aware of a barely perceptible similarity between the works. Very carefully Frank placed everything back in the folio, retied the ribbons and threw the lot at de Hory telling him that if he didn't leave Los Angeles within twenty-four hours, the police would be called. It was Frank who later initiated an enquiry into de Hory's activities.

From October 1961, de Hory's work began to be marketed and sold by a shady French agent, Fernand Legros, who took a forty per cent cut and then demanded more, often forgetting to send de Hory his share. One morning in the autumn of 1962, Legros turned up at Sotheby's with two so-called 'Dufy' gouaches of racecourses under his arm. One of the receptionists on the front counter rang to ask me to come down and inspect his property. He introduced himself, removed the gouaches from the folio and placed them on the counter for me to estimate and take in for the next sale. Straight away I thought there was something strange, something that did not ring true about them. After careful examination, I felt that the execution was too crude and the colours lacked the intensity one finds in genuine Dufys. I told Legros that Sotheby's would not be interested in selling them. At this he became very heated, arguing, 'Why not? Parke-Bernet Galleries in New York and the Paris auctioneers have been happy to sell other similar ones as authentic Dufys. Why won't you take them?' I replied, 'I'm not happy with them' and refused to say any more. But he persisted and made such a commotion to the extent that I felt I had to get him out of the building. Placing my hand firmly on his back, I steered him, or rather pushed him out of the front door, something I had never done before or since. To my great satisfaction the whole Elmyr de Hory affair became public and Legros was eventually found guilty of fraud and forgery and spent a few months in prison in Paris. He died of

throat cancer in 1980 while Elmyr de Hory committed suicide in 1976.

It is a strange and curious factor that looking now at de Hory's fakes, they seem so facile and such obvious, unlikely pastiches. It turned out that Frank Perls, with whom I compared notes, and I were the only ones, to my knowledge, among many experienced international experts and dealers, who sussed him out at that time. I can only explain this as an example of the herd instinct: if one accepts, then the rest will follow. The irony of it all is that now, his own, genuine paintings are somewhat sought-after and sell for a few thousand pounds each from time to time in auctions.

Fortunately scholarship, as a result of extensive research and accessibility to archives aided by the speed of computerisation, has vastly improved in the last forty years. Now that so many monographs or *catalogues raisonnés* of Impressionist and 20th-century artists' work have been published, it is far more difficult for a forgery to slip past unnoticed, although an occasional work, allegedly by a minor artist or by a better-known painter whose work is still waiting to be completely and minutely classified, may do so. Works on paper however, have not been so completely studied and categorised, so there still remains scope for mis-identification and skulduggery.

CHAPTER SEVENTEEN

The Dealers

The Old Paris Dealers

Dealers and collectors of Impressionist and Modern paintings have had the advantage, in almost every instance, of experiencing little problem with attribution. Not only were the majority of the paintings signed and dated, but for many years only one dealer was their principal agent, championing their cause from the early 1870s onwards. This far-seeing and dynamic international dealer was Paul Durand-Ruel, owner of the famous gallery in the rue Laffitte, who represented many of the principal Impressionist painters. He had the foresight to photograph and record everything that passed through his hands and made meticulous notes in oversized ledgers regarding the date he bought a painting from an artist, the amount paid, and subsequently the price when sold to collectors or dealers, a practice which was continued by his son, Joseph, and grandson, Charles, until the gallery finally closed for business in 1974. It is an extraordinary archive, meticulously maintained by his great-great-grand daughter, Flavie Durand-Ruel, together with her aunt and uncle, Caroline Godfroy and Paul-Louis Durand-Ruel. It has contributed to the establishment of many *catalogues raisonnés* for the main Impressionist painters, catalogues which are virtually complete records of their total œuvre.

My grandfather Jules was a frequent visitor and client of the gallery and bought many works from Paul Durand-Ruel. Many years later, Paul Durand-Ruel's grandson Charles befriended me and introduced me to a number of his friends, in particular Baron Louis de Chollet who lived in Fribourg in Switzerland, and who was to consign several paintings to me

for sale. His most valuable painting was a good Waterlily painting by Monet, which his widow asked me to sell for her in April 1989 when it unexpectedly made £4 million at the height of the market, well above its estimate. Charles Durand-Ruel was a charming, forthright character from whom I learnt a lot about the Impressionists. He had been very fond of and much admired Jules and as a result was especially kind to me, welcoming me to his gallery, taking me into his old stock rooms and pulling out paintings from the racks for me to enjoy. This direct link to his famous grandfather, as well as to mine, touched me deeply and meant a lot in my developing knowledge of the pre-war Paris market.

Early in my career, I was privileged to meet two other French dealers who were to become my mentors and remained friends until the end of their lives. Paul Brame, a real gentleman and one of the grand old French dealers, had a great eye and knowledge. He had written the Degas and Seurat *catalogues raisonnés* with his close colleague and friend, César de Hauke, a distinguished, even eccentric-looking gentleman. De Hauke had impeccable taste and lived in a grand apartment on the rue du Faubourg St Honoré, which I only visited once shortly before he died in 1965. Many years later, I discovered he had had a very unsavoury reputation due to his dealings with the Germans, handling Jewish property, and selling pictures of suspicious provenance to American museums during and after the war; facts only revealed much later when secret wartime archives became publicly accessible in the 1990s.

These, mostly venerable, dealers had also known and admired my grandfather; his reputation was such that he was still remembered for many years after his death in 1943 and well into the time I spent at Sotheby's. When they heard from one of my cousins in Paris that I had joined Sotheby's, they came to introduce themselves at one of my early sales and invited me out to lunch. They talked a lot about him – providing a fascinating insight for me – and I continued seeing them in Paris and London. In Paris they would show me their stock of pictures, many never previously seen publicly, and talked about the Impressionists, many of the famous paintings that had passed through their hands and the great collectors they had known.

Paul Brame would also occasionally give me pictures to sell or send me a client of his who wanted to sell at auction, but would have nothing to do with the Paris auctioneers. On one occasion in the late 1960s, I offered him a pair of Seurats, painted on cigar-box lids, which were rare and previously unrecorded works. I had initially gone to him to have them authenticated, as he was the Seurat expert, but I also knew that it would be difficult to obtain an export licence for them. As their owner was

unwilling to go through that whole process, he asked me to sell them privately. We agreed a price and I offered them to Paul Brame who was happy to buy them at that figure, and moreover for cash which was a usual practice, legal in France in those days; and Sotheby's received its normal commission for having engineered the transaction.

A London dealer whose company I enjoyed and who supported me during those early years was Dudley Tooth, owner of Arthur Tooth & Sons, an old, established firm in Bruton Street in London. He specialised in British and French paintings, both the Impressionists and Modern painters such as Nicolas de Staël, Jean Dubuffet and Sam Francis. Dudley Tooth was a portly, kindly disposed gentleman and very welcoming to me, as was his young assistant, Martin Summers, who was soon to move to the Alex Reid & Lefevre Gallery, in the building next door. As these Paris dealers sometimes did, he would contact me whenever he wanted to sell something, either from his own stock or for his clients. I will always remember the maxim he often repeated 'Buy at Christie's and sell at Sotheby's', a satisfying position to maintain.

The last of the old school of dealers I often visited in Paris, and one of my generation, was Daniel Malingue. We first met in the 1960s before he had his own gallery in the avenue Matignon, a fine space where he continues to organise important exhibitions of modern painters. I first met him in New York where he told me a story I have never forgotten. At the time he was one of those dealers without a gallery who travelled between Europe and the United States with a folio of colour transparencies of paintings he had for sale, visiting local dealers and collectors. On one occasion he went into a certain Madison Avenue gallery in New York where he saw a painting by Maurice de Vlaminck. Having agreed a price, he continued on his way and dropped into a gallery a few doors down. When the owner asked him what he had for sale, Malingue showed him his portfolio. The only picture that interested the dealer happened to be the Vlaminck owned by his neighbour, but which he had never seen. Malingue said what he wanted for it, and after negotiation, they agreed on a figure, which realised a tidy, quick profit for Malingue: the New York dealer never knew where the painting came from. I was much amused by his spirit of opportunism. He continues to be well respected in the art world and is a loyal supporter of the auction houses where he has bought many excellent pictures over the years. When I first knew him he looked quite lugubrious; one day, as we were good friends, I had the nerve to tell him not to look so downcast, but to start smiling more, which I was certain would help him in business. He eventually followed my advice and I can only presume he has seen the benefits.

In the 1960s and 1970s, Sotheby's was achieving, on the whole, better prices for Impressionist and Modern pictures than Christie's, who had been historically much stronger than us in selling Old Master Paintings, due to their long standing and binding connections to Country House collections. Then, from the early 1980s, once Christie's began holding sales in New York, their Impressionist sales began to gather strength, while Sotheby's was making a concerted and successful effort to grab a much bigger share of the Old Master market.

For various reasons, Paris was a gold mine for us. We were getting a lot of business there, not least because a majority of the anglophile *haute bourgeoisie* did not trust the Paris auctioneers, some of whom at the time had, I believe, ways of doing business that acted against the interests of private sellers and buyers. They often had secret arrangements with their dealer friends to knock down lots cheaply, thus creating a closed, immoral market. England had a long tradition of specialist knowledge in many fields with a reputation for professional probity, whilst French experts tended to be hand in glove with the auctioneers, an unhappy situation that inevitably led to conflicts of interest. Added to which, PCW was highly respected by serious collectors in France while I was becoming known through my extended family connections.

Furthermore, PCW and I cultivated the Paris dealers as an excellent source of Impressionist and Modern pictures and once we had opened an office in 1967, this kind of business rapidly increased. I would always, on my monthly trips to Paris, do the rounds of the dealers I had got to know and trust. There were so many opportunities in the 1960s and '70s, in particular, for these dealers and their international colleagues to buy at the Hôtel Drouot and turn the works straight over to us in London as the price differentials were quite significant. One of the problems in Paris was the fact that there were over seventy different fine art auctioneers; each one had to be qualified in family and commercial law, under the umbrella of the Ministry of Justice, a practice established in the 16th century. They were, therefore, limited as to what business they could do, unlike the English auction houses, which were free, capital-based, commercial enterprises. Also, French auctioneers could not solicit business abroad and as there were so many of them it meant that no one auctioneer could ever put together a significant sale of say sixty important lots that would attract international buyers, as Sotheby's and Christie's have consistently been able to do. Neither were they able to create an auction house with specialist departments, relying on the French custom of an independent expert, often a dealer, bringing the business to Drouot. Additionally, as one wandered through Drouot, there was always the sentiment that something immoral

was happening, especially amongst the *Savoyards*, a union of porters who handled all movements of lots in sales. In 2010 the old scams of their trade were finally publicly revealed and they no longer exist.

Everything changed when European regulations of 10 July 2000 forced the French Government to break the monopoly and open up the auctioneering to foreign companies such as Sotheby's and Christie's, allowing us to hold our first auction in Paris on 30 November 2001. Indeed, Sotheby's was the first foreign auction house to sell in France under the new regime. Where once there were seventy auctioneers, that number has since been considerably reduced. Those who were forced to close down received some compensation from the government, while the more forward-looking began to join forces so as to make a stronger impact. However, they do not achieve the level of Sotheby's or Christie's total sales in Paris, although both houses continue to export a very significant amount of property to London and New York.

Jan Krugier

Of all the dealers, Jan Krugier was culturally the one I had the closest affinity to and our long friendship rested on our similar passions and dedication to art. I admired his unique vision, his very sharp eye and the predilection for the kind of artists of the 19th and 20th centuries that included the romanticism of Géricault, Delacroix and Victor Hugo, the classicism of Ingres, Cézanne, Seurat and Picasso and the symbolism of Redon and Ernst. These were the painters, all superb draughtsmen, who formed the basis of his art dealing and personal collecting. They and their work can be seen as a reflection of his anguish; an anguish which I felt strongly defined his very special character. An interview with *Die Welt* in 1999 characterises that quite succinctly when Jan said, 'Collecting is a kind of psychotherapy. That's the way I tried to close Pandora's Box, to reconcile myself with other human beings and to live with the memories haunting me.'

Jan was an elegant figure who, in later years, sported a distinctive mass of white hair, a cigar and a cane. Passionate, irascible, generous, charming and supremely courteous with an impish smile, he was the epitome of a 19th-century Central European gentleman. Born in Poland in 1928, he showed an early passion for art; his father was himself a collector. His mother had died in childbirth when Jan was five years old. After the German invasion of Poland, he joined the Resistance aged only twelve. Eventually he was captured and sent to Auschwitz where

Jan Krugier, 2004
(photograph Jean-François Bonhomme)

he was fortunate enough to be chosen as a messenger with other children. Following the infamous march in January 1945, he ended up in Bergen-Belsen from where he was liberated by the British in April 1945. Later, the Swiss Red Cross recovered Jan from a holding camp at Buchenwald and sent him to Switzerland. There he had the good fortune to fall upon a family friend, Margaret Bleuler, who took him to Zurich and became his adopted mother.

As Jan wanted to be a painter, he was sent to art school in Zurich in 1946. The summer before finishing art school, Miss Bleuler sent him to the Engadine to paint and it was there, at meal times, that he met Alberto Giacommetti who was living nearby in the village of Stampa. In 1950 Jan went to live in Paris, where his friend and mentor Giacometti discovered other talents in him and eventually persuaded him to become an art dealer rather than a painter. After two years in Paris, he married and settled in Geneva in 1953 and soon formed a partnership with Jacques Benador, the son of a local dealer. Together they travelled around Europe, carrying pictures in their little van and creating a successful business. Jan finally opened his own gallery, with financial help from his father-in-law, in Geneva in 1962, showing such painters as Bram van Velde, Giacometti, de Staël, de Chirico and Morandi. Four years later he opened a gallery with Albert Loeb in New York which lasted until Loeb decided to return to Paris in 1972. Many years later Jan returned to New York, to a large space in the Fuller building.

It was while travelling around the United States in 1966, that he met his second wife, Marie-Anne Poniatowski, herself a gifted artist who was having an exhibition of her drawings in Los Angeles. The following year they saw each other again in Paris and subsequently never parted. Together, the Krugiers built an extraordinary collection of superb drawings, among the finest in private hands, that covers all periods of artistic achievement from the 15th to the 20th century. The collection has been exhibited in some of the great museums around Europe, including Berlin, Venice,

Madrid, Paris, and Vienna. Ever the showman, prone to grand gestures, I felt his decision to travel the collection around the world was a justification for his life, leaving a legacy for him to be remembered by.

Always active in the auctions, Jan made many sophisticated purchases, often buying against the current trend. He had a strong sense of what he wanted: fine quality, great provenance and often works of a more obscure, perhaps darker nature, by the painters he loved. He tended to bid quite discreetly and part of the reason for this was in order to prevent his competitors seeing what he was doing. But sometimes he was so circumspect that his bids went unnoticed by the auctioneer and this would enrage him, leading to altercations in the saleroom. I often had to placate him and smooth his ruffled feathers, explaining that it may not have been entirely the auctioneer's fault. Eventually, I arranged to put him in a 'sky box' above our New York saleroom where he could watch the proceedings below while transmitting his bids via the in-house telephone circuit.

The only time Jan met Picasso was in 1947, when a group of young Spaniards who had also been deported to German camps, took him to his studio in Paris. Jan said Picasso was very nice to him, but he never saw him again. The story of Jan Krugier's involvement with the Picasso estate has become part of his achievement and his legend. Marie-Thérèse Walter, the artist's famous mistress in the 1920s and '30s, contacted Jan soon after Picasso's death, as she wished to sell a number of works that Picasso had given her, but was not permitted to sell during his lifetime. Jan agreed to help her and, accordingly, exhibited and successfully sold the group at his gallery in Geneva.

The events then jumped to the period when Picasso's estate was finally settled after years of wrangling and lawsuits; the legitimate and illegitimate heirs were to receive their inheritance in the form of a vast quantity of paintings, drawings, sculpture and prints. During the summer of 1976, the Krugiers were on holiday in Venice, when Marie-Anne, an astrologer, had a premonition and insisted they return to her parent's château in the South of France. Upon arrival, Jan was told that a woman had been leaving messages for him to contact her daughter, Marina Picasso, the painter's legitimate grand-daughter, which he duly did. Marina had in fact attempted to find him in Geneva that summer, only to go to the wrong address as the gallery had recently moved. She was looking for a reliable expert to help her both choose and manage her share of her grandfather's estate and mentioned that she was approaching him on the recommendation of Marie-Thérèse. Naturally, Jan did not hesitate in accepting to be her advisor and a contract was signed by the end of September.

By then her brother Pablito had died and since Marina had received little support from her grandfather during his lifetime, it was agreed by all parties that she should be allowed to make an initial selection before the others received their share. This was, of course, after the State had chosen about a fifth of the value of the estate in lieu of tax for the future Picasso museum.

In about 1978 Jan asked me to come to Geneva to help him make that first choice, as he wanted an independent expert to help him and on the basis that two minds were better than one. We spent several days looking through thousands of archival cards, each attached to a tiny photograph, making our choices based on quality, value and future marketability. We finally decided on a group of Cubist works, of which few were left to the heirs, as the State had taken some of the finest examples. We also chose a magnificent group of works on paper, all based on the theme of the Minotaur, a subject that fascinated Picasso throughout the 1930s, along with a number of early works including an extremely rare 1905 sketchbook full of small watercolours of clowns and circus people. Once Marina had made her initial choice, the heirs proceeded to draw lots for their proportion of the estate.

The next stage of my involvement was to quickly help provide Marina with a sum of money she so desperately needed. Jan and I decided that, to avoid denuding her collection of the better works at that stage, we would put together a group of rare Picasso prints for sale at auction. I had them consigned to Sotheby's in New York in 1982, as we felt the American market was the best at that time for Picasso's prints. Marie-Anne Krugier remembers well the time she and Marc Rosen, head of the Print Department, affixed the Picasso estate stamp to each sheet in order to legalise their release on to the market. This was done because Picasso only signed works he sold during his lifetime, be they paintings, drawings or prints. The successful sale of the 79 prints realised a total of just under $600,000.

For almost thirty years Jan managed Marina's inheritance for her conscientiously, supporting the values of the vast collection and fulfilling the terms of the contract. Before selling any of her works, he made sure he always had her agreement on the price. Starting in 1981, Jan began touring various selections from her collection around the world. Whenever she needed funds, he would carefully select from the immense stock of paintings, drawings, prints and sculpture. This became even more essential after Marina began establishing orphanages for Vietnamese orphans and abandoned children in Thu Duc and Ho Chi Minh City. The whole exercise regarding Marina, and her share of Picasso's estate, was

a fabulous experience and helped create a lasting friendship and much respect for each other.

When visiting Jan at his gallery in Geneva in 1998, I discovered a touching link between him and my grandfather, Jules. Jan showed me a beautiful painting of a reclining nude by Delacroix which he had just acquired; I immediately realised this was a work that had belonged to my grandfather and had been sold in his 1932 sale. We were equally pleased to learn this.

I knew Jan had been quite ill, but was deeply upset when I learned that this old friend of mine had died of a long-standing blood disorder at his home in Geneva on 15 November 2008 at the age of 80. When I called Marie-Anne to offer my condolences, she told me that just a few days earlier he had bought at Sotheby's Impressionist and Modern Art sale in New York, Picasso's *Nus Masculins,* a monochromatic painting of 1942 I had always much admired. Jan had originally acquired the painting from the Marcel Mabille sale, which I had handled in 1986, and had subsequently sold the work to a collector soon after, but he had always wanted to acquire it again one day. Finally his wish came true, some twenty years later and, I thought to myself, what an admirable way to act during the last days of one's life, a true collector to the final moments.

Heinz Berggruen

Another long professional relationship I treasured was with Heinz Berggruen, one of the shrewdest and most sophisticated dealers in Europe since the end of the Second World War. I first met him in 1962 and would often visit him at his modest, discreet-looking gallery on the rue de l'Université in Paris, where we used to sit and chat about paintings, people and the goings-on in our rarefied and sometimes scandalous art world. He had a fine eye and we loved looking together at his recent purchases by some of the great Modern masters. Occasionally, he would give me a few pictures to sell at auction but, in reality, he bought much more in the auctions than he ever sold. He also became a good friend of David Nash and in the 1980s, after giving up his gallery, he preferred consigning property to us in New York as he believed the market was better there. In fact, I felt that the results in London were often as good as those in New York as there has always been a strong European market; however, I suppose, part of the reason was that Heinz was living in an apartment at the Carlyle Hotel in New York for a number of years.

Having fled Germany and moved to America in 1936, he spent the

war in the US navy. Once the war was over and after a spell as a journalist, he decided to settle in Paris, where he became an art dealer. As he was always eager to recount, his first contact with artists was before the war, when he had a brief affair with Frida Kahlo, at the encouragement of her husband Diego Riviera. He opened a small gallery in 1947, specialising in the sale of original lithographs and etchings by Chagall, Matisse, Miró and Picasso. This was soon to be the foundation of a successful business, but he soon began to deal in paintings and drawings as an adjunct to his main bread and butter activities. A man of small stature, Heinz had a warm, friendly nature, with a dry, sometimes wicked sense of humour which particularly appealed to me. Although he spent thirty-five years in France, he never quite integrated into the Paris art community. He was foreign, Jewish and German, without a doubt a sore point to many so soon after the end of the war, but he had an appealing manner that made him successful in buying works from artists, their widows or mistresses. I was once told that in order to secure the purchase of a picture, he would sometimes use the name of his secretary, Mlle de Rothschild, in order to allay the suspicions of a seller who feared Heinz would not be able to pay. He was very proud of the many catalogues he published for his exhibitions, often with lithographic covers by his artists and containing prefaces by highly respected critics and art historians, including his friend Douglas Cooper, with whom he published Douglas's great work, the *catalogue raisonné* of Juan Gris' paintings.

Heinz gave the impression he was always hungry for business, but then so was I, which I suppose was a quality to be applauded. It was not so much to make money, but a deep desire to find and acquire pictures of real quality. Heinz had an acute, stern eye and was a true connoisseur, equally passionate about works on paper as he was for oil paintings, recognising that some of the most beautiful works created by the artists he liked were drawings and watercolours. It is still possible, as it was then, to find masterpieces at much more affordable prices than oil paintings. This was so true of the painters he loved and collected for himself – think of Cézanne watercolours and Seurat's dark *conté* crayon drawings, of Picasso, the ultimate modern draughtsman and Klee, the great colourist with his poetic compositions. The largest part of the collection he formed was devoted to Picasso; namely from the Cubist, Neo-Classical and Dora Maar periods.

Heinz was much liked and admired by collectors from all over the world. One person who acquired a large part of his collection from him was Norman Granz, the well-known jazz promoter and manager of several great singers such as Ella Fitzgerald. He had begun collecting in the 1950s

and had accelerated his activities after meeting Picasso one day on a beach in the South of France. In 1968, as a result of his divorce, Granz found himself forced to sell part of his collection. His friend Heinz advised him to go to Sotheby's where Peter Wilson and I were thrilled, after some tough negotiating, to have the opportunity of selling such a distinguished group of works, mainly Picassos and Klees, where we so clearly recognized Heinz's influence. It wasn't until nearer the time of the sale that we discovered that Heinz had slipped several of his own paintings into the sale, including

Heinz Berggruen in his gallery, rue de l'Université, 1965 (photograph bpk Manfred Tischer)

Ma Jolie, a late Cubist painting by Picasso. Although it seemed that Heinz had purchased it back for himself, he had in fact bought it for Granz at the auction. It remained in Granz's collection until it was sold by Sotheby's in New York in 1995, along with five others, all by Picasso, bar one important Cubist Léger. Such were Granz's excessive demands for high reserve prices, that *Ma Jolie* was the only one to find a buyer.

As his collection grew from the 1980s onwards, especially after closing his gallery, Heinz began thinking what to do with it as he certainly never owned a house large enough to hang all the works and he did not want to 'warehouse' it as so many collectors of Contemporary Art now so regrettably do. The first step he took was to make a magnificent gift of ninety Klees to the Metropolitan Museum in 1987. However, they were never properly displayed and appreciated as he would wish, which really upset him, so he turned to Europe and began to think that Switzerland might be an appropriate place to show the collection as he and his wife, Bettina, had apartments in Geneva and Gstaad. He was offered an exhibition at the Musée d'Art et d'Histoire in Geneva in 1988, but the resulting minimal public attendance and enthusiasm was disappointing, perhaps because the *Genevois* are not as sensitive to art as the Swiss Germans in Zurich and Basel.

Two years earlier, Heinz's son Olivier, had joined my department as a cataloguer of drawings, while at the same time he had become friends

with John Leighton, then Curator of 19th-century Paintings at the National Gallery in London. He felt the Gallery could be interested in exhibiting his father's collection, which indeed it was. Heinz was approached by the Director, Neil MacGregor and the Chairman of the Trustees, my old friend, Lord (Jacob) Rothschild. Before long, a five-year loan was agreed, and in 1991 the pictures went on public view, beautifully hung in rooms next to the Impressionist Galleries. Heinz was delighted by the response of the London art world and the public who came in their hundreds of thousands to enjoy it. At the end of the term, the Gallery was keen to purchase Seurat's exquisite, luminous painting, *Le Port de Gravelines,* a masterpiece of Pointillism, which Heinz had bought from the heirs of Samuel Courtauld. I was asked by John Leighton and Heinz to come up with a value and proposed a suitable figure would be $25 million, considering how few important compositions Seurat had painted in his short life, the great majority now all in museums. This figure was accepted, and, in appreciation, Heinz made a gift to the National Gallery of seven sketches by Seurat, all little oils painted on cigar box lids. On the subject of Seurat, one of the great masterpieces of Post-Impressionist painting, his staggeringly beautiful smaller version of his famous painting, *Les Poseuses,* (Barnes collection, Merion, Pennsylvania), appeared in a Christie's sale in 1970. I felt it fetched a disappointing price of £433,000 and was delighted to learn a year later that Heinz was able to buy it from Artemis, the Art Fund (of which he was a Director) who had acquired the painting at the auction. Disappointingly, he sold it in the 1990s, along with all his remaining Seurat drawings, a decision tied to funding the establishment of his museum in Berlin, and it is now in one of the finest private collections on the West Coast of America.

Heinz Berggruen was born and spent the first eighteen years of his life in Berlin. After a period of sixty years he returned, lured back by Professor Dube, Director General of the Berlin Museums, who had attended the National Gallery opening in London. He told Heinz that he was very keen to show the collection in Berlin and offered to exhibit it on a more permanent basis in the Stulerbrauten, one of a pair of neo-classical buildings opposite the Charlottenburg Palace, which until then had housed Berlin's antiquity collections. Heinz was delighted with the proposition and in 1996 the new museum, *Die Sammlung Berggruen,* was opened to the public. Andrew and I, along with his many friends and colleagues, were invited to the grand opening; we loved the classical proportions of the building and the intimacy of the relatively small rooms, which were perfectly suited to this very personal collection that consisted of so many smaller works.

The museum has a very special, homogenous feel to it, concentrating as it does on Heinz's dedicated passion for Picasso, Braque, Matisse, Klee and Giacometti. With regard to the Picasso holdings, no other museum, aside from the Picasso Museums in Paris, in Malaga and the Ludwig Museum in Cologne, has such a wide range of paintings, drawings, watercolours, prints and sculpture, running from the Blue Period, on to the Cubist, Neo-Classical and Dora Maar periods right up to one of the painter's last works executed in 1971. The pastel, *Nu Assis s'Essuyant le Pied*, bought in our 1979 Paul Rosenberg sale, was one of the Picassos I have most cherished of the thousands that have passed through my hands. It meant a lot to me that Heinz was the buyer and that it has remained as one of the key works in his now famous Berlin museum. Heinz wrote in his memoirs *Highways and Byways* that, at the Rosenberg auction: 'I took the opportunity to acquire some of my most beautiful Picassos. I am thinking, above all, of the pastel of 1921, from his monumental Neo-Classical period, portraying a woman seated drying her feet. Classicism reached its zenith in this which has evolved from the European tradition of painting, and whose sensuality reminds me of certain portraits of women by Goya and Ingres.' Eventually Berlin acquired a majority of the collection for a modest sum, a symbol of Heinz's generosity to the city of his birth.

In 2001, astonishingly, he sold seven works from the collection which had been on exhibition in the museum. I can only presume this opportunity may have been so financially appealing to Heinz that it enabled him to make future provisions for his family. His old friend, Simon de Pury, head of a re-vamped Phillips auction house in New York, which at the time was owned by Bernard Arnault, majority shareholder of the retail giant, LVMH, had offered him an enormous guarantee, hoping this could really establish Phillips' arrival on the international auction scene. Not surprisingly, the sale in May of that year was a financial disaster; the values had been so inflated that there were few interested buyers. Although several works by Cézanne and a drawing by van Gogh did sell, it was at a considerable loss to Phillips and Arnault. In fact Bernard Arnault has kept the best of the unsold works for himself. The most expensive of the failures was van Gogh's *Jardin Public, Arles*. Although an important painting in its size, date and subject matter, I considered it lacked the magic of his greatest works, but I could understand why Heinz had originally wanted to own a significant Post-Impressionist painting and why, later, it did not satisfy him sufficiently to give it a permanent place in the museum. He must have come away very satisfied that he had negotiated and received such an amazing

sum of money by way of a guarantee. It just showed the old fox still had many tricks up his sleeve!

In the last years of his long life, he continued buying avidly for the collection, for example, adding *Nu Jaune*, a magnificent study for *Les Demoiselles d'Avignon*, which he bought in 2005 at Sotheby's, New York, for $12 million, a record price for a Picasso work on paper. It was sold by Walter Buhl Ford II, who had acquired it forty years earlier, three months after it had appeared in the famous André Lefevre sale in Paris in 1964. Heinz had been very active in those sales and I can only assume he was outbid on it, but he waited patiently all those years before finally getting it for himself. With his sharply honed eye for quality, he never lost that burning collecting fever and a boldness to pay high prices for the ultimate work if he had to.

There have been long-lasting links between the Strausses and the Bergguens. I remember fondly the day Heinz and I bumped into each other at Geneva airport. It was 1969 and I was telling him about my joy at the recent birth of my daughter, Julia on 23 April, Shakespeare's birthday, and the coincidence of my son Andrew, being born on Michelangelo's birthday, 6 March. The next time I saw Heinz was at our usual late June sale in London. To my astonishment, he handed me a package, which contained two etchings by Dali, one portraying Shakespeare and the other Michelangelo. And then, in 1987, a year after Olivier joined my department, Andrew arrived in Paris and soon developed an excellent friendship with Heinz, as he has with Olivier, and now sits on the Berggruen Friends of the Board in Berlin.

Coincidentally, one of the first projects undertaken by Heinz when he arrived in Paris was to publish Hans Bellmer's 1949 edition of *Les Jeux de la Poupée*, an album containing original, hand-coloured photographs. A small number of these books have since been broken up and the photographs sold individually; in fact two of them have been bought by Andrew and another couple by my wife, Sally, who was quite bowled over when she first saw one at the Basel Art Fair in 2005. Recently Andrew told me a lovely story about Heinz's final purchase which was of a small group of fine drawings by Bellmer: it seems there is no coincidence that Heinz and Bellmer, both of whom were born in Berlin and lived in France, shared the same initials HB, and Heinz's first art publishing was *Jeux de la Poupeée* and his last purchase was not a Picasso but a Bellmer.

Heinz died in 2007 at the age of ninety-three, survived by his wife, Bettina; fortunately, his children are continuing the spirit of the museum, adding important works with plans to expand exhibition space into a former army barracks attached to the main museum building in

Charlottenburg. Now that Jan Krugier and Heinz Berggruen have both gone, I feel a strong sense of loss for these friends, who both had the kind of connoisseurship, knowledge and belief in their passions that one rarely finds today.

The Nahmad Family

For more than forty years, the Nahmad family, Jewish merchants emanating from the Middle East, have had the greatest influence on Impressionist and Modern Art auctions in London, New York and Paris. Heirs to a Syrian banking fortune, Giuseppe (Jo), the elder brother and head of the family, and his two brothers David and Ezra, have been dealing in art (and in currencies which have often fuelled their buying sprees), since the early 1960s. Arriving in Italy from Beirut in the 1950s, their first venture into the art world was to open a gallery, the Galleria Internazionale, in Milan. Since then, having closed the Milanese enterprise, they operate from galleries in New York and London, where they have much more business freedom than in Italy, where regulations governing the import and export of works of art continue to be restrictive.

However, the majority of their activities take place in the salerooms across the globe. They are great believers in buying most of their stock at auction, largely from Sotheby's and Christie's, as it's only there that they can quickly acquire such large quantities of work without having to source much property from private collections and the trade itself. They have built up a stock consisting of thousands of pictures which are mainly stored in their concrete, bunker-like warehouse at the Geneva Freeport.

Jo, the elder of the three brothers, now lives a reclusive life in Monte Carlo and Paris. He has a prodigious memory for everything he and his brothers have bought since the 1960s, keeping thick wads of notes in his pockets which record the prices of all his transactions in multiple currencies, whether dollars, sterling, euros, francs or yen. Although we knew, on the whole, what they were buying, we had little knowledge of where or to whom they were selling, although they did a huge amount of business with the Japanese in the 1980s, with some American clients through their Madison Avenue gallery and, closer to home, with friends and business associates across Europe.

The two other brothers, David and Ezra, have always deferred to Jo. David, a slim, nervously gregarious man, is a risk taker, a backgammon champion who has won and lost millions in the casinos. He is seen everywhere, gossiping, always seeking one's opinion on a painting for its

quality and commerciality, often critical, but with a sensitive nature and precise taste. Ezra, a gentle and likeable man, is much quieter and less involved in the trading, focusing on treasury and accounting for the family. Jo never married. Ezra's son, named Helly, after his grandfather, runs their London gallery, and is the only one in the family who has a passion for Contemporary Art. In fact, some years ago, he made a killing by buying a large group of Damien Hirsts, selling for a considerable profit. David's son, also called Helly, has an astute financial brain and runs the family's Madison Avenue Gallery, ably assisted by the gallery's manager, Marzina Marzetti (who happens to be the god-mother of my grand-daughter Victoria). But on the whole, the Nahmads don't like buying very contemporary art, as they consider it too risky and an uncontrolled market. Their two galleries, each run by the Hellys, have in recent years shown stunning exhibitions, accompanied by lavish catalogues, of Monet, Picasso, Modigliani, Kandinsky, Léger, Miró and Ernst, mostly from their own very considerable stock.

At every auction fathers and sons can be seen, accompanied by their wives and one or two hangers-on, occupying six or eight front-row seats, right under the gaze of the auctioneer, to whom they discreetly signal their bids while, at the same time, looking around to see who dares bid against them. One of them, usually David, is on the phone to his brother Jo, bidding on any number of lots which they feel are worth trying to buy, hopefully in a price range near the low estimate. However, they are also known to bid quite aggressively for a particularly important work they might really desire.

Their buying pattern ranges from the most commercial, bread and butter paintings by artists of the School of Paris (Utrillo, Vlaminck, Foujita, Soutine) or 20th-century Italians such as De Chirico, Morandi and Fontana, while at the same time successfully bidding on some of the finest pictures on the market, whether by Monet, Picasso or Modigliani, and holding on to them until the market is just right to produce a substantial profit. Take, for example, Monet's *Pont du Chemin de Fer à Argenteuil,* one of the most beautiful works by Monet that has passed through my hands twice, for which they paid £6.2 million in 1988 and sold twenty years later for $37 million or Picasso's *Femme accroupie au Costume turc,* modelled by his wife, Jacqueline, acquired for $2.6 million in 1995 and resold for ten times as much in 2007.

Throughout the successive decades, in good times or bad, during the several recessions I have endured, the Nahmads could be relied upon to be continually active in the sales, and what I admire them for is that in those difficult years, they were the ones who kept on buying and

Claude Monet, *Pont du Chemin de Fer à Argenteuil*, oil on canvas 1873, private collection, from the Cargill, Barlow and Nahmad collections

supporting the market. However, they were never that easy to deal with. They had a distinct middle-eastern attitude to business and had a real aversion to paying on the due date, dragging out payments, often for months. This was such a regular feature that the auction houses had to resort to selling paintings from their stock to help pay for the previous sale's purchases. I can still envisage with a shiver the never-ending, tortuous process of standing for hours on the cold concrete floors of their Geneva warehouse in the middle of winter, flipping through stacks of pictures trying to pick a few works I felt had a chance of selling at their prices. They were quite accommodating as to what we chose, but then agreeing estimates and reserves was quite another matter. In spite of all this, the support they gave the market was invaluable and the paintings we took from them often helped pad out the sales when not much property was being offered during the recessions of the 1970s, '80s, and '90s and presumably now at the end of the first decade of the 21st century. There is no question that there isn't any dealer in the post-war years who has transformed the auction business more than the Nahmad family.

The Paul Rosenberg Sale

Only once have I had the pleasure of selling a collection formed by one of the legendary dealers of the first half of the 20th century. It was in March 1979 that I received one of those calls from David Nash asking me to be in New York the next day to see a collection which the owners wanted sold in London. Taking the last flight of the day from Heathrow, David and I turned up the next morning at the Rosenberg Gallery on 79th Street, where we were met by Alexandre Rosenberg and his wife, Elaine. He told us that he and his sister in Paris had decided to sell an important part of the family holdings of paintings and drawings by artists the gallery had represented between the two world wars.

Paul Rosenberg's father, who had founded the gallery in Paris in 1878, had started experimenting with contemporary artists such as Degas, Monet, Pissarro and Cézanne. Paul Rosenberg opened his first gallery in London, which was then followed by his Paris gallery in 1905; following the German invasion of Paris in 1940, he moved to New York.

The painters in the sale, apart from Matisse, had all been under contract to Paul Rosenberg. Picasso, his principal artist, in fact lived in a grand apartment next door to the gallery on rue la Boëtie between the two wars, and was heavily represented in the auction along with Braque, Léger, Laurencin and one painting by Matisse. David and I spent an exciting morning looking at all the works and agreement was quickly reached once we had discussed the estimates and the terms of the sale with Alexandre Rosenberg.

The sale of Modern Pictures from the Rosenberg Family Collection took place early in July 1979, the sixty-two lot catalogue consisted largely of thirty-four works by Picasso, covering the period from 1918 to 1939 when Paul Rosenberg had Picasso under contract. Included was a superb drawing of *Pierrot* from 1918, followed by a magnificent series of post-Cubist paintings, culminating in his 1925 masterpiece, *La Bouteille de Vin,* which was bought for £460,000 by Ernst Beyeler of Basel. This large painting brought together a guitar, a bottle of wine, a glass and apples on a kitchen table, painted, I feel, as a homage to the still lifes of Cézanne. Personally, what most delighted and moved me in the sale was a series of works from his Neo-Classical period of the 1920s and '30s. The finest examples, which I would have loved to own, were a pastel, *Nu Assis s'Essuyant le Pied* of 1921, and a gouache, *Le Sculpteur et sa Statue* of 1933, both bought respectively for £280,000 and £152,000 by Heinz Berggruen and now in his Museum. The other well-represented painters were Braque and Laurencin who sold well; the Laurencins mainly

Paul Rosenberg's Picasso,
Nu Assis s'Essuyant le Pied,
pastel 1921,
Berggruen Museum, Berlin

bought by the Japanese who loved her pretty paintings of young women done in shades of pale pink and blue.

The sale was a resounding success and all lots sold, bar two, for a total of £3,278,000, a significant amount for an auction thirty years ago. Of the two that did not sell, both were sold immediately the auction was over: a tiny Cubist Picasso was taken by Jan Krugier while the Laurencin was snapped up by Jo Nahmad, who has always specialised in coming up to the auctioneer at the end of a sale to try and cheaply mop up any unsold lots.

The Collectors

The most excitingly anticipated journeys were those to the great collectors and their collections. Not only did I enjoy discovering paintings unknown to me or admiring masterpieces in private houses, but what was particularly thrilling from a business point of view was to learn that part or whole of the collection was to be disposed of. Traditionally we had used the term 'the three Ds' as the principal reason behind the need for sales: death, divorce and debt, and then a fourth D was added to the list: de-accessioning, whereby a museum or an institution sells works superfluous to their collection in order to finance new acquisitions or building extensions such as the Museum of Modern Art and the Guggenheim have done in New York.

I loved discovering how a collector had developed his taste and his eye, how he had acquired his collection, what were his special likes and dislikes, why he had chosen certain works by a painter and not others, what were the buying opportunities in his day, for example in the years after the Second World War, or was he constrained by the limited availability of great paintings in more recent times? I have found it fascinating that so many collectors since the 19th century have been Jewish, either European or American, and this applies to dealers as well. Perhaps it's because I too am Jewish that I have found it so comfortable dealing with them; we share the same traditions and culture, and a deep sensitivity towards the arts.

The next stage was to value the pictures and discuss them with an owner who might be happy with the figures, while another might have his own exaggerated ideas, in which case I would have to try and persuade that person that what I had quoted reflected the current state of the market.

Once agreement had finally been reached, negotiations regarding the commission rates and expenses we would charge would follow. As the years went by, these were increasingly waived in the face of the competition vis-à-vis Christie's or other auction houses, or even a major international dealer who had the wherewithal to handle a large, valuable collection. On the other hand, if we could not agree on the estimates, a vendor might approach another auction house hoping it would accept his conditions. In that case it would be particularly galling when the picture actually found a buyer. Winning over the collector or the estate and having the collection consigned for sale led to great satisfaction and relief. These were the highlights of any year, and they certainly did not occur every year, but the early 1960s and the later '70s were rich in successive collections, as was the latter part of the 1980s in London. In the United States it was even more evident, where inheritance taxes were high and tax evasion was out of the question, contrary to habits in certain other countries where non-declaration of cultural assets was prevalent.

France, to a certain extent, continues with America to be the prime source of material for sale at auction, particularly for Impressionist and Modern works. Many of the collections that had been formed in France, remained with the family of the original collector and passed down the generations, on occasion resting quietly in the same family's dusty drawing room or bank vault for over a hundred years. Even now, in the 21st century, forgotten collections containing masterpieces of the late 19th and early 20th centuries can surface from the depths of a deep Swiss bank vault or very private apartments in the more affluent arrondissements of Paris. Although these are rare events, a cycle of replenishment, in the form of massive collections of Post-War and Contemporary Art, has finally gathered some pace in France, principally in the hands of François Pinault, the owner of Christie's, followed less assiduously by his arch-business rival, Bernard Arnault, who has commissioned the architect Frank Gehry to design a museum for his retail empire, LVMH.

Collecting in such bulk, searching out new artists from all over the world, is a highly conspicuous factor of our times, collecting not just for personal enjoyment, but buying on a massive scale with the ultimate goal of creating one's own museum. Those who have done so most successfully in the past hundred years include Dr Albert Barnes in Philadelphia who created the greatest private museum of Post-Impressionist and early 20th-century painting, to Solomon R. Guggenheim in New York, followed after the Second World War by the ambition and vision of such collectors as Peter Ludwig in Germany, Giuseppe Panza in Italy, Charles Saatchi in London, and in America among such passionate, driven men as Joseph

Hirschorn in Washington DC, Paul Getty in Los Angeles and Norton Simon in Pasadena, all of whom built or had museums named after them.

Although there were many avid and astute collectors in France in the late 19th century (e.g. Caillebotte, Rouart, Camondo and Jules Strauss), Paul Durand-Ruel, the Impressionists' principal dealer and champion, decided he would introduce Impressionist paintings to the Americans in 1886. He was very well received, particularly in New York, Boston and Chicago where collectors such as Martin Ryerson, Potter Palmer and the Havemeyers began buying some of the finest works in significant numbers from his 5th Avenue gallery with courage and perspicacity. The Havemeyers were the greatest collectors of all, acquiring works of art from about 1880 until Louisine Havemeyer's death in 1929, leaving the greater part of the collection to the Metropolitan Museum. And it was part of this collection which so inspired my love for paintings when I was first taken to see them at the age of six in 1942. It's that link with the Impressionists, via my grandfather's early collecting and the impact of the Havemeyer pictures, that has always made me feel spiritually and physically close to the Impressionist movement.

A little known fact is that the British were amongst the first outside France to show interest in collecting Impressionist paintings. One of the earliest collectors was Henry Hill who lived in Brighton and who bought some of the finest of Degas' early work, including the famous *L'Absinthe*, which he purchased in 1876, only a few months after it was finished. Henry Hill was to keep the paintings until his death in 1892. Depicting a couple sitting forlornly in a Paris café, *L'Absinthe* is now in the Musée d'Orsay. Ever since I was a child and first saw it reproduced in a book, this painting has remained a work for which I have a singular passion; I am fascinated by the power and invention of Degas' compositions, by the intensity of emotions he is able to impart, and if I were able to own two paintings by Degas, they would be that particular one and *La Place de la Concorde,* the painting I had held in my arms in the State Hermitage Museum in 1993.

Although the British were early collectors of Impressionism, few of them kept their paintings for long and it was only after the First World War that really serious collecting began. The greatest collector was undoubtedly Samuel Courtauld, who had made a fortune in the textile industry manufacturing artificial silk, and using the profits to acquire some of the finest Impressionist and Post-Impressionist paintings available on the market at that time. Although he made superb gifts to the National Gallery, most of his collection was housed at Home House in Portman Square, that magnificent Adam building where he lived and which became the home of the Courtauld Institute of Art in 1932 until it eventually relocated to

Somerset House. It is surprising to think that when Margery came to England from Melbourne in 1956 in order to study there, paintings by Cézanne hung on the walls of the students' tea room, and although bits of buns sometimes flew around the room at tea time, these masterpieces suffered no ill effects.

William A. Cargill

Few events over the decades can match the excitement I felt when the Cargill collection appeared at Sotheby's 'Arrivals' department in the winter of 1963. The story of this collection originates in Paris with Alexander Reid, a Scot, who lived in Paris from 1886 to 1889 while working with Vincent van Gogh's brother, Theo, at the Galerie Boussod & Valadon. Alexander Reid lodged with the brothers for six months and Vincent, who looked remarkably like Reid, sketched and painted him on several occasions (one of these portraits now hangs in the Kelvingrove Art Gallery and Museum in Glasgow). Returning to Glasgow, Reid opened his own gallery and became the catalyst for introducing the work of the French Impressionists to Scottish collectors in the first half of the 20th century. He was an important source for one particular major Scottish collector, William Cargill.

The son of David S. Cargill, founder of the Burmah Oil Company, William Cargill lived with his mother in a large house in Carruth, Bridge of Weir, outside Glasgow. He and his half-brother David were part of a group of great Scottish collectors who, from the end of the 19th century, had been buying some wonderful Impressionist pictures. David Cargill's own collection was dispersed before and during the Second World War and his paintings are now to be found all over the world, although some can still be seen in the Kelvingrove Art Gallery.

William Cargill began by collecting 19th-century Dutch paintings and then, in the 1920s, he started buying French paintings, in particular a series of works by Henri Fantin-Latour and Camille Corot. With the help of Alexander Reid, his interest developed further and led to him buying impressive examples by Degas, Renoir, Monet and van Gogh. After 1926, when Reid joined forces with the Lefevre Gallery in London, William Cargill made several trips to what had become the Alex Reid & Lefevre Gallery, making many important purchases there. There is an irresistible story that his purchase of Toulouse-Lautrec's *Scène de Ballet* led to the resignation of his housekeeper – she refused to live in the same house as dancing girls!

Following his mother's death, William Cargill became a recluse and, as a consequence, his collection remained the least known in Scotland. He died in November 1962 and in the late winter of the following year, Tom Honeyman, director of the Kelvingrove Art Gallery, who was in charge of his estate, informed his friend John Rickett at Sotheby's that he was consigning the collection to us for sale. David Nash was sent up to Scotland with two van drivers to collect the pictures from Cargill's Carruth home, and there he found them, in their original crates, mostly stored underneath beds and tables: Cargill, having seen the works once in the galleries where he purchased them, presumably decided it was enough for him just to know that he owned them. David told me that as he took down one of the few paintings that were hanging on the wall, the wire snapped, rusted through in the damp Scottish house – fortunately, he caught it before it crashed to the floor. Cargill had built a tremendous collection and still, forty-seven years later, it is one of the finest I have handled.

The sale took place on 11 June 1963 in London and raised £1,280,000, way above our or anybody else's expectations. Among the highlights, and one of my favourites, was a Degas pastel, *Danseuse Basculante,* whose first owner had been the sister-in-law of the painter, Walter Sickert. It was bought by Norton Simon from Los Angeles for a huge £105,000. Eight years later he resold it with us in New York for the dollar equivalent at the time of £220,000, when it was acquired by Heini Thyssen (now in his eponymous Madrid Museum). Its reserve price was £25,000, but it was customary then, and is often still the case, that the estimates and reserve prices in estate sales are pitched modestly as a way of tempting buyers to hope they might find a bargain, although in these situations what happens is so

Edgar Degas, *Danseuse Basculante*, pastel *circa* 1879, Thyssen-Bornemisza Museum, Madrid formerly Cargill and Norton Simon sales

often the opposite. The *Danseuse* was notable for the brilliance of its colour, an immediacy, a shimmering quality that can only be achieved by the use of dry, coloured layers of chalks that are the ingredients of a pastel and was executed in 1879, during a period when Degas produced many of his finest ballet scenes. The next lot was a much larger oil titled *Répétition sur la Scène: Cinq Danseuses*, which was painted a few years later, but fetched only £55,000, half the price of the pastel. To me it confirmed what many of us have always thought, that Degas was more successful working with pastel and gouache rather than oil paints.

From Arthur Tooth & Sons, William Cargill had acquired my other great favourite in the sale: a fabulous painting by Claude Monet, *Le Pont du Chemin de Fer à Argenteuil*, which was bought by Mr and Mrs Sydney Barlow from Los Angeles for £77,000. Quite a large picture for Monet at that period (1874–5), it represents boats sailing on the blue waters of the Seine, crossed by a white railway bridge, a train chugging over it, belching white and pale blue smoke. So evocative of those early Impressionist years, it has all the feeling and atmosphere of a bright summer day in the Ile de France. Another special reason why I am fascinated by this Monet, is its links to some aspects of my background: the painting had belonged both to Alphonse Morhange, who was a great friend of my Strauss grandparents, and to Maurice Barret-Decap, the first husband of Mme Kahn-Sriber (the old friend of my father whose sale I had organised in 1975). It reappeared in the Barlows' own sale of eighteen paintings with us in April 1979 when it was purchased by Stavros Niarchos for £420,000. He decided to sell it at an auction in London in 1988 when the Nahmads acquired it for £6.2 million. Twenty years later, in May 2008, the Nahmads sold it for $37 million, a perfect example of how a great painting can show huge appreciation in value over a period of forty years.

Another masterpiece by Monet I loved was *Bateaux de Plaisance à Argenteuil*, painted a year later in 1874. This ravishing study of sailing boats moored on the Seine, depicted in brilliant sunshine, had been acquired by my great aunt, Valentine Esmond, in 1928. It was eventually inherited by her daughter Diane Wallis (one of the cousins who had met me off the boat in New York on that traumatic day in 1941), herself an accomplished painter. She parted with it in the late 1970s, but to my chagrin and disappointment sold it to a Swiss dealer for less than I thought it was worth. Fortunately, as these things happen, it did finally come my way as the buyer kept it for only a few years before consigning it to us in New York in 1981. Bought by a German dealer in Cologne for a client, I have yet to see it resurface.

Claude Monet is for me the quintessential Impressionist painter. He

created and developed a way of painting that rendered the light, colour and atmosphere of nature. The early experimentations of the late 1860s culminated some thirty years later in his paintings of the Waterlily pond at Giverny. Monet's singular vision continues into the 21ˢᵗ century to influence and inspire the way painters interpret landscape.

Other pictures in that fabulous sale included Camille Pissarro's *Pont de Charing Cross, Londres,* one of his rare London pictures and the only one I know of that he painted in 1890, the year he was experimenting with the scientific principles of Pointillism, that optical style of painting originated by his friend Georges Seurat. Quadrupling its reserve of £12,000, it was bought by Paul Mellon, who also had the perspicacity to buy Gauguin's *La Ronde des Trois Bretonnes,* one of the painter's loveliest and most delightful works from his years in Pont-Aven. Painted in Brittany in the summer of 1888 it shows three Breton girls in their traditional costume, dancing in a wheat field. It fetched £75,000 and, along with the Pissarro, was one of the many gifts Mellon gave to the National Gallery in Washington. He also acquired three of the prettiest Renoirs in the sale, each one a tribute to his great eye.

The last picture I should mention is Vincent van Gogh's *Moulin à Montmartre,* painted in Paris in the spring of 1887. It had previously belonged to my aunt Françoise Sorbac (my father's sister) and her husband Roger, but unfortunately, rather like my grandfather, they had to sell their collection in March 1931 during the Depression, shortly before my grandfather's own sale. At the Cargill auction, the painting was bought by Knud Abildgaard, a distinguished Danish collector and head of LEO, a large Danish pharmaceutical company that had been the first to produce penicillin outside the UK and the USA. He lived in a beautiful house on the shores of the Baltic, north of Copenhagen, but distressingly a fire destroyed the house in 1967, including the van Gogh and so another link with my grandfather disappeared, consumed by the flames.

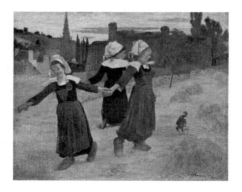

Paul Gauguin,
La Ronde des Trois Bretonnes,
oil on canvas 1888,
National Gallery, Washington DC

Dr A. Roudinesco

Dr Alexandre Roudinesco, an elderly doctor of Romanian origin living in Paris, was a well-known collector who had decided to sell his large collection of School of Paris paintings. It consisted of a group of fine paintings by Van Dongen, Utrillo, Chagall, Dufy, Vlaminck, Marquet and a group of late Signacs. He had acquired them between the two world wars, mainly from the artists themselves, when they were still relatively inexpensive. I had already been to his apartment to catalogue and estimate the collection with David Nash's invaluable assistance, and PCW had been to see him to negotiate the terms of a sale scheduled for October 1968 in New York. Dr Roudinesco was relatively happy with the estimates we gave him and now the time had come to get him to sign the contract. We had made an appointment to visit him on 21 May 1968, which happened to be the worst day of the famous student riots.

France was completely shut down. There was a general strike with no public transport of any kind, and all scheduled flights were cancelled in and out of France. Peter Wilson, being of an adventurous nature and extremely determined, was not about to abandon getting to Paris that day, so he decided to charter a two-seater Piper Aztec which was owned by the Duke of Richmond and Gordon. Soon after we took off from the airfield at Goodwood, we received a message that Orly and Le Bourget airports were totally shut down and that the air traffic controllers had joined the strike. PCW persuaded the pilot, John Gibbons, to continue the flight across to France and to see if we could land at Le Bourget. The skies of northern France were empty. On our approach to Le Bourget, John Gibbons could see that the control tower was empty, the runway deserted and so we landed, undisturbed. Valentine Abdy, forewarned of our possible arrival and in a spirit of optimism, was there to meet us. He drove us into Paris without too much difficulty, as most of the riots were on the Left Bank and, fortunately, Dr Roudinesco lived in the *17ème* arrondissement, on the right bank, well away from any disturbances. The Doctor and his lawyer were so flabbergasted at our appearance, albeit fifteen minutes late, for which we apologised, that within five minutes they happily signed the contract. We then all proceeded to have a good lunch at a nearby restaurant and set off back to Le Bourget. Our pilot had been told we could take off at our own risk, and so we did, arriving back in London with the signed contract later that afternoon. The next day, the story of our adventures made the front page of *The Times* under the heading 'Sotheby's Wins Through', although the report was partly inaccurate as it said we flew back with a Picasso; totally improbable as that would

Dr Roudinesco's Dufy,
Les Trois Ombrelles,
oil on canvas 1906,
private collection

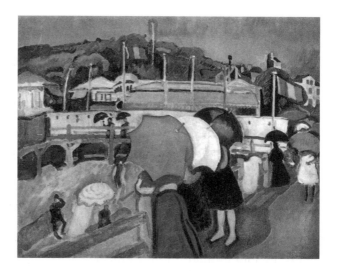

have been tantamount to smuggling a painting out of France.

We agreed to the owner's demand that we sell his collection in New York as there was a better market there at that time for works by the painters of the School of Paris. The seventy-lot sale in October 1968 was very successful from everybody's point of view, realising many excellent prices, in particular for Paul Signac's *Pont des Arts* of 1925 which realised $125,000, while the star piece of the sale, Raoul Dufy's *Les Trois Ombrelles,* one of the finest paintings of his Fauve period, made the same price. These results may seem minimal to us now, but in 1968 they represented an amazing success. Of the thirteen artists represented, nine achieved record prices and the sale made a remarkable total of $2,783,000. Dr Roudinesco, however, was only moderately satisfied, being one of those typical French collectors of the time for whom the prices realised are never enough and whose greed often surpasses reality, or as my mother used to remind me, 'Your eyes are bigger than your stomach.'

Norton Simon

The next significant event concerned Norton Simon, who had bought Degas' *Danseuse Basculante* in 1963. Born in Portland, Oregon in 1907, he enrolled to study law at the University of California, but soon dropped out to found a sheet metal distribution company. This venture enabled him to invest $7,000 in a near-bankrupt orange juice bottling plant in 1927, which in turn led to the foundation of the highly prosperous Hunt Foods, a household name in America. Norton Simon Inc, his holding company,

included McCall's Publishing, Canada Dry, Max Factor cosmetics and Avis Car Rental. From the 1950s on, Norton Simon began forming what was to become a quite superb collection of Old Master, Impressionist and early 20th-century paintings. In 1969 he decided to retire and devote his time to collecting art, extending his interests the following year to include Indian and South-East Asian art. Since his collection had become too large, he began selling a group of Impressionist paintings, drawings and sculpture in 1971.

As soon as PCW was contacted by Simon, David Nash immediately telephoned me in London to say that we had to be in a Los Angeles warehouse at 6 pm the next day to value the works. I flew to LA the next morning and, after an eleven-hour flight, was taken direct to the warehouse, where we examined all the property and made our estimates. I stayed on for one more day to visit the Los Angeles County Museum of Art and to devise the sales strategy we were going to present to him, and then had to fly straight back to London. That was a thrilling visit and over the years several more sudden, long-distance flights to negotiate special sales took place, notably for the Paul Rosenberg collection in 1979, the Havemeyer and Florence Gould sales in 1983 and 1984 and the Kameyama adventure in Tokyo in 1990: such short bursts of travel to see great pictures played a special role in my career, including a recent twenty-four hour return trip to Manhattan to view and appraise damage suffered to Picasso's 1932 painting, *Le Rêve*, after its owner, Steve Wynn, inadvertently put his elbow through the canvas in an excited moment when showing the work to friends. Steve Wynn, owner of the Mirage Casino in Las Vegas, and famous for the quality of the collections he has amassed and publicly exhibited, had just negotiated to sell *Le Rêve* to another collector for what would have been the highest price ever paid for a work of art. As a result of the incident the sale was cancelled.

From the early days I was always eager to meet collectors and develop loyal relationships with them. Some of them, fortunately, were keen to seek my advice, but some not. Some liked to get one's opinion and then do the exact opposite, or ask everybody and do nothing. A classic case was Norton Simon, who was at times a difficult and very complex man to deal with. He could go back on his word, as some dealers experienced, reneging on done deals, or indulge in complicated bidding arrangements with the auction houses. A notorious example of failing to observe one's own specific instructions happened the day Rembrandt's portrait of his son Titus came up for sale at Christie's in London in March 1967. Norton Simon decided to bid himself while demanding absolute secrecy. His instructions were that as long as he was sitting down, he was

bidding; if he stood up he was not. If he sat down again he would not be bidding unless he raised a finger. But when it came to the sale he broke his own rules and bid out loud, then stopped. In the confusion, the auctioneer knocked the Rembrandt down to the Marlborough Fine Art gallery in London. Simon stood up, furiously exclaiming that by not bidding he was actually bidding and forced a very reluctant Christie's to reopen the bidding. He made one more bid, Marlborough declined, and Titus was sold to him for 798,000 guineas (£828,450). Marlborough, and their presumed client, must have been furious, both with Simon and especially with Christie's. This was proof of the power he had over the market, but it is unlikely that such bidding practices would be accepted today, and certainly the auctioneer would not re-open the bidding once the hammer had come down. Now, behind the scene negotiations would take place between the disputing bidders until a satisfactory conclusion was reached, or not.

Between 1971 and 1974 we held three separate sales for Norton Simon. The first, following our trip to Los Angeles, took place in New York in May 1971 and consisted of seventy-four lots which realised a total of $6.5 million, a very considerable total then. The sale had several memorable aspects, the most significant being eight of the finest works by Edgar Degas. Cargill's *Danseuse Basculante*, which Simon had bought for £105,000, now sold for approximately double at $530,000. A cast of Degas' famous bronze of a fourteen-year-old ballet dancer at the Opéra in Paris, wearing a muslin tutu, made $380,000. Norton Simon soon acquired a second, very fine cast of the little dancer along with the complete set of the seventy three 'modèle' casts, which he purchased from Desmond Corcorane and Martin Summers at the Lefevre Gallery in London. Even though a total of twenty-eight casts of this sculpture were made in the

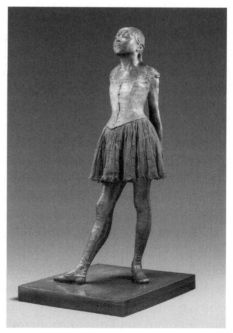

Edgar Degas' bronze sculpture
La Petite Danseuse de Quatorze Ans, original model executed 1880, private collection

Lord Sieff's Cézanne watercolour, *Nature Morte, Bouilloire, Pot-au-lait, Sucrier et Sept Pommmes*, *circa* 1895–1900, J.Paul Getty Museum, Los Angeles

1920s from Degas' original wax model of 1880, this work has always been much sought after and rarely appears on the market, although several did so at auction in London and New York in the 1990s, some achieving prices exceeding $12 million. Then, in February 2009, a superb cast was sold by Sotheby's in London for £11.8 million, an astonishing price achieved at a time of deep, global recession, proof of the durability of great works of art, especially when you consider this same cast had been sold five years earlier for £4.5 million.

Another of my favourites in the sale was one of the remarkable paintings of the Paris boulevards that Pissarro worked on throughout the 1890s. *Boulevard Montmartre, Mardi Gras* of 1897 is amongst the finest of that group and is unique in the impression it gives of the vast crowds of people hurrying along under a storm of confetti and streamers while watching the *Mardi Gras* parade. The buyer, at $230,000 was Armand Hammer who also bought the most expensive painting in the sale, Vincent van Gogh's *L'Hôpital de St Paul à Saint- Rémy* for $1,200,000. Although large and quite impressive, I do not consider it to be amongst the best paintings of that extraordinarily fertile year when he was being cared for in the hospital. It is now in Armand Hammer's own Los Angeles museum and is perhaps the best picture there. Born in New York, Armand Hammer was of Russian origin. Various entrepreneurial schemes, particularly in the Soviet Union in the 1920s, led to his becoming CEO of Occidental Petroleum, and he used a small part of his fortune to collect Impressionist and Post-Impressionist paintings which now represent the core of his museum.

Another marvellous painting was an early Signac, titled *Collioure, La Plage du Faubourg*, painted in 1887 at the beginning of his mature Pointillist

period. I have always much admired the way Signac was able to render the calm, clear, soft light of a summer morning in the Mediterranean. Selling for $250,000, it now belongs to an old friend of mine who lives partly in New York, thus allowing me to occasionally admire it again, along with some of the other lovely pictures he has discerningly and astutely acquired over the years.

Two years later in 1973, Norton Simon reappeared on the scene with a second group of pictures for sale. Once again there were several great works on offer. Another sensational Degas from his best years – *Répétition sur la Scène*, a gouache and pastel of a principal dancer being led through a rehearsal by her ballet master – Simon had bought it at Parke-Bernet in 1965 in what in fact was the first sale under its brand new Sotheby's ownership. A former Havemeyer picture, the Degas had been sold by one of the heirs for $410,000, and then eight years later fetched $780,000. I never could understand why Simon sold these masterpieces when he was in the process of forming a superb collection himself. He also sold a magnificent Cézanne watercolour for $620,000, bought at one of my sales in London in 1967 for £145,000 the property of Lord Sieff, brother-in-law of Simon Marks, founder of Marks and Spencer. This masterpiece re-appeared once more in 1982 when a French collector sold it at Sotheby's for £480,000. It is now one of the gems in the Getty Museum. Cézanne's *Vase de Tulipes*, a painting I found rather harshly painted and not at all to my liking, reached $1.4 million, above its reserve of $1.2 million, and was in fact bought by Simon himself, through a third party, while Manet's *Nature Morte aux Poissons,* a study of a salmon lying on a kitchen table, seemingly ready to be poached, did not sell.

Therein lies a murky story: in order for us to secure the Simon consignment, PCW had to agree to guarantee the price of his Manet, meaning that he would receive the agreed figure regardless of whether the

Edouard Manet,
Nature Morte aux Poissons,
oil on canvas 1864,
Norton Simon Museum,
Pasadena

work sold or not. David Nash reminded me recently that, in the final stages of negotiation, David and I (together with Simon's curator, Daryl Isely) were asked by PCW to leave Norton Simon's office while they hatched their final, devious plans for the sale. That figure was $1.5 million and, if I remember correctly, there were no bids for it at all, resulting in Sotheby's becoming its new, very reluctant owner. We learnt a lesson the hard way that lifeless pictures of dead fish are notoriously difficult to sell, except at very low prices, whatever the quality of the painting itself. The final twist in the Manet fiasco was that after a couple of years languishing unsold in our vaults, PCW finally sold it for about half the price to the only buyer interested who happened to be Norton Simon himself! At the time Simon said he only included the Manet and the Cézanne to spice up the sale and that he never really wanted to let them go. After that flop, it was to be many years before Sotheby's returned to the guaranteeing game. A year later Norton Simon made the last of his auction sales; this consisted of a fine group of 19th- and 20th-century drawings and watercolours that sold successfully in my April 1974 sale in London.

Even after these sales, Norton Simon still had a large collection of pictures which he continued to add to over the years and for which he needed a permanent home. He was fortuitously approached by the Pasadena Museum of Modern Art in the hills above Los Angeles which was having financial difficulties due to over-expansion in previous years. In 1974 Simon took over the management and assumed its debts. Renamed the Norton Simon Museum of Art and reopened in 1975, he made it into one of the most striking museums on the West Coast, notable for its very good collections of Old Master paintings, including Rembrandt's portrait of his son Titus, Indian and South-East Asian sculpture as well as a very fine collection of Impressionist and Nabis pictures, together with an extensive group of truly beautiful works by Degas and Picasso.

Antonio Santamarina

One of the wealthiest *estancia* owners in Argentina, Antonio Santamarina had what was regarded as one of the finest collection of Impressionist paintings in South America. Peregrine Pollen, head of Sotheby's New York office, often used to travel there to cultivate the local collectors, and was a friend of his son who, in February 1964, came up with the charming idea of presenting his father with a catalogue of his collection to celebrate his eighty-fifth birthday in August the following year. I was charged with the mission and, accordingly flew down to Buenos Aires and spent ten

days cataloguing the 112 paintings, drawings and sculptures Antonio Santamarina had amassed between 1895 and 1930. Like many wealthy Argentineans he would spend time in Paris every year, visit the museums and call upon the many prominent dealers along the way from whom he made most of his purchases.

A distinguished, softly-spoken gentleman, he would sit quietly in his study or his drawing room, while I went around taking the pictures off the walls to catalogue them, measuring and noting details from labels on the back that would help me establish their history. We talked in French about how he had made his collection and the people he had met in Paris, including some of the famous dealers and even my grandfather Jules, from whose collection he owned Sisley's *Inondation à Port-Marly* and Monet's early work, *Inondation* of 1868: I was delighted to see for the first time two paintings that had once belonged to Jules.

Buenos Aires was in the middle of its usual summer heatwave and it was not easy to concentrate in the airless apartment, but nevertheless I had an enjoyable time there. I was fascinated by the fact that, in the southern hemisphere, thousands of miles away from France, the city had a very French feel, both architecturally and gastronomically.

On returning to London, I continued researching the collection and had such pleasure in cataloguing and designing a beautiful book (for private family circulation) bound in red morocco leather, the cover title *La Collection de Monsieur Antonio Santamarina* tooled in gold lettering. It was a varied and most interesting collection, containing beautiful works by Manet, Degas, Monet, Morisot and Renoir, as well as a group of bronzes by Rodin and a large number of paintings and drawings by Toulouse-

Antonio Santamarina's Toulouse-Lautrec, *Au Cirque Fernando, Ecuyère sur un Cheval Blanc*, pastel and gouache on board 1888, private collection

Lautrec for whom Antonio Santamarina had a special fondness.

I flew back to London via Brazil, a country I had been fascinated by and always wanted to visit. It was in total contrast to Argentina, far more exotic, far less European. I was enchanted by Rio de Janeiro, especially since I was there during Carnival. Its multi-racial people, a blend of many cultures, Portuguese, African and Amazonian Indian, were dancing in the streets to the exciting throb of the samba, clad in the multi-coloured skimpy costumes of the samba schools. On my last day in Brazil I made a quick trip to Brasilia, spending my time wandering around the newly built capital, still largely uninhabited, the immense boulevards flanked by the rather soulless architecture of Oscar Niemeyer.

After Santamarina died in 1974 at the age of ninety-two, his children decided that most of the collection should be sold. Accordingly, the best pictures were sent to London, but before the sale could take place, the Argentinean government claimed the works had been taken out of the country illegally and were part of Argentina's 'patrimony'. Once the legal and political issues had been resolved, Antonio Santamarina's widow agreed to donate the remaining works to the nation, finally allowing the sale to take place at New Bond Street in the summer of 1974.

Naturally, as was to be expected with a sale of pictures that had such a distinguished provenance and had been unseen in Europe for over fifty years, the auction more than exceeded all our expectations. To take a few examples, Alfred Sisley's *Inondation à Port-Marly*, which had been in my grandfather's 1902 sale, had been acquired by Antonio Santamarina in Paris just after the First World War from the Galerie Georges Petit. Executed at the height of Sisley's powers in 1876, and estimated at £80-100,000, it sold to Heini Thyssen for £111,000.

One of the rarest and historically important works was Renoir's depiction of a group of his closest friends, Camille Pissarro amongst them, painted in his rue St Georges studio in 1876. Bought by Santamarina in 1920, it now fetched £150,000. Amongst the other highlights of that sale was a group of paintings and drawings by Toulouse-Lautrec, the finest of which was a rare pastel and gouache of a circus rider on a white horse, painted in 1888 which made £210,000.

There was only one Degas in the auction, but what a ravishing work it was. The *Salle de Danse* is a very pretty, quite small pastel of a group of dancers in the rehearsal room of the Paris Opéra. The young dancer in the foreground, wearing a bright blue bow at the back of her white tutu, stands looking down at her feet. I will always remember that pastel, not just for its refined quality, but because, some time before it went on public view, who should come into my rather small office overlooking New Bond

Street but the Philadelphia media magnate, Walter Annenberg, then American Ambassador to London, and his wife. A tall, portly man, speaking in a deep, formal voice, he had asked to see the Degas, explaining that he could not be in London at the time of the sale. He, therefore, had someone bid for him and was successful in buying it for £142,000, a figure way over its top estimate of £100,000. It is now in the Metropolitan Museum of Art, to whom he bequeathed a large part of the fabulous collection he formed during a period of some thirty years.

Amongst Annenberg's gifts to the Metropolitan Museum was one of Picasso's masterpieces, *Au Lapin Agile* of 1905. This magnificent painting of a couple of circus performers, depicts Harlequin (in fact a self-portrait) and Columbine (Germaine Gargallo – Picasso's mistress at the time) sitting in the famous cabaret of that eponymous name in Montmartre and had been painted to decorate the main room of the cabaret. It had previously been owned by Joan Whitney Payson (the sister of another famous collector, Jock Whitney), who with her husband had made a wonderful collection of late Impressionist and early 20th-century paintings, mainly in the 1930s and '40s. She had owned van Gogh's *Irises*, which her son John sold at Sotheby's in 1987, and in November 1989 she sold *Au Lapin Agile* for $37 million, which was at that time the second highest price for a work by Picasso. In fact, his self-portrait, which he titled *Yo Picasso* (*Me Picasso*), had made the record price of $43.5 million just six months earlier.

Painted in 1901, this highly-coloured, van Gogh-influenced, flamboyant portrait depicted the young artist wearing a white blouse, sporting a bright orange scarf around his neck with deep piercing Spanish eyes, all set against a deep blue background. *Yo Picasso* had a very interesting history: Hugo von Hoffmanstahl, the Austrian playwright, bought the painting with his first royalties for the libretto of the opera *Der Rosenkavalier,* which he wrote for Richard Strauss in 1911. The work did not appear on the market again until the Hoffmanstahl family sold it at

Pablo Picasso, *Yo Picasso*, oil on canvas 1901, private collection

Christie's in 1970 for £130,000. It then passed through the hands of two collectors in quite a short space of time and ended up with a Swiss based investor. He in turn put it up for sale in 1981 at Sotheby's in New York, when it fetched a then record price for a modern painting of $5.3 million. *Yo Picasso* remained with the buyer, Wendell Cherry, until 1989 when he sold it, once again with us in New York, for $43.5 million against an estimate of $15-20 million. Acquired by perhaps the greatest, very private collector of Impressionist and Modern art since the Second World War, it has remained in that collection ever since, sometimes on loan to the Zurich Kunsthaus and occasionally exhibited, most recently in *Picasso et les Maîtres* in Paris in 2008.

Richard Weil

Richard (Dick) Weil from St Louis was one of those typical American collectors who have an excellent eye and specialised in making a collection of important Modern pictures from the 1950s onwards, buying mainly from dealers in New York, London and Paris. He had a number of striking works by Picasso, Braque, Gris, Léger, Miró, Kandinsky, Dubuffet, and Nicolas de Staël, which hung in his relatively modest house opposite Washington University in St Louis. Every June, from the late 1960s onwards, when we first met and became friends, he would come to London, staying at Claridge's. He would routinely invite me to lunch at his hotel and each time would make sure I ordered one of the large servings of Devonshire crab which he knew was a great favourite of mine. We would gossip about art and he loved hearing the latest anecdotes about the dealers and the auctions. He was no longer buying much by then (his house was full), but he loved attending the summer auctions and visiting local dealers, in particular Desmond Corcorane and Martin Summers at the Lefevre Gallery in Bruton Street.

In turn, during trips to the States, I would go and see Dick in St Louis and we would spend a day or two together, visiting other local collectors such as the Pulitzers, the Schoenbergs, and his mother-in-law, Mrs Etta Steinberg, who owned a number of beautiful Impressionist paintings. On one of my visits in 1973, Dick told me, to my surprise, that he had decided to give me his superb 1909 Picasso Cubist picture for sale. *Femme Assise* is one of those paintings which is the finest of its genre and was sold, after spirited bidding, to a very private New York collector (who still has it in his collection) for £340,000, a huge price for the day at a time when Cubism, in particular, was much favoured by the most

sophisticated of connoisseurs, such as Heinz Berggruen, Douglas Cooper, Ernst Beyeler and Leonard Lauder.

Some years later Dick began talking to me about selling a large part of his collection, as he felt that old age was beginning to affect him and he therefore wanted to settle his affairs. This would have made a sensational sale but, to my utter astonishment, one day I heard that the Basel dealer, Ernst Beyeler, had turned up in St. Louis and made him a cash offer for all his most valuable paintings. Dick later explained to me that his wife Florence was very ill and as he was himself in a depressed mood, he had accepted Beyeler's offer. He realised, though, that he had made a serious mistake and told me he had been stupid to give in to Beyeler so easily. I thought it was a shame that such a fine group of pictures wasn't able to benefit from the excitement of an auction, where they undoubtedly would have fetched much higher prices and Dick would have so appreciated a fine catalogue as homage to his taste and his collection. Eventually, we did manage to sell what remained of the collection when his family consigned a lovely group of works on paper, small sculptures and a few excellent paintings to our sale in New York in May 1997. The rarest work, which used to hang in the entrance hall of the St Louis house, was one of Juan Gris' *papiers collés* of 1914,

The La Roche Cubist Braque, *Femme Lisant*, oil on canvas 1911, Beyeler Museum, Riehen

Richard Weil's Cubist Picasso, *Femme Assise*, oil on canvas 1909, private collection

an exquisite collage much coveted by collectors of Cubism, which made $1.1 million.

However, during my career I did have the pleasure of having handled the sale of two of the most important Cubist pictures: Dick Weil's *Femme Assise* of 1909 and a superb 1911 Georges Braque consigned by one of the heirs of Jacques La Roche, the famous Swiss collector. In the early 1920s he had filled his Le Corbusier house on the Bois de Boulogne with one of the most famous collections of Cubist masterpieces, including Braque's *Femme Lisant* which realised an astonishing £6 million in 1986 (against the estimate of £2-2.7 million) and was bought by Ernst Beyeler (now in the Beyeler Foundation, Riehen). At his death, La Roche left part of his collection to the Basel Kunstmuseum and the other part to his two Swiss nephews, one of whom sat on the board of a Swiss bank with Jürg Wille, head of our Zurich office, and who decided to sell his Braque, which realised a figure that still remains the record price for any of his paintings.

Robert von Hirsch

The saga of the British Rail Pension Fund and the great series of sales of the von Hirsch collections in the summer of 1978 were the ultimate highlights of my years at Sotheby's. Born in Frankfurt-am-Main in 1883, Robert von Hirsch began his working life at Offenbacher, his uncle's leather and tanning firm. Under his eventual guidance, Offenbacher was to become an enormously successful and internationally famous firm, to the extent that it was visited in 1913 by the Tsarina Alexandra and her brother, the Grand Duke of Hesse. As a young man, Robert von Hirsch had already begun to collect fine French and German first editions. At the age of twenty-two he met Georg Swarzenski, the Director of the Städelsches Kunstinstitut in Frankfurt and later Edmund Schilling who was head of the print department there. With the encouragement and advice of these two men he developed an extremely impressive knowledge of the arts. When he was twenty-four years old, in 1907, Robert von Hirsch bought his very first paintings, *La Rousse au Caraco blanc* by Henri de Toulouse-Lautrec and Picasso's *Scène de Rue* of 1901. Over the next several years he added Medieval and Renaissance works of art of the most superb quality and rarity, acquired from some of the great collections such as the Hohenzollern-Sigmaringen and the Guelph treasure from the State Hermitage Museum sales of the 1920s, to form what was by the 1930s an unrivalled collection, famed throughout Europe and visited by museum directors, art historians and collectors from all over the world.

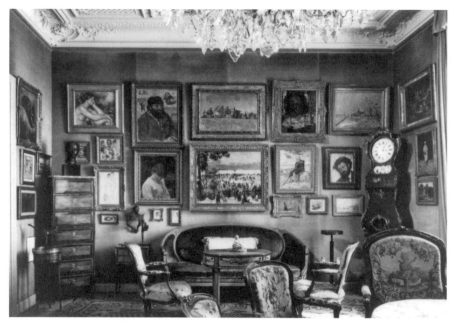

Robert von Hirsch's Impressionist paintings hanging in his drawing room at his house in Basel

By 1933, however, it was clear that, as a prominent Jewish businessman, he would have to leave Germany and accordingly he applied for permission to emigrate to Basel with his collection. This was granted on condition he gave the German nation Lucas Cranach the Elder's *Judgement of Paris*, eventually restituted to him after 1945 and which he later bequeathed to the Basel Kunstmuseum. He married the sculptress Martha Dreyfus-Koch, the daughter of Louis Koch, the famous 19th-century German jeweller. His house, and the garden created by his wife, became a cultural centre for art lovers. Her influence widened the range of his collection which, by the 1950s, included Medieval works of art, early Italian and German paintings, Renaissance bronzes, Dutch, German and Italian drawings, 16th- to 18th-century furniture, Impressionist paintings and drawings and finally, after the Second World War, a strong group of early 20th-century works by Picasso, Matisse, Modigliani and Soutine, very much the taste of Martha, and all of which hung in their dining room.

Peter Wilson had become close to the von Hirsch family during the time he was sent to Germany after leaving school to learn German and happened to be in the same class as Richard Dreyfus, Robert von Hirsch's stepson. When PCW decided to open an office in Zurich, Switzerland's financial capital, it was through his old friend Richard that he was introduced to Jürg Wille. In 1968 the office was established, run by Wille

and his partner Freddy Schwarzenbach. I too was connected to the Dreyfus family as Vera, the niece of my grandfather, Pierre de Gunzbourg, had married the head of the Dreyfus bank in Basel and our two families had remained close. More surprisingly, my mother recently told me that Richard Dreyfus had been one of her unsuccessful suitors in 1933. I had met him soon after joining Sotheby's and would often visit him in Basel. He was another of those passionate collectors whose principal interest was in collecting fantastic art of all cultures, from the Renaissance through to Symbolism and Surrealism, which he greatly enlarged after marrying his second wife, Ulla.

During the second half of the 1960s, I began going to Basel to make regular insurance valuations of his 19th- and 20th-century collections. It was a real joy and a fascinating experience to be shown the many treasures around the house by Robert von Hirsch himself. Each room was devoted to a different collecting area. The Impressionist paintings were in the drawing room, hung one above the other in two rows, 20th-century works in the dining room, Medieval works of art and Renaissance paintings in the library and 19th- and 20th-century drawings and watercolours in his study on the first floor. Returning to deliver the valuation he would question me sharply, complaining, 'Justify your prices, they're too high.' And so I did, more or less to his satisfaction, although he would sometimes grumble about them in his stern, but quiet manner. But once he had begun to respect my knowledge, I started to develop a warmer friendship with this elegantly dressed, highly-cultured man with whom I so enjoyed discussing the history and the qualities of his collections. In fact I was so affected by his taste and the way he arranged his great objects in the various rooms of his house on the Engelgasse, that I soon began to collect Medieval works of art and early textiles which I placed on antique tables, much as he had. Thinking back on those days, I realise the reason I was so drawn to him was that, although a generation younger than my grandfather, Jules Strauss, not only were they both from Frankfurt, but I saw in him many of the same qualities of connoisseurship and collecting passions.

I vividly remember the day in 1971 when he asked me to come and see him. He explained that he needed to raise some money for his annual tax bill and had decided to give me his Signac for sale. He had always been convinced that I had overvalued it and, therefore, wanted me to prove to him that I knew what I was talking about by selling this fine, early Pointillist painting, *Herblay, Temps Gris, Saules*, painted in August 1889, which I had valued at £25,000 the previous year. Accordingly, I included it in my July sale and was delighted to see it race beyond its reserve and sell for £38,000. Many years later it reappeared at auction in London in

2005 and this time made £960,000, a result which I suppose would have really astonished him. Thereafter, he readily accepted the values I gave him and we were able to relax more in each other's company, not having to quibble over the prices.

Robert von Hirsch died in 1977 at the age of ninety-four. His step-children, Richard Dreyfus and his sister Lolo Sarnoff, consigned the entire, vast collection, apart from a few bequests, to us in London, a natural enough progression, considering the old friendships with Peter Wilson and Jürg Wille. After his wife died in 1965, Robert von Hirsch had decided that, after his own death, his collections should be sold at auction for, as Jürg Wille was to write in the introduction to the catalogues: 'The old collector believed in the free circulation of works of art and wanted his collection to be distributed on the market; but he also mentioned that relatives, friends and museums would inherit chosen pieces.'

The collection was so extensive that the 700 lots were spread among four catalogues: Old Master Paintings and Drawings, Medieval and Renaissance Works of Art, Continental Furniture and Textiles and a fourth volume of Impressionist and Modern Paintings, Drawings and Sculpture. The sales themselves took place over six days in June 1978, after selected works had been, very exceptionally, exhibited at the Royal Academy, where I was allowed the great privilege of arranging the hanging of the pictures in what are now known as the Madejski rooms. It was a rare treat to catalogue the 144 Impressionist and Modern works, although compared to the kind of exhaustive essays accompanying each lot in the evening sales over the last twenty years, in 1978 we only included in our notes any information we could find about the provenance and where the work might have been illustrated and published. To no one's surprise the von Hirsch sale was an unprecedented success.

I took the opportunity of inviting our clients and friends to a reception on the Sunday evening before the Impressionist sales which were to start the following evening. That timing happened to coincide with the final of the 1978 World Cup in Buenos Aires. I suspected there would be quite a few football enthusiasts among the guests, so I set up large television screens, tables and chairs in all the galleries, and while everyone was enjoying the delicious cold buffet I had organised, most watched the match, suitably excited, when Argentina beat the Netherlands 3–1. This party turned out to be the most successful we had ever given before one of our sales.

The catalogue was divided into two sections, the paintings the first evening, the drawings the next. They consisted both of masterpieces and more intimate, often small works of much lower value that the von Hirschs

Robert von Hirsch's
Cézanne watercolour,
*Nature Morte au Melon
Vert, circa* 1900–5,
private collection

had gathered over the years, ranging from a superb Matisse oil to a sweet little drawing by Pissarro. Amongst the pictures, the most notable were a Renoir painting of figures skating on the Longchamps racecourse executed in the winter of 1868 (£160,000); *La Rousse au Caraco blanc* by Toulouse-Lautrec, which was his first purchase in 1907 (£230,000 to Heini Thyssen); a Modigliani, *Jeune Femme à la Robe Jaune* (£165,000 to Jo Nahmad) and Matisse's *Nature Morte à la Dormeuse*, an enchanting work painted in 1939–40, which Paul Mellon purchased for £310,000, the top price of the sale.

The drawing sale the next evening was even finer in quality, containing an extraordinary group of works on paper by Cézanne and van Gogh. The British Rail Pension Fund had a field day, acquiring one of Cézanne's most important watercolours, *Nature Morte au Melon Vert,* for £300,000, which they subsequently sold in their 1989 sale for £2,200,000, its buyer himself selling it at Sotheby's in New York in 2007 for an amazing $22,000,000, evidence once more of the astronomical rise in value of great works of art over a thirty-year time span. It was interesting to note that three other very fine Cézanne watercolours were bought by the great dealer/collectors of our time: Heinz Berggruen, Ernst Beyeler (both of whom have founded their own museums) and Jan Krugier. Of the three van Gogh pen and ink drawings, one went to a Greek collector for £200,000 while the other was purchased by British Rail for £205,000 and sold by them eleven years later for £2,100,000, once more to that most distinguished of collectors, Paul Mellon. Every single lot was sold (this is traditionally referred to as a 'White Glove Sale') to international collectors, dealers and museums.

The other sales in the series also produced extraordinary results, in particular two Medieval enamels of such superb quality and rarity that each sold for over £1 million. The final total of £18,500,000 (the Impressionists

contributing £5,850,000) was a figure that had never before been realised for a collection, but then again never had a house revealed so many treasures, at least not since the beginning of the 20th century. It was a tremendous privilege and honour to have been so closely associated with Robert von Hirsch and his collections.

A last word: as a personal souvenir of those fascinating years, I bought a pair of Louis XV beechwood armchairs in the Furniture sale, which came from his drawing room where we used to sit together discussing the latest news from the art world.

Moshe Mayer

An astute collector I admired was Moshe Mayer, an Israeli who lived mainly in Tel Aviv and who had made his fortune largely though construction projects in West Africa. He had been collecting since the 1940s and from the mid '70s onwards used to attend our London and New York sales, usually in the summer with his wife Sara. Their annual routine, as with Dick Weil, was to come and view the sales with me, followed by tea at Claridge's where we would go through the catalogue together. He would point out the lots he fancied and would ask me for my thoughts as to quality, condition and the possible price these lots might fetch. He managed over a period of more than forty years, to accumulate a most desirable collection of paintings, without having to spend a fortune. In his collection was an excellent late Monet Waterlily painting, a small, typical Tahitian period Gauguin, works by Degas, Pissarro and Renoir, a superb Bonnard, two Blue period compositions and a late *Mousquetaire* painting by Picasso, a 1913 Cubist Léger, Matisse and Miró. All in all it was a fine, representative collection of some of the best examples by these artists. The painting that probably

Robert von Hirsch's van Gogh, *La Bergère d'après Millet*, oil on canvas 1889, Moshe Mayer collection, Tel Aviv

meant the most to him was Vincent van Gogh's *La Bergère d'après Millet,* a boldly painted study of a shepherdess dressed in various shades of blue, seated on a bale of yellow hay, executed while he was in the hospital in St Rémy in 1889. As one of the treasures of the Robert von Hirsch sale, Moshe Mayer had really wanted it, but for some reason dropped out of the bidding too early. It was bought by a European collector for £210,000 and Moshe immediately regretted not going further. However, as often happens, only three years later, the van Gogh reappeared on the market in my April 1981 sale; this time he was determined not to lose it, but he had to pay £550,000, considerably more than in 1978 and well over its estimate of £280-350,000.

Moshe Mayer and I had talked of an eventual auction after he and his wife had died, an auction that would have rivalled most of the other great sales that I had organised. However, during his last years, he lent an important group of paintings to the Tel Aviv Museum of Art, and after his wife Sara died, his two daughters inherited the collection. To my knowledge nothing has come up for sale, even though Rivka Saker, Sotheby's representative in Israel and I did our best to tempt and persuade them (as did John Lumley of Christie's) to sell all or part of their parents' collection. Nevertheless, for almost twenty years, Moshe Mayer and I enjoyed his collecting experience together and his friendship and loyalty gave me singular pleasure.

Marcus Mizné

There are always exceptions to these successes and the sale of Marcus Mizné's collection in 1982 was a disaster for which I was responsible. Of Eastern European origin, Marcus Mizné was tough to please, but with an eye for good pictures. Over a twenty-year period he had acquired some excellent 20th-century pictures (along with some drab examples), including one of Kandinsky's great abstract compositions of 1914. In the early 1980s, Mizné contacted me from his Houston home to say that as he had reached a certain age, he had decided it was time to dispose of the large number of paintings that for some years had been resting in Day and Meyer's cold, dark warehouse in Manhattan. Before flying down to Houston I went to the warehouse with David Nash to examine, estimate and make a selection for a significant single-owner sale which, due to Mizné's tax status, would be held in London rather than New York.

Going to Houston for the first time was exciting; after spending the first morning on a fascinating tour of NASA's Space Centre I enjoyed

the afternoon by visiting the Houston Museum, Dominique de Menil's famous Surrealist collection and the inspirational Rothko chapel. At the end of the day I went to see Marcus Mizné at his apartment, high up in one of Houston's contemporary buildings. I had known him for many years as he would occasionally appear at our sales, although most of his pictures had been bought from dealers. From past

Marcus Mizné's Kandinsky, *Improvisation V*, oil on canvas 1913, private collection

experience, I anticipated he would not be easy to deal with and in no way did he disappoint me. He had very inflated ideas of price and I had to fight hard to get him to agree to estimates and reserve prices that I thought were within the realms of possibility, but because he was prepared to include a number of important paintings, I was really keen to get these works for sale. Negotiating the terms of the sale with him was also a nerve-racking business, so it was a relief to finally come to what I believed was a satisfactory, but probably risky conclusion. It was one I had always been prepared to take if the property was of sufficiently fine quality. I also hoped that when it came to the crunch, just before the sale we could persuade him to lower some of the reserves. Unfortunately, I did not quite realise how utterly unpopular he was with the trade over the years. Although they attended the sale, they held off from bidding on any of the lots, and put off as many private buyers as possible.

The result was that only a few lots were sold. Amongst those that did sell was a rare Piet Mondrian from his first abstract period, painted whilst he was in Paris in the winter of 1912–13. Estimated at £750-850,000, we managed to get Mizné to reduce the reserve to £600,000 and luckily found a buyer at that level in Heini Thyssen, who was bidding on the phone, unaware of what was going on in the saleroom. We did sell a 1913 Kandinsky watercolour, but not the magnificent 1914 *Improvisation V* which had an optimistic reserve of £2 million. He had acquired the painting from Heinz Berggruen, shortly after Berggruen had bought it for £50,000 in our June 1964 auction of fifty paintings by

Kandinsky consigned by the Solomon R. Guggenheim Museum. An important Léger *Contrastes de Formes* of 1913 and a fine 1927 Mondrian were amongst the miserable failures, but we did manage to find buyers for a Fauve van Dongen and a 1941 Picasso portrait of Dora Maar. This was a tough lesson to learn, but I obviously didn't judge just how disliked he was, particularly during a time of economic crisis and a market that lacked confidence.

The Havemeyer Sale

Early in 1983, during the months of management turmoil in London following a loss-making year in 1982, the first in living memory, both houses were asked to present a proposal for the sale of pictures from the estate of Horace and Doris Dick Havemeyer. Horace had inherited them from his parents, Henry and Louisine Havemeyer, the first great American collectors of Impressionism in the 1880s. Even before her marriage, Louisine, whilst a twenty-year-old student in Paris, had bought her first painting, a Degas ballet scene at the insistence of her great friend, the American painter Mary Cassatt, herself a close friend of Degas. In Louisine Havemeyer's autobiography, *Sixteen to Sixty: Memoirs of a Collector,* Louisine wrote about her first purchase, 'I scarce knew how to appreciate it or whether I liked it or not, for I believe it takes special brain cells to understand Degas. There was nothing the matter with Miss Cassatt's brain cells, however, and she left me in no doubt as to the desirability of the purchase and I bought it upon her advice.' Degas was her special favourite and she came eventually to own more than 120 of his works. She died in 1929 and left over 1,000 paintings and other works of art to the Metropolitan Museum, the remainder being divided among her three children.

Once again I received one of those momentous calls from David Nash in New York, asking me to come and see a fine group of Havemeyer pictures with him. This was a crucial time and it was vital that we succeeded in getting this particular estate for sale. We had lost the Armand Bartos collection to Christie's because Bartos had scandalously been scared into believing (presumably by the competition) that we might not be able to pay him the sale proceeds, a totally unfounded rumour circulating due to the previous year's losses. Therefore, to hold a sale of material from the magical Havemeyer collection was the most prestigious event possible. We had to win it. Accordingly, I hopped on to a plane that evening, not Concorde as had once been the case, but arrived in time for the next

morning's appointment. We already knew that Christie's were viewing the collection that afternoon, so it was crucial that we made the best impression possible. As soon as we entered the apartment on Park Avenue, we were stunned to be surrounded by a group of some of the most important and delightful paintings we had come across for many years. David and I looked at each other in astonishment as we slowly walked around the rooms in order to first get a general impression. These were paintings and pastels that for the most part had not been seen in public since the end of the 19th century and thus had an extraordinary freshness about them, linked to a rare state of preservation that was to be such a factor in the eventual outcome of the sale. The undoubted jewel was one of Degas greatest works, *L'Attente*, which Horace Havemeyer purchased in 1895. In her memoirs, his wife Louisine writes a charming description of it: 'During a visit to Europe, Durand-Ruel allowed Mr Havemeyer to select a number of pictures from his private collection. It was this privilege which placed several of Degas' finest works in our collection. One is called *L'Attente*. A ballet girl, waiting to be called, is seated upon a bench and is leaning down to tie her sandal; by her side is another figure, probably her mother. The latter is poorly dressed and is also leaning forward, upon an umbrella, which she holds in her hand in a difficult position. It is rather sombre in tone and in subject, but is the perfection of art in every detail.' Seeing this work brought back to me the first powerful reactions I had at the age of six when my mother took me to the Metropolitan Museum for the first time, and it was precisely this kind of Havemeyer masterpiece that so seduced me and lit the fire of a lifetime passion for Degas.

We then proceeded to examine each picture with the greatest of care, taking each one down from the wall, not only to look at it in a better light by the window, but also to see what labels there were on the reverse that would be a vital clue to their history. David and I had always been fascinated by the history of paintings, to whom they had belonged and where they had been exhibited, and looked for clues to reveal these facts. As we talked and examined each work, discussing its special merits, in general just expressing our enthusiasm, we were fully aware that the principal heir and the estate's lawyer were following on behind us, quietly listening to what we were saying. It was a bit unnerving, but we tried to ignore their presence. At one point, David and I were horrified to see that a flake of paint was about to fall off one of the paintings, so we immediately suggested that the canvas be placed flat on a table to prevent any further losses and that we would get a restorer to examine and stabilise it until it could be properly restored in his studio. This was readily agreed to.

The next day we sent a written proposal, laying out our terms, our valuation and how we would prepare and present the collection for sale. A short time later we heard the fantastic news that the sale had been consigned to us. Out of curiosity David asked why they had chosen us rather than Christie's. Mr Havemeyer told him he liked the way we had looked at the pictures and how we so obviously cared for them, while Christie's, on the other hand, simply made their list, without taking the paintings off the walls or showing much enthusiasm. The resulting sale, *Impressionist Paintings and Drawings from the Estate of Doris D. Havemeyer* (Louisine's daughter-in-law), took place on 18 May 1983 and marked the beginning of an increasingly buoyant market which lasted seven years until the debacle of late 1990, when the Japanese 'bubble' economy collapsed.

The sale of sixteen lots began and ended with a rare group of five landscape pastels by Degas. Although Degas was not widely known as a landscape painter, the best made a respectable price, for those days, of $120,000. Degas' pastels, not unexpectedly, were the stars of the collection. His ravishing masterpiece, *L'Attente*, realised $3.4 million, a record for a work by the artist. Norton Simon and the Getty Museum decided to buy *L'Attente* together so as not to outbid each other, thus permitting both institutions in the Los Angeles area to display it on a rotational basis, an arrangement which continues to this day. Although double the estimate, the price pales in comparison to the £16 million for an equally beautiful pastel, *Danseuse au Repos,* sold in 1999.

Edgar Degas, *Au Café Concert: la Chanson du Chien, circa* 1875–7, private collection, from the Havemeyer auction

Degas' *Au Café Concert: la Chanson du Chien* deservedly made the second highest price of $3.1 million. This enchanting vision in tones of green, soft pinks and oranges of a café singer, her mouth open as she sings, her hands held out in an expressive gesture to the crowd behind her, is a work of unsurpassed genius. It was bought by Wendell Cherry, the Louisville, Kentucky collector who, in just a few years before his untimely death, put together a collection of the finest quality

from what was then available on the market. I was delighted that this pastel, worthy of the greatest museums, and one that I longed to own, had gone to the best home possible. He also successfully bid for a fine Corot portrait of a young woman and a ravishing painting of a vase of pink roses by Manet. The other painting I loved was a delicious still life of flowers in a vase by Cézanne which made $1.9 million. The final total for this landmark sale was $16,835,000. Indeed this sale and others of the late 1970s and early '80s were to change the landscape of the art market: higher prices could now be achieved at auction rather than privately by a dealer and this marked a major turning point that was to radicalise the auction market.

An Egon Schiele Masterpiece

Ever since I first came across Egon Schiele's paintings at the Belvedere in Vienna in the 1960s, I have been fascinated, even mesmerised, by his starkly candid interpretations of the human figure. So, the day his 1914 painting *Lovers I*, depicting a naked couple lying interlocked in an attitude of anguished despair on a bed of crumpled white sheets, was offered to us for sale, became a landmark event. This was triggered, one day in 1984, when I received a call from our office in Hamburg telling me that a local lawyer wanted to see me about the sale of a painting by Schiele on behalf of a client. I flew out two days later to meet him and, having discussed my proposals and the terms for a potential sale, he sent me to examine the work itself which was being stored in a Freeport warehouse in Zurich. Seeing it for the first time under a dim neon light, I was absolutely stunned by this large, remarkable composition, charged with emotion and painted in tones of white, grey and yellow with dramatic touches of red in the four corners of the canvas.

Before reporting back, I called David Nash to tell him what I had just seen and to discuss an estimate, which we felt could be set in the region of £2.5 – 3 million. This figure was way more than any other Schiele had ever fetched, but we were convinced that such an important work, one of the few major paintings remaining in private hands, would have strong appeal to discerning collectors. I transmitted this estimate to the lawyer, whose client accepted our proposal, and I accordingly included it in our forthcoming December sale. Our opinion of the value turned out to be fully justified when it sold for an excellent £2.9 million to Wendell Cherry. Unfortunately, his wife didn't like the painting and wouldn't let him hang it in the house so, for two years it hung in David's office. Cherry then tried to sell it at Christie's in 1987, but it failed to sell, much to David's relief

Egon Schiele, *Lovers I*,
oil on canvas 1914,
private collection,
courtesy Neue Galerie,
New York

who chastised him for this disloyalty. Thereafter, Cherry and his widow, to my knowledge, only used Sotheby's for any subsequent auction sales, including this great Schiele which made $4.2 million (about £2.7 million) in 1993 during a recession, less than Cherry had bought it for nine years earlier.

Looking back at the fabulous Classic Modern paintings I have personally handled during almost forty years, the Schiele remains very high on the list, matched only by a Klimt, Cubist Picassos and Braques, Kandinsky Improvisations, Neo-Classical Picassos from Paul Rosenberg's collection and Surrealist paintings by Ernst, Dali and Magritte.

Stanley Seeger

Stanley Seeger, a charming, Bohemian figure, the son of a mid-western oil tycoon, had no interest in his father's business, but remained fascinated by art and collecting. He is an impulsive buyer and has made several interesting collections over the years. In his twenties, he went to live in Rome where he formed his first excellent, representative collection of Italian contemporary art of the 1940s and '50s, part of which Sotheby's sold in their Milan saleroom in the 1990s.

He then moved to London in the 1960s and it was soon after that I became aware of him. The time he was living at Sutton Place, a famous Tudor estate in Surrey, coincided with the resurgence in taste for Victoriana

and Art Nouveau, which for generations had been languishing in the doldrums. To deal with this sudden interest, Sotheby's converted the Pantechnicon, a furniture depository in Motcomb Street, Belgravia, into a secondary auction room which became known as Sotheby's Belgravia. Marcus Linell, an English porcelain expert, was recalled from New York, where he was head of the Works of Art department, to be its first manager. Peter Nahum, a Victorian picture expert transferred from Bond Street to run the new picture department, along with a young assistant, Christopher Cone, who was a friend of Marcus.

It was at one of these Belgravia sales that Stanley met Christopher for the first time. Soon after their meeting, Christopher arrived one morning in a brand new sports car and handed in his resignation; he had been 'taken up' by Stanley and the two men are still together after all these years. Stanley and Christopher have made a number of eclectic and fascinating collections; everything from Victoriana to furniture and rare objects, to 20th-century British paintings and drawings, Impressionist and Modern and Contemporary Art, including a superb collection of works by Picasso. Every so often they would go through a period of saying, 'Let's get rid of everything' and as soon as they had done so, they would start buying again. This is what I would term a severe case of 'artoholism', a malady and addiction for which I have much sympathy.

Stanley and Christopher made a practice of always bidding by phone and on one occasion in the mid-1980s, Melanie Clore was on the line with them, when someone tripped over the telephone cable, pulling it out of its socket, leaving them incommunicado. The auctioneer, Julian Barran, refused to wait for a link to be re-established and, in the meantime, the picture was knocked down to somebody else. Stanley and Christopher were deeply offended, claiming that Sotheby's had deliberately insulted them and, as a result, they transferred all their business to Christie's. However, all was not lost. In July 1989 they consigned a few drawings to an Impressionist sale at Christie's, including a van Gogh ink drawing from the Arles period which was somewhat faded, but quite a pleasant one none the less. Christie's auctioneer, Charlie Alsop, now Lord Hindlip, then chairman of Christie's, made a slightly disparaging remark about the van Gogh, which may or may not be the reason it remained unsold. The next thing I knew, the very same day, was that Christopher was on the phone, telling me what had happened. He and Stanley were terribly upset at the way they had been treated by Christie's. Fortunately I had remained in touch and was on good terms with them, so I suggested that Christopher straight away come and have a cup of tea with me. I let him pour out his woes and gave him as much sympathy as I could, not difficult to do since

it was the 'opposition' which had insulted them. He vowed they would never deal with Christie's again.

A year later in August 1993, Christopher contacted his old friend Marcus, to say that he and Stanley had decided to sell their Picasso collection. This had been assembled over a period of thirteen years, mainly quite discreetly at auction by Stanley. I was, as usual at that time of the year, on holiday in the South of France, but immediately flew to Zurich where I was joined by Marcus, David Nash, and John Tancock who had flown in from New York. All the Picassos were in a Freeport warehouse on the outskirts of Zurich, where we spent the afternoon devising sensible estimates and a sale plan. Due to the long-standing fascination that American museums, collectors and dealers had for the work of Picasso, we all felt strongly that New York would be the best place for such a sale, a concept which Stanley and Christopher were happy to go along with. Although we were in the middle of the severe global and art market recession following the Japanese 'meltdown' of 1990, we instinctively felt that single owner sales had historically done well during times of downturns in the market.

The sale on 4 November 1993, with an introduction to the catalogue by Picasso's biographer, John Richardson, consisted of eighty-eight lots: paintings, drawings and watercolours of varying quality, ranging from an oil painting of 1900 to one of his last drawings executed in July 1972. This cadaverous self-portrait, drawn in pencil when Picasso was ninety-one, is a most unsettling work foretelling his death nine months later. It was bought for $430,000 by that avid collector of late Picassos, Gilbert de Botton, who was bidding on the phone with me from London. Strangely enough, the first drawing in the sale was another nude self-portrait executed seventy years earlier at the age of twenty-one.

The second lot was a superb blue and white chalk portrait sketch of Angel Fernandez de Soto, one of the artist's closest friends from his days in Barcelona, which Stanley had bought at Christie's five years earlier for $172,000, at the height of the booming market of the late 1980s. This time it sold for $480,000, thus reinforcing our conviction that a single-owner Picasso sale, held during a recession, could be a resounding success, suitably confounding the many critics who said that Sotheby's was crazy to contemplate selling so many Picassos in one go, especially when the market was so weak. The first oil in the sale was *La Danseuse Bleue (Pierrot et Danseuse)*, painted in Paris in 1900 during Picasso's first trip to the city. Aged only eighteen, he painted a number of brilliant works evocative of the night life and entertainments in Montmartre at the turn of the century. Stanley had bought the work from

Stanley Seeger's Picasso,
Cartes à Jouer, Paquet de
Tabac, Bouteille, Verre,
oil on canvas 1914,
Berggruen Museum, Berlin

us in London in 1984 for £270,000; in 1993 it realised $1,150,000.

My favourite in the group was an extremely fine 1914 Cubist painting, *Cartes à Jouer, Paquet de Tabac, Bouteille, Verre*, a richly painted work whose tapestry-like surface is dominated by tones of green. I first discovered this painting on a visit to an old collector in Zurich with Jürg Wille in 1981 and thought it a striking and strong example of Synthetic Cubism, a painting in which Picasso combined different mediums – sand, oil, paper, charcoal, and lettering – into a single, complex image. Stanley had purchased it at Sotheby's in London in 1981 for the equivalent then of $613,000, and it now went to Heinz Berggruen for $1.9 million and is one of the many gems in his Berlin museum. Other notable highlights included *Femmes et Enfants au Bord de la Mer,* an important painting from that extraordinary period in 1932 when Picasso was at the height of his love affair with Marie-Thérèse Walter. It was bought by a notable American collector for $4 million (acquired by Stanley for $1 million in 1983), while an impressive composition from his Late Period, *Femme Nue à l'Oiseau et Flutiste* of 1967 was purchased by Ernst Beyeler for $1.3 million (having made $210,000 in 1981). He kept it for himself and it now hangs in his museum in Riehen. This exciting sale realised over $32 million, a total that far exceeded our expectations and, furthermore, every one of the eighty-eight lots sold. Knowing Stanley's unbridled passion for art shopping, I wasn't that surprised to learn he soon bought another work by Picasso!

CHAPTER NINETEEN

Valuations

Valuing collections for insurance, probate and family division was one of the principal and most important services we offered as it enabled us to forge strong relationships with these clients and get to know their collections intimately. It was something I always looked forward to, especially when substantial collections such as those of Peggy Guggenheim, Robert von Hirsch, Louis Franck, Stavros Niarchos, Pauline Karpidas and Henry Moore's own collection were involved. Peggy Guggenheim's in Venice was the first major one I did and it was the most difficult. She had agreed to exhibit her collection of 189 paintings at the Tate Gallery at the end of December 1964, but she had demanded very high insurance values which the Tate disputed. Accordingly, I was asked by the Tate, presumably with Peggy's agreement, to negotiate more sensible figures with her in Venice. This I did in October and it was quite fascinating to go around the collection, examining each picture carefully, closely followed by Peggy who was not in the best of tempers after having her values disputed. When I had finished, she dragged me into her bedroom, sat me down next to her on her bed, famous for its headboard by Alexander Calder, with her Lhasa Apso dogs scrambling over us. Then began a quite long, unpleasant process of negotiating a figure for each of the pictures; we finally agreed on a compromise figure of $5,328,950, acceptable both to her and the Tate.

The first fortunes made after the Second World War in Europe were created by Greek ship-owners, who realised the opportunities on offer by buying up American Liberty ships for such derisory sums as $10,000. Over 2,500 were built between 1941 and 1945 to carry vast amounts of food and raw materials to England. These ships enabled them to corner a major

part of the world shipping market, especially after the closure of the Suez Canal in 1956, when longer sea routes around the Cape of Good Hope meant greater profits. By the 1950s, several of the Greeks had begun collecting Impressionist paintings of the highest calibre and within a few years were forming impressive collections, led by Basil Goulandris and Stavros Niarchos, who had insatiable appetites for masterpieces. Niarchos's first acquisitions were at the Gabriel Cognacq sale in Paris in 1952, the first auction of an important collection after the Second World War. At about the same time, he bought one of the great Paris houses, the Hôtel de Chanaleilles, filling it with magnificent French furniture and silver. Then in 1957, his big coup was to buy most of Edward G. Robinson's fabulous collection, which he had to sell as part of his divorce settlement. Of all the Hollywood collections formed by actors, producers and directors, his was the finest, containing superb paintings by all of the Impressionist and Post-Impressionist painters. (In fact I had the pleasure of meeting him in 1973, when he asked me to come and see him at Claridge's, after which we sold much of what was left of his remaining pictures that summer. I found him to be down to earth and friendly.) The following year saw the famous Goldschmidt sale. Having successfully bought the Robinson collection *en bloc,* Niarchos tried the same coup by approaching Goldschmidt's son Erwin after Sotheby's had announced the sale to the press and offered to buy the seven paintings outright for £600,000. Persuaded by PCW that he would realise more by leaving them in the sale, Erwin rejected Niarchos's offer. Infuriated, Niarchos refused to attend the sale, although he did manage to buy van Gogh's magnificent *Jardin Public à Arles* when it re-appeared in Henry Ford II's auction in 1980.

In the subsequent years until his death in 1996, he continued buying at most of the great sales in London and New York, a tradition continued by his son Philip. I only met him once, but found him uncommunicative, which was a shame as I would love to have talked to him about his collecting. However, this was not the case with the manager of his art collections and horse racing activities, Marke Zervudachi. An unpretentious, gentle man, a few years older than me, he had an excellent eye. We became good friends and it was a pleasure to discuss the merits of a sale and its pictures with him. Naturally, it was PCW who maintained an excellent relationship with Niarchos and who arranged for us to value his vast collections for insurance purposes on a regular basis. This was one of the landmarks of my career: usually accompanied by David Nash or one or other of my colleagues, I travelled to Paris to examine the pictures there, then on to Monte Carlo, where some of his best Modern works were hanging in his huge 115 metre long yacht, Atlantis II, and lastly to his chalet

in St. Moritz. Those in New York were valued by David Nash and I occasionally accompanied him.

There was one amusing little incident that occurred when David and I went to Niarchos's apartment on 5th Avenue to prepare another insurance valuation. In order to properly catalogue his bronze cast of Degas' *Petite Danseuse de Quatorze Ans*, we had to make a note of the cast number and foundry mark, which are usually found on the sole of one of the feet. We looked, but could find no trace of them. Finally, David got his torch, lifted up the dancer's muslin tutu, and, at that very moment, just as we found the number at the top of her inside thigh, the maid came into the room and gave us a decidedly funny look. She quickly left before we could explain ourselves, leaving us to laugh at this 'saucy' incident.

The last time I valued the pictures in the Paris house, I was joined by Andrew and Emmanuel Di Donna. It was very refreshing and interesting to see how they reacted on seeing these paintings for the first time in their very grand setting, giving me a different perspective on several of them.

The Greeks were not the only shipping magnates who collected art. Another I admired and became fond of was the Israeli Sami Ofer. He had already collected modern Israeli paintings, but it was not until he was about sixty years old in the mid-1980s that he turned his attention to Impressionist and Modern Art. It happened by chance that an Israeli dealer living in New York persuaded him to come to one of our evening sales in New York. Prior to that he had no interest in buying expensive pictures because, as I heard him tell his son, Eyal, who wanted to start collecting himself, that he was too young and must concentrate all his energies on developing the business first, as he had done. Going to that sale in 1984 captivated him and it was then that he started buying pictures seriously, at first quite modestly, but soon refining a natural eye and aspiring to increasingly better quality. Over the following twenty years or more, he gathered together a group of extremely well-chosen works that have included an impressive number of masterpieces. Like other successful businessmen I have known, he discovered a totally new world of art, of auction house experts, dealers and museum curators. He sought their advice and friendship and Sami and I spent many interesting times together talking about the quality and desirability of pictures coming up for auction; he was always keen to learn and broaden his horizons. Similar to other collectors who are still alive and active, I hesitate for reasons of discretion to write in any kind of detail about their acquisitions and their enjoyment of them, and, thus, can only mention Sami's passion in the broadest of terms.

CHAPTER TWENTY

Competition, Takeover, Collusion

Competition

During the 1960s and '70s, our department encountered little competition in either London or New York from Christie's. For many years, Sotheby's had enjoyed a stronger presence on the Continent and we were successfully operating the biggest auction house in the USA. It was my impression that Christie's had viewed this international market with less enthusiasm and resources than the Old Master market where they were particularly strong, to the point of maintaining an almost monopolistic hold on traditional Country House collections. This was eventually to change over the course of the ensuing decades, as Sotheby's gradually forced its way into these houses, so that by the 1980s, Christie's and Sotheby's both held great House Sales and each had a more or less equal share of the domestic and international auction market for Old Master paintings, be they Italian, Dutch or French on both sides of the Atlantic.

Not only did Christie's not have a firm foothold in the international Impressionist and Modern Art market in those decades, they simply lacked the same quality of expertise. They finally grasped the nettle in 1977, by establishing their own saleroom in New York. The opening of Christie's on Park Avenue should have been a clear signal to Sotheby's in New York that they were now finally in a position to offer much tougher competition in America. Unfortunately, my colleagues at that time didn't wake up to this fact soon enough. For twelve years, they had mostly had their way in New York, with easy pickings among most of the available paintings and collections for sale by auction. Sotheby's commission had traditionally

remained at 10%, but Christie's, the new boys on the block, became very aggressive in the way they went after important property. This manifested itself in their offering enticing terms and financial incentives to sellers and starting what developed into destructive turf wars, culminating in the disastrous US anti-trust investigation of the collusion affair in the mid-1990s and, inevitably, a major loss of revenue for each house.

The first evidence of this competitive approach that I experienced came in 1979 when Christie's, hearing about a possible sale of the Rosenberg collection, stepped in and offered Alexandre Rosenberg lower terms than we had already contractually agreed for the sale. We were absolutely furious, but to show good will and to finally clinch this important sale, we agreed to match Christie's offer of a 4½% commission.

Thereafter, Christie's in New York were battling with us by offering sellers lower and lower terms in an effort to get important consignments by any means possible. This eventually led to situations whereby some vendors were being offered nil commissions, guarantees and, apparently in later years, even offering owners of great collections part of the buyer's premium. Until then the premium, a commission paid by the buyer, had been made sacrosanct by a binding agreement between both houses when it was first introduced in 1975 to augment falling earnings. Consequently, over the past twenty years, the buyer's premium has been steadily increasing, to the point where buyers now have to pay 25% on lots sold up to £25,000, 20% up to £500,000 and 12% thereafter, plus any applicable sale taxes. For some time now, I have considered this situation iniquitous for the simple reason that almost all the work done to affect a sale is for the benefit of the vendor; while very little is done for the buyer who is forced to pay the premium, apart from any advice about the sale he may seek and such post-sale services as arranging shipping or restoration work. By the start of the 1980s my New York colleagues had woken up to the situation and begun to compete seriously for business. Although Christie's sold nine exceptional paintings from the collection of Henry Ford II in 1980, thereafter, during the rest of the '80s, most of the American estates and collections were sold at Sotheby's, such as those of Leigh Block, Edgar Garbisch, André Meyer, the Havemeyer family, Florence Gould, Sally and Victor Ganz, John T. Dorrance, Kaufman and Ortiz-Patino.

Competition for the best collections during the 1980s and 1990s became ever more intense and sometimes overly aggressive. Collectors and lawyers acting for estates were demanding and being offered lower and lower commission rates, financial advances and sweeteners. Increasingly, the two houses were offering to guarantee the sale of property, whereby the vendor received a minimum price, regardless of whether the work or

works sold or not. The auction house in turn would receive a percentage participation on any amount above the agreed, fixed, guaranteed figure; thus, if a painting sold very well, the auction house could earn a significant profit for itself, but if unsold, it had to pay out the vendor and became the owner of the work. In time, this combination of factors was to take a serious toll on our respective earnings, particularly as both houses were being landed with unsold guaranteed pictures.

The Taubman Takeover

This climate of hostile competition took hold following what was to be an extremely difficult time for Sotheby's after Peter Wilson's retirement to his house, the Château de Clavary, in the South of France in the spring of 1980. It had long been expected that Peregrine Pollen, head of Sotheby's in New York, would become chairman in his place, but PCW, who had turned against Peregrine after several differences of opinion, instead decreed that his cousin, the Earl of Westmorland would succeed him. Frank Herrmann, author of *Sotheby's: Portrait of an Auction House*, wrote of PCW's retirement: 'Bond Street will seem different without PCW's tall, elegant, powerful frame strolling about the galleries. There are many who will miss the style he has made his own in the rostrum at major sales: the pregnant gesture, the momentary pause, the head tilted left and the come-on smile, the raised eyebrow, the deprecatory look that says "You really should have made another bid" or that instant communication with a hesitant bidder that generates confidence, and the slow cadence of the falling gavel that gives competing buyers every chance to come in with another bid'.

David Westmorland, a thoroughly decent man, was somebody PCW thought, as was his wont, he could dominate. A close-knit cabinet of four consisting of David, Peregrine, Graham Llewellyn, head of the Jewellery department, and Peter Spira, the Finance Director, was formed to run Sotheby's worldwide operations. It soon became apparent that this was not a particularly cohesive team, with tensions and disagreements surfacing that were not beneficial to running an effective international business, particularly at a time of serious economic downturn. The combination of these two factors resulted in a drop in the value of our publicly held shares both on the London and New York stock exchanges. Sotheby's was getting deeper and deeper into trouble, earnings were dropping and in 1982, we posted our first annual loss in the region of £1 million.

Shares in the company began to be bought in quantity, and particularly by two New Yorkers, Stephen Swid and Marshal Cogan,

modest collectors and owners of General Felt Industries and Knoll Group, the well-known manufacturer of contemporary furniture. Swid and Cogan were also known for buying up companies that were experiencing financial difficulties and the 'Gang of Four' was not at all happy when they received a hostile bid. At one of the meetings concerning the takeover Graham Llewellyn rather rashly said he would blow his brains out if they were successful. This unfortunate statement was gleefully repeated by the press, but luckily no blood was shed by Graham.

Gordon Brunton, the managing director of Thomson Newspapers in London, was asked to investigate the situation at Sotheby's, where he had been a non-executive director since 1978. He first interviewed each senior head of department in turn, both in England and the United States, asking for our views on the current situation. Following his enquiry, Brunton recommended that the Gang of Four step down and that Julian Thompson, who had joined Sotheby's a few years after me, should take over as Chairman: Julian was a brilliant Chinese porcelain expert and head of the Oriental Works of Art department. PCW was made Honorary Life President. He had continued to maintain a very close involvement, almost to the point of interference, in the way Sotheby's was run and Gordon Brunton had the unenviable task of telling him that his persistent involvement in the workings of the London office must stop. Brunton was respected by PCW who, after all, only wanted what was best for Sotheby's and so backed off.

To combat Swid and Cogan's takeover bid, we needed a 'White Knight' and while Brunton's enquiry was under way the Knight rode in, in the form of an American entrepreneur called Alfred Taubman. David Metcalfe, the son of Fruity Metcalfe, the Duke of Windsor's aide and friend, was the god-son of the Duke, as was David Westmorland. He had known Alfred Taubman for many years and, after a particularly successful real-estate deal, Taubman asked if he had any investment ideas. Knowing what was going on at Sotheby's, David Metcalfe arranged a meeting between him and Westmorland.

There were other connections too: David Metcalfe's wife had been married to Sir Alexander Korda, whose collection was the first I had catalogued in 1962. Alexis Gregory, my good friend during my first year at Harvard, was an old friend of Alfred Taubman and became one of the investors in his takeover of Sotheby's. He has remained on its advisory board ever since, and is still president of the international advisory board and a great supporter and advocate of the company.

An architect by training, Alfred Taubman was the king of the shopping malls. A large, tall man, he was a stereotypical, successful American

entrepreneur complete with a fat cigar in his mouth and a deep mid–west drawling voice. Alfred was a pleasant man to work with. He inspired confidence, bringing a wealth of American experience to Sotheby's. He had a good eye and collected fine Chinese porcelain, Impressionist, Modern and Contemporary Art. Alfred was a very affable, friendly man and I remember well his first approach to the senior experts. We had organised a dinner for him in one of our galleries, which he attended with his lawyer and confidant, Jeffrey

A. Alfred Taubman

Miro. Every ten minutes or so during the dinner he would move up two seats, introducing himself and asking questions about us and our departments. It was all quite relaxed and on the whole he made a good impression; we were generally quite happy to accept him as our new American owner, although sad that after 240 years Sotheby's would no longer be an English company.

In 1984 Alfred Taubman appointed Michael Ainslie, former president of the American National Trust for Historic Preservation, Chief Executive Officer with the remit to act as a buffer between Alfred and the New York and London operations. New York continued to be run by John Marion, its President and excellent chief auctioneer. London's Chairman, Julian Thompson, eventually stepped down to be replaced by the Earl of Gowrie in 1985. Grey Gowrie had been Mrs Thatcher's Minister for Culture from 1983 until 1985, when he left the Government. Prior to this he'd been a partner of Thomas Gibson, a well-known and successful Modern Art dealer in London. A former English master at Eton, Grey is a poet and writer, and a much respected figure in cultural circles. After leaving Sotheby's he served as Chairman of the Arts Council for four years. He did a lot for us as a result of his contacts within the government and the museum community. I had known him for quite some time and was delighted that he had joined us. However, I felt he never really quite grasped the intricacies and psychology of the public auction process, perhaps because he had a greater familiarity with the ways of private dealing and government.

Collusion

After nine years as a successful CEO, Michael Ainslie's relationship with Taubman became strained and he resigned. Diana (Dede) Brooks was appointed in his place in 1993. A banker, she had first begun working at Sotheby's in the finance department and by 1985 was the company's Executive Vice-President in New York. There is no doubt that Sotheby's was her life and blood. A diligent and hard worker, she accomplished much, but after she became CEO, Sotheby's also became her obsession and the power she wielded went to her head. She antagonised several senior experts, whose roles she began to usurp, including both Lucy and David Nash who resigned as a result. In 1995, at a time when competition between Sotheby's and Christie's was at its highest and earnings were at their lowest, accompanied by a further worrying downturn in the market, Dede began having secret meetings with Christopher Davidge, Christie's CEO, to try and remedy the serious drop in earnings caused by the intense competition over commission rates. As the court case later revealed Dede and Davidge, at the behest of Taubman and Christie's chairman, Sir Anthony Tennant, finally came up with a non-negotiable, sliding scale of commissions charged to vendors, based on the size and value of a consignment, with a 2% minimum. Agreeing these specific commission rates was, in fact, market rigging and as a consequence both companies' earnings began to grow again, but with a heavy price to pay later.

When the scandal broke, America's anti-trust laws were brought into full effect. The notes which Davidge had made after secret meetings with Dede at Kennedy airport were crucial to the prosecution and, in exchange for handing them over, he gained an amnesty for himself and for Christie's on the basis that the first to blow the whistle would not be prosecuted. However, that did not prevent Christie's suffering the same huge fines as Sotheby's. The outcome was catastrophic for Sotheby's, as it was for Christie's. Three hundred and seventy Sotheby's employees lost their jobs as a result of the downturn in business and an unknown number at Christie's, and both Alfred Taubman and Sir Anthony Tennant, Christie's Chairman, were accused of 'collusion' in fixing commission rates.

Following his trial in April 2002, Alfred Taubman, who denied that such fixing ever came up in any private meetings with Sir Anthony Tennant, was sentenced to a year and a day in a minimum security facility. Dede Brooks did not receive a prison sentence because, in an agreement she had made with the prosecution, she implicated Alfred Taubman as the instigator of the whole affair. In his summing up the

judge stated '…Once the finger of guilt was pointed in your direction, your decision to co-operate was self-serving, not self-sacrificing. You have not earned absolution…' Dede received three years' probation, six months' home detention and a thousand hours of community service plus a fine; she also volunteered to return all her Sotheby stock options back to the company. The whole affair has been written in great detail by Christopher Mason in *The Art of the Steal* and, as I was not personally involved in the scandal, have only alluded to it here, with its effect on the department.

Dede Brooks

I had always remained on excellent terms with Dede; I liked her bubbly personality and admired her extraordinary business acumen, but I blamed this highly intelligent woman for being taken in by Davidge, whom I considered a real snake in the grass. I could never understand why she had been so unprofessional as to have engaged in secret meetings with him, unaware he had made notes of their meetings, which became the prosecution's crucial evidence.

Although there was a lot of talk about adjusting commission rates at the time, the fact that we, on the European Board, were only informed rather than consulted on these matters, seriously upset us. It was a fait accompli and there was nothing we could do to affect the decision on our side of the Atlantic. Our reputation was tarnished and we suffered some loss of business as the public was quite shocked by the behaviour of the New York auction houses. The number of sales that came our way was considerably reduced and the morale of the staff was notably affected for a long time. Many of us suffered personally when Sotheby's shares dropped to an extremely low level, wiping out any real gain from our stock options, and stayed low for a long time as the burden of the fines took its hold on our yearly income for several years.

The anti-trust era will, in time, become a sore blip in the company's history. Sotheby's returned to a healthy position, making considerable profits after a few short years under the leadership of Bill Ruprecht, helped enormously by a resurgent European and global market. As a result, the

PICTURES, PASSIONS AND EYE

company is better managed, although some of my former colleagues resent being bureaucratically over-managed, and the collusion debacle, I hope, should have a positive, long-lasting effect. However, since I left at the end of 2000, competition between the two houses has raged stronger than ever, each side giving more and larger guarantees to the point where, in the summer of 2008, they had totalled an unimaginable $1 billion. Since then the world has gone through a serious recession, although it's now coming out of it, and guarantees have come to a virtual standstill. In the meantime vendors' commissions and buyers' premiums have been raised to bring in considerably more revenue to offset the heavy losses of the previous years.

The Last Decade

The Koerfer Debacle

We all unwittingly make mistakes, Sotheby's as well as Christie's. One such disappointment was losing the sale of a fabulous collection to our rivals. This was similar to a situation in 1989 when Christie's thought they had the John T. Dorrance sale in the bag because the late collector's daughter-in-law was a Christie's representative; in fact Sotheby's made such an excellent presentation that it won the sale. A few years later it was Christie's superior efforts that won them the Koerfer collection. Jacques Koerfer was one of those collectors with whom I had forged an excellent relationship. A German Industrialist who had moved to Switzerland many years before, he had gathered together a superb collection of Post-Impressionist and Classic Modern paintings. With his elegant wife, Christine, he lived in a concrete and glass house designed by the Bauhaus architect Marcel Breuer, built on a steep hillside overlooking the Swiss part of Lake Maggiore near Ascona. A tall, distinguished figure with a rather severe charm, Jacques Koerfer and I got on well together. I admired his discerning taste and he respected my expertise and knowledge of the market.

To get to the house meant flying over the Alps into Lugano's tiny airport in a propeller-powered plane, either from Geneva or Zurich. As it was usually late morning before I finally arrived, we would first sit down to a delicious lunch in their dining room, surrounded by Cézanne, Picasso and Matisse paintings. It was quite off-putting being overlooked by these masterpieces, while at the same time trying to eat and make intelligent

conversation. After lunch, we removed to a vast drawing room overlooking the lake, on whose walls were great works by Léger, Mondrian and Gris. Jacques and I would then chat about the dealers we knew and any special exhibitions we had recently seen. Finally, before I left for the airport, we would walk around the house together, discussing the current value of each individual picture.

Jacques died in the winter of 1993 and the following spring his son Patrick told me that his mother and nine siblings had decided to sell the collection and that they were going to ask Sotheby's and Christie's to make proposals for a sale. The first step was to catalogue and value the pictures. Accordingly, David Nash and I flew to Lugano, where we rented a car for the day. We arrived at the house and it was some time before a maid finally answered the door. Although she seemed to have expected us, she was a bit hesitant about letting us in. Oddly enough after this discouraging start, she disappeared into the kitchen and let us wander around at will.

A number of the best Impressionists were in the dark entrance hall.

MEMORANDUM

TO: AUCTION HOUSES, ART GALLERIES & DEALERS
FROM: SCOTLAND YARD
DATE: JULY 15, 1993

LAST KNOWN PHOTOGRAPH OF THE FAMOUS ART THIEF MIQUEL STRAUSS SEEN PLANNING HIS ABDUCTION OF A VAN GOGH SELF-PORTRAIT. NOTE RED GETAWAY CAR IN PARKING LOT. REWARD FOR INFORMATION LEADING TO APPREHENSION.

Humorous memorandum from David Nash following our visit to the Koerfer house in 1993

The one painting we really wanted to have a good look at was an admirable van Gogh self-portrait, one of only very, very few still remaining in private hands, which he had painted in September 1889 as a gift for his mother, Anna. David and I decided to take it outside where we could examine it properly in daylight, but felt we should ask permission from the maid first. However, we could not find her anywhere, so we took the van Gogh off the wall, went out by the front door, and leant it against a concrete pillar. At this point, to our dismay, a gust of wind blew the door shut, leaving us out in the cold with our booty. To record this momentous event, David photographed me kneeling on the ground next to the self-portrait. When he later developed the film, he saw that by chance he had included the nose of the red hire car in the background. Highly amused by this, he sent me a copy of the photograph captioned: 'Last known photograph of the famous art thief Miquel Strauss seen planning his abduction of a van Gogh self-portrait. Note red getaway car in parking lot. Reward for information leading to apprehension.' Eventually we managed to find the maid who let us in, blissfully unaware of what had happened, and replaced the self-portrait on the wall.

Then came the day when we made our presentation to members of the Koerfer family. We were summoned to a featureless office, in an anonymous building in the centre of Zurich, as were Christie's, who were to appear after us in the afternoon. Apart from me, our team consisted of David, John Tancock, Christoph Douglas, head of Sotheby's Germany, who knew one of the Koerfer children, Simon de Pury and Dede Brooks. We had decided that each one of us would speak for a few minutes on a different aspect of the proposed sale: David as head of the New York department, John who would be writing the catalogue, and Dede to present a financial proposal. As an old friend of Jacques Koerfer, I would talk fondly about him and his pictures. Perched stiffly on chairs facing the family, we each made a little speech. Dede, a tall, good-looking and gregarious woman with a wide smile and big blonde hair, had enviable financial and management expertise, but she was not exactly in tune with old-fashioned European manners and the subtler ways of expressing oneself. She sounded rather brash and I felt that overall our presentation was stilted, unbalanced and lacking in enthusiasm.

When it was Christie's turn, their all-English team asked to sit around a table with the Koerfer family members, which must have created a more relaxed atmosphere. We soon heard that the sale was going to Christie's: the Koerfers had preferred their approach and ideas. I was dreadfully disappointed that the family had not responded

favourably to our expertise and the passion I hoped I had expressed, but obviously it was not enough.

Sometime later I ran into Patrick Koerfer who said that if I had been on my own the family would have responded favourably to Sotheby's proposal, which was flattering but, perhaps knowing how fond I had been of his father, he was trying to save my feelings. Christie's did a fine job, presenting the pictures in several separate catalogues in New York during a four-year period ending in 1998 and producing an overall total of $158 million. The van Gogh self-portrait made $71.5 million, a well-deserved price for such a rare and moving painting.

Mismanagement

By 1991 the recession following the Japanese meltdown had begun to hit the art market quite seriously which forced Sotheby's Holding Board to impose severe cost reductions. This was the time when London's managing director, Tim Llewellyn decided that Marcus Linell and I should take a cut in salary and the hours we worked. At the time, one of the colleagues from whom we received support was Simon de Pury.

I had first come across Simon in the early 1970s when he was on the Sotheby's Works of Art course. A native of Basel, his first job with us was in the Geneva office, of which he eventually became head. During that time he forged quite a close relationship with Heini Thyssen, who persuaded him to leave Sotheby's to be the Director of his fabulous collections of Old Master, Impressionist and Modern pictures, housed at the Villa Favorita on the idyllic Lake Lugano. Following a few successful years there, he rejoined us in 1987 in a much more senior position, as Chairman of our vital Swiss operations and eventually, in later years, Chairman of Sotheby's Europe, before suddenly resigning in 1997 to be a dealer in Geneva. A slim, elegant figure, quietly spoken yet exerting an aura of charm and old-fashioned courteousness, Simon used these qualities to great effect, persuading a number of Swiss and other international collectors to consign important property and collections for sale. Together we would visit some of the fabulous collections located mainly in Zurich, Basel and Geneva. Driving around Switzerland in his car, it amazed me that a man of his quiet demeanour loved listening to loud rock music whilst he was at the wheel and I was fast asleep, probably having just come off an early flight from Heathrow.

Simon was not an expert in any specific field, but he had an instinctive feel for the value of important works of art, fuelled by an

ambition which is the driving force of his nature. In the early 1990s he expressed an ambition to become the Impressionist department's chief auctioneer, a role which hitherto had traditionally been the privilege of the Chairman or a senior member of the department. Simon saw this as an ideal platform to show off his theatrical skills and advance himself in Sotheby's worldwide operations, whereas I felt that this prerogative should fall to someone in the department with the necessary specialist knowledge of the subject and the clients, such as Julian Barran or as at present, the UK Chairman, Henry Wyndham. Simon, with his characteristic persistence, managed to persuade Grey Gowrie and Tim Llewellyn to let him have his way, much to my annoyance. During discussions I had raised my objections, but soon realised I had been out-manoeuvred and that it was already a fait accompli. However, I must admit, Simon evolved into a fine, extrovert auctioneer, shouting out the bids in a number of languages in operatic tones, with grand flashing gestures to an audience, many of whom loved this highly-charged spectacle.

Enormously ambitious, Simon's next target was to be head of the Impressionist department and how he managed to get what he wanted has remained a mystery to me. About a year after he became our auctioneer, he finally got his wish. By means of using his persuasive abilities, I believe, Tim and Grey promoted Simon to become both head of the Impressionist department and of all the other picture departments in 1992: anxious to do anything to keep him on board, they asked me to step down from both these roles, another fait accompli infuriatingly done without involving me in the decision.

I was of course furious and hurt by the conspiracy of three colleagues, but on reflection soon realised what a relief it was to have the managerial and administrative elements of my responsibilities taken out of my hands. Senior and middle management, including the legal and compliance departments, had all begun to have an increasing say in controlling the way we ran our daily affairs. For so many years since the 1960s I had had extraordinary freedom in running the department my way, in making many financial decisions, from offering special terms to vendors, including pre-sale advances and arranging credit terms for buyers whom I had known and trusted for many years. Everything we now did had to be approved and signed off by managers, who were not always familiar with the nature and character of the auction world and its clientele. Every action had to be justified; arbitrarily artificial targets had to be reached. Bureaucracy and red tape had taken over. From a firm traditionally run by its experts, by the 1990s the heads of the expert departments were now being controlled by the 'men in suits', eager to satisfy the company

shareholders whose only goal was profit. This state of affairs was something that Marc Blondeau foresaw in 1987 and David Nash and Lucy Mitchell-Innes in the 1990s.

I was now in a position where I was able to do what I most enjoyed, which primarily meant dealing with the sellers and buyers, the collectors and dealers, using my abilities, knowledge and experience of the market to bring important pictures and collections in for sale. In a spirit of generosity, in spite of what had transpired, I offered to help Simon but he seemed very reluctant to ask for any advice apart from values. Being very much his own man, he was secretive about his clients and not a team player, not the best of qualities if an international department was to operate successfully. Simon was a brilliant and dynamic business-getter, but management was not his forte. Within a year spent running between London, the Continent and New York, he was made to realise that this was not a suitable role for him and that the Impressionist department needed to be managed properly by someone who had a great deal more experience and expertise in that field, with their feet firmly planted in one city.

By now, Grey and Tim were consulting me on the future of the department. We decided that I was of more value travelling the world business-getting and certainly I did not wish to be involved in managing a department again. Melanie was deemed the right person to succeed me and was accordingly promoted in 1993. She had all the skills required, enjoyed management and had an admirable talent for looking after and enthusing the members of the department, while dealing with senior management and forcefully getting things done the way she wanted for the benefit of the sales and our clients. We worked well together, I was doing most of the international travel, mainly around the Continent, Japan and the United States, and she was much more home-based. I speak French fluently with a smattering of a few other languages, while she was more focused on British and American opportunities and didn't enjoy travelling as much as Philip Hook and I did. We were a well-balanced team together with our key colleagues on the Continent.

Following David Nash's resignation, Dede Brooks appointed me worldwide Chairman of the Impressionist and Modern Art department in 1997. I had forged an excellent relationship with her; we respected each other and seemed to agree on many of the policies for the departments. After Alex Apsis, who had replaced David, decided to resign as head of the New York department in 1997, Dede asked me to play a supervising role in the department until a suitable replacement was found. I accordingly spent two weeks every month in New York between 1997 and 1998.

Within several months we had identified a possible candidate, Charles Moffett; Dede sent me down to Washington to meet and see what I thought of him. We met in his office and then went to talk more privately in a local Starbucks. I found Charlie to be an engaging and highly intelligent person. He appeared keen to leave the museum world for the quite different atmosphere of an auction house and was duly appointed head of Impressionist and Modern Art in New York early in 1998. Charlie, a distinguished academic and much respected historian and connoisseur of Impressionism, had been the curator of 19th- and 20th-century paintings at the Metropolitan Museum and the National Gallery in Washington DC before finally becoming Director of the Phillips Collection.

A van Gogh Watercolour

In spite of these demoralising events, my last four years were marked by the sale of three Impressionist masterpieces in London and an involvement in the sale in New York of one of the finest American collections ever assembled; these represented some of the most exciting events of a long career. By the latter part of the 1990s the market had regained much of the strength lost after the Japanese 'bubble' had burst in the first year of the decade, at least for important pictures which were being more sought after than ever, fuelled in part by the expected profits of the short-lived dot com euphoria of the mid to late 1990s. The first of these masterpieces was the most important van Gogh watercolour to have appeared at auction, certainly in my time. This is not surprising considering that so many of his finest works on paper were never sold, as they were inherited by van Gogh's nephew and eventually ended up in the purpose-built van Gogh Museum in Amsterdam.

It must have been in 1991 that Hugues Joffre came back from a trip to visit Post-War art in local collections with Lady Victoria Leatham, *chatelaine* of Burghley House and our East Midlands representative. They had visited a lady in a remote village not far from Stamford in Lincolnshire, who said she had some Impressionist pictures she wanted valued. One can imagine their surprise when they came across a van Gogh and a few other less valuable works. I remember Hugues excitedly coming into my office to tell me what he had seen. As soon as was convenient, 'Vicky' Leatham took me to the cottage belonging to an elderly woman who showed us in, sat us down in front of her van Gogh and offered us a cup of tea. I was unable to take my eyes off the watercolour, but we had to observe the niceties and pleasant conversation before I could have a really good look

and take it off the wall for a detailed examination. What immediately occurred to me was that, as almost perfect facsimile reproductions of Degas, van Gogh and Cézanne drawings and watercolours had been produced in Germany in the 1920s, this possibly could be one of them.

First of all, I needed to know how she had acquired it, and as soon as she said it had belonged to her mother, Anne Kessler, it all clicked into place. Anne Kessler was a well-known collector I knew of, but had never met. I also knew that she had made a significant bequest to the Tate. Her father, Jean-Baptiste-Auguste Kessler, had been one of the founders of Royal Dutch Shell with Marcus Samuel (1st Lord Bearsted) and Henri Deterding. Needing extra capital investment in 1902 to develop their oil fields in Indonesia and the Caucasus, they had gone to my great-grandfather, Emile Deutsch de la Meurthe and his brother Henry, who agreed to invest and buy shares in this new company. And when in 1921 my great-grandfather decided to sell their oil company, Jupiter, it was to Royal Dutch Shell that he sold.

The watercolour was duly taken off the wall and examined in daylight by the window, revealing that this was no reproduction and, extraordinarily, it was still in its original, fine condition. These delicate works in ink and watercolour are so prone to fading when exposed to light for a prolonged period of time. Miraculously, this van Gogh had been carefully looked after. The subject of the watercolour was a panoramic view of the fertile plain of La Crau that ran between Arles and Les Alpilles, a chain of rocky hills, to the north. Executed in early June of 1888, van Gogh first drew the composition roughly in pencil, then in great detail in reed pen and brown ink before applying the final layers of watercolour and gouache, thereby creating a fully finished work. Writing to his brother Theo on 12 June 1888, Vincent wrote of 'fields green and yellow as far as the eye can reach...It is exactly like Salomon Konnink – you know, the pupil of Rembrandt, who painted vast level plains.' In this magnificent watercolour titled, *La Moisson en Provence*, the eye is first attracted to fences, grasses and a blue hand-cart in the foreground, before being drawn back through the landscape, jumping from one red-roofed house to another before reaching the famous Abbaye de Montmajour in the distance on the left and Les Alpilles on the horizon.

The watercolour had a distinguished history and was among the very first works by van Gogh to be sold by his sister-in-law, Joanna. *La Moisson* was purchased in 1899 by the famous German art historian and critic, Julius Meier-Graefe, who published it in *Germinal*, an important Berlin journal, that same year. Two years later, he sold it to Jos. Hessel, a partner in the well-known firm of Paris dealers, Bernheim-Jeune.

Vincent van Gogh,
La Moisson en Provence,
reed pen, brown ink,
watercolour and gouache
on paper 1888,
private collection

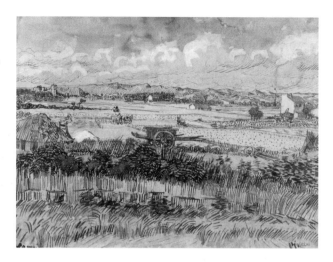

Passing through the hands of the famous Berlin modern art dealers, Paul Cassirer and Alfred Flechtheim, during and after the First World War, it finally turned up with Paul Rosenberg in Paris before being consigned to the Alex Reid & Lefevre Gallery in London who sold it to Anne Kessler by 1930.

Mrs Kessler's daughter wanted to have an idea of its value for her family's trust. It has always been difficult to value works that have an almost unique quality and for which there are few if any precedents. The value of £6 million I quoted was based on the $7.6 million that an important pen and ink drawing (without any colour) of the same date made in New York in November 1990. I was thanked for the visit and there seemed to be no prospect of its sale in the immediate future. That was the last I heard of it until I was contacted in the spring of 1997 by Anne Kessler's grandson, the beneficiary of the Trust that owned it. He had decided to put it up for sale in order to start collecting Contemporary Art. You can imagine how excited I was at this news. He and his wife were a friendly couple and easy to deal with once I had explained the intricacies of the auction system to them; they were happy to accept our estimate of £6–8 million with a reserve of £6 million and a sale the following June. However, a few weeks later he came to see me with the disturbing news that he had received a private offer of £8 million, but allowed us the possibility of auctioning it, if we felt the picture could sell at least at that figure. It was quite a dilemma, but Melanie, Philip and I, in particular, felt confident that one of van Gogh's most important works on paper would make that, if not more. On that basis he decided to keep it in the sale, but we published 'estimate on request' in the catalogue. When asked what we

expected it to fetch, we would say 'in the region of £8 million', which was justifiable due to its quality and rarity.

During the pre-sale exhibition, *La Moisson* was much admired but dealers and knowledgeable collectors thought our estimate was high, so it was with some trepidation that we feverishly awaited the outcome of the sale. When the auctioneer, Henry Wyndham, our UK chairman, began the bidding there was at first no reaction in the room or from the bank of telephone bidders. I was beginning to feel desperate when, finally, Dede Brooks raised her hand to signal a bid from the client she was on the telephone with. No one else bid, so Henry quickly knocked it down to her for £8 million; to my enormous relief the gamble had paid off. The buyer was an Austrian who, in the 1990s, was buying a number of important works for investment, but when he ran into financial difficulties, far too soon to realise any kind of profit, he started re-selling many of the works he had bought. Six years later he put the van Gogh up for sale with us in New York, but it realised only $9.2 million as against the £8.8 million (with the buyer's premium), it had cost him. I don't feel it was the market that had changed, but people realised this was a forced sale as the estimate was only $7-9 million, far lower than the purchase price. It so often happens that a great work, when first sold after generations in a family, can make a substantial price, but when re-offered after a relatively short space of time it loses its initial surprise factor and sells for a disappointing figure. Evidence once again that art is a successful long-term investment, unless one is lucky enough to buy during a deep recession and then quickly resell in a booming market.

Monet's *Bassin aux Nymphéas*

The second highlight was one of Claude Monet's legendary *Bassin aux Nymphéas* paintings. This was a prime example of Monet's fascination for the waterlily pond he had created at his property in Giverny and where he spent the last thirty years of his life, painting its ever changing reflections, moods and vibrant colours. In this picture, executed in 1900, we see how the artist has interpreted and depicted the thick carpet of waterlily pads and flowers, surrounded by the dense green and red foliage of late summer. The eye is drawn towards the middle distance to the blue-painted Japanese bridge which Monet had built, inspired by his love for the Japanese woodcuts he collected.

I had first seen this painting thirty years earlier when it belonged to a former colleague who had been Sotheby's first Finance Director in the

Claude Monet, *Bassin aux Nymphéas*, oil on canvas 1900, private collection

1960s. Of German-Jewish origin, he had emigrated to England before the Second World War, bringing with him several fine Impressionist paintings he had inherited. After the war he had continued collecting, acquiring the *Bassin aux Nymphéas* from the London dealer, Marlborough Fine Art in 1954. Although he and I had discussed insurance values during the few years he worked at Sotheby's, I had had no communication from this very private gentleman for almost twenty-five years. Timing our communications and relations with clients is a crucial element in judging situations correctly. I felt it would have been inappropriate to contact him, unless he was to call on me first. And this he did at the beginning of 1998, asking me to come and see him in his modest house in St. John's Wood. He told me that he had decided to move to a flat near Sloane Square and needed to raise some money from the sale of a few of his pictures. He pointed to the four paintings he was contemplating, but the Monet was not one of them. The next day I sent him the letter he requested with my estimates, together with a calculation of what might be the net sale result after the deduction of capital gains tax. Rather cheekily, I also advised him that just selling the Monet would probably satisfy his needs, as it was obvious to me that it would excite a lot of interest, yet never expecting he would agree to part with the most important painting in his collection. We based the estimate on the price realised by an almost identical composition, which had sold for £5.5 million at Christie's ten years earlier, at a time when the Japanese were buying so heavily. As he had wanted realistic, conservative estimates, I quoted him a figure of £4-6 million.

For several weeks I heard nothing from him. Melanie nervously kept on pressing me to contact him, asking, 'Has he received the letter? Could you chase him up? We want to know what he's decided.' I told her to hold her horses, knowing so well from experience that this was the very kind of person not to be harassed or chased. I had to be patient. Then the fateful day arrived; on Friday 13 February he called me to say he had decided to sell the Monet. Keeping my emotions under control, I calmly asked him when he would like me to have it collected. 'Any time,' he said, so Sotheby's carrier was at his door the following Monday, delivering it to us an hour later. You can't imagine how flabbergasted I was and how happy all my colleagues were; it was going to be the highlight of our summer sale.

The build-up to the sale was intense. We sent it, with other pictures, on a pre-sale tour of the highlights to New York, Paris and Zurich, not only in the hope of attracting potential bidders, but also as a way of promoting Sotheby's image in those major collecting cities. On the evening of the auction on 30 June 1998, the saleroom was packed, the atmosphere was intense, the press and TV cameras were squashed into the back of the room and I was in a mood of high nervous excitement. The bidding quickly surpassed the top estimate and rose to £12 million, already double the top estimate, and then slowed leaving it to two collectors, both American, to battle it out over the phone. Finally, after almost five enthralling minutes, Henry Wyndham knocked it down to the successful bidder, amid loud applause from the room.

The final hammer price was £18 million, a record for a Monet that stood until the summer of 2008, when a much larger and later Waterlily painting fetched £36 million. The seller was not in the room, so I immediately called him, telling him, 'The sale has done well – you might perhaps like to sit down.' He curtly said, 'Tell me, what was the price,' to which I replied, '£18 million!' A very reserved gentleman of the old school, he simply said, 'Thank you very much. Goodbye.' I must admit I had hoped for a more effusive reply, but the whole outcome gave me great satisfaction.

Degas' Ballet Dancer

The summer of 1999 saw the sale of the third of these Impressionist masterpieces to pass through my hands – a pastel and gouache by Edgar Degas which Andrew had uncovered in Paris. It happened that he received a telephone call in 1996 from a lady asking him to come and look at three

drawings by Degas she wanted his advice on. Although Degas drawings can be very beautiful and expensive, there is a great number of low value, inconsequential sketches. However, when the woman told him she lived on the Place François 1er, one of the most exclusive addresses in Paris, he offered to stop by the next morning, instinctively feeling that this visit could be a lucrative one. In an elegantly furnished apartment, he was greeted by Robert Gerard, a tall, distinguished man well into his nineties, his wife and one of their sons. M Gerard, an agile man for his great age, immediately rushed Andrew into his dark bedroom with closed shutters overlooking the Place François I, and shone a torch on to three of the most stunning works by Degas that Andrew had ever seen in a private house.

M Gerard's torch revealed three extraordinary pastels by Degas: *Danseuse au Repos*, a most beautiful work, depicting an exhausted ballerina resting on a bench at the Opéra, *Femme au Piano*, an unusual and refreshing subject and last, but not least, one of Degas' greatest pastels showing a troupe of dancers in rehearsal in front of a window, an exquisite and powerful study of light and movement.

The old man explained that his grandfather had been a close friend of Degas, and that he had been surrounded by Degas' works ever since he was a child and that one of his favourites, *Femme aux Chrysanthèmes*, now one of the Metropolitan Museum's highlights and a picture that I had especially loved as a child, once hung in his bedroom. Andrew made some quick calculations realising that M Gerard must have been born around 1900 and sheepishly asked if he had ever met Degas. '*Mais, bien sur!*' the elderly man boomed. His grandfather, Jules-Emile Boivin, a French industrialist and co-founder of the Sommier sugar company, regularly invited Degas to his house and had acquired the pictures either directly from him or through his dealer, Paul Durand-Ruel, in the 1880s.

Andrew asked me to accompany him on a second visit to help him value the works, knowing how much pleasure I would get out of seeing them in their original setting. M and Mme Gerard and their son told us that they felt it was time to consider estate planning and the future of these works by Degas. They said they realised it might be difficult to obtain export licences for all three works to leave France. Andrew suggested arranging negotiations with the Direction des Musées de France, the body that governs all French museums and authorises and issues these licences, or *passeports* as they were called, in association with the Ministry of Culture. After lengthy negotiations permission was finally granted to export two of them. However, they were allowed to leave France only on condition that the superb pastel of a group of dancers rehearsing was passed to the Musée d'Orsay in lieu of taxes due. There it now hangs where it is rightly

Edgar Degas, *Danseuse au Repos*, pastel 1879, private collection

heralded as one of the museum's finest amongst its extensive collection of Degas. The two other pastels, *Danseuse au Repos* and *Femme au Piano* were now free to be sold on the international market.

By early 1999 the market was in full swing and the family decided to sell both pastels, though sadly M Gerard had passed away during the time of the negotiations with the French State. Sotheby's was chosen to handle the sale, given the invaluable advice Andrew had provided the family, our expertise and the relationship he had built up with them; the two pastels were therefore sent for sale to London. While *Femme assise au Piano* was certainly the lesser of the two, *Danseuse au Repos,* executed *circa* 1879, still in the simple white box frame with gold filets Degas had himself designed, is a stupendous pastel and gouache of a young dancer seated on a bench, in deep reflection, exhausted after having completed her ballet exercises. This was the ultimate example of a work in original, mint condition, in a superb state of preservation, as fresh and as beautiful as the day it was painted. To my mind this was the greatest Degas to appear on the market since before the war, along with the Havemeyers' pastel, *L'Attente,* sold in 1983 for $3.4 million.

It made quite a stir in the press when we announced that the *Danseuse au Repos* was coming up for sale at the end of June of that year: the very first time it would appear on the market since Robert Gerard's grandfather had bought it 114 years earlier. The pastel had never before left French soil, but soon it was to criss-cross the globe, making two stops in the United States. As with the Monet a year earlier, the saleroom was buzzing with anticipation. Once again a fierce bidding war took place. With Melanie Clore bidding on the telephone for an American client, the

Degas, estimated at £5-7 million, fetched the quite astonishing hammer price of £16 million and established a new record for the artist. Nine years later, it reappeared on the market, in a Sotheby's sale in November 2008, just as the market was beginning to be hit by the financial meltdown. Nevertheless it sold for $33 million, a not unreasonable profit over and above the $28 million (which included the buyer's premium) the purchaser had paid.

The Whitney Auctions

John (Jock) Hay and Betsey Whitney and Jock's sister, Joan Whitney Payson, were great American collectors of Impressionist and Modern paintings. They had an unerring instinct for buying some of the best pictures available to them on the market, both before and after the Second World War, when works of that quality were still relatively abundant. Since purchasing it in 1947, Joan Payson had for many years owned one of van Gogh's famous paintings, *Irises*, painted at the hospital in St Rémy in the spring of 1889. When her son, John Whitney Payson, sold the work at Sotheby's in 1987, it made a then astonishing sum of $49 million. This price was achieved because Dede Brooks had given special terms to the buyer Alan Bond, an Australian entrepreneur, whereby Sotheby's would lend him half the purchase price, the other half to be paid in instalments. Security for the loan was the painting itself, a very dangerous precedent which, when revealed, created a scandal. Thereafter, Sotheby's stopped making those kinds of loans. The sale of the *Irises* was eventually cancelled and the painting was sold to the Getty Museum.

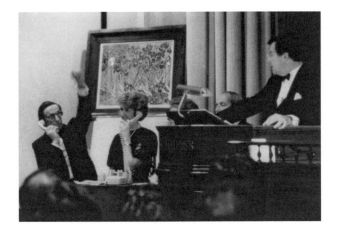

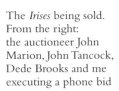

The *Irises* being sold. From the right: the auctioneer John Marion, John Tancock, Dede Brooks and me executing a phone bid

At the time Jock Whitney was United States Ambassador to the Court of St James, my mother, who had first met him during the Second World War in New York, took me to see his collection. This was in 1958. He had covered the walls of Winfield House, the Ambassador's official residence in Regent's Park, with a superb selection of some of his finest paintings. Simply put, this was the first time I had ever seen such an array of masterpieces in a private house. It was quite mind blowing to suddenly come upon some of the greatest works by Manet, Degas (which was the first work he bought in 1928), Renoir, van Gogh, Seurat, Gauguin, Cézanne, Toulouse-Lautrec, Picasso, Matisse and many others.

Upon his death in 1982, he left the collection partly to his wife Betsey and partly to their philanthropic Greentree Foundation, named after their house and estate in Manhasset, Long Island, created 'to benefit the furtherance of peace, human rights and international co-operation'. The Whitneys had lived in a large, rambling, unassuming-looking house on Long Island close to New York City, yet it contained an indoor swimming pool, squash courts and rarest of all, a Real Tennis court. There was a total of 173 rooms, all of which had to be carefully examined, their contents recorded and valued for probate. Experts from the Decorative Arts department were amazed at having to cope with cataloguing some 110,000 knick knacks: porcelain figurines, oriental lacquer, gold and silver boxes and a multitude of fascinating objets d'art Betsey had collected during her long life.

The family had been loyal Sotheby's clients for many years and, in fact, the first major painting that had to be sold after Jock's death, was Renoir's, *Le Moulin de la Galette,* a smaller variant of the Musée d'Orsay's most popular Impressionist masterpiece. The excitement surrounding that

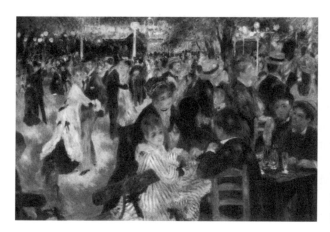

The Whitney Renoir,
Le Moulin de la Galette,
oil on canvas 1876,
private collection

1990 sale was electric, as it also included three of the finest paintings imaginable by Kandinsky, Chagall and Modigliani consigned by the Solomon R. Guggenheim Museum. That was the last sale before the market plummeted following the Japanese debacle. The Renoir, to everyone's astonishment, made a record-breaking price of $71 million, to be eclipsed only twenty-four hours later when van Gogh's *Portrait du Docteur Gachet* was sold at Christie's for $75 million.

Both were bought by a Japanese millionaire, Ryoei Saito, the founder of the Daishowa Paper Manufacturing Company. He was the ultimate personification of conspicuous spending and financial power during the 'bubble' economy explosion and eventual implosion in Japan. Reports from Japan were that he never hung the two masterpieces, but kept them in specially made boxes. After his death in 1996, both pictures had to be sold to repay massive loans he had taken out with a financial institution. The sales were handled very privately by Sotheby's and speculation raged for years as to their final whereabouts, how much they were sold for and the identity of the buyer or buyers. From the various snippets of information I have heard, I surmise that they eventually found their way back to Europe to a very private and secretive collector of masterpieces whom, I also believe, was the under-bidder on both pictures at the 1990 auctions.

Although many of the most important works in the Whitney collection were donated to the Museum of Modern Art in New York, the National Gallery in Washington DC and Yale University Art Gallery (where Jock Whitney had been an undergraduate), sufficient works remained to supply two extraordinary sales. Following Betsey Whitney's death in 1998 at the age of one hundred, the executors of their estate instructed us to prepare a probate valuation of the contents of the house at Manhasset and the apartment in New York. Once again I had the thrill of crossing the Atlantic on a flying visit to see at first hand the famous collection I had last seen in London when it was exhibited at the Tate in 1960.

The first sale took place on 10 May 1999. In that initial auction, one of the paintings I had most admired in the house and which I feared might have been given to any of the museums, was one of the two extremely rare, final studies for Georges Seurat's masterpiece *Un Dimanche à la Grande Jatte* of 1884 (Art Institute of Chicago). This particular study of a landscape with sailing boats on the Seine, depicts a scene devoid of figures, while its sister picture in the Metropolitan Museum includes all the figures which are such an element of the finished masterpiece. It was the first of the significant paintings in the auction, making $32 million, although I was

The Whitney Seurat, *Paysage, Ile de la Grande Jatte*, oil on canvas 1884, private collection

surprised it did not sell for more considering how rare and important it was. Another delightful painting depicting the Seine in 1874 was Claude Monet's *Automne sur la Seine, Argenteuil,* a vision of tranquillity suffused in the light of an afternoon sun. This made a surprisingly modest $2.6 million, but the highlight of that first sale was Paul Cézanne's majestic still life, descriptively titled *Rideau, Cruchon et Compotier,* one of the series of wonderful paintings of that subject which the artist perfected throughout his life. This excellent example from his mature period was bought for $55 million by Steve Wynn.

Picasso's *Nature Morte à la Bouteille de Rhum*, a brilliant Synthetic Cubist work, quite reminiscent of the painting in Stanley Seeger's 1993 sale, realised almost $7.2 million. This was a work that had originally belonged to Gertrude Stein, one of the very first collectors of Picasso's works, and had been sold with a large group of other Cubist paintings from the estate of her lifelong companion, Alice B. Toklas in 1968, to a group of American connoisseurs and the Museum of Modern Art. In fact, just prior to that event Peter Wilson, David Nash and I had gone to view them in a bank vault in Paris with a view to selling them in either London or New York. But, sadly, the lawyers of the Toklas estate decided to take a more direct route by selling them to an American consortium which had offered a very high price in order to acquire them and divide them up among themselves. This was a great disappointment to me, as I had anticipated an incredible sale of the rarest Cubist works by Picasso collected by his friend and admirer, the iconic Gertrude Stein. The Whitney 1999 sale, which also included a fine group of drawings and many

pretty, small sculptures by such artists as Daumier, Rodin, Maillol and Henry Moore, realised a more than satisfactory $128 million.

The second auction took place in May 2004, consigned by the Whitneys' Greentree Foundation, three years after I had retired from Sotheby's. The catalogue contained several of the remaining masterpieces from the collection such as Edouard Manet's *Courses au Bois de Boulogne* ($23.5 million, which Betsey had given Jock as a birthday present in 1942) and other racing scenes by Degas, Dufy and Munnings which mirrored Jock Whitney's lifelong interest in the horse racing world. The greatest excitement of the season was generated by the appearance of Picasso's 1905 *Garçon à la Pipe,* which many expected might finally breach the $100 million mark at auction, finally surpassing the record of $82 million made by van Gogh's *Portrait du Docteur Gachet* in 1990. The Whitneys had bought the painting in 1950 from Walter Feilchenfeldt in Zurich (whose son Walter had spent a year and a half with me in 1965–66) for $30,000. It had previously belonged to the family of the famous Berlin collector, Paul von Mendelssohn-Bartholdy and was the finest Pink Period masterpiece left in private hands. This ravishing painting of a Parisian boy crowned with roses, in blue overalls, a pipe in his hand, seated firmly on a stool, shows him framed against bouquets of roses on a pink wall, his parted legs lending the canvas a strong compositional balance. Enhanced by the simplicity and purity of the two dominant colours, pink and blue, this powerful and poetic vision of a boy has extraordinary appeal.

Seated near the front of the saleroom, rather than behind the bank of telephones when I used to be a member of staff, I could feel the excitement building as the painting appeared on the easel. The auctioneer, Tobias Meyer, started the bidding, slowly at first, speeding up for a while until after the $80 million mark had been reached, the bidding was now being fought between two people, one on the telephone with a member of staff, the other waving his bidding paddle furiously right at the back of the room, barely visible in a sea of onlookers, until he finally won through. The final price, $93 million, which with the buyer's premium added amounted to $104 million, justified our conviction that the old record held by van Gogh's *Docteur Gachet* since1990 could be broken. The identity of the buyer has never been revealed though it was surmised that it was one of the new breed of Russian collectors. The total for the two sales realised $310 million and, if one adds *Le Moulin de la Galette,* the final sum rises to a remarkable $381 million.

The End of 'A Life at Sotheby's'

So ended the 1990s, a decade of moving in and out of recession to a new millennium, a renewed period of ever higher prices for the few masterpieces available. It really was the sale of these fabulous works by van Gogh, Monet and Degas that excited and brought my passions to the boil. Our 2000 summer sale included a classic, Impressionist Monet of 1870, *La Plage à Trouville,* which sold for £10 million, and incidentally had been owned for a time by the Havemeyers' friend and advisor Mary Cassatt, and then became one of the earliest Impressionist paintings sold in America by Durand-Ruel. Surprisingly, and rather fittingly, the very last sale I was directly involved in was not to be an Impressionist auction, but a sale devoted to Surrealism, the first of its kind, that was conceived and organised by Andrew from Paris. We immensely enjoyed working together on this ground-breaking venture that achieved a record price for a Dali of £2.6 million, which stood until this year. It is startling to realise that Monet was alive and occasionally painting when the Surrealist movement came into being in 1924. A few weeks later, on 31 December, I retired from Sotheby's and that last year, the first of the new millennium was a presage of a radical new turn in my life, in every way a new beginning.

1999 saw dramatic changes in my life. It all started on my return from the May sales in New York. I had caught a cold which soon developed into the annual bronchitis which I had suffered from since early childhood. But this time, in spite of courses of antibiotics, it didn't go away and by the beginning of June my doctor referred me to an oncologist at the Royal Brompton Hospital. Following a series of tests, he diagnosed lung cancer and to my horror said I would have to undergo an operation and might lose part or even the whole of my right lung. On the morning of the operation, at the end of that month, as I was about to be wheeled into the operating theatre, the surgeon had a look at the latest x-rays taken the previous evening and discovered that the tumour on my lung had miraculously halved in size. He immediately realised that what I had could not possibly be cancerous, but was simply an abscess the size of a walnut, and told me to get dressed and go home.

The relief we all felt can hardly be imagined and, to everyone's astonishment, I insisted on going back to the office the very next morning, in time for the pre-sale view of the following Monday's June sale in which Degas' *Danseuse au Repos* was due to be sold. Within a few weeks, following an intense course of antibiotics, I had completely recovered, felt quite rejuvenated and confident that life offered more challenges and opportunities.

Sally and me in Brittany,
2001 (photograph
Laurence Jarousse)

At the beginning of that year I had begun to develop a friendship with Sally Lloyd Pearson, a colleague whom I had occasionally run into around the building, especially during sale days in the galleries. Sally, born in 1952 in North Wales, had read History and History of Art at Leicester University and has a great love of many aspects of art. She had been at Sotheby's for seventeen years, starting in the 19th-century Sculpture department where she spent four years as assistant to Robert Bowman, before moving on to Client and Auction Room Services. By 1997 she was Director of Auction Room Services which involved the staffing and running of the Front of House areas including the café. As well as other sale-related activities, paddle registration and House Sales, she was involved in the great German auctions of the princely collections of Princess Gloria Thurn and Taxis at Regensburg and the Margrave Maximilian of Baden at Baden-Baden, where her knowledge of German after years of living in Düsseldorf proved so useful.

Once I left hospital my friendship with Sally took a deeper and more significant turn: by the autumn we had fallen deeply in love. Slender and enchanting, with a gorgeous smile, Sally has a most engaging and generous personality which I found irresistible. By the end of the year my relationship with Sally had blossomed and we had to make a decision about our future; we had no hesitation in deciding we had to spend our lives together. Sad as I was to leave my home of forty years, I was thrilled that my life was looking to exciting new horizons and challenges. Following three years living in London, we finally decided to leave London for Norfolk where we were lucky enough to find the Georgian house of our dreams.

After almost forty years, I was getting tired and disenchanted by the ever more demanding nature and draining pressures of the corporate nature of the business. Quite simply the fascination and the passion I had experienced working at Sotheby's had finally seeped away. I announced my decision to resign in October 2000, just a few months short of my normal retirement age. My colleagues were astonished and could not understand why I should want to leave after 'only forty years at the helm', but in the end they understood my feelings and why I wanted such a change of direction in my life. When I finally did leave, it was in a spirit of friendship. They generously organised a grand dinner for me. I knew I would be expected to make a speech, something I loathed doing, but on the way to the dinner I came up with an acronym that reflected all the qualities I believed were needed to be successful and respected in this rarefied world: that word was P.I.S.S. an acronym for 'Passion, Integrity, Scholarship and Service'. It was delightfully received and when Henry Wyndham, our Chairman, stood up to speak, the first thing he said was, 'Michel, you have been pissed for forty years!' How wrong he was as I hadn't been drunk since my Oxford days some forty-five years earlier, although often inebriated by the excitement of handling great pictures and collections.

By chance, I had received an unexpected call from a close associate of Bernard Arnault in July 2000, asking whether I would be willing to meet Arnault, who wanted to make me an interesting proposition regarding his London auction house, Phillips. Bernard Arnault, a tall, refined looking man in his early fifties, was Chairman and majority shareholder of LVMH (Louis Vuitton Moet Hennesy), the huge French retail conglomerate he had built up in a relatively few years. Following a second meeting, I told him, that although I might wish for a change, I would only do so if I was to move on to an exciting new project. I said that I would not be interested in joining his auction house, but wondered whether he had ever thought of forming a collection of Contemporary Art for LVMH in Paris, much as his arch-rival in France, François Pinault, was doing. The idea appealed to Arnault, as he realised that a museum would be an important boost to the image of his company, especially since Pinault had recently announced his plans, later abandoned, to build his own museum on an island in the Seine. By the end of September a financially advantageous contract had been signed and I was to start work on the project on 1 January 2001. Unfortunately it was to last only a year as the tragic events of 9/11 and the subsequent down-turn in business meant that LVMH and Arnault in particular had to review the structure of his companies and make considerable savings. The board realised it could

not be seen to be acquiring expensive art while thousands of employees were being made redundant.

The following year, I withdrew entirely from the auction world and decided to enjoy peaceful and fulfilling days in the Norfolk countryside. Naturally, I continue to spend one or two days a week in London seeing my family, in particular my mother, now in her 96th year, as well as visiting Sotheby's and the other auction houses to keep abreast of the market and the emerging trends which are important to my role as advisor to several collectors and institutions, including the State Hermitage Museum, St Petersburg. I cannot resist the thrill of a major auction to observe a market whose foundations I helped shape, or the opening day of an Art Fair to see an astonishing array of old and new art.

My life at Sotheby's has given me tremendous satisfaction: one rarely has the opportunity to transform one's passion into a profession. I knew from childhood where I wanted to go and was most fortunate that, through the help and connections of my mother Aline and my step-father Isaiah Berlin, I was able to plunge into the perfect career for me, a career that satisfied my love for painting, for the history of art and, quite quickly to my surprise, I discovered a penchant for the business side of an auction house. Early timidity and a lack of self-esteem fuelled my ambition to succeed, to organise the best sales, to run a well-organised department and to mentor successive homogenous teams of young specialists, several of whom have earned themselves very senior positions at Sotheby's on both sides of the Atlantic.

For almost seventy years my life has been totally absorbed by art and, as David Hockney recently said so succinctly, 'I get intense pleasure through the eyes.' In spite of a sometimes difficult and unhappy childhood, much affected by the early death of my father, I have, thanks to the genes and passions inherited from him and from my grandfather, fostered and encouraged by my mother and grandmother, Marie-Louise Strauss, had and continue to have, a very fulfilling, fascinating and passionate life.

Halvergate, Norfolk 2010

This second edition is also dedicated to the memory of Sami Ofer and Stanley Seeger who both recently passed away.

July 2011

Bibliography

Berlin, Isaiah, *Enlightening, Letters 1946–1960*, edited by Henry Hardy and Jennifer Holmes, Chatto & Windus, London 2009

Berlin, Isaiah, *Mr Churchill in 1940,* John Murray, London 1949

Berggruen, Heinz, *Highways and Byways*, Pilkington Press, 1998

Berggruen, Heinz, *J'étais mon meilleur Client, Souvenirs d'un Marchand d'Art*, L'Arche, Paris 1997

Bowra, C.M., *Memories*, Weidenfeld & Nicolson, London 1966

Buckle, Richard, *In the Wake of Diaghilev*, Collins, London 1981

Demoriane, Hélène, *Jules Strauss et ses Disciples*, in *Connaisance des Arts*, August 1961

Fleming, Ian, *The Property of a Lady*, published in *The Ivory Hammer, the Year at Sotheby's 219th Season 1962–1963,* Holt, Rinehart and Winston, New York 1963

Havemeyer, Louisine, *Sixteen to Sixty: Memoirs of a Collector*, privately printed for Louisine Elder (Havemeyer) and the Metropolitan Museum, 1961

Hermann, Frank, *Sotheby's: Portrait of an Auction House,* Chatto & Windus, London 1980

Hockney, David, a quote from *Imagine,* BBC 1, 30 June 2009

Ignatieff, Michael, *Isaiah Berlin: A Life*, Chatto and Windus, London 1998

Kostenovich, Albert, *Hidden Treasures Revealed*, The State Hermitage Museum, St Petersburg with Weidenfeld & Nicolson, London 1995

Lacey, Robert, *Sotheby's: Bidding for Class*, Time Warner, London 1999

La Famille Deutsch de la Meurthe. d'Hier à Aujourdhui, Editions Pour Mémoire, Paris 2010

McKnight, Gerald, *Picasso's Disputed Millions,* Bantam Press, London, 1987

Mason, Christopher, *The Art of the Steal: Inside the Sotheby's - Christie's Auction House Scandal,* Putnam's Sons, New York 2004

BIBLIOGRAPHY

Norman, Geraldine, *The Hermitage: Biography of a Great Museum*, Cape, London 1997

Pietrovsky, Mikhail, article in *Hermitage Magazine*, winter 2004

Richardson, John, *The Sorcerer's Apprentice: Picasso, Provence and Douglas Cooper*, Alfred A Knopf, New York 2000

Richardson, John, *Sacred Monsters, Sacred Masters*, Cape, London 2001

The Robert von Hirsch Collection, the Collector, his Houses, his Bequests, p.22 quote by Abbé Dulaurens, Sotheby's 1979

Shakespeare, Nicholas, *Bruce Chatwin*, the Harvill Press, London 1999

Strauss, Michel, *Lasting Impressions: Notes on a Colourful Career*, Sotheby's *Art at Auction, The Year in Review*, Conran Octopus, London 1996

Talbot, Ken, *Enigma!* ONT, London 1991

Tancock, John, *The Sculpture of Rodin*, David R Godine for the Philadelphia Museum of Art, 1976

Taubman, A. Alfred, *Threshold Resistance,* Harper Collins, New York 2007

van Gogh, Vincent, *The Letters, The Complete Illustrated and Annotated Edition*, Volume 4, Letters 623, 657 and 741, Thames and Hudson, London 2009

Wildenstein, Daniel, *Monet or the Triumph of Impressionism*, Taschen, Wildenstein Institute 1996, vol.I

Acknowledgements

I owe a special debt of gratitude to Judy Stewart whose advice, help and guidance throughout the writing of my memoirs has been invaluable in pointing me in the right direction. She has provided me with the structure for such a project, some necessary research and above all encouragement to undertake what seemed to me initially a mammoth task, the like of which I had never tackled previously. Others have assisted me in editing a manuscript that needed much valuable revision. These are my wife, Sally, whose adherence to correct grammatical principles and sentence construction, has made this memoir flow far more fluently than I could ever have achieved. My son Andrew has read most of the chapters and contributed many ideas and details of our family and professional lives. Finally the strict editing by my sister-in-law, Martine Halban, has prevented me including irrelevant passages and helped me produce what I hope is an interesting account of the extraordinary life I have had at Sotheby's.

I am eminently grateful to members of my family and those former colleagues with whom I recorded our memories of the years we worked together and the exciting sales and events we shared. All have been invaluable in helping me remember the past, especially since I never kept a daily journal, and have been generous with their recollections. To the following I give my sincerest thanks: Aline Berlin, Sally Strauss, Andrew Strauss, Julia Strauss, Nadine Baer, David Nash, David Ellis-Jones, Thilo von Watzdorf, Julian Barran, Marc Blondeau, Marcus Linell, Melanie Clore, Philip Hook, Stephen Somerville and Marie-Anne Krugier. Others who have given me much assistance include my grand-daughter Victoria Caetana Strauss who suggested the title of my

memoirs, Jana Gromova, Lucy Economakis, Alexander Halban, Nick Wilby, Leslie Gardner, Paul Horan, Henry Hardy, Evelyne Ferlay, Matthew Weigman and the Sotheby's press office, Hayley Thompson and her Spire team for the design and production. I would also like to thank Caroline Pirie who had the unenviable task of transcribing recordings of conversations, made sometimes in situations where it was difficult to filter out background noise. Finally, I owe a deep debt of gratitude to my half-brother, the publisher Peter Halban, along with his wife Martine, for bringing this work into fruition.

Credits

Index

CATALOGUE

des

Tableaux Modernes

ET AQUARELLES

COMPOSANT LA

Collection de M. Jules Strauss

Préface d'Arsène ALEXANDRE

Dont la vente aura lieu à Paris

HOTEL DROUOT SALLES Nos 7 & 8

Le Samedi 3 Mai 1902, à 2 heures

COMMISSAIRE-PRISEUR :	EXPERTS :
Mᶜ PAUL CHEVALLIER	MM. BERNHEIM JEUNE
10, rue de la Grange-Batelière	8, rue Laffitte et 36, avenue de l'Opéra

EXPOSITIONS :

PARTICULIÈRE : *Le Jeudi 1er Mai 1902*

PUBLIQUE : *Le Vendredi 2 Mai 1902*

De 1 heure 1/2 à 5 heures 1/2

ENTRÉE PAR LA RUE GRANGE-BATELIÈRE